*Penguin Handbook*
Photography

Eric de Maré, A.R.I.B.A., has been enthusiastically
'building with light', as he calls photography,
since he was given a box camera on his tenth
birthday. He was born in London in 1910 of
Swedish parents, but has Huguenot ancestors. He
worked on the *Architects' Journal* for some years
and then started freelancing by canoeing across
Sweden with his wife and a camera. In 1948 he
explored the English canals and this resulted in a
special issue of the *Architectural Review* and a book,
*The Canals of England*. His other books, mostly
illustrated with his own photographs, are *Britain
Rebuilt, Scandinavia, Time on the Thames, The
Bridges of Britain, Gunnar Asplund, London's
Riverside, Photography and Architecture, Swedish
Cross-Cut: A Book on the Göta Canal, The City of
Westminister: Heart of London, The London Doré
Saw: A Victorian Evocation, London 1851: The Year
of the Great Exhibition, The Nautical Style, Wren's
London* and, companion to this volume, *Colour
Photography* (also available in Penguins). Between
1965 and 1967, an Arts Council exhibition of his
architectural photographs on *The Functional
Tradition* toured the U.K. As a Social Credit
advocate of long standing, he spreads the idea
that, with machines to toil for us, a new age of
creative (paid) leisure for all should be our aim.
Meanwhile he tries to lead as free a life as
monetary pressures will permit.

To
all who remember Vanessa

# Contents

PART ONE

## History and Purpose

PART TWO

## The Camera and How to Use it

# Contents

# List of Text Figures

# List of Text Figures

# List of Plates

## List of Plates

## List of Plates

# Introduction

## The Purpose of this Book

This is a book for the amateur. The word amateur is used here in its full sense to mean not only tyro but lover.

The chief aim of the book is to teach the unskilled novice how to use the camera as a tool for creative personal expression. It is written so that it can be understood by those who have never taken a photograph in their lives before. At the same time it should interest the advanced amateur in that he may be able to use it for reference, to glean useful tips from it, to gain a clearer conception of what he wants to 'say' with his camera and perhaps to find inspiration in the illustrations.

The reader may merely wish to learn how to obtain adequate records of his children as they grow and then he may like to skip Part I, for this is historical and philosophical. But these chapters should interest the earnest amateur. We can understand the present only by knowing the past. As G. K. Chesterton wrote: 'A man sees more of things themselves when he sees more of their origin; for their origin is a part of them, and indeed the most important part of them.'

We must also understand clearly what we are aiming to do if we are to be successful. 'Each operation has a *raison d'être*, that is an *object*; that object once determined fixes the nature and the value of the means,' said a famous general. My history and theorizing are therefore not purely academic; they are practical.

I have included a section on colour photography, but cinematography has been omitted as being too special a subject. Suffice it to say that the mastering of still photography is the main step towards the mastering of moving photography.

## Introduction

### What is Photography ?

The word comes from the Greek *photos* meaning light and *graphos* meaning writing. Writing with light. The word camera comes from the Greek *kamara* meaning anything with an arched cover. It has come to mean a room or a box, a photographic camera being a light-tight box with a light-sensitive film at one end and a lens or pin-hole to admit the light image at the other.

The effect of light on certain chemicals is to change their character and in so doing to make them appear grey or black. Hence the film in a camera records the light parts of an object as dark and the dark as light. A negative is produced from which a positive must be made on light-sensitive paper or film before the proper image of the recorded object is revealed. Though this negative-to-positive process is more complicated than one which would give a direct positive on the film, it has three great advantages: a master negative is produced from which any number of prints can be produced; a positive enlargement (or reduction) can be created; and adjustments can be made during printing to obtain, by controls of various kinds, the best possible results.

All this is elementary and from these basic statements I will evolve a full explanation of modern cameras and processing technique, including the development of the Latent Image on plate, film, or paper and its permanent fixing with chemicals.

### The Value of Photography

I hope that the book will also be of interest to those who are concerned with the visual arts in general. It may help, in some small degree, to set photography in its own proper place among these arts. Painters and sculptors are apt to despise the creative claims of photographers. This is due to ignorance, prejudice, and perhaps to a weariness with the spate of Cotswold cottages, coarse old skins, and cosy kittens which fill the annual photographic exhibitions.

But photography should be recognized as an art in its own right – a limited art and an art 'not fine', but an art nevertheless.

Like every other medium of expression, photography must realize its limitations, but it must also realize its own unique, intrinsic powers. To try to define those powers is another purpose of this book.

It is said that the number of amateur photographers in Great Britain is now over fourteen million who, in 1968, spent £95,000,000, and that in America two out of three families own one or more cameras. Photography might therefore be called a new Folk Art – a folk art of the technological age.

Photography is also a new international language and supports a great international industry; as such it is represented by the famous international photographic fair held at Cologne every two years and called Photokina, which, as well as being a trade exhibition, is a world forum having cultural ideals.

The general effects of photography on modern life have been universal and incalculable. The camera has, indeed, given us a new way of seeing things. It has provided us with a Third Eye. The late Laszlo Moholy-Nagy, who was one of the original teachers at the famous Bauhaus school of design at Dessau during the Weimar Republic days, has expressed this well in his book, *Vision in Motion*:

Photography has not yet achieved anything like its full stature; has not articulated its own intrinsic structure. Yet this lack of 'results' does not contradict the almost unbelievable impact which photographic vision has had upon our culture. It is unprecedented that such a 'mechanical' thing as photography – regarded so contemptuously in the creative sense – should have acquired in barely a century of evolution the power to become one of the primary visual forces of our life ... Many people may not realize it, but the present standard of visual expression in any field, painting, sculpture, architecture, and especially the advertising arts, is nourished by the visual food which the new photography provides.

So important did Moholy-Nagy consider photography to be that he could add:

The knowledge of photography is just as important as that of the alphabet. The illiterate of the future will be the person ignorant of the use of the camera as well as of the pen.

## Introduction

There perhaps he exaggerated, but it is certainly true that the camera can help to provide an education by means of which all the visual arts can be the more appreciated and enjoyed. The very act of photographing a fine building, for example, will somehow enable the photographer to see that building thereafter with a fresh vision – almost as though he had himself taken a hand in its creation. The photographer develops his Third Eye and both the visible world and the visual arts thus become for him the richer and the more full of wonder and interest.

I have noticed that people who have not been educated in visual aesthetics will often accept with delight even purely abstract patterns when they are produced by photography, whereas they are unable to enjoy such abstract form in painting, drawing, or sculpture and are even irritated by it; prejudice excludes enjoyment. This suggests that photography can be a *way in* to the appreciation of all the visual arts, an educational eye-opener – and that it could be treated as such in schools.

Photography is a satisfying means of expression open to anyone with a few pounds to spare. Technique is not hard to acquire, in spite of the alarming array of handbooks and of complex glittering equipment on show at the photographic shops. Nor need essential equipment cost much; even an old box camera can do remarkable things if its limitations are accepted.

The camera has revealed new wonders and surprising patterns in the world around us – the close-up texture of a piece of sawn wood, the design of human skin magnified 40,000 times by the electron microscope, the ploughed spirals of a sabotaged airfield seen from a plane (Pl. 31), the lovely organic pattern of an electrical discharge (Pl. 55, bottom), even the smell-swirl of a coffee bean, to take a few random examples out of thousands of possibilities. The photographer can select from apparent chaos an aesthetically significant pattern in space-time if he has developed his Third Eye with which to see it. 'For this is the power of the camera: it can seize upon the familiar and endow it with new meanings, with special significance, with the imprint of a personality.' (Beaumont Newhall in his *History of Photography*.)

At any rate, photography is fun. This book may help you to find it so.

**PART ONE**
*History and Purpose*

# 1 Historical Sketch

## Development of Photography as a Science

When artists began to apply perspective to painting in Renaissance times, they found the *camera obscura* – the dark-room – useful. It is believed to be an Arabic invention of the eleventh century and was first used for observing solar eclipses. Leonardo da Vinci described the idea. It consisted of a dark room having a minute hole in one wall through which light entered, casting an inverted image of the outer world on to the opposite wall. In 1550 Girolamo Cardano produced a more brilliant image by substituting a lens for the pin-hole. The principle of the camera has therefore been known for some time.

Light-sensitive chemicals were not known to the Renaissance painters and the image produced by the *camera obscura* was traced on to the wall, perhaps as the basis for a painting or sketch. At first the camera was large enough to contain a man but later it was reduced in size. In the eighteenth century the *camera obscura* – now also *portabilis* – consisted of a box with a lens at one end and a ground-glass screen at the other so that the image could be seen outside the camera. Finally a model was produced having a mirror within (like a reflex camera) which cast the image upwards and allowed it to be seen the right way up. Such cameras could be transported anywhere and were much used by amateur artists.

The effect of light on chemicals has also been known for a long time, two of its aspects being the tanning of human skin and the bleaching of cloth by sunlight. A Chinese scholar has claimed that he has found traces of china plates made sensitive to light by chemical means 2,000 years ago. The darkening of silver nitrate when exposed to sunlight was recorded by Angelo Sola in 1614 and in 1727 Johann Schulze, the German physicist, discovered that a mixture of chalk, silver, and nitric acid turned to deep purple and could form images when exposed to light. Then

later in the century Carl Scheele, the Swedish chemist, found that the blackening of silver salts by light was due to the liberation of pure silver; he also found that the violet end of the spectrum blackened the salts far more quickly than the other rays.

Both the optical and chemical foundations of modern photography were therefore known well over two hundred years ago.

At the beginning of the nineteenth century, Thomas Wedgwood, the son of the founder of the Wedgwood potteries, was making negative prints by bathing paper in silver nitrate solution, laying a drawing on glass over it, and exposing it to light. He found that half-tones could be recorded in this way as well as black and white. He also tried to record images through the *camera obscura*, but the silver nitrate was not sensitive enough and attempts to use the more sensitive silver chlorate were not successful. Nor was Wedgwood able to fix his results; as soon as the paper with the image upon it was exposed to the full light the whole sheet soon became black all over.

In permanently fixing images the Frenchman, Joseph Nicéphore Niépce (1765–1833), was more successful. He produced a plate which could bear a latent image – that is an image which is not visible until it has been developed in a chemical. He later applied an acid fixing method to glass plates exposed in a camera and in this he was apparently at least partly successful.

The one record of Niépce's photographic work in existence came to light only recently and this definitely established him as the first man to have obtained a picture from nature with a camera in the modern photographic sense. This record was reproduced in *The Times* for 15 April, 1952, with a description by a correspondent (Mr Helmut Gernsheim). It is on a highly polished pewter plate and shows a somewhat woolly view of the courtyard of Niépce's house taken from the window of his work-room. A label on the back in the writing of the botanist, Francis Bauer, F.R.S., who recognized the importance of Niépce's discovery, describes the picture as the first successful experiment from nature. In the words of *The Times* correspondent:

Niépce coated the plate with a solution of bitumen of Judea, which he found was soluble in certain oils in its normal condition but became insoluble after exposure to light. Its light-sensitivity was low, and the

exposure in the camera lasted about eight hours on a summer's day. After exposure, the latent image was made visible by washing the plate with a mixture of oil of lavender and white petroleum, which dissolved away parts of the bitumen which had not been hardened by light. The result was a permanent direct positive picture.

There is no exact agreement on the year when Niépce first succeeded in taking a permanent view from nature, but the inscription on the giant stone plaque which travellers from Paris to Marseilles can see by the roadside at St-Loup-de-Varennes, four miles south of Chalon, where Niépce's country estate called Gras was situated, reads: 'Dans ce village Nicéphore Niépce inventa la Photographie en 1822.' The metal of the plate of the world's earliest photograph, however, has suggested to experts that the proper date may be in 1826 – that is nine years before Talbot produced his first paper negative showing the lattice window of his library at Lacock Abbey and eleven years earlier than Daguerre's earliest surviving work, a still life of 1837 made in his studio and now preserved at the *Société Française de Photographie*.

In 1829 Niépce joined in partnership with Jacques Mandé Daguerre (1789–1851) after several years of mutual secretiveness and polite distrust. Daguerre was a skilled scenic painter, one of the inventors of the spectacular Diorama with its lighting effects moving over painted landscapes, and Niépce badly needed the help of Daguerre's camera technique. In 1833 Niépce died and Daguerre then proceeded to modify Niépce's Heliography, producing his first Daguerreotype in 1837.

The new process consisted in rubbing over a copper plate with silver mixed with a pumice powder and sweet oil. The plate was then washed in a liquid consisting of distilled water and nitric acid in the proportions of 16 to 1. Next the plate was slightly heated over a flame and the plate was then washed a second time in diluted nitric acid. The room was darkened and the plate was placed over a tray of iodine which, slowly evaporating, formed a yellowish coating of silver iodide on the plate's surface. The plate was now placed in the camera which had been previously focused on an exterior view; the exposure lasted from five to forty minutes according to the light conditions. No image was apparent until

the plate was placed in a box above a pan holding mercury which was heated up to 117°F. The mercury vapour rose, combined with the silver iodide, and the image was slowly revealed; the process could be watched through a peep-hole. When development was complete the plate was washed in distilled water saturated with common salt or with hyposulphite of soda heated nearly to boiling-point.

After Daguerre's process had been made public in 1839 it became a craze and Daguerre was lionized. A contemporary Frenchman relates:

Opticians' shops were crowded with amateurs panting for daguerreotype apparatus, and everywhere cameras were trained on buildings. Everyone wanted to record the view from his window, and he was lucky who at first trial got a silhouette of roof tops against the sky. He went into ecstasies over chimneys, counted over and over roof tiles and chimney bricks, was astonished to see the very mortar between the bricks – in a word, the technique was so new that even the poorest proof gave him indescribable joy.

By 1842 great improvements had been made. For one thing, a double lens passing sixteen times more light than the old single meniscus had been invented in 1840 by Professor Josef Petzval and had been produced by Peter Voigtländer in Vienna. For another, an accelerator called Quickstuff, by giving an additional fuming of the plate with bromine, could allow less exposure time. Now portraits could be made with exposures of less than a minute whereas previously exposures of 8 minutes under bright sunlight had been necessary. Now also the finished surface of the plate could be hardened and enriched in appearance by treating it finally with a solution of gold chloride. The result of these improvements was the growth of commercial portraiture indoors. In New York in 1850 no less than seventy-one galleries were in existence and in England Richard Beard, at one time a coal merchant, made £40,000 in one year from the chain of daguerreotype studios he owned.

The best examples of daguerreotypes are beautiful things, showing exceptionally fine detailing. But the method had disadvantages and led to a dead end. The single plate could not be duplicated, it was expensive, and its surface was fragile. At the

same time as Daguerre another important figure had entered the stage – the English patrician and amateur scientist, William Henry Fox Talbot (1800–77). He had already been experimenting along his own lines while Daguerre was developing Niépce's Heliography, though neither knew of the other's work until 1839. Then Talbot heard of Daguerre's experiments and this spurred him on to produce his first and best possible results from his own methods.

In 1833 he had been on holiday in Italy and had amused himself there by casting landscapes on to paper through a *camera obscura*. These were 'fairy pictures, creations of a moment', he wrote in his book, *The Pencil of Nature*, published with photographic illustrations in 1844. He goes on: 'It was during these thoughts that the idea occurred to me – how charming it would be if it were possible to cause these natural images to imprint themselves durably, and remain fixed upon the paper!' The key word there is 'paper'.

Returning to England, Talbot at once began experimenting, and during his researches he learned about Thomas Wedgwood's work. Before long he had managed to produce a light-sensitive paper by bathing it first in a solution of common salt (sodium chloride) and then, when it had dried, in one of silver nitrate. Together the chemicals formed silver chloride. On this treated paper he made contact negatives, as Wedgwood had done, of things like lace and leaves – what we would call photograms today. He fixed the prints either with common-salt solution or with potassium iodide so that they could be examined in daylight. The fixing was inadequate and the prints slowly darkened all over.

Sir John Herschel, the astronomer, became interested in Talbot's work and, in a letter of 1839 to Talbot, Herschel applied for the first time to his friend's experiments the word Photography in place of the term Photogenic Drawing which Talbot was using.

Talbot's photograms were, of course, negatives, but he soon evolved a method of reversing them to form positives by printing them on to a second sheet of sensitized paper. Here also Herschel established two more words in photography: the first picture he called the Negative, and the reversed copy the Positive.

This negative-positive method was a most important advance and gave a great advantage to Talbot over Daguerre in that any number of positives could be printed from the one original negative. The principle remains a fundamental of modern photography. Nevertheless the daguerreotype was at first far better in detailing than Talbot's woolly paper product.

In time Talbot improved his methods. Herschel suggested to him that a more permanent way of fixing results might be achieved by using hyposulphite of soda to wash away the surplus silver chloride, and this suggestion Talbot adopted. He also made his paper more sensitive to light by bathing it in potassium bromide as well as in silver nitrate. And before long he was using cameras in the grounds of his beautiful home.

In 1840 his chemical process was modified and the results were first called Calotypes and later Talbotypes. This new process, unlike the previous ones, involved the latent image. The paper negative was first bathed in silver nitrate and then in potassium iodide. Silver iodide was formed and this became extremely sensitive to light when the negative was further bathed in a mixture of gallic acid and silver nitrate. This mixture was also used after exposure to develop the latent image. The fixing was done as before in hot hypo and printing was done on his silver chloride paper.

These calotypes, though less commercially successful than the daguerreotypes, were made by many people under the patent Talbot had secured, two notable photographers in this medium being a painter, David Octavius Hill, and a young chemist, Robert Adamson, who worked together in Edinburgh. Their photographic portraits are now renowned and are indeed of a unique character, conceived in respect for the paper medium in bold, simple masses of light and shade with limited detailing (Pl. 1). Their pleasing character is enhanced rather than weakened by the texture produced by the paper fibres of the negative through which the light had to pass when a print was made. Details could not be fully conveyed, in spite of the use of the finest and thinnest papers and in spite of the improvement brought by waxing the paper negative to increase transparency.

In America the calotype did not become popular, but in France

it flourished, especially under the hand of Louis Blanquart-Evrard, who evolved improvements, especially in the coating of his paper with white of egg to make a smooth surface. First proposed as a negative paper, it was later generally adopted during the rest of the century for prints under the name of Albumen Paper. Blanquart-Evrard also made his printing paper more sensitive so that prints could be reproduced rapidly in bulk, and he set up a print factory where handsome albums of architectural and travel photographs were made by the thousand.

From all the above facts it can be seen that no single person invented photography, but that it evolved and that the 'inventor' was a composite, international figure.

Calotypes could not produce brilliance of detailing and for some time experiments were made to use glass as the basis of negatives. Here the difficulty was to make the silver salts stick to the shiny surface of the glass and many substances were tried, including snail slime. Then in 1847 Niépce de Saint-Victor, nephew of Nicéphore Niépce, invented the Albumen Plate having iodized white of egg as an ingredient of its coating. This gave excellent adhesive results, but it was so insensitive that only landscape or architectural work produced with long exposures was possible with it; portraiture was out of the question. But in 1851 along came Frederick Scott Archer, an English sculptor, with a new and important invention – the Collodion Process. It was soon to supersede the calotype entirely and eventually the daguerreotype too.

Collodion, discovered in 1847 as a protection for wounds, is a mixture of gun-cotton (cellulose nitrate) and alcohol and forms a strong skin on a glass plate when it dries. Archer added potassium iodide to collodion and then coated the glass plate with it by flowing the liquid over it; then dipped the plate into silver nitrate in a dark-room, placed this in a light-tight holder with a sliding front, and exposed the plate in the camera while it was still wet. Development was made in pyrogallic acid or ferrous sulphate and then the film of collodion was stripped from the glass, washed, fixed in hypo or in potassium cyanide solution and washed again. Soon the film was left permanently on its glass backing. The process became known as Wet Plate. The images produced were

of excellent definition and combined the brilliance of the daguerreotype with the advantage of printing from a negative of the calotype (Pls. 3, 8 top, 17 top, 28 top, 29 top, 47 top).

After the collodion, or Wet Plate, the next major advance was the Instantaneous Photograph made on a dry plate. As an issue of the *British Journal of Photography* of 1879 rightly remarked, the year would 'be looked back to in the future as one of the most noteworthy epochs in the history of photography' because in 1878 Charles Bennett, basing his work on the earlier experiments of Dr Richard Maddox, with a negative emulsion made with the gelatin invented by Maddox to which cadmium bromide and silver nitrate were added, had produced plates which could take snapshots at 1/25th of a second. Beside being fast, these plates could be inserted into the camera in a dry state. This was a revolutionary advance for now, not only could snapshots be taken with the camera held in the hand instead of on a tripod, but all the cumbersome clutter of Wet Plate, as well as all its messy preparation, could be avoided. Moreover, the plates could be processed after exposure at any time in a comfortable dark-room. The new use of gelatin was very important; it is still a basic ingredient in photographic emulsions and has no less than five functions.

The successful Wet Plater had to be a determined character and of tough moral fibre. Every exposure needed skilful preparation and individual treatment, and the casual, hit-or-miss ways of modern photography with its easy dry plates and films bought ready-made in a shop, were not possible. For a start, the Wet Plater had to carry with him an enormous camera, a huge tripod, a batch of heavy glass plates, a dark-room tent, and a chest of chemicals, apart from bottles, dishes, and a supply of distilled water. Having prepared his plate and exposed it, he had to develop it and fix it at once. And the cost of glass plates and silver nitrate was high. Francis Frith, a master wet-plate photographer, who recorded Egyptian temples in the 1850s, has related how the heat within his dark-room tent was sometimes so intense that the collodion boiled; at other times sandstorms would ruin his plates. The studio wet-plate man was, of course, not so affected and during wet-plate days professional portraiture flourished.

When the dry plate came in, manufacturers began to make these new plates in quantities and the business of processing other people's work *en masse* was born. During the 1880s modern amateur photography, and the huge commerce it supports, was born, and many kinds of hand cameras came on to the market. The most famous firm of all was founded by George Eastman (1854–1930), who began as an amateur and later manufactured dry plates at Rochester, New York. In 1888 he introduced his first Kodak camera, a box which was loaded at his factory with a roll of paper coated with a gelatin-bromide film taking a hundred exposures. The whole camera was sent to the factory after the exposures had been made and there the roll was processed, the gelatin film being stripped off the paper and mounted on glass. Then the camera was reloaded and returned to the owner. 'You press the button; we do the rest.' In 1889 Eastman introduced to the public the transparent celluloid film and these the amateur could process himself. (Celluloid had been invented by Alexander Parkes in 1861.) That was a tremendous advance.

The early hand cameras were often called Detective Cameras because surreptitious snapshots could be taken with them. They became a popular craze and were sometimes disguised as paper parcels, or pieces of luggage, or they were hidden in hats and the handles of walking-sticks. They brought a new power – that of the documentation of human activity realistically, the capturing in permanent form of the fleeting instant of life passing by. Thus was born photographic journalism – that is, if we discount the earlier wet-plate 'stills' of war-photographers like Fenton and Brady.

When the dry gelatin film had become established, photography grew more scientific. Precise measurements of the effects of light on films were made and in this work Hurter and Driffield were pioneers. In 1890 they published the results of their researches in the *Journal of the Society of Chemical Industry*, opening their article with the classic aphorism:

The production of a perfect picture by means of photography is an art; the production of a technically perfect negative is a science.

Hurter and Driffield also brought an advance in processing technique. Their calculations made possible the development of

films and plates by the time-and-temperature method – the development, that is, in complete darkness during an exact and predetermined time fixed according to the length of exposure, the kind of developer used and the temperature of the developer during processing. No longer was it necessary to watch the development of negatives in a dim red light and so produce uncertain results empirically. This advance meant that the discovery made by Hermann Vogel in 1873 could be applied – the discovery that if emulsions were treated with certain dyes, they became more sensitive to other colours than blue and the more correct rendering of colour tones could be secured. In time plates and films which were more or less sensitive to all colours except red came to be called Orthochromatic. Finally, in the 1880s a new emulsion was produced which was sensitive also to red and this was called Panchromatic.

Emulsions for printing papers also developed and became more sensitive to light. The old form of paper called P.O.P., or Printing Out Paper, was printed in the sun with the plate in contact with the paper; the image appeared visibly and this was fixed with hypo. The new emulsion held a latent image and had to be developed as well as fixed, but it had the advantages that printing could be accomplished rapidly in artificial light and enlarging became possible. This was called Gaslight Paper and was used up to recent times for contact printing. The enlarger itself, however, is as old as the year 1857, for then an American, David Woodward, invented the Solar Camera, a huge affair used in sunlight which required exposures taking many hours.

Towards the end of the nineteenth century the camera itself was developing, especially so its lenses. In 1884 barium crown glass was applied to lenses, which allowed far more correct rendering of the outside world. Soon the new Anastigmat lens replaced the old Rapid Rectilinear, which had at least cured the trouble of the curving of vertical lines at the sides of the picture; the anastigmat cured other faults too.

By the end of the nineteenth century, then, modern photography was firmly established. The technical advances made since then have been rather in degree than in kind – at least in black-and-white.

Two minor printing innovations came as side-streams in the nineteenth century. The first was the platinum printing paper patented by William Willis in 1873. Platinum is more stable than silver and so more permanent prints could be made with it. Moreover, platinum printing paper gave charming results in its softness, its range of tones, and in the variety of matt texture in the paper backing, which could not be attained with the glazed albumen paper. Platinum paper went out in the 1930s, perhaps because of its cost and because of the great improvements and added variety of the silver papers which the manufacturers were producing.

The second innovation was the gum bichromate process, which seems to have been discovered in the 1850s but was revived as a vogue in the early part of this century. The process consists of grinding pigments, mixing them with gum arabic as a medium and with soluble potassium bichromate, and applying this mixture to the paper as a wash. When dry the paper is exposed to daylight under the negative and the print is then developed in warm water until the unexposed parts of the pigmented gum are washed away. The process allows considerable control in printing because local areas can be washed away by hand with a brush dipped in hot water and weak areas can be strengthened by re-coating the print and re-exposing. In that it is a control process it is similar to the later Oil, Bromoil, and Bromoil Transfer methods because modifications can be made in all of them by manual manipulation of a brush.

These control processes have for some time been severely criticized by 'straight' or 'pure' photographers, partly because the temptation to copy freehand graphic arts such as crayon or charcoal drawing has rarely been resisted by its exponents. They have one useful feature, however: they produce everlasting prints.

During the twentieth century the most significant developments, apart from those in colour, occurred in the 1920s when lenses were improved to such a degree that 'what you can see you can photograph'. With these lenses came the miniature camera, and through the years of this century steady improvements have been made in films, printing papers, and developers. Thus enlargements can now be made to almost any reasonable

size, not only from the whole of tiny negatives but even from selected parts of these negatives.

As a result of these advances, an Available-Light, or 'Use What You've Got' school has arisen, a school which prefers to be free of lighting encumbrances and to snap under whatever lighting conditions happen to be available – perhaps even in an ordinary room lit only by tungsten lamps (Pl. 16 top), or in a street at night. Devotees of this school are able to extend the conditions where direct, natural, straight photography is possible with the aid of $f/2$ lenses, fast films, fast developers, faith, hope, and the charity of good luck.

The first and most famous of the miniature cameras was the Leica, in which thirty-six negatives measuring 1 inch by $1\frac{1}{2}$ inches could be taken on 35-mm. cinematograph film. Its inventor was a German, Oskar Barnack, who was a microscope-maker in the Leitz optical works. There he constructed the first Leica camera as an instrument for testing the correct exposure for cinema film. These new hand cameras were a development of the earlier Detective Cameras; they were called Candid Cameras because they enabled snapshots to be taken even indoors without the sitters being aware that they were being photographed. An early Leica exponent was a Berliner, Erich Salomon, who became so renowned for his photographs of the famous that the French statesman, Briand, is reported to have remarked: 'There are just three things necessary for a League of Nations conference: a few Foreign Secretaries, a table, and Salomon.'

Lenses are still made from glass and this means that, owing to grinding problems, their surfaces must be spherical in shape. This causes aberrations which are corrected by building up a complex of concave and convex lens components. If aspherical lenses could be made, they would become much simpler and more correct. Perhaps transparent plastics may before long produce a revolutionary advance in lens making, for plastic lenses could be moulded to any required shape. So indeed may glass but at some cost.

Precision enlargers and fine-grain developers have made possible the enlargement of miniature negatives to sizes of 30 inches by 40 inches at least. Another gain for the miniature camera is that

the cost of each negative is so cheap that the wasting of a number of experimental shots on one subject is of little consequence.

The final major development in black-and-white photography has been in artificial lighting, especially in its application to portraiture and studio work. But the roots of modern lighting go back some way. In the middle of the nineteenth century Nadar, the Paris artist and wet-plate photographer, first experimented with artificial light and with this managed to record the Paris catacombs piled high with human skeletons. And in 1870 an American advertisement shouted: 'A Revolution in Photography. Pictures taken by Artificial Light. Equal to Sun-pictures!' In commercial portraiture, controlled lighting became in the last decades of the nineteenth century as important as the scenery, the props, and the retouching.

Magnesium flash-powder, with its uncertainty, its fumes and its stink, was among the first methods of lighting indoors, but in 1929 a great advance came with Ostermeier's German patent for electric Photoflash bulbs filled with aluminium foil. At first these bulbs were ignited with the camera on a tripod and its shutter left open. Today the Photoflash bulb is attached to the camera so that the opening of the shutter coincides with the flash; this synchroflash makes snapshooting possible with the camera held in the hand and pictures can now be taken anywhere, at any time.

The latest lighting development has been in the electronic lamp, an expensive but wonderful gadget which, now made in small sizes, is tending to replace the flash bulb. It was first designed in 1931 by Dr Harold E. Edgerton of the Massachusetts Institute of Technology as a means of photographing rapidly moving objects, and, in principle, it consists of building up current to a high voltage in a condenser and then of discharging it in a gas-filled glass tube. The flash is of great intensity and of brief duration – perhaps 1/3000th of a second – and the flash can be repeated rapidly at will. This means that stroboscopic pictures can be made – that is the recording on the one negative of a moving object in a series of positions (Pl. 25 bottom). Such recording is of particular value in scientific research, but it has aesthetic possibilities too. Another value of the electronic lamp is that it can record rapidly moving objects as though they were static – a

bullet passing through a sheet of glass, the splash formed by a drop of milk (Pl. 55 top), an owl in flight (Pl. 38 top).

Modern photographic lighting, in which we must include also the brilliant flood lamps which can be manoeuvred and kept continually burning as we seek the right effect before exposing, has given the photographer a new scope, especially in portraiture.

Another recent development is the electric exposure meter, which came into general use about 1930. This has greatly simplified the old problem of accurately calculating correct exposure.

One hundred years of development can be summed up thus: The first daguerreotypes, taken in sunlight in 1839, needed an exposure time of about one hour. In 1975 an American scientist clearly photographed a bullet passing through an apple at one three-millionth of a second exposure.

Before long ordinary commercial films for amateur use having fifty times the present highest speeds may be made. And photography may undergo a revolution: Xerography now allows prints to be made without wetness by electrostatic means; negatives may be made the same way in time. The photographic industry now uses more silver than the Royal Mint; one day it may use none.

Another possibility is that before long the photographer will load only with negative colour films when these have been perfected and become lower in price, for then good black-and-white prints will be obtainable from them as from the present black-and-white films as well as colour prints.

## Development of Photography as an Art

From the start schools of painting influenced photography – literary-romanticism, every-picture-tells-a-story naturalism, impressionism, post-impressionism, expressionism, cubism, surrealism and action painting. And in its turn photography has influenced painting, whether painters are aware of that or not. The confusion of photography with the freehand graphic arts has from the beginning put a brake on photography as creation.

Though daguerreotypes first represented townscapes, landscapes, and still life, they became chiefly applied to portraiture.

Each plate was a single work kept in a decorated leather case and considered by the middle-class people who patronized the new process as a kind of jewel and something also of the type of portrait which only kings and noblemen had hitherto been able to afford. The daguerreotype was considered to be a kind of 'painting', and therefore 'art'. The talbotype, or calotype, however, with its rougher texture and detailing and its power of being repeatedly reprinted, was regarded more as an 'etching', and rather less of a 'fine art' in that it could be mechanically reproduced.

Talbot described photography as a 'royal road to *Drawing*'. The Scottish collaborators, Adamson and Hill, were strongly influenced by painting, especially by Rembrandt's works, but they produced masterpieces of a specifically photographic character in spite of that, using the calotype paper negative deliberately to create an effect of well-balanced compositions built up of broad tonal masses (Pl. 1). Octavius Hill is remembered now for his photographs – not for his paintings.

The naturalistic Victorian painting, in which the subject matter, the 'story', was mistaken for aesthetic content, was little different in intent and appearance from such composite photographic works as Rejlander produced. As a critic of 1861 remarked in an article entitled 'On Art Photography': 'Hitherto photography has been principally content with representing Truth. Can its sphere not be enlarged? And may it not aspire to delineate beauty, too?' Photographers, he wrote, should produce pictures 'whose aim is not merely to amuse, but to instruct, purify and ennoble'. Rejlander's allegorical 'The Two Paths of Life' typifies this approach with its moralistic depiction of Religion, Charity, and Industry opposed to Gambling, Wine, Licentiousness, and other vices – Repentance being in the middle. Today we do not regard such moralizing as having any direct connection with art.

In portraiture this kind of puritan preaching was not possible and from the beginning photography has displayed its own best qualities in this sphere. Mrs Cameron produced genre pictures which oozed sentimentality, but her famous portraits are unselfconscious, powerful, and directly photographic in quality (Pl. 3).

Another great portraitist in wet plate was Nadar, alias Gaspard Félix Tournachon, writer and painter of the Latin Quarter, who

produced in his studio many unaffected, and technically excellent, portraits of the notabilities of his day – Sarah Bernhardt, Baudelaire, and Dumas (Pl. 47 top) among many others. Though he believed himself that he was deserting art when he took to the camera, he was certainly an artist-craftsman in photography, and he loved to experiment. Apart from having taken the first photographs by electric light, he took the first photographs from the air. A well-known caricature by Daumier depicts Nadar taking pictures of Paris from a balloon and the caption reads: '*Nadar élevant la Photographie à la hauteur de l'Art*' – a statement more true than ironical.

As the collodion wet-plate process improved, many amateurs became interested in photography and it is their work, rather than that of the commercial professionals, which attracts us today by its creative and technical excellence, perhaps because these people were intelligent, cultured, and broad in outlook. Their voices were often heard at the new Photographic Society in London (called the Royal Photographic Society since 1894), which had been formed in 1853. The artistic claims of photography were now firmly established, but for many years its unique character as a medium of expression was not realized – at least not consciously; it was still considered to be a kind of drawing or painting.

At one of the early meetings of the Photographic Society, Sir William Newton, a miniature painter, gave a talk 'Upon Photography in an Artistic View', in which he suggested that photographs could be touched up in various ways to give results 'in accordance with the acknowledged principles of Fine Art'. For example, negatives could be taken slightly out of focus to give a soft effect and negatives could be retouched by hand. This opened a heated controversy on photographic aesthetics which has lasted to this day. As early as the 1850s photographers were faking in skies with double negatives in a way that is still often done, the reason for this being that the collodion plate was over-sensitive to blue and registered skies as bleak, white blanknesses; they were 'baldheaded'.

This combination printing was applied in other ways – for example by the Swedish painter, Oscar Rejlander, who worked in England and whom we have already mentioned. In 1857 he pro-

duced his well-known allegorical piece, 'The Two Paths of Life', which measured 31 inches by 16 inches and was made up of no less than thirty separate negatives. Queen Victoria, an amateur photographer herself, was so impressed by it that she bought a copy for ten guineas.

What is surprising about the work of these early photographers is that, though they were possibly even more confused about aesthetics than we are today, they did so often produce beautiful results – results which will always be admired in spite of changing ideas and fashions.

Among the early inspired amateurs were Mrs Julia Margaret Cameron and the Reverend Charles Dodgson, Lewis Carroll, author of *Alice in Wonderland*. Writers seem to have been particularly attracted by photography; Charles Kingsley, Samuel Butler, Victor Hugo, Auguste Vacquerie, and Oliver Wendell Holmes were all amateurs in wet plate. Later Bernard Shaw became an enthusiastic photographer and more recently Dr Julian Huxley produced some very good travel photographs in both black-and-white and colour for his book, *From an Antique Land*.

Mrs Cameron's portraits are now famous; they are surprisingly modern in feeling, especially in their bold use of the close-up of the head. She was fifty when she took up photography in 1864 and as she has recorded: 'From the first moment I handled my lens with a tender ardour.' Her success in portraiture must have been due to a large extent to her dynamic personality, for there is no doubt that a good portrait is produced as much by the effect of the operator's character upon the sitter as by his or her technical competence and sense of form. The almost magical and entirely personal results which a human being can produce with the mechanics and chemistry of photography are nowhere displayed more clearly than in these portraits by Mrs Cameron, which are by no means always technically brilliant. An intimation of how she achieved her portraits of famous people is revealed in her autobiography, *Annals of My Glass House*, where she writes:

When I have had such men before my camera my whole soul has endeavoured to do its duty towards them in recording faithfully the greatness of the inner as well as the features of the outer man. The photograph thus taken has been almost the embodiment of a prayer.

Among the masters of wet plate were several men who first used the camera for reportage and documentation. A barrister by profession, Roger Fenton was both the first Secretary of the Photographic Society and the first man to photograph war scenes. He was, in fact, the world's first press photographer. In 1855 he sailed to the Crimea and in the following year returned home with over 300 negatives of the Crimean War (Pl. 29 top). Unfortunately they were not scenes of action because the collodion plate was not fast enough for that, but they showed that the camera could record the real, unromanticized, yet intense aspects of war as no draughtsman or painter could.

Another early war photographer was Matthew B. Brady, who recorded with a team of twenty and his 'Whatizzit' dark-room wagons many grim pictures of the American Civil War, often under dangerous conditions (Pl. 28 top). He was a courageous little man with a pointed beard and a pointed nose who had been a fashionable daguerreotypist in New York and had won the international photographic competition held at the 1851 Crystal Palace Exhibition. To obtain the most vivid possible results, Brady often used a stereoscopic camera and so today we can view scenes from the American Civil War in 3D. His war effort ruined him financially and he died in a poorhouse.

Brady's portraits are as good as his war pictures and of his famous portrait of Abraham Lincoln which was reproduced and widely circulated during Lincoln's first Presidential campaign, Lincoln himself declared later to his colleagues: 'Make no mistake, gentlemen, Brady made me President.'

Documentation of this kind gives photography an asset possessed by no other medium. This asset may not be directly aesthetic but it is one which can evoke poignant and poetic feelings for posterity when it looks at the vivid and realistic records of past events and people long since dead. Evocative poets, as well as historians, should be grateful to the inventors of photography.

The arrival of the Instantaneous Photograph gave the camera the ability to capture the fraction of a movement and to hold it in permanence. This helped to release photography from its ties with the graphic arts and showed that, apart from its documentary powers, the camera could greatly increase the extent of our vision

of the world. For example, no one really knew what happened to a horse's galloping legs until Eadweard Muybridge, an Englishman who had emigrated to America in his youth, proved in the 1870s – for the sake of another man's wager – what no one had hitherto believed: that all four feet are off the ground at one moment but *close together* and not, as the painters had shown them, widely outstretched. He demonstrated this with a series of pictures obtained by a row of cameras. Significantly, Muybridge (his real name was Muggeridge) produced thousands of photographs of the human body in motion for the specific purpose of creating an atlas for the use of artists and not intended as works of art in themselves.

Muybridge's fame rests less on his having been credited with the murder of his wife's lover and on having been acquitted than on having been the first photographer to record animals and human beings in motion. The film industry owes much to him. Some of the locomotion pictures of Muybridge were fixed in a rotating apparatus called the Zoöpraxiscope to give the impression of actual movement and this was the forerunner of the modern film projector.

With the popularization of photography through the dry plate and the Detective Camera, a serious movement was born to establish photography as an art and to save it from loss of status brought about by the commercial photographers and the snap-happy multitudes. The arguments on whether or not photography had a right to call itself an art now began in earnest. Those who argued that it had were themselves often confused and ambivalent, including that famous exponent Peter Emerson who in 1886 published his delightful book, *Life and Landscape on the Norfolk Broads*, containing forty platinotype prints (Pl. 12 top). His was honest, unaffected, 'straight' photography. In 1889 he published his *Naturalistic Photography* in which he forcefully expounded his aesthetic theories and, though few today would agree with every word he wrote, the book did help to clarify the confusion, for Emerson understood well the limitations and the possibilities of his medium. He objected to re-touching and called it 'the process by which a good, bad, or indifferent photograph is converted into a bad drawing or painting'. He added: 'The technique

of photography is perfect; no such botchy aids are necessary.'

Emerson's aim was to reproduce nature and, in order to increase 'naturalness', he advocated exposure with the lens slightly out of focus – not for the sake of obtaining arty effects but because he considered that nothing in nature has a sharp outline. 'In this mingled decision and indecision, this lost and found, lies all the charm and mystery of nature.' Perhaps he was being influenced by the Impressionists; he certainly admired Whistler.

His idea brought strong protests, especially from the crystal-sharp, small-stop men. Combined with the influences of the Impressionists in painting, especially of the blurred, watery effects of Turner and Whistler, it also brought much soft-focus photography (Pl. 22). Then, suddenly, Emerson decided that it was wrong to confuse art with nature, and renounced his former claim that photography was a legitimate form of art. All that photography could and should do, he said, was to represent nature and nature was not art. In his *Death of Naturalistic Photography* he boldly proclaimed:

I throw my lot in with those who say that photography is a very limited art. I deeply regret that I have come to this conclusion. . . . The all-vital powers of selection and rejection are fatally limited, bound in by fixed and narrow barriers. No diffieral analysis can be made, no subduing of parts save by dodging – no emphasis, save by dodging, and that is not pure photography. Impure photography is merely a confession of limitations.

Of course, within his false premises, Emerson was right. He failed to see, as we see today, that photography has very great powers of selection and rejection but not in the way Emerson meant. We also see today that the eye itself accepts and rejects, that the vision of the human eye is itself largely a convention in that so-called visible reality is not reality at all but a creative relationship between the sense of sight and some kind of mysterious contradictory composition of photons and waves. What light and matter really are we do not know, but our vision itself creates nature and 'reality' from the mystery. That is why the artist is so important; he increases our visionary powers; he increases the scope of 'reality'. There is subtle wisdom in Oscar Wilde's remark that 'nature imitates art'.

In Emerson's day men thought they knew what matter was, for his was a 'nothing but' period. At that time, too, aesthetes could hardly dissociate the word Art from the term Graphic Art, and Graphic Art often meant the making of your representations 'true to Nature', even if you obtained your effects by roundabout means such as the Impressionist painters used. In painting Cézanne changed all that, even though he himself was always trying to discover Nature's visual secrets. After him photographers began to think consciously about Form-for-form's-sake, and to realize that the camera could select Significant Form from the chaos of the whole visual environment and could make an aesthetic comment upon it.

All such arguments as Emerson raised are brought about by semantic confusion – confusion about words. To Emerson, as to so many others (yes, even now), the words Art and Painting were often considered to be synonymous. The photographer indeed often feels himself to be a somewhat inferior kind of artist to the painter instead of an artist working in a different medium from the painter. If painting is superior to photography as a medium its superiority lies both in being less restricted and in showing that almost direct touch of the human hand which gives it a special charm of its own.

But the painter should bless photography, partly because the new ways of seeing things which photography has given us have stimulated the painter's imagination and partly because its challenge in the early days revitalized painting and forced the modern movement into being; it compelled painters to depart from academic, naturalistic representation, which was a realm where the camera showed itself to be much more efficient and successful with much less effort. The whole modern movement of design from Cubism onwards to the pure abstractionism of painters like Kandinsky and Mondriaan (Pl. 45) owes its origin partly to the challenge of photography to academic painting.

All the time, of course, the visual arts react on one another and it is significant that the first exhibition of Impressionist paintings was held in Nadar's galleries. Impressionism, whose leading exponent was Edouard Manet, may, indeed, have been the result of a half-conscious desire to escape from the competition of

photography, because the breaking down of solid forms into a multitude of brightly coloured splashes could not be reproduced by the mere mechanical means of photography. Later, photography tried – without colour, of course – to ape impressionistic painting by means of soft focus and the gum-bichromate and bromoil processes.

The new vision provided by the wide-angle lens affected painters such as Toulouse-Lautrec. Indeed, Lautrec, like Walter Sickert, saw nothing wrong in painting directly from photographs. Max Ernst even combined photography with painting in his compositions. But these were artistic licences and did not mean that men who were as good in their medium as Lautrec, Sickert, and Ernst confused painting with photography. They would certainly not have done what some successful Victorian portraitists like Franz Lenbach and Sir Hubert van Herkomer did – painted on top of photographs to save time and make money. Eventually even the Royal Academy frowned on such a method, for in 1933 it removed three paintings from its annual exhibition because it was discovered that they were composed of photographic enlargements pasted on to canvas and painted over.

Cubist, Surrealist, and Futurist painters were definitely influenced by the serial motion pictures of Muybridge. All the arts benefit from such reciprocal exchanges and this does not invalidate or weaken the unique possibilities of each medium. The graphic arts undoubtedly offer far wider creative scope than photography, for they are less trammelled, but that does not mean that they are 'better'. One does not say that an orchestral symphony is 'better' than a piano sonata or that an oil painting is better than an etching. It is merely different and accepts its particular limitations and its own special scope.

In 1893 a rival body to the Photographic Society was formed, whose members disagreed with the prevailing standards of aesthetic judgement. It was called the Linked Ring and held an annual exhibition named the London Salon because the word suggested 'its application by the French to certain fine-art exhibitions of a distinctive and high class character'. In spite of fresh standards, the confusion between photography and painting persisted.

The Linked Ring began to publish its famous *Photograms of*

*the Year*, which provides us with an interesting record of developments through the years. The word Photogram was used because the editor considered this to be a more correct derivation from the Greek than Photography, little realizing that some fifty years later it was to be applied to a method of creative photography which dispenses with the camera.

Among works first exhibited at the Salons and reproduced in *Photograms of the Year* were those of Alfred Stieglitz, a New Yorker who went to Germany to study as a youth. He received eventually no less than 150 medals for his pictures and it was he who carried on the struggle to establish photography as an art after Emerson had abandoned it – partly by his own brilliant examples and partly through such literary work as his editorship of *The American Amateur Photographer*. He gained an international reputation both on account of his own photographs and on account of his encouragement of 'straight' photography through the propaganda of the Photo-Secession, a body founded in New York in 1902 which had a world-wide effect. But Stieglitz was no bigot and pointed out that the important thing was the result which was produced by the photographer's vision, imagination, and purpose.

Among those whom Stieglitz encouraged was the American, Edward Steichen, who is both painter and photographer, though his fame rests on his photography (Pl. 44 top). Another great photographer who came under the influence of Stieglitz is Paul Strand, whose work has done as much as anyone's to reveal the the camera's unique potentialities. Strand was among the first to reveal, for example, the precise and formal beauty of modern machinery and to comment photographically upon it. His words, written in 1917, are clear and admirable:

The photographer's problem is to see clearly the limitations and at the same time the potential qualities of his medium, for it is precisely here that honesty of vision is the prerequisite of a living expression. This means a real respect for the thing in front of him expressed in forms of chiaroscuro . . . through a range of almost infinite tonal values which lie beyond the skill of human hand. The fullest realization of this is accomplished without tricks of process or manipulation, through the use of straight photographic methods.

45

An interesting part of Strand's technique lies in all his prints being made by contact from negatives 8 inches by 10 inches or less, a method also used by another brilliant American, Edward Weston, who was the first photographer to be honoured by a Guggenheim Memorial Foundation Fellowship (Pls. 8 bottom, 32 top, 48 bottom). In his *Daybook* in 1926, Weston wrote: 'The camera sees more than the eye, so why not make use of it?'

The object of these straight photographers is to obtain absolute, detailed sharpness all over the print by using a large plate and a small stop. Their work is almost brutally direct and produces something more than realism – that is a personal, selective communication, probably in a close-up – which comes to us with a dramatic impact. It may be the black shape made by a broken pane of glass (Pl. 49 bottom), the pattern of white cracks on the black hood of an abandoned car, the cross-section of an artichoke, or the forms and textures of sand dunes in the desert (Pl. 32 top).

The nineteenth century also had its straight photographers, in spite of its fashion for Pictorialism, a school which still persists and was defined as late as 1929 in the *Encyclopaedia Britannica* as 'photography applied to the production of pictures in the accepted artistic tradition' – in other words, the 'naturalistic' painting tradition. Among the early straight photographers who take their places with men like Nadar, Fenton, and Brady, were Jean Atget of Paris and Paul Martin of London. Both of these men produced remarkable photographic documentaries of their beloved home cities. They were the Faithful Witnesses, the social recorders and the precursors of the modern, realist documentary photographers whose work filled the pages of picture magazines like *Life*. Atget never exhibited and received little recognition until the year before he died, when a few of his Paris pictures were reproduced in the magazine, *La Révolution Surréaliste*. Among the early straight photographers were also Thomson and Smith, who produced in the mid-1870s, before either Atget or Martin, their vivid and fascinating period scenes of London street life (Pl. 17 top).

The great Russian film photographers of the 1920s have had a strong influence on the new, straight photography – the makers of films like *Battleship Potemkin, Earth,* and, more recently, that

visual masterpiece, *Storm over Mexico*. Other influences have
been such books as Albert Renger-Patsch's *The World is Beautiful*
published in 1926, Franz Roh's *Photo-Eye* of 1929, and Walter
Hedge's *The Sculptures of Michelangelo* and *Chartres Cathedral*
with their fresh visions of ancient works of art. The tradition is
continued today by photographers like Professor Hürlimann.

The new architectural puritanism of Functionalism – itself
partly the progeny of Cubist painting – had its effects on photo-
graphy in the 1920s, especially on the Continent, where photo-
graphers found new ways of expression in purely abstract,
architectonic composition, not merely by selection of formal
patterns in the general environment through straight photo-
graphy, but by actually building up patterns deliberately by such
means as the photogram (pp. 188-9) and the light box (p. 190)
and by all kinds of experimental tricks such as double or treble
exposures (Pl. 57), dropping oil into the developer or controlling
negatives during printing. The chief value of this experimentation
lay in its being a splendid educator of the Third Eye.

This seeking for formal, abstract perfection is sophisticated; it
is bound to have a limited appeal and we must realize that even a
subjective abstract pattern must somehow, somewhere, have
found its inspiration, if only by associations, in the objective,
outer world of 'reality' – inspiration which the eyes have seen
there and passed on to the unconscious mind, where it is digested
and later re-created symbolically in a lighting mood or a struc-
tural, textural composition.

In recent decades photography has expanded its scope to
regions which other media cannot explore. With the miniature
camera the artist can take exposures lying on his belly in the
gutter, or perched on a pinnacle high above the town, or in a
diving bell deep down in a tropical sea, or in an aeroplane high up
in the stratosphere. We have now gained the points of view of the
worm, the bird, and the fish; a fascinating new range of patterns,
forms, textures, and perspectives has been revealed. The minia-
ture camera can go anywhere that a man can go – sometimes even
further – and there it can make instantaneous records which, for
obvious reasons, the draughtsman and the painter cannot make.

Today straight, selective photography, and the seeking of

pattern, are tending to give way in popularity to informal documentary and speed photography, partly as a result of the call of the picture magazines and newspapers. Significant Form is desired less than journalistic comment or social documentation – sometimes social satire or propaganda. The stress is upon the capturing of the fleeting instant – dancers in mid-air (Pl. 9 top), the sudden expression on the face of a card player (Pl. 20 top), children playing among bombed ruins. None of these different aims is necessarily better than others and all can create works of art. Nor are they mutually exclusive. That artist, Henri Cartier-Bresson, for example, can combine them all in a telling unity – the significant pattern, the significant event, the significant instant, the social, philosophical, and personal comment, the particular aspect of reality as seen and united by one personality and the universal symbolism of that particular aspect (Pls. 15 top, 17 bottom, 64 top).

Purely scientific photography often has an incidental aesthetic appeal and thereby increases our vision, especially when applied through microscope or telescope (Pls. 54 bottom, 55 top and bottom). The famous architect Le Corbusier once pointed to the illustrations in a scientific magazine and said that they:

take the cosmic phenomenon to pieces under our eyes; amazing, revealing and shocking photos, or moving diagrams, graphs and figures. We are attacking the mystery of nature scientifically. . . . It has become our folklore.

Through modern methods of printing reproduction, photography has given a new power to the journalist; in that way it is changing the world. As an old Chinese adage says: 'One picture tells more than ten thousand words.' Still photography alone – quite apart from cinematography – is of gigantic force, both for good and evil. In its goodness it has given us another means to capture and convey 'the music and the magic of reality'.

Development of Colour Photography

Colour photography is older than is generally believed. Both Niépce and Daguerre tried to reproduce colours, but without

success. In 1891 startling results were obtained by Gabriel Lippmann, a physics professor at the Sorbonne, using a method of reflection from an underlying polished surface which caused the formation of coloured light waves in the image layer. This is the only direct method of colour photography yet conceived, but it is not a practical process and so it has not been developed. Development has come with indirect processes and all modern colour photography provides an *imitation* of the original colouring and not a direct reproduction, however correct it may (sometimes) appear to the eye.

In 1860 Professor James Clerk-Maxwell, the British physicist, proved by demonstration that any colour can be recreated by mixing red, green, and blue light in different proportions because the human eye possesses three elements which are sensitive to these three colours. Together these three primary colours create white light, but red and green together make yellow, red and blue make magenta, and blue and green make cyan-blue. The three primary colours – red, green, and blue – take up one-third of the colour spectrum each, while the secondary colours – yellow, magenta, and cyan – take up two-thirds of the spectrum each. The range of hues made possible by mixing the three primary colours in varying proportions is infinite. On this three-colour principle the whole of modern colour processes depends – colour photography, colour printing, and colour television.

The first results in colour photography were obtained by taking three photographs, one of which had been taken through red glass, another through green, and the third through blue. Lantern slides were made and each was projected through its appropriately coloured filter in such a way that the three projections coincided on the screen. The result was an effective picture in more or less correct colouring.

Others developed Maxwell's discoveries – notably Louis du Cos du Hauron, a Frenchman, and Hermann Vogel, the German chemist, who in 1873 found that dyes could be incorporated in photographic emulsions.

In 1892 Frederic Ives of Philadelphia designed a camera which would make the three negatives on one plate, in a trefoil pattern of circles, with a system of reflectors, prisms, and filters. A glass

positive was then made from the negative and was viewed through an eye-piece in the Photochromoscope, which also had a complex system of reflectors, prisms, and filters combining the images into one. Later Ives simplified this in his Lantern Photochromoscope which projected the three pictures first through three filters – red, green, and blue – and then through three lenses directed to form one image on a screen. He then made a camera and a viewer which were further simplifications. The viewer, called the Kromscope, which projected stereoscopic pictures in full colour, he demonstrated to the Royal Society of Arts in London in 1896 to the delight and astonishment of his audience.

But the single picture in colour which could be seen as a whole had arrived with an invention of 1893 made by a Dubliner, J. Joly, who produced one negative instead of three. He achieved this by placing a screen in contact with a black-and-white photographic plate – a screen of tiny ruled lines in the three primary colours lying close together, each one too thin to be seen individually by the eye. When the plate had been developed, a reversed transparency was produced from it and this was fixed permanently in contact with the screen. According to the lightness or darkness of each tone originally recorded on the negative by the filter, more or less light penetrated through the tiny filters of lines to blend the three primary colours in varying proportions according to the varying filtration, thus creating the correct colours. For instance, if an object reflecting only pure red light was photographed the plate was not affected behind the microscopic blue and green filters of the screen because these absorbed the red light; only the red filters admitted light and so blackened the negative. When the negative was reversed to a positive transparency, the black of the negative became white and so transmitted only red through its filter.

This is called the Additive or Screen-plate method and was first commercialized successfully in 1907 in the Autochromes invented by the brothers Lumière, the plates themselves in this case being covered with tiny grains of potato starch dyed in the three colours, mixed in equal proportions and flattened on to the plate under great pressure. Other methods were applied. Dufaycolor, for example, was made with a geometric mosaic of dyes applied direct

to the plate and having about a million colour elements per square inch. Agfa Screen-plate had an irregular mosaic of grains of coloured resin.

Most of these Additive methods have given place to Subtractive methods, the principle of which was first developed by du Hauron. The processing of Additive methods is simpler, but they have the disadvantages that (i) the mosaic becomes visible as a grain on enlargement, (ii) the transparencies produced absorb about three-quarters of the light passing through them so that very powerful lamps are needed to project them, and (iii) paper prints cannot readily be made from them because of this heavy light absorption. The newer Subtractive processes have none of these disadvantages.

What is the Subtractive method ? Black absorbs all light rays of all colours; white reflects all rays; a colour absorbs some rays and reflects others. When red light falls upon a cyan-blue object, for example, the object appears black because the light contains no blue or green rays which can be reflected and the red light is absorbed. To take another example, a coloured glass filter absorbs some parts of the waveband of the spectrum and transmits others – to be simpler, it absorbs some colours and transmits others; a green filter looks green because it *absorbs* the blue and the red of white light passing through it; it does not *impart* its colour to the white light.

Now, the Additive method starts with darkness and builds up the three colour stimuli, while the Subtractive method works in the opposite way by starting with white light and cutting down the three stimuli of the primary colours to the required level by interposing the right amount of dye of each colour between the source of white light and the eye.

This is achieved in various ways. An old method was the Tri-colour Carbon. Here three colour-separation negatives in black-and-white were made through filters of the three primary colours. Each was then printed on papers sensitized with emulsions containing yellow, cyan, and magenta pigments. The emulsion skin was stripped from each print and then all three skins were super-imposed in register on a sheet of paper. The three negative exposures, took a few seconds to accomplish so that moving

objects could not be recorded unless, of course, a special camera taking three exposures at once was used.

In 1935 the first one-exposure film which could be used in any camera was introduced: the 35-mm. Kodachrome transparency. This consists of three separate emulsions on one film, the top being sensitive only to blue, the second only to green, and the third only to red. Between the first and second layers is a yellow dye (removed during processing) to absorb the blue light which has passed beyond the first layer. The film is developed as a negative and then reversed into a positive transparency and, since this processing is complicated, it is carried out by the makers or by other specialists.

Other subtractive films are now being manufactured which can be processed by the amateur, as well as films producing negative transparencies from which paper prints can be made. But these will be described later in greater detail in a practical way, for here we have been concerned only with historical progress.

# 2  *Photography as Creation*

## The Meaning of Art

How can photography be used as a creative medium? We cannot answer that question until we are clear – or at least as clear as we can be – on the answer to the question: What is art?

No one has yet found an adequate answer. At least we believe, we *feel*, that art is important and an essential expression of a culture. Perhaps if we knew why it was important to us we should have solved the mystery of life itself.

One definition says that art is 'unity in diversity and diversity in unity'. *The Concise Oxford Dictionary* defines a work of art as 'skilful execution as an object in itself'. Ruskin defined it as 'human labour regulated by human design'. Aldous Huxley says that 'art is the organization of chaotic appearance into an orderly and human universe'. John van Pelt, in his *Essentials of Composition as Applied to Art*, writes that a work of art is 'that which, having been intentionally created, is capable of producing the sentiment or impression aimed at by the artist in all persons able to respond to such sentiments or impressions'. H. Osborn in *Theory of Beauty* calls the beautiful 'the organization of perceptual material into an organic whole by the artist', while Arthur Hammond in *Pictorial Composition in Photography* calls art 'the production of beauty for the purpose of giving pleasure'. Sir Herbert Read says 'Art is emotion cultivating good form'. Clive Bell in his famous work, *Art*, calls it Significant Form. A poet said that 'beauty is truth and truth beauty', which is vague enough because, jesting apart, what is truth? Among the best definitions is that of William Morris: 'Anything that you take pleasure in doing is art.' Then we are given this kind of thing: 'Aesthetic pleasure is the subjective concomitant of the normal amount of activity not directly connected with life-serving function, in the peripheral end organs

of the cerebro-spinal nervous system.' Presumably this means that artistic creation is a form of sensual play.

None of these definitions gets us very far, although they help a little. They beg the question. Significant Form, maybe, but significant of what?

In a remarkable but little-known work called *The Foundations of Aesthetics*, the three authors, C. K. Ogden, I. A. Richards, and James Wood, attempt to classify the different theories of aesthetics which have been advanced through the centuries. The authors do appear to come to some general conclusion of their own which is expressed in a Chinese saying:

> When anger, sorrow, joy, pleasure are in being but are not manifested, the mind may be said to be in a state of Equilibrium; when the feelings are stirred and co-operate in due degree the mind may be said to be in a state of Harmony. Equilibrium is the great principle. If both Equilibrium and Harmony exist everything will occupy its proper place and all things will be nourished and flourish.

In other words, art harmonizes tensions and in so doing symbolizes abundant life. Its origins in pre-history seem definitely to be connected with the allaying of hunger – with hunting, food growing, and fertility ritual, and always somewhere it contains a quality of magic.

We can at least say this: A work of art in any medium is the deliberate creation of a unity, a wholeness to which nothing can be added and nothing taken away without spoiling that unity. Why we consider art to have value, why it stirs us, we do not really know – at least not intellectually, for it is concerned finally with human emotions, and about the depths of the human mind and of the life mystery we understand very little. Art, however, seems to possess a stimulating, life-giving quality. Perhaps its origin is largely physiological – the externalized expression of pleasurable body movements and good mental and physical health. Perhaps, to quote that distinguished critic, Sir Herbert Read, again: 'Our homage to an artist is our homage to a man who by his special gifts has solved our emotional problems for us.'

The healing balm, the enjoyment of a 'good' state of mind, the easing of tensions, both psychic and physical, which comes both

from contemplating a work of art and, even more, from having created one, is certainly powerful and well-known to doctors and psychiatrists. Moholy-Nagy writes well:

Today, lacking the patterning and refinement of emotional impulses through the arts, uncontrolled, inarticulate, and brutally destructive ways of release have become commonplace. Unused energies, subconscious frustrations, create the psychopathic borderline cases of neuroses. Art as expression of the individual can be a remedy by sublimation of aggressive impulses. Art educates the receptive faculties and it revitalizes the creative abilities. In this way art is rehabilitation therapy through which confidence in one's creative power can be restored.

All men are to a more or less degree artists – at least potentially – and not necessarily in the fine arts, because there is no clear dividing line between art and craft. Creativity can be applied to almost every activity – cooking, dressing, town-planning, ship-building, human relationships, photography. But for every artistic activity the basic principles are timeless, immutable, and universal. They apply equally to a good piece of drama as to a symphony, to a poem as to a painting, to a novel as to a love affair, to a cathedral as to a photograph.

What are these principles? Wholeness, as such, is not enough. A work of art must contain tension and diversity within its wholeness if it is to avoid boredom – Contrast, Repetition, Climax, Balance, Cohesion. These are the principles which harmonize psychic tensions and so produce works of art.

Contrast brings vitality and strength – contrast, for instance, between darkness and light, solid and void, vertical and horizontal, roughness and smoothness, mechanical lines and organic lines, plainness and decoration, the large and the small; in music in particular, between softness and loudness, discord and harmony, fast and slow movements.

Repetition of motifs will help to bring unity. In music this will be the recurrence of a melodic phrase, repeated in different ways; in architecture it may be the repetition of windows of one size or of a coherent 'grammar' of detailing.

Focal Climax is the dominant, binding part of a composition to which all the other parts are related, to which they point and

which they enhance. In a play, this will be the most dramatic moment, coming probably towards the end. In a building it will perhaps be a tower or a main entrance. In a painting or a photograph it will be the centre of attraction, which will itself almost never be in the centre of the picture and will often be subtly concealed as the dominant point.

Balance means equilibrium either in time or space – time in the case of music or drama, space in the visual arts. Balance means the placing of the Focal Climax in the right place in relation to the other parts and the placing of all parts in right relation to each other. This cannot be achieved by the intellect alone. It is of the greatest importance in a photographic composition and must finally be achieved by sensibility and intuition. Does it *feel* right? Not do I *think* it feels right? Are the 'weights' of tone and form in the right proportions and positions to keep the whole organization poised?

Cohesion depends on all the above principles but on something more as well – the main 'purpose' or vision of the artist – the 'story' he wants to communicate, the simple, binding idea he has experienced and wishes to externalize. In photography this cohesion should be particularly simple, and it must have singleness of purpose. A good photograph will have an immediate impact on the viewer whether of interest, surprise, pleasure, humour, lyricism, or horror. It never bores.

## Photography as an Art

Through these canons or principles all the arts are linked. That is why one hears architecture called, rather self-consciously, Frozen Music, that is why some sensitive people see different colour combinations when they hear different chords of music, and that is why a striking photograph is sometimes called dramatic.

Nevertheless, each medium has its own ways of saying things, and photography is no exception. If photography is like any other art, it is much nearer to architecture and to sculpture in the formal sense than to the graphic arts. Aesthetically, architecture can be appreciated in two ways: first as form in space – that is

externally as sculpture; secondly, as the arrangement of space – that is internally as time-space relationships, time being included because one moves about within the spaces and discovers new relationships as one moves.

It is in the first sense that photography and architecture are linked, because both are concerned with the composing of three-dimensional forms, light and shade and, not least, texture. Form and texture are given meaning in both architecture and photography by *light*. No wonder then that architecture provides splendid raw material for the creative, selective photographer. Fine architecture is not necessary to such a photographer; architectonic composition can be achieved in photography from a squalid slum, a rotting fence, or a bombed ruin. And a fine building of any period may provide photographic inspiration less on account of its own intrinsic beauty than on account of the photographer's Third Eye which sees relationships caused by selection, maybe under unusual lighting conditions – perhaps only parts of the building or details making patterns which were not deliberately intended or foreseen by the architect. In fact, it is the selected part or detail which usually provides the best photographic material and may tell us more about the building as a whole than would a general view.

Black-and-white photography stands on its own feet, however, in being able to create compositions in an infinite range of gradations between black and white. That is where it is unique. Photographic chiaroscuro reveals light and shade in their interdependence and, in doing this, artificial lighting has greatly added to the photographic possibilities. In a sense, photography is building with light; light is the medium of infinite plasticity. It formalizes 'reality'.

In this building with light, what are the various applications – apart from those which are purely scientific and are not intended to evoke aesthetic pleasures? They can be summarized thus:

*1. The Record.* This covers portraiture, architectural photography, landscape photography, and is intended to convey information about a person or a place while creating compositions which possess Significant Form.

*2. The Selected Composition.* This is where the sensitive, probing, imaginative, and selective Third Eye is particularly needed to find Significant Form in a visually chaotic world. It can be discovered anywhere by those who have eyes to see it – maybe part of a farm implement, the close-up of a human hand, jetsam on a beach, the detail of a beetle's wing seen through a microscope, the pattern of hedgerows seen from a church tower in the setting sun. Here the close-up is particularly selective and revealing. This field can approach close to (4) – Abstract Form.

*3. The Captured Instant.* This is the significant event or moment whose recording has become possible with speed photography – using the electronic flash perhaps to capture a row of Can-can girls with frills and legs wildly flying, the expressions on the faces of a crowd at a football match when a goal is scored, seagulls planing, a wave breaking into shimmering fragments. This can be reportage, documentation, pictorial journalism, social comment. And it can be art too.

*4. Abstract Form.* This brings photography nearer to classical (as opposed to 'programme') music, for it is concerned only with formal relationships and is divorced from real things and people. This is possibly the most creative kind of photography for here no direct stimulus is provided from the outer world and the creator must rely entirely on his own imagination in order to produce interesting results. Many means are open to him like the photogram (pp. 188-9), the light modulator, or the light box (p. 190). This is unlikely to become a popular field for the amateur, yet it provides excellent visual training for any kind of photography.

*5. The Experiment and Trick.* Here also imagination is needed. The possibilities in this field are many and the amateur may be able to invent some for himself. Known and established tricks are solarization (Pl. 59 top), double or multiple exposure on one negative (Pl. 57), combination of positive and negative images, use of prisms in front of the lens, distortion by mechanical or chemical manipulations of the negative during or after development, photomontage, physiographs (p. 191), and so on. This is hardly straight photography and one might say of a result pro-

duced by such methods: '*C'est magnifique, mais ce n'est pas Daguerre.*' Nevertheless, it is photography and its creation requires both skill and imagination.

*6. The Series.* This is the assembly into a coherent whole of a sequence of photographs, either on one mount, or within the pages of a book or magazine, or within the leaves of the old-fashioned, but by no means despicable, album. The making and mounting, or lay-out, of a series is an art in itself – the co-ordination of a number of good single pictures into one theme. A feature in a picture magazine is a typical example, when the most telling photographs are selected from a pile, arranged in sequence to tell a story, carefully set on each page both to make a strong and interesting arrangement as a page, to make pages contrast with one another, and to express the story with power and simplicity. Contrast of shapes, sizes and tones, rhythmical repetition, subtle relationships of areas between pictures, white spaces and lettering must be considered. The amateur can apply this technique him-self in an album to obtain lyrical, dramatic, comic, or interestingly documentary results – perhaps the local life of his own district, his children at play, a wood seen through the seasons, the drama to be found amidst the sunlit steam of a railway terminus, the tone poem of a snowy day. I believe that here lie possibilities which have not been fully enough explored by amateurs who tend to concentrate too exclusively on producing the single mounted exhibition print.

\*

A few remarks now on subject in photography: Art historians talk a lot about the Romantic and the Classic schools, especially as applied to painting. This is a big matter and has blurred edges, but speaking broadly one can say that Romantic design depends for effect on associations and 'atmosphere', on psychological mood; it generally has an escapist taste for the exotic – like the Gothic Revival in architecture or the Victorian painting of wild and picturesque landscape. The Romantic tends to be individu-alistic and in the Victorian days provided a world of escape for the middle classes away from the squalor of industrialism which they had done so much to produce. The Classic, on the other hand,

depends for effect on purely formal composition; form here is more important than the mere representation of some object. The Classic tends to be restrained and to keep within recognized conventions – like Greek architecture or early eighteenth-century portraiture. Romanticism tends to develop in unsettled periods and at its extreme it expresses false and undisciplined emotion. Classicism tends to develop in stable periods and at its extreme becomes mechanical, sterile, and purely intellectual. The best works of art have at least something of both – strong, controlled form of universal significance as well as strong, personal, subjective feeling.

Romanticism is born in writing and so leads to the picture that tells a story rather than one which shows excitement about form, texture, and colour. It contains poetic sensibility and, to quote Geoffrey Scott from his *Architecture of Humanism*, it

idealises the distant, both of time and place; it identifies beauty with strangeness. ... It is always idealistic, casting on the screen of an imaginary past the projection of its unfulfilled desires. Its more typical form is the cult of the extinct. In its essence, romanticism is not favourable to plastic form. It is too much concerned with the vague and the remembered to find its natural expression in the wholly concrete.

In photography an example of Romanticism might be one of those dreamy, soft-focus, other-world landscapes wreathed in mist, perhaps with a castle tower silhouetted in the distance. At its worst, Romanticism in photography leads to the nauseating 'fancy dress' picture. A case of Classicism might be a straight, close-up detail of the precise cogwheels of a clock carefully selected in view-point to provide the most satisfying composition.

This raises the question of titles. Today some believe that a photograph should not require a title and that its subject matter should be self-evident. That is a reasonable enough belief. At least as an aesthetic concept, a picture should certainly be able to stand on its own without dependence upon a literary title. On the other hand, a title is often a pleasant and informative adjunct. For instance, however fine a portrait may be in itself we might like to know the name of the person represented; and in the case of a street scene or a landscape we might like to know, just incidentally, where it is. Against all precedent, I would say that

if titles are used they should be long and informative rather than short, to explain why, where, when, and how the creator made the picture.

Geoffrey Scott's architectural critique can be applied as a whole to the aesthetics of photography. Scott admits Romanticism to be an essential part of the human make-up and not necessarily to be disparaged. 'Romanticism is a permanent force in the mind, to be neither segregated nor expelled.' But he concludes that the firmest approach is Humanism. By Humanism he means that 'we transcribe architecture into terms of ourselves'.

If we apply this Humanism to photography, we see that a photograph which is a work of art will have its lines, forms, and spaces so arranged within its rectangle that it will be *physiologically* satisfying in an architectonic and Humanist sense. For example, balance of 'weights' and tones will be satisfying because we ourselves like to feel balanced and stable on our two legs in whatever position our body may be.

Apart from such purely physical ones, there may be, in a good photograph, other Humanist influences at work stemming from the unconscious mind. Vertical forms will suggest upward movement, aspiration, a man walking proudly upright. Horizontal forms will suggest repose, quietness, a person asleep. Rounded, containing forms will suggest femininity and protective stability. The curve, too, will symbolize femininity; also intuition, softness, and unregulated growth. The straight line will symbolize masculinity, purposive intellect, firm man-made structure, and man's deliberate control of nature. Darkness will symbolize fear, despair, and death; light will symbolize love, happiness, and life.

Again, just as we dislike weakness, indecision, and anxiety in a human being, so we dislike them in a photograph. There must not be two or more competing themes or two or more points of equally strong interest in one composition, for example, nor equal areas of dark tones and light tones. Nor do we like a picture cut in two by a horizontal line, because this will represent unresolved conflict.

The Humanist approach may be said to be a Classical one. Today the photographer is rightly, I think, tending towards the Classical. He sees the romantic, the sentimental, the literary

descriptive, as of less value than the significant moment and the significant evocative form selected and captured from the outer world of reality and expressed in simple, powerful shapes, lines, tones, and textures, either to stress the form's symbolic and universal meaning or to enhance the 'story', the dominant idea, the comment. Life is not tidy, and so the photographers who have recorded life most brilliantly, men like Cartier-Bresson and the late Werner Bischof, have tended deliberately to create an atmosphere of the casual in their compositions; nevertheless, behind that casual effect lies strong, whole composition.

A final word on the aesthetics of colour photography: Amateurs tend to think that colour photography will oust black-and-white entirely in time – merely because it has colour. But that is not necessarily so. Colour photography needs quite a different creative approach from that towards black-and-white.

Modern colour photography has been developing rapidly since the end of the war. Whether or not it will eventually be more popular than black-and-white among amateurs is an open question. It probably will – for the wrong reasons.

Colour offers far less technical latitude than black-and-white; technique must be far more exact and careful. It does not yet offer the same possibilities of speed, of capturing the significant moment. Control – directly with the camera and indirectly during processing – is much more restricted than it is in the case of black-and-white. An eye trained to translate the outer world into monochrome must train itself again to create in colour instead of the chiaroscuro of form, light, and texture, the 'building with light'. Moreover, the reaction of the eye to colour is often conditioned by subjective factors so that the result on the colour photograph may often be unsought and surprisingly unpleasant. Trees are not always as green as they seem to the eye and their midday colouring will be quite different from their sunset colouring. A pink dress may become grey under green foliage – yet we continue to think of it as pink; and adjacent colours affect each other so that a red will appear to be a different hue when surrounded by blue than when surrounded, say, by dark brown.

A number of intellectual theories about colour have been propounded, but these cannot be relied upon; in the end, good colour

compositions can be obtained only by sensitivity, intuition, and experience. It can be said that as a general rule some colours do not harmonize, others do; pale blue dislikes dark green; pink dislikes orange; pale violet dislikes dark blue. But this is far too broad a generalization and disharmonies may be needed in small doses in order to combat too much sweetness – to give a kick.

Broadly speaking, I would say that the possibilities of personal expression are far more exacting, far more rare, far more restricted and restricting in colour than in black-and-white. Art requires personal selection and omission, and this is much more difficult to achieve in colour than in black-and-white because colour cannot be discovered with a camera in the way that form, tone, and texture can. I could count on the fingers of the two hands the number of colour photographs which have given me aesthetic thrills. Most colour photographs have either an anaemic quality or they contain far too many colours which have no harmonic relationships with each other, colours which revolt the eye. There is no strength or meaning in them. And colour photographs lack that charm of surface texture which paintings can achieve; flat surfaces of dye do not stimulate the tactile sense.

Time may change these views and until the future of colour photography is clearer I would not go so far as to sympathize with John Ruskin's declared hope that he would never live to see photography in colours.

As in black-and-white, *selectivity* is the great need and after that *simplicity*. The range of colours must not only harmonize and contrast with each other to make a telling composition, they must be restricted in range. As one general rule, fairly neutral hues should be maintained overall with bright colours concentrated at one or more focal points. As another general rule, one colour should dominate all the others.

The colour photographer must realize that his medium is no more 'natural', no more a representation of nature as the eye sees it, than is black-and-white. This can be a creative advantage and should be deliberately exploited. As in black-and-white, the photographer must escape from the conventions of the painter by realizing that he is dealing, not with solid pigments with their

special effects and textures, but directly with coloured light recorded with clear dyes.

The greatest aesthetic scope in colour photography undoubtedly lies in tricks and experiments, and that field has yet to be more fully explored: colour filters to provide strange, unnatural effects, the deliberate distortion of the colours in the outer world, the patterns made in space-time by fireworks or moving lights, coloured photograms, coloured physiographs, the diffusing of some colours and so on.

In colour the wide landscape and the broad, detailed view should generally be avoided; far more striking results come from the bold and simple close-up.

# 3  Composing

## The Value of Composition

For decades a split among creative photographers between the new, straight, selective school and the old Salon school existed which was formed by lack of clear distinction between photography and painting and between photography and literature.

Composition and technical brilliance are of the greatest importance to the Salon exhibitor. He is not to be criticized for that but for believing that composition and technical perfection *precede* expression. By expression I mean the personal comment, the report, about form, movement, another human being or about some aspect of life, which the photographer is trying to make. This has led the straight people to despise composition and even to avoid the word, using, instead, one such as 'arrangement'. But why change one perfectly good word for another which means the same thing?

Some photographers are so strongly in revolt against the old, obsessional, Salon school, whose aim appears to be to achieve the obvious, quiet, and static compositions of eighteenth-century landscape painters, that they deliberately try to throw the baby of expression out with the bathwater of composition. But good composition is not necessarily quiet or static or obvious. Some modern aestheticians are even going so far as to deny the long-held view, originated by Aristotle, that unity is the basis of a beautiful work of art. This denial (not, I believe, justified by evidence) might be called Romantic Nihilism. It has arisen in a culture which is in a state of flux and upheaval. Creative photographers are being affected by it, sometimes with interesting results – results which, on deep analysis, reveal splendid, if subtle, composition – that is, unity.

I believe that composition is fundamental to any visual art

including photography. It should not, however, be too self-conscious, too intellectual. Intuition must be the final arbiter and intuition may want to break the rules for its own purposes – such as splitting a picture in half perhaps to give the schizophrenic atmosphere the subject demands. After all, we do not live in a calm period and art in any form is bound to reflect that lack of stability, possibly as a violent, Picasso-like protest against it – a protest *against* disorder.

Composition is an essential part of a good photograph; photography as an art has no meaning without it. But composition, like technical craftsmanship, is a means and not an end. Expression is the end. If composition is made the end, the result will be self-conscious, artificial, and lifeless. Expression and composition are like life and body – a unity. Body by itself is a corpse.

Expression of the theme of a picture, a theme which has aroused your interest and emotion, will condition and dictate composition. To take a crude example in portraiture: What you want to express is the character you are portraying; a calm, precise, self-contained, and confident sitter may suggest a completely symmetrical, three-quarter length portrait showing the hands, the whole forming a triangular structure; a vital, rugged, tense, and restless character would be better portrayed, perhaps, by a close-up of part of the head, the focal interest being concentrated well to one side as highlights around the mouth.

Composition cannot be learned by rule of thumb; it cannot be taught intellectually by means of established canons. It can only be learned by training the muscles of the Third Eye, for good composition is not founded on science but on impulse and sensibility.

The great Ruskin had some wise words to say on this matter:

If a man can compose at all, he can compose at once, or rather he must compose in spite of himself. And this is the reason for that silence which I have kept in most of my works on the subject of Composition. Many critics, especially the architects, have found fault with me for not 'teaching people how to arrange masses'; for not 'attributing sufficient importance to composition'. Alas! I attribute far more importance to it than they do – so much importance, that I should just as soon think of sitting down to teach a man how to write a *Divina Com-*

*media* or *King Lear*, as how to 'compose', in the true sense, a single building or picture. . . . A picture is to have a principal light ? Yes; and so a dinner is to have a principal dish and an oration a principal point, and an air of music a principal note, and every man a principal object. A picture is to have harmony of relation among its parts ? Yes; and so is a speech well uttered, and an action well ordered, and a company well chosen, and a ragoût well mixed. Composition! As if a man were not composing every moment of his life, well or ill, and would not do it instinctively in his picture as well as elsewhere, if he could. . . . It is well that a man should say what he has to say in order and sequence, but the main thing is to say it truly.

If we are too much aware of the composition in any work of art, instead of what it is trying to express, then it is almost certainly a poor work. We should be so absorbed by what the artist is trying to convey that we should be quite unaware of the mechanics of the structure as such. We should merely feel that the thing is right and satisfactory and could not have been expressed better in any other way by that particular artist. His personality will be indelibly stamped upon it, since everyone has his own vision of the world which he conveys to others through his medium. The artist arranges his structure, whether a piece of music, a novel, a building, a painting, or a photograph, mainly by instinct combined with a knowledge of his medium. Then the critics start analysing his creation and the artist is probably amazed to find how clever he has been.

The would-be photographer will now be asking: 'But can I develop this instinct, this impulse ?' The answer is: 'You may never be able to develop it; you may be form-blind, just as some people are colour-blind or tone-deaf. On the other hand, you probably already have it in you strongly and merely need to give it a walk.' As the French say, you must go hunting for images with your camera – *à la chasse aux images*. The power will, of course, be conditioned by the culture and the period into which you happen to have been born and it can be strengthened and cultivated by self-education – by merely looking at the best works of art in every medium, especially contemporary works of art produced by recognized masters; also by taking pictures yourself of anything and everything which gives you a visual thrill. In

doing so you must rely on your inner eye without allowing too much interference either from conscious deliberations or by what others have done. Remember always that your theme will condition your composition. And *be yourself*.

A description of my own approach to photography may help the amateur. I am a semi-professional in that I illustrate my writings with my own photographs. My theme is therefore fixed before I start and my aim is to create an interesting series to fit the theme. I have written and illustrated books on canals, on the Thames, on Scandinavia, on British bridges. In the latter case, for example, my aim was not merely to provide adequate records of the old and new bridges in these islands but to express the beauty of form, texture, structure, and drama they possess individually, not necessarily as a whole but through selected details and unusual angles seen under special lighting conditions – the texture of the huge granite slabs of a clapper bridge weathered by 2,000 years of life and seen for a moment in unusual light at sundown; the theatrical grandeur of the central tower of the Forth Bridge seen silhouetted against a grey sky just as a tiny train was steaming across it (Pl. 62 top). Interesting formal patterns resulted, more from the theme than from deliberate preconceptions in composition. After some experience I find that with my theme clear and simple the best way of capturing it with the camera comes to me almost like a smell which I nose towards and then, suddenly, there is the picture in the ground-glass screen of my Rollei like an astonishing and delightful revelation.

## The Canons of Composition

Ruskin said: 'It is impossible to give you rules that will enable you to compose. If it were possible to compose pictures by rule Titian and Veronese would be ordinary men.'

Yet I propose, in spite of what I have written, to give you some 'rules', or at any rate a few hints on composition, for what they are worth, in the trust that the reader will not take them too seriously but will regard them merely as a kind of pump-priming to start him off, so that before long he will be pumping

up the deep, fresh waters from his own well of intuition.

I have already mentioned the principles which apply to every kind of medium. Let us now apply them directly to photography.

*1. Contrast* gives vitality, variety, and interest. It lies between roughness and smoothness, the vertical and horizontal, straight line and curved line, nearness and distance, darkness and lightness, largeness and smallness, plainness and decoration, sharpness and fuzziness. In an architectural photograph, for instance, contrast can be obtained between the geometrical forms of the structure and the organic forms of foliage.

A special application of Contrast lies in Interchange – that is the setting of a dark tone against a light tone and a light tone against a dark in different parts of the same picture. This is especially valuable in portraiture where the lighter side of a face can be set against a dark background and the darker side against a light background.

*2. Repetition* makes for a harmonizing rhythm. It may be a row of trees, windows on a façade, books on a shelf, cloud forms, or some other motif. Unless the subject demands it, the repetition should not be too mechanical or it becomes monotonous.

*3. Climax* is the most important point in a composition – the focal point, the principality. It will probably express the core of the theme – perhaps a lonely figure in a deserted street. Lines will tend to lead towards the climax and to be bound to it. It will probably be near the edge of the picture, and the nearer the edge it is the more insistent and the stronger it will become (and the more it will need a compensating balance) (Pl. 44 bottom). The point where vertical and horizontal lines, drawn a third of the way across the picture, intersect – the well-known Intersection of Thirds – is said to be a good point for a climax.

*4. Balance* is the placing of values in equilibrium on an imaginary centre line. It is a matter of weight of tones, forms, and points of interest so that the whole feels as though it would not fall one way or the other if poised like a card on a knife edge. Intuition is particularly necessary here.

Balancing a picture is a very subtle process. For example, if a

black tone is too heavy, the weight on its side can be lightened by a touch of white; or in a perspective view, a distant tree on the left may seem to have the same weight as a near tree on the right because we sense that it is the same size in nature.

5. *Cohesion* implies order and continuity, so that every part of the whole is related somehow to all the other parts to tell the 'story' with power and decision. Here theme and composition coalesce. When complete cohesion is achieved we have created a work of art in that nothing can be added and nothing subtracted from it without killing the whole effect. However complicated the composition may be in its detailing, the general result will be one of simplicity and forcefulness.

Talk about composing can be reduced to fourteen words by quoting Pope's couplet on the landscaping of Windsor Park:

> Where order in variety we see
> And where, though all things differ, all agree.

## Hints on Composing

Here are some general, random hints to follow the canons:

Do not be vague about what you want to photograph. For instance, do not be led away by a beautiful landscape and believe that you can capture the whole of it with any effect. You must *select* in order to create telling, decisive form. By selection you may be able to express the whole far more effectively; a close-up of a fir-cone may be a far better comment about a winter morning than a broad view of a pine wood in the snow.

Look for the telling detail and the close-up and look for the simple, bold line and form which will dramatize the subject. Broad views can make fine pictures, but mostly they contain too much unco-ordinated detail to have power. The closest possible view of your subject is usually the best – for then intrusions and irrelevancies will be avoided.

Remember that the camera will record everything which comes within the compass of its lens. This may sound obvious, but too often the novice concentrates so profoundly on the matter which

interests him that he fails to notice the distracting details around it; but the camera will notice them.

Select, Simplify, Emphasize, Contrast, Unify – these are the watchwords. Do not try to tell more than one 'story' at a time and remember that what you leave out is as important as what you put in. You cannot successfully photograph two equally important themes together – for example, the beauty of your girl friend and the beauty of a Gothic doorway; you must decide which is the more important and build up on that.

Try to obtain your picture whole on the complete negative at the instant of exposure. It may be possible to create pictures in the dark-room from parts of negatives, and the photographic magazines are full of instructions on how to do this. But except in rare cases this is an unsatisfactory method and reveals that the photographer did not really *feel* his picture as a complete whole when he pressed the trigger.

Most of the famous photographers print from the whole negative. Henri Cartier-Bresson says:

> For me the content [of a photograph] cannot be separated from the form and by form I mean a rigorous plastic organisation through which only our conceptions and emotions become concrete and transmissible. That is why a good photograph becomes meaningless if 'cropped', just as 'cropping' under the enlarger cannot, to my mind, make up for lack of formal rigour at the time of shooting the picture.

Emphasis gives power and character to a picture. It means that a part of the picture, the main climax or focus of the picture, is strengthened by the other parts, not weakened by them. Interest is concentrated – a human head, for example, by its background. Emphasis is obtained by selection and simplification and by other means too. The climax could be made crystal sharp against a blurred, out-of-focus background or, conversely, by allowing the climax to be blurred against a sharply defined background (Pl. 64 top).

Lighting, of course, plays an important part in emphasis; a highlight will stand out against a dark background and *vice versa*. Again, emphasis may be made by contrast in size – perhaps a minute figure walking at the base of a forest of gigantic trees or

of the columns of an Egyptian temple. And, as already mentioned, the nearer the edge of a picture the climax is the more powerful will its emphasis be.

The greater the emphasis, the greater the drama. Dramatic power depends a great deal on light effects and strong contrasts in tone to stress bold and simple shapes. It can also be provided by the emphasizing of three dimensions either by stressing the perspective or by stressing the depth of the different planes – the close plane such as a wall, the copse beyond, and the mountains beyond that, the mountains themselves perhaps receding into mistiness in ever more distant planes.

Obtaining a sense of depth by receding perspective is particularly valuable in architectural photography – for example, in the converging lines of an arcade which lead the eye into the distance where the climax of interest lies; here, as well as the converging lines, the diminishing sizes of equal objects will stress the depth, such as receding caps and columns, receding ceiling panels or floor patterns.

A feeling of depth – pure illusion, of course, since we are expressing space in the two dimensions of the photographic print – is also enhanced by the fading away of detail and perhaps also by making the foreground deliberately out of focus.

A useful way of enhancing the effect of depth is to include a close object in the picture, preferably of dark tone and thus probably an object in shadow. This device is too rarely used by amateurs, yet it is simple and remarkably effective (Pl. 14). When it is used it is often of a trite nature, such as the framing of a distant view by a close arch or doorway. This is not necessarily a bad trick, but it has been overdone and it tends to force unity in too obvious a manner. More interesting close objects included to give a sense of depth might be a hand out of focus just below a portrait face, a pair of trees, the backs of heads in a crowd along the base of the picture, or part of a near-by statue with buildings filling the background. When using this trick *be bold*; bring the near object as close to the camera as you dare so long as it does not conflict in value with your distant focal point. If the close object *is* the climax, then, of course, the situation is different and

you are not trying to obtain a feeling of depth by this means. The close object to give depth must generally be on the opposite side of the picture to the climax of interest so that it may act as a balancing weight.

The converse of a sense of depth can also give a sense of drama – that is the effect of relief. Instead of feeling that we are moving into the picture, the picture seems to move out towards us. The effect is usually obtained by manipulating light and shade, whereas a sense of depth is usually provided by converging lines of perspective or by receding planes.

Remember always that you are trying to express a theme, an idea, to make a photographic report about something, through the medium of light reflected from three-dimensional *form*. Therefore keep the form clear, unequivocal, and simple. The composition as a whole should be governed by a few strong leading lines. A scene taken from above, possibly from a bridge, of a railway goods yard may be dominated by a bold curve of receding railway lines leading to the climax in the form of a black engine puffing great white clouds of steam into the top right-hand corner – or a beautiful tall tree will be crossed low down in the distance by a horizontal line of a bridge having a rhythmical row of arches; in this latter case the two main lines will form a cross, their intersection coming towards the lower left-hand corner; in such a picture the sky must be filled with some interesting clouds contrasting the geometry of the cross with its more amorphous curves. In ways like that architectonic unity is achieved.

In general, asymmetrical composition will be more interesting than symmetrical and the more easily found. Symmetrical composition tends to be too obvious, rigid, and dull. However, it need not be despised provided it is deliberate and provided the subject, perhaps one of formal grandeur, calls for it. Hesitation between symmetry and asymmetry will give a feeling of weakness and therefore of disunity and must always be avoided. In portraiture a symmetrical close front view is rarely satisfactory, perhaps because human faces are never exactly symmetrical themselves.

Line is fundamental to photographic composition, as it is to all picture making. We have to arrange lines, straight and curved, within the rigid rectangular frame to make an interesting and

telling pattern. The main lines may be broken, but the eye should be able to sense the general directions.

A common and clear lineal arrangement in a picture is the pyramid; others are the circle, the ellipse, the L-shape, the S-shape, or the simple cross. The kind of lineal form in a composition will influence the mood of the picture. In conformity with our humanist philosophy, the oval will suggest softness and femininity, a vertical S will suggest vitality and motion, for as Michelangelo asserted, 'the greatest grace a picture can have is that it expresses life and motion, as that of a flame of fire'. Stiffness and angularity will suggest masculine strength. The horizontal straight line gives a sense of quietness and repose, whereas a diagonal line gives a sense of direction and virility, for it is the longest line obtainable within the rectangle of a frame; if unsupported, it may convey a sense of falling.

1. Basic forms of composition as revealed by Henry R. Poore in his *Pictorial Composition*. The reader may be entertained in trying to discover which form predominates in each of the photographs on the plates in this book.

Be careful with diagonals, and indeed with all straight lines; they can destroy a picture by being too dominant and harsh. They can cut a picture in two parts and they can lead the eye too abruptly right out of the picture. To prevent a straight line taking the eye away it can be stopped at the ends near the frame by short cross-lines – perhaps a distant tree or the spire of a church on the horizon in the case of a landscape.

Composition depends on the right placing of lines, forms, and tones within the containing shape of the whole picture. The shape is itself important to the composition; a long horizontal rectangle will suit a quiet subject; a tall vertical one will suit a dynamic subject; a square may suggest the normality of everyday life.

Other points in framing: If a sense of vigorous action is wanted the picture space should be well filled. Because of our habit of

reading from left to right, sense of movement will be greater if the direction of a picture – say of a procession of people – is shown moving in the opposite way from right to left. In portraits see that the face is looking into the picture rather than out of it – that is to say, make the area in front of the face wider than the area at the back of the head.

Scale may be important in composition, especially to stress contrast and emphasis through differences in sizes of objects. Scale is the sense of size of an object in relation to ourselves. In an architectural photograph various things can provide scale – for instance, steps built to suit the human foot, Georgian window panes whose conventional size is at once recognized, or human figures themselves (Pls. 4, 5).

This indication of scale is particularly important when the photographer wants to make a comment on the grandeur, say, of a mountain scene (Pl. 35). The photographer knows how vast is the scene, but is this vastness revealed to others when looking at his picture? If nothing shows, by comparison, the size of the mountain face, the picture will fail in its intention. Probably, in a case like this, one or more human figures should be included in the picture to give scale, while at the same time providing a strong climax to the whole. The figures, however, should be small and distant because foreground figures tend to reduce the sense of vastness rather than to enhance it.

A feeling of great size and grandeur can be increased by a simple trick, especially in architectural work. The trick was often used by the great Italian etcher, Piranesi, especially in his theatrical interiors of Roman prisons. It consists of including in the picture elements which have the same form but are vastly different in size: a giant arch, for example, will look even more gigantic if around it are placed one or more very small arches to give contrast and emphasize the scale.

When all has been said about composition we come at last to the simple practice of the American architectural photographer, G. E. Kidder Smith (Pl. 43), who has written on the subject:

One could argue about it for a hundred and three years. . . . Many ingredients are needed: a dominant (usually), a certain equilibrium (*very* rarely symmetry), variety of line, mass, light and shade, rhythm,

and other abstruse elements which one can read about in the savants' notebooks. I try to sidetrack all divine triangles and optical metaphysics by the simple device of squinting. Squinting gives contrasts similar to that on the final print and helps to flatten the three dimensions of the scene into the two of the photograph.

# 4   *What They Say*

## A Collection of Aphorisms

The following aphorisms from the writings of well-known photographers and others who have trained and sensitive eyes may be of didactic use and help to summarize what I have been trying to say. I agree with them all.

' "You have set photography amongst the mechanical arts! Truly, were photographers as readily equipped as you are to praise their own work in writing, I doubt whether it would endure the reproach of so vile a name." I claim no originality for this protest. I have merely taken it from Leonardo da Vinci's note-book, substituting "photography" for "painting". . . . The cream of the joke lies in the fact that da Vinci tells us that the old critics called painting "mechanical" because it was "done with the hand". After all, photography is an "Art" which has made but little progress since the days of D. O. Hill, and photographers are only beginning to discover the flexibility of pure photography. Possibly photography has failed to earn its status as a Fine Art, because so much of it has been "done with the hand".' – A. J. Anderson in *The ABC of Artistic Photography*, Stanley Paul & Co., 1910.

'If photography is used merely as a technical process to record some visible fact, it is an adjunct to science. But if it is used to express, since all expression is emotional, selective and personal, it cannot avoid the use of art.' – Peter Rose Pulham in a Third Programme talk, January 1952.

'The rigid form of the sonnet has never circumscribed the poet. In the so-called limitations of its means may be discovered one of photography's most important and distinguishing features.' – Edward Weston.

'If three different photographers are given the same model, the same lights, the same background, the results will be as different as if three artists are given the same piece of paper, paints, and model.' – Cecil Beaton in *Photobiography*, Odhams, 1951.

## Photography

'When Michelangelo was asked to define art, he is reported to have said: "Give me a block of marble and I hew off everything unimportant." This is also the case in photography. Yet the majority of photographers violate this most important fundamental law. They subordinate the essentials to the irrelevant details, or they gather in a single photograph several themes of which a single one would be important enough to stand by itself. A part of an object may often express more than the whole. One flower expresses more than the most artistic arrangement of a whole bunch, one blossom more than the whole flower. Heads and hands reveal more, and give you a more intimate knowledge of the individual portrayed, than a full-length or half-figure portrait. Or let us take the case of a landscape. It is not the "beautiful view" which determines the value of the photograph – this would only result in a picture postcard. The art lies in restricting oneself to the intrinsic values. Part of a meadow, and a fence (to define the foreground and to give line and space to the whole), behind that nothing but clouds and sky – so simply and adequately can the sensation of a summer day be expressed in a photograph. . . . As only a few essentials are depicted they become *ipso facto* symbolical. What van Gogh said of painting may also be a guide to photographic art: "The figure of a labourer, some furrows in a ploughed field, a bit of sand and sky, are serious subjects so difficult, but at the same time so beautiful, that it is indeed worth while to devote one's life to the task of expressing the poetry hidden in them." ' – Helmut Gernsheim in *New Photo Vision*, Fountain Press, 1942.

'The camera is, by its nature, an instrument for working in time as well as space . . . its most precious and typical qualities are the power to catch movement too rapid for the painter and the capacity to ensnare and exploit the casual element in life, the chance encounter, the sudden change of light, or fleeting expression.' – John Piper in the *Manchester Guardian*, 11 September 1952.

'There must be that relationship between the man with the camera and his subject which allows him to see it for a moment, as it flies, as nobody else has ever seen it before or will ever see it again. And there is no doubt that every single one of us has an individual vision, if we allow ourselves to find it and explore it. The way to get at it seems to me to be to ask oneself not "now how can I take a good photograph ?" but "what do I like enough to make me want to photograph it ?" ' – John Piper in *Photoguide Magazine*, August 1950.

'I have always maintained that the photographer should simplify his

technique so that the mind is free to concentrate on essentials. . . . The modern obsession with apparatus and technique may result in efficient craftsmanship; but, after all, seeing the picture, composing it, and seizing the psychological moment for exposure is the main thing.' – E. O. Hoppé in *Hundred Thousand Exposures*, Focal Press, 1947.

'Photography is to me the simultaneous recognition, in a fraction of a second, of the significance of the event as well as of a precise formal organisation which brings that event to life. . . . This visual organisation must come from an *intuitive* feeling for plastic rhythms, which is the backbone of the arts. Composition must be one of our *constant* preoccupations right up to the moment a picture is about to be taken – and then feeling takes over.' – Henri Cartier-Bresson in *Images à la Sauvette*, Verve, Paris, and Simon and Schuster, New York.

'It is not surprising that beginners with pictorial aspirations should usually start by choosing inherently picturesque subjects. For one thing, they are fairly difficult to miss. In the impressionable years of childhood, most of us have had them so frequently pointed out by adults that, when we are grown-up, the unconscious mind telegraphs "picturesque" in the same instant the conscious mind identifies the subject. What is more natural, therefore, than to turn first to these "ready-made" pictures when we wish to make pictorial photographs. The favourite picturesque subjects include: old-world cottages; village churches; horses ploughing; cows browsing; swans; ruined castles and abbeys; windmills; sailing boats; sunsets; and woods carpeted with bluebells. The pictures resulting are invariably no more than simple records, showing little or no evidence of artistic perception, as – contrary to general belief – it is actually more difficult to produce effective and original works from inherently picturesque subjects than from less hackneyed material.' – John Erith in *Pictorial Photography*, Fountain Press, 1951.

'The possibility of "isolating details from surroundings" as Mr Gernsheim puts it, is in my opinion the photographer's greatest privilege. He can stop you to concentrate on something which the eye roving over the whole of a wall or a statue may miss completely.' – Nikolaus Pevsner in a Foreword to *Focus on Architecture and Sculpture* by Helmut Gernsheim, Fountain Press, 1949.

'In every photograph the moment is fixed forever. In some it is the

very moment that we prize, because it is such vivid history. In a few the moment magically becomes forever.' – Beaumont Newhall in *The History of Photography*, the Museum of Modern Art, New York, 1949.

'A technical "failure" which shows some attempt at aesthetic expression is of infinitely more value than uninspired "success".' – Cecil Beaton in *Photobiography*, Odhams, 1951.

'The old saying, "The camera cannot lie", is wrong, of course. Photography is *not* objective. Firstly, every photograph is an abstract, a transformation of colour values into the grey-scale. Already here there are endless possibilities of subjective representation. Secondly, only a small tone-scale is at our disposal in which to express the infinite wealth of tone values which we find in nature, from gleaming white down to the deepest black; it comprises only the thousandth, even ten-thousandth, part of the original tone-scale. Thus we have not only to find an analogy to colour, we have also to transpose the entire gradation of light intensity. Thus considerations of style, of composition, play an important rôle in "objective" photography in addition to technical considerations, and, most of all, the personal conception of Nature and ability to re-create. The photographic problem goes, therefore, much deeper than the mere depiction of something seen in the world of phenomena.' – Helmut Gernsheim in *New Photo Vision*, Fountain Press, 1942.

'Photography is, above all, reporting. But between reproducing and creating there is, after all, only a difference in degree: no absolute distinction. Careful selection from the infinite variety external objects offer, the way of presenting them, the manner of lighting, the gradation of light intensity, the degree of depth of field, the choice of perspective and section, etc. – all these combined afford a broad scale of freedom to produce new and expressive forms.' – Helmut Gernsheim in *New Photo Vision*, Fountain Press, 1942.

'A photographer has certain objectives: to report, to entertain, to convey a mood, to inspire. To do so, he must have a feeling for his subject. No one can do inspired work without genuine interest in his subject and understanding of its characteristics. Ask yourself these all-important questions: *Why do I want to take this picture? What do I actually want to say? Which quality impresses me most? How can I best record it on film? What can someone else get out of such a photograph?* Then try to put into your picture what you feel, and what you want

someone else to feel when he looks at your work.' – Andreas Feininger in *Advanced Photography*, Prentice Hall, New York.

'That there may be a limit to abstractionism has been suggested by a number of aestheticians, among them Professor Stephan Pepper in the *American Journal of Aestheticians*, who has said that painting may well reach a dead end due to a basic superficiality resulting from the lack in the pure abstract of any fabric of cognitive and associative ideas. Much of modern painting is nothing more than visual decoration, a form of applied art. And here is the possible source of some frustration on the part of the painter, since the painter does not like to think of himself merely as a decorator. He wants to "make comment", to be a prophet of his times. Professor Pepper suggests a way out in a partial return to representationalism, in much the manner of Picasso's *Guernica*. In this way, abstractionism can enrich form and be in turn enriched by meaning. Photography, by virtue of its representationalism, is never so divorced from the fabric of cognitive and associative ideas and does not face this danger. Photography, in fact, is quickly becoming a visual language.' – Ira Latour in *Photography*, December 1953.

'The eyes without the mind would perceive in solids nothing but spots or pockets of shadow and blisters of light, chequering and criss-crossing a given area. The rest is a matter of mental organization and intellectual construction. What the operator will see in his camera will depend, therefore, on his gifts, and training, and skill, and even more on his general education; ultimately it will depend on his scheme of the universe.' – Bernard Berenson in *Aesthetics, Ethics and History*.

'All the world about us is filled with wonder and splendour – the trees and clouds, the mountains and valleys, the glitter of the sunlight on the surface of moving water – who is to gainsay their beauty, and yet sometimes we forget. Even our towns, which are often called ugly, respond to the opened eye of the artist, for nothing is irretrievably ugly. . . . Life should be so ordered that every human being may have some means of expressing this appreciation externally, of giving back that which he has received. . . . And some can appreciate, but think they have no ability to pass on their dreams or visions or realities to their fellow-men, but this is a great mistake. The means of expression is always found if the urge is strong enough. And photography has helped many in this respect. A rudimentary knowledge is so easily obtained. Even a child can press the inevitable button, and behold an artist in the making.' – Alvin Langden Coburn in *The Photographic Journal*, April 1923.

**PART TWO**

*The Camera and How to Use It*

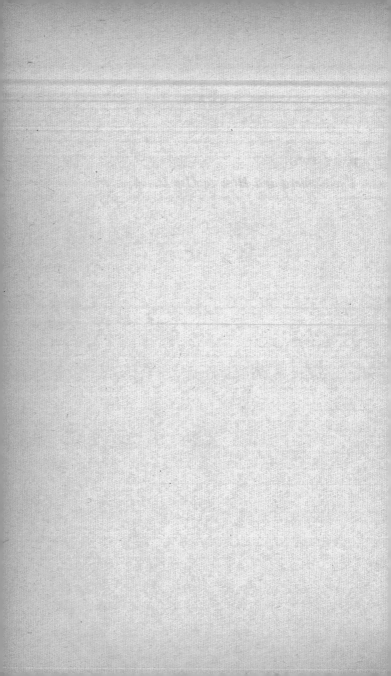

# 5 Cameras

## How a Camera Works

First I must explain the main principles by which every camera works. It is important to understand them, especially so *the relationship between Lens, Shutter, and Diaphragm*. When they are understood any camera can be manipulated without difficulty.

A camera consists basically of a light-tight box having a lens at one end and a holder for a plate or film coated with light-sensitive emulsion at the other. In the case of roll film an arrange-

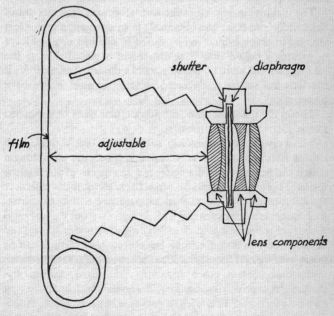

2. Basic parts of a camera.

ment keeps a length of the film flat at the back of the camera between two spools.

In order that the image may be sharply focused on to the emulsion at whatever distance the object to be photographed happens to be from the camera, the distance between the lens and the emulsion can be adjusted in most types of cameras; for instance, the light-tight box may be partly composed of pliable bellows which can be opened or closed like a concertina.

Light is admitted through the lens by opening and closing a shutter placed either near the lens or close to the film or plate. In all the better cameras the time during which the shutter remains open can be adjusted to suit the conditions of light prevailing when the photograph is being taken; this time may vary considerably, possibly between one second and one thousandth of a second. The shutter generally has a mechanism by which it can be kept open for as long as required – for hours if necessary.

The diaphragm, as well as the shutter, controls the amount of light which can enter the camera. It is an opening, more or less circular in shape, which can be varied in size by moving a lever or turning a milled ring. The diaphragm is placed close to the lens or, like the shutter, actually within the lens barrel itself, if the lens has several glass components – as most lenses have nowadays.

These, then, are the three most important parts of a camera: LENS, SHUTTER, DIAPHRAGM.

The very cheapest cameras, such as the box variety, have neither a shutter which can be varied in speed, nor a diaphragm which can be altered in diameter, nor any means of altering the distance between lens and film to achieve sharp focus wherever the subject to be photographed happens to be. But, of course, such cameras are inexpensive and, though they can only be used within strict limitations such as bright light when snapping and beyond a certain distance from the subject, good pictures can be made with them if these limitations are accepted (Pl. 16 bottom).

Cameras contain other apparatus than lens, shutter, and diaphragm, such as view-finders, film-holders with knobs to turn on a new section of film after an exposure has been made, range-finders to calculate the distance of the subject from the camera

so that focusing can be accurate, or, in the case of the twin-lens camera, an extra lens to provide an exact image in focus of the subject on a ground-glass screen. Some cameras also have bellows which can be moved up and down or from side to side so that the lens can incorporate, for example, the whole of a high building in a picture without having to point the camera upwards, or to incorporate a side view not obtainable in any other position; such movements are called rising fronts and sliding fronts. These things will be explained later. Meanwhile let us concentrate on the Lens, the Shutter, and the Diaphragm.

## The Lens

Light is the photographer's medium and he controls it first with his camera to make a negative and then with his enlarger (a kind of camera in reverse) to produce a big positive print from the negative. The glass lens which admits the light is therefore the most important part of a camera; the sharpness of the negative largely depends upon its accuracy.

We do not know what light is, but we do know how it behaves. We know, for instance, that it travels through outer space at 186,000 miles a second and at a slightly slower speed through air. Through glass it travels even more slowly than through air. We also know that light travels in straight lines through homogeneous materials which are transparent and that it is either absorbed by, or reflected from, opaque materials.

Light travels through glass at about two-thirds the speed at which it travels through air. Therefore, when a beam of light reaches a plain sheet of glass with parallel faces, having been travelling in a direction at right angles to those faces, it is slowed down as it passes through the glass and regains its former speed as it emerges. Its line of travel through air, glass, and air again is then in a straight line. When a beam of light reaches a sheet of glass at an angle of more or less than 90 degrees, however, it does not continue in a straight line but slews round slightly because its speed is checked on the skew; it then passes through the glass in a straight line and when it emerges into the air it slews round

again at the same angle as that at which it was travelling before it entered the glass. When light passes through a *prism* of glass – that is, a piece of glass having a pyramidal section or, to put it another way, with its outer surfaces not parallel but sloping towards each other – it changes direction as it enters the glass, continues in a straight line through the glass, and as it emerges slews further round still; it does not then continue in its original direction as it would have done if the glass sides had been parallel. Thus a triangular prism of glass changes the direction of a beam of light by bending it twice. A simple camera lens, like a reading glass, is in effect a series of prisms of infinite number having their sides sloping at different angles.

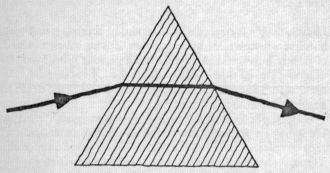

3. How a beam of light bends when passing through a prism of glass.

A primitive form of camera is one which has no lens but admits light through a minute hole – a pinhole. The image it forms at the back of the camera is not absolutely sharp because the beam of light travelling from each point towards the camera is slightly dispersed as it passes through the hole; the hole is not infinitely small and it has a certain definite diameter even though it seems so minute. The light from each point of the subject travels through the pinhole to form a series of narrow cones of light; hence each point of the subject creates a slightly diffused image of itself on the back of the camera – the size of the base of the cone; the whole image is therefore slightly blurred. Moreover, the light entering a pinhole camera is so limited that a compara-

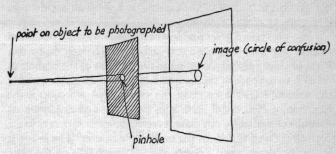

poiot on object to be photographed

image (circle of confusion)

pinhole

4. Blurring of an image in a pinhole camera.

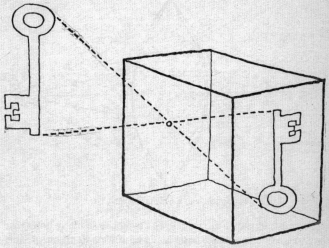

5. How an image is produced in reverse in a pinhole camera.

tively long exposure would be needed to form an image on a light-sensitive plate or film placed at the back of the camera. The image formed at the back of the camera is, of course, upside down and left to right; it is inverted. This can be understood if we imagine our eye placed at the top of the camera back and looking through the pinhole; we shall see the bottom of the subject. With

our eye at the bottom of the camera back we shall see the top. The same applies to each side.

If we now take a great number of pinholes within a circle and behind each hole we place a very small prism having the correct slope of sides varying according to the position of the pinhole in relation to the back of the camera, not only do we vastly increase the amount of light entering the camera but we control the direction of each ray of light from every point of emanation on the subject so that we can make it converge with other rays to the correctly placed surface at the back of the camera. The image is no longer blurred, and a sharp, focused image falls on the plate or film, which is said now to be on the Focal Plane.

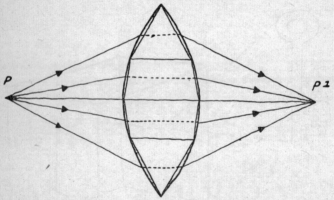

6. Beams of light passing through a simple convex lens.

To continue our theorizing, if we now make so many holes that they make one complete, large hole and if we add all our prisms together to make one piece of glass with two convex faces we have a complete camera lens of a primitive sort.

The simplest camera lens is therefore a piece of glass circular in shape in front and bulging outwards at each side when seen on edge. Each bulge is part of the circumference of a circle when seen on edge, though the whole is part of the bulge of a sphere.

An important feature of a camera lens is that light from every point of the subject photographed passes through every part of

the lens. Thus, if part of a lens is covered with black paint, or if it is scratched, the complete image will still be cast on the back of the camera, even though the amount of light entering the camera will be less and the image therefore of reduced intensity.

Apart from the variation in the amount of light they admit, the chief difference between the pinhole camera and the lens camera is that, though the whole pinhole image is slightly blurred, images of objects near the camera will be almost as sharply defined as those of objects far away from it, whereas the lens image will only be sharp for the images of those objects which are at a certain distance from the camera; objects nearer the camera or farther away from it will be out of focus. In a pinhole camera the focal plane can be anywhere so far as sharpness of image is concerned – at least in theory; in a lens camera only images falling on the focal plane will be sharp. The distance of the focal plane from the lens will vary according to the distance of the subject to be photographed from the camera.

A convex lens with pronounced bulges will refract, that is bend, light to a greater extent than one having shallow curves – assuming, of course, that they are made of the same kind of glass having the same refractive power. The former lens will focus light rays much nearer to itself than the latter. It will have a shorter focal length – that is the distance between the lens and the point at which a distant image will be in sharp focus. When we speak of a 4-inch lens, for instance, we mean a lens having a focal length of 4 inches. Normal lenses in cameras have a focal length which is about as long as the diagonal of the picture they produce. Wide-angle lenses have very short focal lengths.

When the distance between film and lens is set at focal length, subjects a long way away from the camera will be in focus but near subjects will be blurred. If a near object, say 3 feet away from the camera, is required to be in focus – that is, if its image is to fall sharply on the focal plane where the film lies – the distance between film and lens must be increased. The larger the lens is and the more light it admits, the more necessary does the accurate adjustment of the distance between film and lens have to be.

However distant a subject is from the camera, it can in theory never be exactly in focus when the distance between film and lens

is at the focal length because the rays from the subject which reach the lens are never quite parallel; but in practice a sharp image is obtained at focal length of any subject, however distant, beyond about 100 feet from the camera. Even beyond 20 feet the adjustment of distance between lens and film which is needed is very small. When the distance between lens and film is the focal length of the lens, then the camera is said to be set at Infinity.

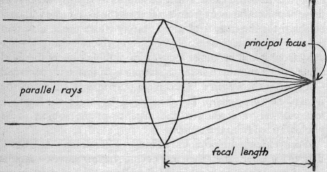

principal focus

parallel rays

focal length

7. The light rays from a distant object can be regarded as parallel; when they have passed through a lens they will throw a sharply defined image at a point which is at the focal length away from the lens. When the lens of a camera is at the focal length away from the film it is said to be set at Infinity; when close objects are required to throw a sharp image on the film, the distance between lens and emulsion surface must be longer than the focal length. A lens is specified by its focal length.

For a lens having a 4-inch focal length producing a $2\frac{1}{2}$-inch by $3\frac{1}{2}$-inch negative, the adjustment of the distance between film and lens needed to focus subjects between 3 feet and 25 feet away from the camera is about 13/32 inches, whereas between 25 and 100 feet it is only about 1/32 inch. In practice this means that the nearer a subject is to the camera the more pronounced is the distance between lens and emulsion and the more accurate must the adjustment of that distance be. This can be clearly observed in a camera where the plate or film can be replaced with a ground-glass focusing screen.

In practice some latitude is permissible in focusing a camera accurately, because the human eye does not notice a slight con-

fusion in the image on a print. Reasonable sharpness may be said to consist of a Circle of Confusion in a print of no more than 1/100th of an inch when the print is viewed at 10 inches' distance.

Permissible confusion in definition is closely related to what are termed the Depth of Field and the Depth of Focus. Now these are matters of the greatest importance in photography and they must be clearly understood by any would-be photographer who wishes to use any kind of camera other than a box with a fixed focus.

*Depth of Focus.* This is the distance by which the lens can be moved towards, or away from, the film when the subject is in focus without producing noticeable confusion and blurring of images on the final print. The larger the lens is, and the more light it admits, the shorter becomes the depth of focus possible, and, *vice versa*, the smaller the lens the greater becomes the depth of focus possible. Thus, as already stated, the pinhole camera has a depth of focus which is infinitely great in theory; in a box camera with a small lens the depth of focus is much longer than it is, for instance, in the biggest and best of lenses in the most expensive camera *used at its fullest aperture*.

But the word Aperture now needs explaining. It is the size of opening of the diaphragm. When the diaphragm is at its fullest aperture, light can pass through the whole of the lens. The smaller the aperture is made, the less is the whole lens used and the less, therefore, is the amount of light reaching the sensitive surface of the film or plate. Now, the smaller the aperture is made the greater becomes the permissible depth of focus – that is to say, the clearer and less diffused will the images of near and distant objects become. Thus when the diaphragm is 'stopped down' to its smallest possible size it will be possible to obtain a photograph in which a gate-post only 3 feet away will appear as sharply defined as a mountain peak 10 miles away. In such a case, of course, the length of exposure time allowed by the shutter will have to be comparatively long – perhaps 1/10th of a second.

If the diaphragm is opened as widely as possible so that the whole lens is in use, the depth of focus becomes short and it will be impossible to obtain sharp images of all objects which are any

distance apart – unless, of course, the camera is focused at Infinity and all objects to be recorded are 100 feet or more away from the camera. With the diaphragm wide open, the exposure time needed is relatively short. Thus what we lose on the swings we gain on the roundabouts in either case. With a large lens, a wide-

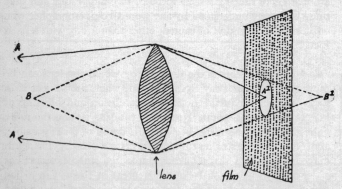

8. When a distant object casts a sharp image on film the image of a closer object will not be sharply in focus for it will be cast sharply behind the film at point $B^1$. On the film itself the image of B will take the form of a blurred circle of confusion. But as the diaphragm of the lens is 'stopped down', i.e. made smaller in diameter, the circle of confusion will grow smaller and the depth of field will thus be increased. The smaller the diaphragm stop the more sharp will the image of all objects, near and far, appear on the film.

open diaphragm, and a very short exposure we can record sharply a horse galloping on a dull day, but the hats of the spectators a few feet away will be blurred. With the same lens but smaller diaphragm aperture (or, alternatively, with a smaller lens) to record such a subject would mean a longer exposure; then the result would show everything in sharp focus including the hats but excluding the horse which would be blurred, not because it was out of focus but because it had moved forward during the time of the exposure sufficiently to blur the image on the film.

Depth of Focus is sometimes called Depth of Field but this is wrong, because though the two are related, they are not the same thing. Depth of focus, as we have seen, is *inside* the camera

whereas depth of field is *outside* it. Objects nearer to, or farther away from, an object which is exactly in focus upon the focal plane of the camera may produce tolerably sharp images at the same time; the distance outside the camera within which these objects give sharp images is the depth of field. *Depth of field is always greater for distant objects than for near ones.* Like depth of focus, it can be increased by reducing the size of the aperture of the diaphragm – that is by 'stopping down'. (The depth of field behind and in front of an object at 3 feet from the camera may be only a few inches, whereas at 20 feet it could be as much as 30 feet beyond the subject.)

Depth of field is greater for lenses having short focal lengths than for those having long focal lengths; that is to say, the wider the angle of the lens the greater will be the depth of field and *vice versa*. (Width of angle will be explained later.) Without depth of field within which definition of images of objects at different distances from the camera is tolerably sharp, photographs representing three-dimensional depth, such as an architectural shot of a long arcade, could not be made.

The extent of depth of field depends on four factors: (i) The standard of sharpness desired by the photographer. (Contact prints, for instance, will need far less sharpness of definition than big enlargements.) (ii) The focal length of the lens. (iii) The aperture of the diaphragm. (iv) The distance between the camera and the object which is to be kept in sharpest focus.

*Types of Lenses.* I have described a camera lens simply as a piece of circular glass bulging outwards on both sides. But this is the crudest form of lens; the better lenses are much more complicated and are made up of several pieces of glass fixed in accurate relationship to one another by means of metal frames and holders or barrels. These are called Compound Lenses.

For general purposes we can distinguish between three types of lens. The simplest, used only on the cheapest cameras, is the single-glass Meniscus; this allows very little light to enter the camera so that it can be used only out-of-doors in bright weather, unless time exposures are given. (Box cameras have these lenses very often and owners should make greater use of time exposures

95

with them than they usually do, using a tripod or standing the camera on a firm base.) The Meniscus has many faults or aberrations and gives comparatively poor definition.

A better lens is the Rapid Rectilinear. This has four glasses and is often found on old folding hand cameras. It is not much made or used today but is a great deal better than the Meniscus; it may admit four times as much light and, as its name implies, it is free of at least one aberration – vertical lines do not appear curved at the sides of the negative.

The best type of lens is the Anastigmat corrected for most aberrations such as astigmatism, colour refraction, curvature distortion, flare, and uneven illumination.

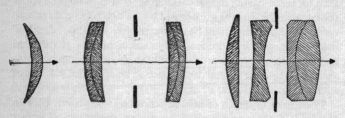

9. Three types of lens in section: left, the simple meniscus; centre, the rapid rectilinear still found on old cameras; right, a modern anastigmat of four elements, in this case the famous Zeiss Tessar.

The perfect lens has yet to be produced and it is probably only possible in theory. For practical purposes a good modern anastigmat can be said, however, to have no serious aberrations. All the best cameras have anastigmat lenses varying in quality and light-admitting capacity and they may contain three to nine glasses, each having different curvatures on their faces and some being composed of two parts cemented together.

*Angle of View.* Focal length of lens determines its angle of view and therefore the amount of the object to be photographed which will be recorded on the film or plate. The shorter the focal length, the greater will be the angle of view; hence the term Wide-Angle Lens. Conversely, the longer the focal length the narrower will be the angle of view of the lens. It follows that the larger the

negative, the longer will be the focal length of the lens required
to fill it.

A lens of normal focal length is fitted to most cameras – that
is a lens having the same focal length as the diagonal of the nega-
tive size it produces; the angle of view in this case is about 50
degrees. The negative of a normal lens will therefore produce

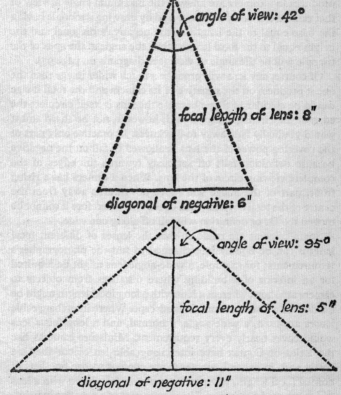

10. Relationship between focal lengths, diagonals of films or plates, and
angles of view of an 8-inch lens used for a quarter plate camera (3¼ in.
by 4¼ in.) and of a 5-inch lens used for a whole plate camera (6½ in. by
8½ in.).

a much wider picture than the human eyes see when the head is kept still, for then the angle of our view is only 25 degrees. Exceptionally wide-angle lenses will take in 100 degrees (more than the 90 degrees of a right angle). A lens of long focus may have an angle of view of only 20 degrees. The standard lens of a miniature 35-millimetre camera has an angle of view of 45 degrees.

If the focal length of a lens and the diagonal of the negative it produces in a camera are known, the maximum angle of view of that camera can easily be discovered by drawing a triangle having the base equal to the length of the negative's diagonal and the height equal to the focal length; then the angle at the apex of the triangle will be the angle of view (see diagrams on page 97).

Of course, any lens will produce a much wider image than the one it produces on the negative of its camera and the total image would be circular in shape because the lens is itself circular; the edge of the circular image would, however, not be sharp and it would gradually fade away to blackness. In practice only part of the covering power of the lens is allowed to fall on the negative because definition falls off seriously towards the edges of the complete viewing circle of the lens. When a camera has a rising front, part of the image will move downwards away from the centre of the total covering area of the lens; therefore it cannot be moved too far or definition will fall off along one edge.

Some cameras are made so that the lenses of different focal lengths can be rapidly interchanged to suit the photographer's requirements; for example, a wide-angle lens might be required for an interior of a building where distances from objects to camera are short, whereas a lens with a long focal length might be needed for a distant mountain landscape. Where interchangeable lenses are used, a wide-angle, a normal, and a long-focus lens would cover nearly every requirement. Miniature cameras like the Leica or Contax have interchangeable lenses but they are costly and, in general, amateurs are content to use one lens of normal focal length. Most cameras are, in fact, fitted with a lens which cannot be removed. Using only part of a negative in printing will have the same effect as using a lens of long focus, though, of course, the size of negative used will then be small.

As already stated, the lens with the shorter focal length will

have a greater depth of focus than one with a longer focal length; it will therefore be able to encompass a greater depth of field. That is true, at least, if it is assumed that both lenses are worked at the same aperture of diaphragm and at the same distance from the object to be photographed. But if the short-focus lens is moved nearer to the object so that it will produce the same size image as the long-focus lens situated farther away from the object, the depth of field for both lenses will be the same.

Note that if an object is photographed from the same position with lenses of different focal lengths, the lens with the short focal length will include in the image everything the long-focus lens includes and a great deal more besides. Therefore, exactly the same picture can be obtained with the short-focus lens as with the long-focus lens by enlarging the required part of the negative produced by the short-focus lens. Thus any lens will act as a long-focus lens if it is used to produce an image on only a small part of the negative. The focal length of a lens controls the size of the image produced on the emulsion of the negative; it does *not* distort the image, as is too often believed. Nevertheless, strange effects are produced by lenses of very short or very long focal lengths. For example, a lens of short focal length, that is one having a wide angle, may seem to produce a peculiar and abrupt – though not, in fact, incorrect – perspective as compared with a lens of long focal length taking the same picture from a much greater distance away. A telephoto, or very long-focus, lens will also appear to produce distortions such as that strangely foreshortened cricket pitch we see on news films of test matches where all the figures seem to be of the same size whatever their positions on the field.

Many amateurs will know the disappointing results of a landscape picture which includes hills. In our memories the hills are impressively high, whereas our photograph shows them as far-off hillocks, dim and dull. This the result of using a lens of too short a focal length for the subject. The only way to make the hills look impressive is to cut down the amount of the negative to be printed or enlarged and that will mean an increase in graininess and a loss of definition in the finished print as compared with a print for which the whole negative is used. Alternatively we can

go back to the scene and photograph it again from a point much closer to the hills.

Let me explain focal length in another way, for it is important to understand this matter. Take a sheet of glass, say 8 inches high by 6 inches wide, and look through it at a view containing a nearby church and distant mountains, holding the glass 20 inches from the eyes. Let me say that the church will almost reach from top to bottom of the glass and the mountains will fill at least a quarter of the area of the glass. That picture seen on, or rather through the glass will represent the same picture as a lens of long focal length will produce on a plate or a film. Now place your eye 10 inches from the glass and the whole scene is different – just as it would be in a camera with a lens of short focal length; the glass will contain a much wider scene and both church and mountains will be half the size relative to the glass area that they were when your eye was 20 inches from the glass. However, the first 20-inch picture will all be included in the 10-inch picture and the perspective will be just the same in both cases.

Let us say, now, that the first picture with your eye 20 inches

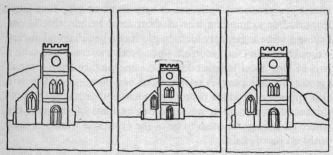

11. Effects produced by lenses of different focal lengths. Left, the image produced by a lens of long focal length. Centre, the same image produced from the same position by a lens of short focal length. Right, the image produced by a lens of short focal length when the position of the camera is much nearer to the church than the one adopted for the images at left and centre; the church now appears as large as on the image on the left but the mountains have not increased in relative size.

away from the glass produced a more interesting picture than the one seen when your eye was only 10 inches away from the glass.

Can you obtain the same composition with your eye at 10 inches if you move your position? The answer is No. With your eye 10 inches from the glass you move towards the church until it is as large as it was with your eye at 20 inches – that is to say, it is almost as high as the glass. So far, so good; but what has happened to the mountains? They have hardly changed their size at all relative to the church and the total area of the glass; they will therefore appear dwarfed in relation to the church as compared with our original 20-inch composition. To obtain roughly the same composition as this desired original, you will have to move very much closer to the mountains and there look for another church or building altogether.

Incidentally, long-focus lenses with very wide apertures are very difficult to make so that in general their light-admitting quality is low compared with that of short-focus lenses.

*Coated Lenses.* Sometimes unwanted, scattered light enters the camera through the lens; this may be oblique light coming from a very bright surface such as the sky above or from a brilliant highlight outside the field of view. Such light is reflected from the surfaces of the lens components and the more complex the make-up of the lens – the more glasses it has – the more of this so-called flare-light is likely to enter the camera. A lens-hood reduces oblique light and, if the camera allows it, *should always be used*; it cuts out much unwanted light from the lens and so makes the negatives crisper.

Today lenses can have their surfaces coated, or bloomed, to reduce the flare-light and most compound lenses are treated so by the makers during manufacture. Such coating adds to the crispness of negatives. The coating is a thin deposit of a substance, such as magnesium fluoride, which has a lower refractive index than the glass. It produces a distinct purple bloom but this does not mean that extra exposure must be given, for, if anything, the coating tends to reduce required exposure times, though not to an extent that need influence decisions about length of exposure or size of diaphragm aperture.

*Supplementary Lenses.* Lenses are either positive or negative. A

single positive lens is convex in shape – its faces bulge outwards; its effect is to bend the light rays inwards to a point. A single negative lens is concave in shape – its sides bulge inwards; its effect is to bend the light rays outwards so that they never meet.

A compound camera lens or objective may have some of its parts negative, but the lens as a whole will be positive in its effect.

Now, the focal length of a camera lens can be shortened by placing a single positive lens in front of it and it can be lengthened by placing a single negative lens in front of it. Such supplementary lenses are available for some cameras in which complete lenses cannot be interchanged. For example, a so-called Portrait Attachment lens is obtainable for box cameras; this is a simple positive lens which enables close-up portraits to be taken, and similar lenses are available for twin-lens cameras which will enable pictures to be taken as close as 12 inches from the camera. Negative lens attachments are also obtainable for some cameras which will convert the normal camera lens into a lens of long focal length so that distant objects will be brought nearer. A detachable telephoto lens can be obtained for a few cameras and this has a short back focus so that extra bellows extension is not needed to increase depth of focus. Though it has exceptionally long focus, a telephoto lens is different in construction from an ordinary long-focus lens.

*Treatment of Lenses.* A lens should be handled with respect and it should be kept clean by an occasional wipe with a soft chamois leather or with a special lens-cleaning tissue. Dust particles should be flicked off with a sable brush before the lens is wiped so that the surface is not scratched. Always wipe away greasy finger marks because human grease is acid and corrosive. Avoid wiping the surface with anything abrasive, such as a gritty handkerchief, because optical glass is soft glass. Wipe away raindrops or salt-water spray as soon as possible.

Beware of condensation, however slight, forming on the lens surface through sudden change in atmospheric conditions, for this will fog the negative on exposure. If you wish to dismantle a lens to clean its inner surfaces (hardly ever necessary) do so with great care and make sure that the screw threads are not crossed when

you replace them. Do not remove any parts which are cemented into the barrel. On the whole it is far safer to leave all cleaning and repairs of this sort to an expert, especially if your lens is coated.

A cap to cover the lens when not in use will help to preserve the lens and to keep it clean. But do not forget to remove it before making an exposure; this is an easy mistake to make.

## The Shutter

The shutter regulates the length of time during which the diaphragm will admit light through the lens. Its efficiency and accuracy are very important to successful photography and the better the lens, the more important these become, especially for the photographing of moving objects.

Broadly speaking, shutters are of two main types:

> a. The between-lens type
> b. The focal-plane type

More comprehensively, shutters can be listed as:

> 1. Lens cap
> 2. Rotary
> 3. Single leaf
> 4. Everset
> 5. Preset
> 6. Roller-blind
> 7. Focal-plane

1. The lens cap is simply a black cap covering the lens of an old-fashioned stand camera. It is removed with a steady hand to provide exposure and is then replaced. Professionals still use a cap sometimes when exposure time is as long as 1 second or more – perhaps for interior architectural work or even for portraiture. When small stops (small apertures of diaphragm) are used and long exposures are therefore necessary, the exposure cap is perfectly satisfactory. Seconds can be counted by adding the word Thousand between each number – 'remove cap, thousand, two thousand, three thousand . . .'.

2. The rotary shutter is of the simplest sort and is often fitted on box cameras. It consists of a metal disk placed in front of the lens and pierced with a hole. When a trigger is pressed the disk rotates for part of a revolution and in so doing the hole passes in front of the lens and admits the light. Power is provided by a metal spring. The exposure time is usually 1/25th of a second and is the only speed available. Rotary shutters, however, are usually made so that time exposures are possible by pulling out a slide which keeps the shutter fixed in a position where the hole in it remains in front of the lens for as long as required – that is until the slide-catch is released.

3. The single-leaf shutter is slightly more complicated than the rotary. It is often incorporated in simple fixed-focus folding cameras. Here again only one exposure-time is possible – probably 1/25th of a second. Exposure is made by pressing a trigger which moves a shutter blade from its position in front of the lens or aperture and back again immediately, the power again coming from a spring. Time-exposure is effected by holding down the trigger or by a slide.

4. The everset shutter is self-setting – that is to say that one depression of the trigger both tensions the spring and releases the shutter. A long depression of the trigger is needed and the efficiency and accuracy are less than in those of the preset type. The everset shutters are usually confined to speeds of 1/25th, 1/50th, 1/100th second, Time, and Brief Time.

Both everset and preset shutters are fixed between the lens components and have variable speeds. They are fairly complicated in construction. Time and Brief Time are usually designated T and B. Brief Time (sometimes, for some anachronistic reason, called Bulb) is for short time-exposures up to a few seconds and in its operation the trigger is held down by thumb or finger during exposure and then released to close the shutter. Longer time-exposures, when the setting is T, are accomplished by pressing the trigger, removing the finger, and pressing the trigger again, when exposure-time ends.

5. The old preset shutter requires two operations. First the trigger is pressed to tension the spring and again when exposure is made. The Compur is the best known of this type

and is perhaps the best shutter to be had for general purposes.

The more elaborate multi-speed shutters, such as the preset, give exposures from 1/25th second up to 1/500th second and slower exposures of 1/10th, 1/5th, ½, and 1 second. These slower speeds are at least as valuable, if not more so, than the faster ones, especially for landscape and architectural work where great depth of field is wanted.

Multi-speed shutters have several metal blades pivoted round the aperture – three, four, or five in number. The slower speeds are worked by an escapement mechanism, the medium speeds by a set of gears, and the faster speeds by a powerful spring.

The matter of Synchronization (with flash lamps) is discussed on page 162. Some new shutter releases are electronic and these help to reduce camera shake when the camera is held in the hand.

6. The roller-blind shutter is an old-fashioned type fixed either immediately behind or in front of the lens. Still found on stand cameras, it consists of a fabric blind having a square hole in it which on exposure travels across the lens, the motive power coming from a spring roller. The tension of the spring can be varied to give a range of exposure times from about 1/15th to 1/75th second, and Time and Brief Time are provided. The amateur is unlikely to come across this type of shutter unless he plays with large, old cameras.

7. The focal-plane shutter, though similar in principle to the roller-blind shutter, is found on many cameras – on the ordinary reflex, for instance, and on miniature types of camera. This type of shutter is fixed close to the focal plane of the camera – that is close up to the surface of the plate or film. It may be made of fabric or of metal and it often has two blinds. A gap between the two blinds forms a slit which allows the light to pass through to the emulsion when the spring roller is released. The time of the exposure depends both on the size of the slit and the speed with which the slit travels in front of the emulsion. The ordinary reflex camera (not the twin-lens reflex) often has a focal-plane shutter in order that the lens may always admit light to the reflecting mirror which it could not do if the shutter were fixed within the lens.

The focal-plane shutter has one disadvantage. Though the

actual exposure time on any one part of the emulsion may be as set, the actual time taken for the shutter slit to pass right across the whole emulsion face will be far longer than the exposure time. This is of no consequence except when the subject is moving. If it is moving, noticeable distortion of the subject in the image may result. A motor-car, for instance, may appear foreshortened if the car is moving in the opposite direction to the shutter and lengthened if the car is moving in the same direction as the shutter because, by the time the slit has moved from one side of the emulsion to the other, the car will have moved forward slightly.

On the other hand, the focal-plane shutter has advantages not possessed by the between-lens, or diaphragm, shutter: it is more robust, it can give higher speeds and greater accuracy at high speeds, and it makes the interchange of lenses of different focal lengths easier in that each lens does not require its own separate shutter. The between-lens shutter does not achieve speeds greater than 1/800th of a second, whereas the focal-plane shutter can reach 1/2000th of a second. For these reasons press photographers have tended to favour focal-plane shutters. Almost all 35-mm. miniature cameras like the Leica have been fitted with them.

Both focal-plane and between-lens shutters should be treated with respect. Do not keep a camera in a damp place or the mechanism of the shutter may rust. Press the trigger gently; squeeze it like a rifle trigger rather than jerk it, not only out of regard for the delicacy of the mechanism but in order to prevent camera shake. Avoid changing the exposure time on a between-lens shutter once it has been set; this may not cause serious damage but it is not recommended as a habit. Do not leave focal-plane shutters wound up for long periods or the spring will be weakened and speeds will become less accurate. If the blind of the focal-plane shutter is of rubberized fabric, do not leave the camera in the sun or the rays, focused by the lens, will bring deterioration to the fabric; rubber does not thrive in sunlight. And keep the camera warm if it is to be used in cold weather, or its action may be sluggish and exposure times inaccurate. Unless you are a skilled mechanic, leave the cleaning, oiling, repair or adjustment of shutters to an expert.

Two final notes on shutters. In most cameras a plunger release

trigger on the body of the camera operates the shutter, but most shutters can also be released by an attachment about six inches long which is composed of a steel wire inside a fabric casing. This is screwed to the shutter at one end and the knob at the loose end of the attachment is pressed by thumb to expose. Such a cable release is particularly valuable when the camera is on a tripod because it will then reduce that risk of camera shake which attends the pressing of the ordinary plunger release on the camera itself.

Very long cable releases up to 34 feet are now obtainable for use when the photographer wishes to be at some distance from the camera when he exposes. He may, for instance, wish to conceal himself when snapping wild animals or he may wish to be included in the photograph and then be able to choose the moment of exposure. These long cables are operated by a bulb at the end and can thus be released by the pressure of a foot – an advantage when the photographer wants to be in the picture but does not want to record the cable itself in the picture. These cables can also operate synchronized flash, a virtue, for example, when photographing wild animals at night.

Another shutter refinement is the delayed-action mechanism which is incorporated in some of the more expensive cameras, notably in the Compur and Prontor types of between-lens shutters. The shutter is set as usual and after a delay of about 10 or 15 seconds the shutter automatically opens and closes. By its use the photographer can take his place in the picture, perhaps as one of a group or to provide a figure in a landscape. Delayed-action shutters are also made as separate accessories.

## The Diaphragm

I have already said something about apertures and about the diaphragm which controls them, but more needs to be said now. On modern cameras the diaphragm is generally of the type called Iris and this consists of thin metal leaves assembled in such a way that they form a hole which can be varied in size of diameter by pressing a lever near the lens or by turning a ring surrounding the

lens barrel. When open to its widest extent it allows the whole lens to be used and the maximum amount of light can then enter the camera when the shutter is released. Then the length of exposure time can be relatively short, but depth of field will be at its most restricted and careful focusing will be needed – at least if the lens is a large modern one. By stopping down the iris – by making the diaphragm hole smaller in diameter – depth of field will be increased, but exposure time will have to be longer since less light will enter the camera. Definition will also be improved when the diaphragm is stopped down, especially if the lens is a poor one. In old lenses the smallest possible stop will probably give the best definition, but in good modern lenses the best definition is rarely attained at the smallest stop but at about mid-aperture. Experiment will reveal at which stop a lens gives the best definition.

The diaphragm aperture, or stop, thus has two functions:

1. To control the amount of light reaching the film.
2. To determine the depth of field.

Diaphragm stops are marked with numbers prefixed by the letter $f$. These numbers indicate a relationship between the diameter of the aperture and the focal length of the lens, the approximate formula for practical purposes being:

$$f \text{ number} = \frac{\text{focal length of lens}}{\text{diameter of aperture}}$$

This standard relationship or ratio is a great convenience and cameras are so made that the same exposure will be needed at the same $f$ number whatever focal length, or kind, of lens is being used – provided, of course, that the subject to be photographed, the type of film or plate used, and the lighting conditions are constant factors.

The $f$ numbers are only accurate when the lens is focused at infinity – that is on very distant objects. In the case of near objects when the distance between lens and emulsion is drawn out in order to achieve sharp focus the intensity of light reaching the emulsion is less for a given $f$ number. This, however, is only of practical importance when the object is within about three feet of the camera (to be exact within 10 focal lengths from the lens).

Then the correct stop may be as much as double that which is correct for the same conditions with the lens set at infinity. Alternatively the exposure time would have to be doubled if the stop opening remained the same. The formula for correction is:

$$\text{Effective aperture} = \frac{\text{nominal aperture} \times \text{extension}}{\text{focal length of lens}}$$

Standard $f$ numbers are: 1·4, 2, 2·8, 4, 5·6, 8, 11, 16, 22, 32, 45, 64 in English calibration. Continental calibration has a slightly different numbering and the English $f/1·4$ is the Continental $f/1·6$, the $f/8$ is $f/9$, and the $f/64$ is $f/72$. Cameras made on the Continent for the English market, however, have the English calibration.

Incidentally, if you want to change Continental centimetres into inches, as you may if you have a Continental lens marking the focal length in centimetres, remember that 1 centimetre equals 0·3937 inches, or alternatively that 1 inch equals 2·5399 centimetres.

The important facts to realize about $f$ numbers are that:

1. The *smallest* number represents the *widest* aperture.
2. Each $f$ number in the series above reduces the intensity of exposure, i.e. the amount of light passing through the lens, by half.

Thus an exposure requiring 1/50th second at $f/8$ would require 1/25th second at $f/11$ or $1/12\frac{1}{2}$ second at $f/16$ and so on, under the same lighting conditions.

Today most cameras of any pretensions have lenses which give an aperture of $f/4·5$ at the widest. $f/3·5$ is fairly common but $f/2$ and $f/1·5$ are more rare and, of course, more expensive. For most amateur purposes a lens of $f/4·5$ is adequate unless very special subjects are required such as snapshooting in rooms lit only by ordinary tungsten lamps or in theatres during performances. It is interesting to note that $f/8$ requires thirty-two times the length of exposure of $f/1·4$ under the same lighting conditions. Another interesting point is that for an aperture of $f/6·3$ on a 4-inch lens, the depth of field for a subject 5 feet away will be 30 inches; at

$f/3\cdot5$ it will be only 16 inches, but the exposure time needed in the latter case will be only one-third of that at $f/6\cdot3$.

At very wide stops such as $f/2$, as we have seen, depth of field is seriously restricted especially for close-up subjects. Nor will definition be as sharp as for a smaller stop on the same lens.

A lens with a very wide aperture such as $f/2$ is not necessarily a good lens even though it may be costly. The very wide-aperture lenses do not necessarily give better definition than those of smaller aperture even when they are stopped down; for example, a good $f/3\cdot5$ lens at full aperture may give better definition than a poor $f/2$ lens stopped down to $f/3\cdot5$.

The simplest types of anastigmat lenses have maximum apertures of $f/6\cdot3$ but most cameras with anastigmat lenses now go to $f/4\cdot5$ or $f/3\cdot5$. Apertures of anastigmat lenses as wide as $f/2$ or even $f/1\cdot5$ are only found on short-focus lenses like the 2-inch lenses of 35-mm. miniature cameras. This is because only short-focus lenses provide sufficient depth of field to be of much practical use at the very wide apertures.

Let us return once more to this important matter of depth of field. The following formula can be used for calculating depth of field for various apertures or diaphragm stops:

$$\text{Nearest distance at which objects give sharp image} = \frac{HD \times X}{HD + X}$$

$$\text{Farthest distance at which objects give sharp images} = \frac{HD \times X}{HD - X}$$

where $X$ is the distance of intermediate focus (the chief object to be photographed) and HD is the so-called Hyperfocal Distance.

The hyperfocal distance is the distance between the lens and the nearest object which is tolerably sharp when the camera is focused at infinity – say 20 feet from the camera. Box cameras with fixed foci are set at the hyperfocal distance of the lens. If a lens is set at the hyperfocal distance everything further from the camera than *half* the hyperfocal distance will be tolerably sharp – say 10 feet away from the camera.

The HD can be calculated mathematically for any given lens, but this is a somewhat loose calculation in that tolerable sharpness is a question partly of personal taste and partly of the require-

ments of the photograph. The HD can be calculated from the formula:

$$\text{HD in inches} = \frac{F^2}{f \text{ number} \times \text{diameter of the Circle of Confusion}}$$

where $F$ is the focal length of the lens. The diameter of the Circle of Confusion may be taken for general purposes to be $F/1,000$.

Let us say, then, that we are working with a lens of 3-inch focal length at stop $f/8$ (3 inches happens to be the focal length of a Rolleicord lens, or rather it is 7·5 cm. which is nearly 3 inches). The diameter of the Circle of Confusion will be, say, three divided by 1,000 or $3/1,000$ inches. HD will – if my arithmetic is correct – work out at 375 inches, which is about 31 feet. Therefore with camera focused at 31 feet, everything from half that distance – say 16 feet – to Infinity will be tolerably sharp.

Now that we know our hyperfocal distance let us see what depth of field we have if we focus on an object 5 feet away with a 3-inch lens at stop $f/8$. The nearest distance works out according to the formula above at about 4 feet 3½ inches, which is 8½ inches nearer the camera than the main object to be photographed. The farthest distance works out at about 6 feet, which is 12 inches further away from the main object. The total depth of field is thus 1 foot 8½ inches.

From these simple formulae you can work out a table for your own camera which will provide a useful working guide.

But what depth of field should one aim at ? That entirely depends on the subject and the aims of the photographer. As we have seen, a school of photographers existed not long ago which believed in having as great a depth of field as possible on every occasion – the $f/64$ school. Overall sharpness of both near and distant objects was the aim. There is a charm about pictures which have sharp definition all over, especially when the subject relies for its effect on abstract, architectonic composition rather than on the human, literary 'story'.

Today most creative photographers would not be dogmatic on this point. Restricting depth of field by using a comparatively wide aperture can have distinct advantages. The chief of these is that it enhances the sense of three-dimensional depth in a picture;

in an architectural perspective, for instance, a slightly blurred foreground will stress the distant main object which is sharply focused, perhaps a classic façade. Again, in close-up portraiture the head will be the important, focused object, and too sharp a background may weaken the interest and may even create a serious confusion of form – for example, a distant tree may appear to be sprouting straight out of a dignified hat. A great depth of field will also seriously restrict subject matter by lengthening the required time of exposure; this may not be serious when the subject is not moving, but, as soon as movement is there, shortness of exposure time is an important need.

A new way of assessing correct exposure according to the relationship between length of time of exposure and size of diaphragm stop is by Exposure Values. New cameras are being increasingly engraved with scales giving these values. As we have seen, exposure depends on a relationship which can be called IT – that is one between the amount of illumination, I, falling on the film according to the adjusted size of the diaphragm opening (measured in *f* numbers) and the length of time in seconds, T, during which the light is allowed by the shutter to pass through the diaphragm opening and fall on the film emulsion. The variation between I and T is adjusted according to the effects the photographer wants, such as the depth of field desired or the blurring or freezing of movement. The IT relationship will, of course, be governed by the amount of light available and the speed of the film in use, but when these are constant, the IT variations can be expressed as a constant in an Exposure Value number.

This EV numbering has the advantage of simplification in that a correct exposure (in the sense, not only of time, but of the shutter-diaphragm relationship) can be expressed by a single number. A table to convert the Exposure Values to *f* numbering and shutter speed can soon be made and soon be memorized for particular films. A typical case for a moderately fast film might read as follows:

| Exposure Value | 9 | 10 | 11 | 12 | 13 | 14 |
|---|---|---|---|---|---|---|
| Aperture at 1/100 sec. | *f*/2 | *f*/2.8 | *f*/4 | *f*/5.6 | *f*/8 | *f*/11 |

Note that each increase in the EV number requires half the exposure of the number before it. The smaller the EV number the longer the exposure in IT terms must be; thus, if EV 13 requires 1/100 sec. at $f/8$, EV 12 will require either 1/100 sec. at $f/5\cdot6$ or 1/50 sec. at $f/8$.

## Focusing

The shorter the depth of field, the greater the need becomes for accurate focusing. This means that close objects will have to be more accurately focused than distant ones. The smaller the negative size, of course, the more necessary does focusing become if any degree of enlargement in printing is desired. Even with 35-mm. negatives sharp enlargements of 15 inches by 12 inches are possible if they are properly handled.

How does one achieve accurate focusing? That will depend on the type of camera used. In reflex cameras (including the twin-lens type) focusing is easy because it will be achieved by turning a knob until the image in the ground-glass screen looks sharp to your eye. The same will apply to the old-fashioned plate camera where a ground-glass screen will be in place at the back of the camera before the plate-holder is inserted and will provide a brilliant, though inverted, image when viewed under a black cloth (as opposed to the indirect, right-way-up and right-way-round image of the reflex camera which reaches the eye *via* a mirror). These ground-glass images can be very accurately focused by eye if part of them is seen through a magnifying glass; most twin-lens reflex cameras now have such a magnifier incorporated in their viewing hoods.

Excepting the twin-lens type of reflex camera with its separate focusing, or viewing lens which is always open at the widest stop, the reflex camera and the plate camera with ground-glass screen will not only allow accurate focusing by eye but will show the depth of field visually at any stop.

With the ordinary, bellows type of roll-film hand-or-stand camera, focusing will not be so easy, nor will it be with the 35-mm. non-reflex camera. The old hand-or-stand camera may have an

attached brilliant viewfinder which will give you a small indication of the picture you want to take but it will not help you to focus; nor will it show you the correct picture at close distances owing to parallax – that is, its view will not coincide with that of the lens. The hand-or-stand camera may also have a pair of viewing frames, the rear one, against which you place your eye, being small and the forward one being large; when the edges of the two frames coincide in your eye, you will see the picture the camera will take; but again it will not help you to focus the lens and the parallax trouble will also arise here for near objects unless the makers have provided parallax compensation. Focusing will be accomplished by adjusting the distance between focal plane and lens – the depth of focus – according to a scale on the baseboard marked in feet or metres; alternatively the lens may be moved by turning it on its own barrel and then the distance figures will be marked on a ring. When a focusing scale is used the distance of the object from the lens will either have to be assessed by eye or measured by pacing, and the pointer then set at the correct mark on the scale. Extreme accuracy will not be required if the object is, say, 20 feet or more from the lens for then the depth of field will be relatively long; but at near distance such as 4 feet a tape measure is almost essential, the distance being measured *from the lens*. Some hand cameras are made to take plates or roll-film adaptors, and in such models a ground-glass screen with a surrounding hood can be inserted in the plate-holder grooves and accurate focusing can then be achieved by eye – as in the old-fashioned plate camera.

To those who own cameras without focusing screens a rangefinder is valuable. This is a small gadget for measuring distances and may be a loose object carried in the pocket or may be built into the camera or attached to the camera on a sliding shoe. The best kind is the coupled rangefinder attached to the camera and combined with a viewfinder. Two images are seen through it when the camera is out of focus, but the two images coincide when proper focus is achieved. The coupled rangefinder was undoubtedly the chief means of popularizing the 35-mm. miniature for by its use accuracy of focusing can be attained.

## Types of Camera

'What sort of camera should I buy?' is a question which cannot be answered simply, because the perfect camera for every purpose does not exist. One type of camera may be suitable for one sort of photography and another type for another sort. Some are easier to manipulate than others. Some are suitable for architectural work and not for photo-journalism or the snapshooting of moving things; others are suitable for portraiture and not for landscape; others, again, are fairly comprehensive in their scope but are limited in one particular direction. For instance, a 35-mm. is not very suitable for architectural work and a large Field, or stand, camera is more or less useless for action shots.

In general a good piece of advice is to buy as good a camera as you can afford. If you can only afford a few pounds do not be deterred. You can still produce good results if you limit your scope. A famous photographer of yachting pictures has been known to use a box camera on many occasions (perhaps when conditions were rough and a valuable camera might have been ruined); and some years ago a large cash prize running into four figures was awarded to an amateur's picture taken with an old box camera.

Roll-film adaptors are available for plate cameras. They take 120-size roll films and can, for instance, be fitted to 4 by 5 inch format cameras (usually monorail professional cameras taking cut film in holders) so that a wide angle lens then serves as a lens of medium focal length but provides great covering power and thus the fullest use of a rising front (see pp. 117, 184).

To analyse the seven main kinds of camera:

*Box, or Fixed Focus Camera.* This is the cheapest, suitable for snapshooting under good outdoor lighting conditions. As its name implies, it is box-like and cannot be expanded; its focal length is fixed at the hyperfocal distance. The shutter is a simple rotary type giving but one speed, usually about 1/25th second, but a stop for time exposures is usually provided and on the better box cameras today a mechanism for synchronizing shutter action with a flash bulb is incorporated so that indoor and night photographs

can be taken. The lens usually has a stop of about $f/11$ and the better models have a subsidiary portrait-lens built in. Two small brilliant reflex viewfinders are usually provided, one for vertical views and the other for horizontal, though large viewfinders are now often incorporated to form a primitive type of twin-lens camera. Any object within 10 feet of the camera will not be sharp on the negative unless the portrait attachment is used. If photographs are taken with a time exposure, the camera must be placed either on a firm surface or, preferably, on a tripod. Fast-moving objects cannot be photographed unless they are far off. Nor will very big enlargements be sharp. Box cameras are made to be used only with roll films or cartridge films for rapid loading. The lenses of cheap cameras are now mostly made, not of glass, but of plastic.

*Folding Camera.* This is an obsolescent type ranging from one with a single fixed-focus lens and single shutter-speed to intricate models having excellent lenses, multi-speed shutters, and coupled rangefinders. Most folding cameras, however, are of medium quality and price with a $f/6\cdot3$ or $f/4\cdot5$ lens and a shutter with speeds from 1/25th second to 1/100th second. Focusing is generally accomplished by a distance scale marked on the base of the camera or on the lens flange. Viewfinders are generally of the brilliant reflex type with openings showing both horizontal and vertical shapes. Direct vision and wire-frame viewfinders are also attached to some folding cameras, both of which have this advantage over the brilliant finder: they can be used at eye-level – a more natural view-point than that at waist-level. Most folding cameras are designed to take roll film and to be used in the hand, but they can always be used with a tripod, screw-in sockets being invariably fitted. The smaller varieties have the advantage that when folded they are light and compact.

*Hand-or-Stand Camera.* This is also a folding type, but is intended for a wider range of purposes than that normally expected of the hand folding-camera. It can take glass plates, cut films (fixed like plates in dark slides), or roll films used in a roll-film adaptor. Plate holder or roll-film holder can readily be removed from the

back of the camera by sliding it out of side grooves and replacing it with a ground-glass focusing screen having a collapsible hood surround; this screen makes accurate focusing possible by eye and shows depth of field at different stops; when the focusing screen is used, the camera will, of course, have to be fixed to a tripod.

Hand focusing is carried out by means of a distance scale or a coupled rangefinder and the picture is composed in a brilliant viewfinder or through direct-vision or frame finders. Lens aperture is usually $f/4.5$ and the between-lens shutter has speeds ranging from 1 second to 1/250th second.

Two valuable features of this type of camera are the double-extension bellows and the rising and sliding fronts. Double-extension bellows enable a very close view to be focused so that an object can be photographed to full size on the negative. Very small objects can thus be recorded and the copying of photographic prints and enlargements can be made – for instance, of a print on which much retouching has been done.

The rising front, a movement which allows the front of the bellows with the lens to be raised, enables a tall building such as a tower to be included in a picture with its sides still vertical in the image; the camera does not have to be tilted upwards so that verticals appear sloping inwards. The sliding front movement is the same as the rising front but acts horizontally instead of vertically, and is mainly used to reduce violent perspective in oblique views.

Another movement is the swing back which serves the same end as the rising and sliding front, but here the camera is tilted while the back is swung into the vertical, or other required, plane. For extreme cases the rising front and swing back can be used together. A rising front requires a lens of wide covering power, though a small stop will help to reduce fading off and lack of sharpness at the top corners of the picture. The swing back, however, does not require this extra covering power. It may compel the use of a comparatively small stop to bring the whole image into focus, but in cases of extreme depth of field it can be used to increase overall sharpness with a wide stop.

Well-known hand-or-stand cameras are the German Linhof, the Swiss Sinar, and the Swiss Arca, typical sizes being $2\frac{1}{4}$ by $3\frac{1}{4}$

inches and 4 by 5 inches (the latter usually being of the very flexible monorail type, taking plates and cut film in holders, or roll-film adaptors).

*Stand Camera.* This, too, has folding bellows but, as its name implies, it is intended for use only on a stand or tripod. It is a simple, old-fashioned type rarely used by amateurs. But it has its advantages. The bellows can usually be extended beyond the double extension and a rising and sliding front and a swing back are generally fitted. Some models have no shutter but a lens cap only, and when a shutter is fitted it is usually of the roller-blind pattern fitted just behind the lens and giving exposures of from 1/15th to 1/75th second as well as Time. Focusing is effected entirely by means of a removable ground-glass screen and only plates or cut films are used.

This type, often called a Field camera, is inexpensive and particularly useful for portraits, landscapes, and architectural work where movement of the subject is unlikely. Technical perfection is possible with these cameras, especially when large plates or films are used. They should not be despised by the amateur; in fact, photography can perhaps be learned best by using such an instrument at the start, bought second-hand at low cost.

A built-in spirit level is a useful adjunct on these cameras, as it is also on the hand-or-stand type – particularly for architectural work.

*Reflex Camera.* The main advantage of this type is that the subject can be seen in the focusing screen up to the very moment of exposure – unlike the camera with the ordinary focusing screen which must be removed before plate or film can be inserted in its place. Moreover, the image is seen the right way up (though in reverse), whereas in the back-focusing screen the image is seen in reverse and upside-down.

Two sorts of reflex camera are made – the single-lens and the twin-lens. We are concerned now with the single-lens; the twin-lens is discussed later for it is a special miniature type.

The single-lens reflex is constructed thus: It has a roughly cubical box shape within which a mirror set at an angle of 45

degrees reflects the image from the open lens on to a ground-glass screen lying horizontally at the top of the box. It is surrounded by a black hood to exclude unwanted light and so makes the image brighter; this hood can be folded down when the camera is not in use. The shutter is sometimes focal-plane set close to the plate or film, and it is wound up before exposure. When the shutter is released, the mirror is first lifted up by a lever fitted to the exposure trigger so that the light passing through the lens can pass through to the back of the camera; the focal-plane shutter then operates in the way already described. Thus a fraction of time passes after the image disappears from the screen and the shutter is released – a fraction of time during which the image may have altered its position. This is a slight disadvantage which the twin-lens reflex avoids.

Another disadvantage of the large single-lens reflex is its considerable bulk. Folding cameras have been made in an attempt to overcome this and to provide a rising front at the same time, since a rising front cannot be incorporated except, to a very limited extent, in the ordinary reflex camera. The great advantages of the reflex are the ease with which it can be focused, the visibility of the depth of field at different stops, and the large, full size of the image projected on to the screen, which is a great aid to composing.

The older kinds of reflex cameras take plates, cut films, film packs, or roll-film adaptors in sizes $2\frac{1}{4}$ inches by $3\frac{1}{4}$ inches, $3\frac{1}{4}$ by $4\frac{1}{4}$, and 4 by 5. Typical and excellent makers of the older type of reflex are the Soho, the Thornton Pickard, and the Graflex.

Single-lens reflex cameras are now being produced which fall into the miniature class. Such makes have the advantage over the twin-lens miniatures that lenses can be interchanged and that depth of field is visible at different stops. On the other hand, like all single-lens reflexes, large or small, the image cannot be kept in view right up to and during exposure, as it can with the twin-lens. The $2\frac{1}{4}$-inch square single-lens reflexes are the British Agiflex, the Swedish Hasselblad, the Japanese Bronica, the Russian Zenith, the East German Pentacon Six and the new Rollei SL 66. A useful feature of most of them lies in their having interchangeable roll-film magazines so that different types of film to

suit different conditions can be rapidly interchanged before the whole film has been exposed. Focusing can be carried out at full aperture, the stop being pre-set and fixed with a finger-flick after focusing and before exposure. Miniature reflexes, such as the Contaflex, Exacta, Olympus, Leicaflex, and Canonflex, take 35-mm. film and are high-quality precision instruments.

Miniature cameras such as the old non-reflex Leica or Contax can now be converted into a single-lens reflex type by special attachments like the Ziess Panflex. But the 35-mm. true reflex grows more popular.

*Twin-lens Reflex Camera.* This type, though officially graded in the miniature class by the Royal Photographic Society, is not a miniature in the sense of taking 35-mm. ciné film, for it takes a square negative measuring $2\frac{1}{4}$ inches by $2\frac{1}{4}$ inches and gives twelve negatives on 120 film. Its characteristic feature is expressed in its name for it has two lenses, one above the other. The bottom lens is the taking lens and admits the light to the film like any other camera; the top lens admits light only to the full-size view-finder which is also a focusing screen. As in the ordinary reflex, the focusing ground-glass screen lies horizontally at the top of the camera, is surrounded by a collapsible hood, and shows the image reflected the right way up by an internal mirror. The two lenses are fixed on the same base so that when the focusing knob is turned both lenses are in focus. The advantages of this type of camera over the single-lens reflex are that (i) the image remains in view right up to, during, and after the exposure, and (ii) the viewing lens remains wide open so that the most brilliant possible image is always visible, no matter how small the stop may be on the taking lens. On the other hand, the depth of field of the taking lens at different stops is not revealed by the viewing lens – at least not in most models; a few models are fitted with iris diaphragms on both lenses so that depth of field can be seen through the viewing lens. The viewing lens, however, has a wider aperture than the taking lens, even when that is at its widest aperture, and this means that depth of field is never less but always more than that seen on the screen.

The $2\frac{1}{4}$-inch square twin-lens camera is inevitably more bulky

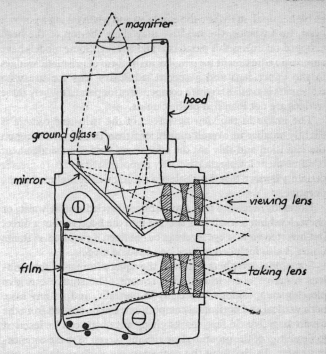

*magnifier*

*hood*

*ground glass*

*mirror*

*viewing lens*

*film*

*taking lens*

12. Section through a twin-lens reflex camera.

than the single-lens reflex miniature but, even so, it measures no more than about $3\frac{1}{2}$ inches by $3\frac{3}{4}$ inches by $5\frac{1}{2}$ inches when closed. Lenses cannot be interchanged (except in the Japanese Mamiya-flex) but portrait attachments for both lenses are available, at least for the Rollei makes when they are called Rolleinars. A telephoto lens was made at one time for the Rollei also, but this proved somewhat unsatisfactory and manufacture has been discontinued.

Another minor disadvantage of the twin-lens type is that parallax is produced when photographing very close objects within a few feet; that is to say, the image in the viewing screen does not coincide with the image cast on to the emulsion, since the two lenses are not in the same position; the image on the screen will

be higher up than that on the emulsion and when taking a portrait head, for instance, the negative may show the top of the head chopped off unless this parallax is allowed for. Some models have automatic adjustment for parallax in the form of prismatic wedges in the upper lens and a special subsidiary lens for use with Rolleinars is available which compensates for parallax where these wedges are not included in the camera.

The image in the viewing screen of the twin-lens camera is slightly smaller in overall dimensions than the image falling on the emulsion and this has the advantages that (i) misjudgement of adjustment for parallax is partly compensated and (ii) a greater certainty is given that the whole of a subject will be included in the negative.

Normally, viewing and exposure are carried out at waist, or chest, level but a small lens is fitted into the hood so that a direct but inverted view at eye level can be obtained if required. A frame finder is also included in the hood in some models.

Some photographers object to the square format of the twin-lens negative but without good reasons. The square can give pleasing compositions, especially in portraits, and, in any case, both vertical and horizontal compositions can be created from the square negative. In fact, masks giving any shape can be inserted to lie on top of the ground-glass viewing screen to make composing easier. In that way the comparatively wide-angle lens can virtually be turned into a lens of long focus by the use of a small piece of cardboard with rectangle cut out of its centre.

The twin-lens reflex is a very easy, fool-proof camera to use and is popular among both amateurs and professionals. The amateur could do much worse than to buy a twin-lens reflex if only because of its ease of operation, and the power of focusing accurately and of composing beautifully which it provides. The type is, indeed, an excellent compromise between the large single-lens reflex and the 35-mm. miniature such as the Leicaflex.

The most famous twin-lens camera is the Rolleiflex. This has been made in various models and most of them are very fully equipped. It came on the market over three decades ago so that great experience goes into the making of current models. Millions of Rolleis and similar makes have been made since the

twin-lens reflex was invented and so founded a new 'school' of photography.

Normally the Rolleiflex lens is a 7·5-cm. Zeiss or Schneider of four elements, the largest stop being *f*/3·5. The shutter is a between-lens Compur with speeds of 1 second to 1/500th second, Time, Brief Time, delayed-action mechanism, and synchronized flash mechanism. The film is wound on by a folding crank-handle which not only stops itself automatically when a new section of film is in position but tensions the shutter at the same time ready for the next exposure so that rapid snapshooting is made possible. The camera also has a device which is becoming fairly common to all cameras, by which two shots cannot be made accidentally on one section of film. Double bayonet-sockets are fitted to the flanges of both lenses to take attachments such as filters, lens hood and Rolleinar lenses for close-up work. The focusing knob is marked with a depth of field indicator.

The back of the camera can be replaced to take a special plate back and, with the help of a film mask, an additional film counter and a special take-up spool (the Rolleikin set), the camera can be converted to take 35-mm. film including Kodachrome colour film. In that case, of course, the focal length of the lens is, in effect, increased and the camera gains, in a sense, an extra lens. The latest Rolleiflex has a baffle interior which helps to reduce unwanted light, such as that which is normally reflected from the black sides of the camera's interior, by reflecting it back towards the lens.

A recent Rolleiflex model has an 8-cm. *f*/2·8 Schneider Xenotar lens with five components. This is not a vast improvement on the ordinary model with its *f*/3·5 lens because the light speed gained – only half a stop – seems hardly to justify the extra cost. The lenses in this case are much larger in diameter so that the standard attachments cannot be used.

A cheaper camera made by the same firm is the Rolleicord, which has fewer gadgets than the Rolleiflex, and is not automatic in its winding. Now they also make a single-lens 2¼ in.-square reflex and a 35-mm. reflex.

*Miniature Camera.* The miniature proper is one which takes a

standard 35-mm. cinematograph film with perforated edges. Like
the twin-lens, this type has created a dedicated photographic
'school' and it produced a revolution when it was first introduced.
Its great advantages are: low cost of negative material, enabling
many experimental and hopeful shots to be taken without the
worry of expense; extreme lightness and portability; interchange-
ability of lenses, wide, normal, and long in focus. With its fast
and fairly short-focus lens, pictures can be taken under poor
lighting conditions with a fair depth of field, indoors and out,
and the fast focal-plane shutter makes the type admirable for
shots where movement is rapid.

This is the ideal 'Candid' camera for documentary, human
interest, and sports work – for the professional, for instance, who
takes a human-interest story for a picture magazine in ordinary
electric lighting.

The 35-mm. camera has its drawbacks like every other camera.
The negatives measuring only 1 inch by $1\frac{1}{2}$ inches are tiny and, if
they are enlarged to any appreciable size, they must be sharp in
definition, free from defects such as scratches, and free from
granularity. Granularity (p. 146) is more likely to occur on fast
films so that, if it is to be avoided, slower films may have to be used
and the value of the miniature as a fast camera is thereby reduced.
Granularity can be lessened by using fine-grain developer for the
film, but this again reduces speed because fine-grain developers
generally demand extra exposure of the negative. Another disad-
vantage of the miniature is that contact prints are more or less
useless owing to their small size and some enlargement is always
needed. Exact focusing is not so easily achieved as in a reflex,
though with the coupled rangefinder, which is usually built into
the better miniature, focusing can be extremely accurate. And
now attachments for converting the camera into a miniature reflex
are available, as already mentioned. Most new 35-mm. cameras
are SLR (single-lens reflex).

The 35-mm. camera needs a fair amount of skill if it is to pro-
duce its best results and the processing of its film must be carried
out with competence and care. Exposure and development must
be accurate and fewer liberties can be taken with it than would be
permissible with larger cameras. Technical perfection must

be acquired; thus the true miniature is not a camera for the occasional dabbler.

The chief advantage of the true miniature lies less in its small size than in its type of lens which, being usually short focus and working in the finest models at a possible widest aperture of $f/1·5$, allows a valuable depth of field at wide apertures. Thus excellent results without too much out-of-focus fuzz can be secured in very poor lighting conditions. The first to have been produced and the most famous true precision miniature is the Leica.

*Sub-miniature Camera.* Among the smallest is the Italian GaMi 16, a remarkable though costly 'sub-miniature' which takes 16-mm. film with or without sprocket holes and among several unusual features has a built-in exposure meter automatically linked with the shutter control and a $f/1·9$ lens; its negative size is 12 by 17 mm. on unperforated film and 10 by 17 mm. on perforated 16-mm. movie film. Other sub-miniatures are the Rollei 16, the Minox (using special film and taking $8 \times 11$ mm. negatives), the Minicord, the Yashica Atoron, and the Stylophot. Both the latter use 16-mm. film and take $10 \times 10$ mm. negatives. The Minicord has twin lenses. A compromise between the 35-mm. and 16-mm. cameras is the half-frame type taking 18 by 24 mm. or 24-mm. square frames on 35-mm. film. The Tessina Automatic from Switzerland is a unique twin-lens reflex taking $14 \times 22$ mm. size.

A special kind of camera is the stereoscopic which takes two images at a short distance apart and simultaneously; these images when printed are re-combined visually either in a hand-viewer or in a projector to give the sense of three dimensions. The stereo camera is by no means new, for Brady used one to record the American Civil War, but with the coming of colour photography, the 35-mm. film, and the new type of projector, stereoscopic, or 3D, photography is enjoying a new vogue.

## Camera Trends

A strong trend towards automation is evident – that is the building-in of a light meter and its mechanical inter-relating with shutter and diaphragm in order to reduce the need for thoughtful and time-taking adjustments of shutter speeds and diaphragm stops by hand.

Complete automation does allow the tyro to take technically good shots without any knowledge of diaphragm stops, shutter speeds, and depth of field problems, and it has come as a boon to many who cannot be bothered to study these matters. It must be realized, however, that fully automatic cameras (fully automatic, that is, after allowance for the film speed has been made) do not allow the photographer to select his own stops or shutter speeds to suit the varying circumstances of movement and required depth of field. In that respect, the semi-automatic camera is preferable because it is more flexible. Here either the aperture can be fixed as desired and the shutter will adjust itself, or vice versa. Perhaps the best arrangement is one where the automation can be disconnected when it is not wanted.

A fully automatic camera has a built-in light meter with a cadmium-sulphide cell which controls the diaphragm stop to give correct exposure. A red signal in the viewfinder indicates when light is not strong enough to give an adequate exposure at the widest stop. The Kodak Instamatic models are the most fully automatic and most easily handled cameras ever made; they take Kodapak cartridges for easy loading and with them the shutter is set automatically to suit the film speed when you load. No skill at all is needed to use such cameras and they are a boon to the casual amateur.

The Kodak Instamatic Pocket cameras, available in seven models, have become immensely popular. They take a new cartridge, Kodak 110, making $\frac{1}{2}$ by $\frac{3}{4}$-inch size pictures in Verichrome Pan, Kodachrome X, Ektachrome X and special new fine-grain Kodacolor II film from which $3\frac{1}{2}$ by $4\frac{1}{2}$-inch enprints (or larger prints) are made. Special Retinamat projectors for the colour transparencies are available. Similar camera makes are the Agfamatic, Canon, Rollei, Minolta, and Instaplus. A larger cart-

ridge than the 110 is the 126 of 26 mm., or one inch square format which some of these small cameras take.

Some new cameras measure the light with a cadmium photocell in very accurate integrated readings through the lens (TTL).

An important new development is the $f/2.8$ Voigtländer Zoomar lens for use with the Voigtländer Bessamatic eye-level 35-mm. reflex camera, or with other 35-mm. reflex cameras having focal-plane shutters. Zoom lenses have been used for some time on cinema- and television-cameras, but until now none has been produced with sufficiently good definition for still cameras. The zoom lens can be adjusted rapidly by eye and is infinitely variable between short and long focus. The Zoomar varies between 36 and 82 mm. (or 62 to 29 degrees in angle of view). Though the lens is a fairly heavy affair of fourteen elements, it conveniently eliminates the need for a number of interchangeable lenses but definition is inferior to that of single lenses of equal quality.

Other zoom lenses are now in production: the $f/2.8$ Schneider Variogon, the Konica Zoom 8, the Vivitar 70–210 mm. and the three Nikon zooms: 43–86, 85–250 and 200–600 mm. focal lengths.

Nikon produce an unusual but useful lens called PC (for perspective control). This contains a movable shutter with a hole in it and serves, in fact like a rising or sliding front. A remarkable lens having a similar effect in a 35-mm. camera is the Schneider-Kreuzdach PA Curtagon.

The Rollei-Magic has a light meter built in above the viewing lens in a neat way and a photo-cell automatically sets the exposure controls according to the speed of film and strength of light. The Rollei-Magic normally takes 120-size film but it has a sixteen-exposure mask set for $2\frac{1}{8}$ by $1\frac{5}{8}$ inches or $1\frac{5}{8}$ inches square (making so-called Superslides which can be projected in most 35-mm. projectors). When inserted, the mask automatically sets the counter.

This new size of $1\frac{5}{8}$ inches square (4 cm. square) is an interesting innovation which is gaining in popularity.

Two other Rollei models are the Tele-Rollei and the Wide Angle. A 35-mm. twin-lens reflex is now available in the Agfa

Flexilette and Optima Reflex having two $f/2\cdot8$, 45-mm. lenses. The Japanese Mamiyaflex is a $2\frac{1}{4}$-inch-square twin-lens reflex with five interchangeable lenses between 65 and 180 mm. The Linhof company has produced a new 70-mm. cassette fitting the Super Rollex film-holder for its Super Technika cameras, which normally take 120-size film in holders. The cassette holds up to fifty-three frames, $2\frac{1}{5}$ by $2\frac{4}{5}$ inches (56 by 72 mm.) on perforated film double the width of the standard 35-mm. film. Another Linhof innovation is this Super Rollex film-holder itself which, without the cassette, takes 120-size film but produces a negative size of $2\frac{1}{5}$ by $2\frac{4}{5}$ inches – that is ten frames per roll as against the usual, but awkwardly proportioned, $2\frac{1}{4}$ by $3\frac{1}{4}$-inch size producing eight frames per roll.

That fascinating American camera made by the Polaroid Corporation and invented by Dr Edwin H. Land – the Polaroid Land camera – has been improved since it was first marketed in 1948. It will produce a finished print either in black-and-white or colour only seconds after exposure. Though the speed of the normal film used is 200 ASA, the Polaroid people now make the fastest film available at 3,000 ASA for use in their cameras – for use also in the special film-holders they make, which can be fitted to most 4 by 5-inch plate cameras, a boon to frantic pressmen.

Polaroid also make monochrome lantern slides for their cameras which can be turned out in 2 minutes after exposure, either $2\frac{1}{4}$ inches square or $3\frac{1}{4}$ by 4 inches (an American standard size for slides). Another Polaroid product is a simple Print Copier which will produce duplicate prints from the negatives, one every minute.

The principle of this remarkable Land camera is that of reversal-transfer by diffusion. The unexposed, unreduced silver, which would normally be removed in a fixing bath, is diffused into a gelatin layer on the positive paper where it is rapidly developed. Several models of the camera are available, taking different sizes. The latest model is automatic. The Polaroid SX-70 is a miniature with a simplified in-camera colour processing.

# 6 *Camera Accessories and Exposure Meters*

## Your Outfit

Do not overload yourself with gadgets. Not only are they costly but they tend to confuse the photographer and they take up too much time. Time may be important; while you are fiddling with gadgets the sun may disappear behind a cloud, the figure standing at just the right spot may move away, or that fleeting expression on a face may vanish.

It is interesting to note that the famous photographer, E. O. Hoppé, writes in his autobiography, *Hundred Thousand Exposures* (Focal Press):

Were I to begin life all over again ... my equipment, based on twenty-five years' experience with many types of cameras, would consist of the following:

A well-made half-plate Field or Studio Camera with a repeating back and three double dark-slides.
A solid camera stand.
A miniature twin-lens reflex camera.
Two flood-light units; one spotlight.
A portrait lens; 12½-inch focal length.
A vertical enlarger.
Darkroom safe-light, clock, dishes, scales, tank, and other accessories.

... 'Gadgetitis' is a psychological condition induced by the desire to compensate for an inferiority feeling. ... I believe that photographers should pay far more attention to studying photographs than apparatus.

Mr Hoppé's list is an unpretentious one, selected, not by an amateur, but by a professional who has undertaken every sort of work – portraiture, landscape, documentary. Cecil Beaton, another famous professional, uses only two cameras, a large studio

type and a Rolleiflex twin-lens. For most amateurs one camera will have to suffice.

The amateur would be well advised to acquire the following accessories:

Camera case.
Lens hood.
Two colour-correction filters.
Sturdy tripod.
Photo-electric exposure meter.
Pair of inexpensive flood-lamp holders and reflectors.

In this chapter I will deal only with cases, lens hoods, tripods, and exposure meters. Filters and lighting equipment are given special chapters later on as they are fairly large subjects.

## The Camera Case

This is almost essential to protect the camera from life's buffetings and also from dust, dirt, and sand. It should preferably be of stout leather. The ever-ready type is available for miniature cameras, including the twin-lens – the type with a front flap which enables the camera to be used in its case. Also available are large hold-all cases to contain, not only the camera, but all its accessories, such as filters, lens hood, spare films, light meter, and so on. But these are unnecessary luxuries. Camera prices are always quoted for camera without case, unless the term 'with ERC' (ever-ready-case) is added.

## The Lens Hood

This is almost essential. It should be used under all conditions and should be regarded as an integral part of the camera even if it is removable. The reason for this is that the hood cuts out unwanted, extraneous, oblique light which may otherwise enter the camera from outside the field of view of the lens. Such light, for instance, may come from the glinting, chromium-plated components on the front of the camera itself. The use of the hood is

especially important when a photograph is taken in the direction of a bright source of light such as the sun, a street lamp, or a dazzling reflection from snow or water. An additional virtue of a hood is the protection it gives to the lens from raindrops or water spray.

The hood should preferably be one specially designed for a particular camera and a particular lens. Its outer shape should be square or rectangular rather than circular; a hood of wrong shape may cut off some of the field of view of the lens and so cause a diminishing of illumination at the corners of the negative. Note that interchangeable lenses may need appropriate interchangeable lens hoods.

Make sure that the interior surfaces of the hood remain both black and matt or the hood may produce just that unwanted result it was designed to eliminate. And get as large a hood as possible – the larger the better.

## The Tripod

A camera cannot be held perfectly steady in the hand and as a general rule an exposure longer than 1/25th second should always be taken with the camera either resting on a firm surface or fixed to a tripod. Camera shake produces fuzzy negatives and though the fuzz may not be noticeable on contact prints or on small enlargements, it will be distinct on big ones. Lack of good definition is often blamed on the lens or the film when it should be blamed on camera shake. When conditions permit, use a tripod even at 1/50th second.

The tripod may be an unwieldy nuisance, especially when it must be carried for long distances, but it must be regarded with respect even by the eye-level, miniature enthusiast. All makes of tripod, excepting the large studio stand, are now telescopic or collapsible and can easily be carried in a case with a shoulder strap.

The lighter and slimmer the tripod, the less effective will it be and even a moderate wind will tend to shake it. If a tripod is seen to be vibrating slightly in a wind, it can be stabilized by suspending some heavy object such as a rock on a piece of string from the

head. However, if you buy a tripod, buy a sturdy one and a tall one. If funds permit, buy it with a ball and socket head attachment so that the camera can be adjusted easily to a level position or to any other position desired, including a directly downward view.

Light but sturdy aluminium alloy tripods are now made which have telescopic legs allowing both of the telescoping sections of each leg to be fixed firmly at any desired position merely by a twist; they also have feet both of metal points and of rubber which can be adjusted by screws to suit the ground surface; a polished floor may cause the points to slip and then the rubber should be brought into use, whereas a turf surface will give a firmer base if the metal points are applied.

A unipod is a makeshift and will serve well enough provided the exposure is not too long; models are available which can be used as walking sticks. For small cameras the chest-pod is a handy device; this is held against the chest or the shoulder like the butt of a rifle so that shots can be made at eye-level.

Other makeshift methods are: (i) simple clamps by means of which the camera can be firmly attached to a chair back, a fence, or similar support; (ii) a chain with the top end screwed into the tripod bush of the camera and the bottom end held tightly to the ground with the foot as the camera is pulled upwards. At some risk, exposures of up to 1 second can be made in this way.

A neck-strap pulled down tightly will also help to reduce camera shake if a tripod is not available and the shot is taken at waist-, or chest-, level.

## The Exposure Meter

Modern films have considerable latitude, so that correct exposure is less important today than it was at one time. Half-a-dozen different exposures could be given for the same subject, one or more being correct for the shadows, others for the highlights, and others for the intermediate tones; yet each negative produced would make a good print. A modern film can reproduce a subject in which the brightest highlight has 1,000 times the intensity of the

deepest shadow. For an average subject without excessive contrasts, four times the correct exposure at least would still produce a tolerable negative.

Nevertheless, careless exposure should be avoided. Underexposure produces flat negatives in which shadows contain too little detailing. Over-exposed negatives are too contrasty and tend to be grainy; they also greatly lengthen the time needed for printing and enlarging, highlights will be blocked and will appear as blank white patches on the print, and the danger of halation will be increased. In general, serious under-exposure produces worse effects than the same degree of over-exposure. A correctly exposed negative is one that makes a print in which the tones of the original subject are reproduced in their correct relationships.

In colour far less latitude in exposure is possible compared with that in black-and-white; the exposure time must be correct within 50% or half a stop, at least for the slower films.

Exposure meters are instruments for measuring the intensity of light and for calculating correct exposure from an adjustable scale. They give a number of exposure times for different aperture stops, or $f$ numbers. But films vary in their sensitivity to light and this variability will have to be taken into account when calculating exposure time. The existence of this variability is not always realized by the novice, but it is important. A film of normal speed (say 100 ASA) will require three times the length of exposure of a fast film of 300 ASA.

But, you may say, no subject has the same degree of light intensity all over; in a landscape the sky will be very much brighter than the shadow of a building. That is true and a rough rule is to expose for the shadows and let the highlights take care of themselves, slight over-exposure being preferable to under-exposure. The aim should be to allow rather more than the bare minimum exposure time where possible, to be on the safe side, but do not over-play this rule, and note that greater care should be exercised in calculating light intensity in contrasty subjects than in those in which tones are flat.

No less than five factors affect exposure time:

1. Intensity of light reflected by the subject.
2. The lens aperture or $f$ number.

3. The speed of the film used.
4. The colour filter used, if any.
5. The type of film developer used. (A fine-grain developer may require twice the exposure time of a normal developer.)

Two main types of exposure meter are in use today:

1. The Visual Exposure Meter.
2. The Photo-Electric Exposure Meter.

For those with limited means, however, neither of these is essential and for them an Exposure Table or Exposure Calculator, available for a few pence, must suffice. A good, new photoelectric exposure meter may cost more than £10, but it does *measure* the light; an exposure table or calculator merely estimates the required exposure according to certain general conditions. Those conditions are the state of the atmosphere, the geographical latitude, the month of the year, the time of the day and the type of subject. Of these conditions, only geographical latitude, month of year and time of day are definitely known; state of atmosphere and type of subject may not be easy to assess. For instance, the exposure table may give readings for Bright Sunlight, Cloudy Bright, Dull, and Very Dull but not for Light Shadow and Heavy Shadow or for Light Interiors and Dark Interiors. However, for most ordinary outdoor photography, an exposure table or calculator is effective enough and experience, combined with tabulated exposure notes, will add to its value. For interiors, on the other hand, tables and calculators are not dependable for there the conditions of light are likely to be far more divergent than outdoors. But it is better to use a table or calculator than to guess.

Several types of exposure tables are available for use both in daylight and in artificial light and full instructions are supplied with them. A valuable set of tables for use in daylight have been prepared by the British Standards Institution (B.S. 935: 1948); these cost only a few pence and are simple and quick to use.

An exposure calculator is merely a kind of mechanized exposure table, its main advantage over the table being convenience of handling and rapidity of reading. A typical example is composed of concentric circular disks of white plastic on which the various

conditions are marked and are correlated by the turning of the disks to give the final answer of the exposure time required, all other conditions being known.

Two kinds of Visual Exposure Meter exist. One is called the Extinction type, and here the human eye judges the light intensity by looking through an adjustable wedge; when the details begin to vanish, a reading will give the correct exposure. A refinement of this extinction type is composed of a graduated wedge in which the dimmest number among a series of numbers which are visible gives the correct exposure reading.

The objection to the extinction type is that the eye is not a good judge of light intensity; it is rather like a measuring rod made of elastic, because the iris of the eye opens and closes according to the intensity of light falling upon it. Allowance for this must therefore be made when using an extinction meter; for instance, greater accuracy is possible if the eye is kept applied to the meter for several seconds before a reading is taken.

Such a meter has advantages and after a little practice the user will be able to obtain fairly accurate results. It is an inexpensive type and, though not normally as accurate as a photo-electric meter, it can be used for lighting conditions too poor to have any effect on the photo-electric instrument.

A much more accurate, more complicated, and more costly extinction meter is the Exposure Photometer. This is comparatively large in size, one make being in the form of a tube about seven inches high. Penetrating the top of the tube is a small telescope through which part of the subject is viewed through a glass cube containing a mirror-spot. On to this mirror from within the tube a light is cast from a bulb lit from a small electric battery and shining upwards through a hole. The size of the hole is adjusted by two opposed wedges. When the wedges are adjusted so that the tone on the mirror is equal to the tone on the subject seen through the telescope, a reading is taken and the exposure can then be worked out on the appropriate scale around the barrel of the instrument. The intensity of illumination of the lamp, or bulb, is kept constant by a rheostat adjusted according to the reading on a micro-ammeter situated at the top of the instrument and working from a photo-electric cell.

This is a very accurate instrument indeed and is not affected by variations in the aperture of the iris of the human eye. Out-of-door variations of intensity between one and 100 can be measured and any particular shadow tone can be accurately judged. For poor lighting conditions, as indoors, the power of the instrument is increased by means of range-shift filters situated over the light-spot above the comparison lamp. For extra bright conditions the power is decreased by means of a filter which can be moved in front of the telescope. Thus the range of the photometer is no less than 1,000,000 to one. Colour filters adjust the light-spot for electric lighting. The photometer is, of course, mainly for professionals. It can even measure the light in a dark-room.

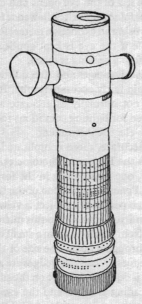

13. Exposure photometer, the most accurate of all light meters.

The photo-electric meter is the handiest and simplest of all to use and is now the most popular in spite of its lack of sensitivity to very poor interior light. It works on the principle that when light

falls on a photo-electric cell a small electric current is generated which, for practical purposes, is directly proportional to the intensity of light. The cell is connected to a micro-ammeter which measures the electric current and so, indirectly, the intensity of light. The micro-ammeter consists of a needle pointing to a scale. By taking a reading and moving a calibrated calculator (usually incorporated in the instrument) to a position indicated by the reading, the relationship between aperture stop, speed of film, filter factor, and developer to be used, and the required exposure time can be easily and rapidly discovered.

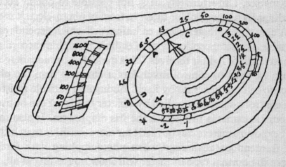

14. Photo-electric light meter.

The angle of light reaching the photo-electric cell is fairly restricted and should be about that of the normal lens, that is, about 45 degrees. The more sensitive, and therefore the more costly, meters have two scales – one for outdoors or good light, the other for indoors or poor light. A photo-electric meter must be used with judgement. A reading for an open landscape, for instance, should not be taken by pointing the meter towards the sky but rather towards the ground. Readings should be taken for the shadows rather than for the highlights, and, if a general reading is taken, exposure should be adjusted according to whether stress is to be on highlights or on shadows. As a general rule, several readings of a subject should be taken and an average worked out. Again, experience will be the best guide.

Note that in artificial light a longer exposure will be needed than that indicated by the meter because films are less sensitive to

tungsten light than to daylight. Allow at least 50% greater exposure than the meter shows.

You must realize that a photo-electric meter does not 'see' exactly the same light as the film sees (fig. 15, p. 141). It sees less violet-blue light than a panchromatic film; it sees slightly less green-yellow than a pan film but the same amount of orange-red. It sees more radiations than the eye, for its sensitivity extends well into the ultra-violet and the infra-red regions; it is therefore a far more accurate gauge than the eye of what pan films 'see'. For most practical purposes, however, these various discrepancies do not matter. Unfortunately, it is not possible to obtain accurate readings by placing colour filters in front of photo-electric meters.

A new type of meter uses a cadmium cell which depends on the variable electrical conductivity of cadmium sulphide according to the strength of light it receives. This meter has the advantage that it can be used to control much larger currents than the photo-electric cell can generate by itself. Acting as a variable resistor, it can control a current supplied by a battery and so it can be used in automatic cameras to operate the iris diaphragm. It also means that exposure meters can be made far more sensitive than hitherto – a tremendous advantage when photographing dark interiors where the normal type of meter will show no reading at all.

The new Lunasix meter of this kind is now on the market. It will give a reading even in moonlight, being over 100 times more sensitive than any conventional photo-electric meter now in use. It presages a new epoch for exposure measurement. One of its advantages is that it can be used on the larger 4 by 5 inch. cameras to measure light very precisely on the film plane itself.

A new way of measuring light is through the lens (TTL), which makes for accuracy and high sensitivity. The new Contaflex Super BC 35-mm. reflex is a TTL type with a cadmium sulphide meter. Here the shutter speed is set and then the stop sets itself for correct exposure.

# 7  Films and Plates

## General

For most amateur purposes films are better than glass plates. Spare films are lighter to carry than plates; they take up less space, are easier to store, can be loaded into the camera in daylight, and do not break into irreparable pieces if dropped accidentally. On the other hand, plates have two advantages over films; they can be developed individually as required and they always lie dead flat on the focal plane within the camera. Films occasionally fail to lie quite flat, though this is not a matter of great concern with most cameras – least of all with the 35-mm. type where sprockets through the holes at each side of the film will hold the film taut. Moreover, a small stop, where this is possible, will reduce, and probably eliminate, any slight tendency to fuzzy focus caused by lack of flatness of the film. The main but rare danger is that vertical lines at the sides may appear slightly curved.

In plate cameras cut film can be used instead of glass plates and then the advantage of light weight is gained and the possibility of breakage is avoided.

These distinctions between roll films, glass plates, and cut films having been clarified, all the following remarks concerning roll films can generally be considered to apply to plates and cut films.

Though the well-known makes of film are all reliable and may not differ from one another to any great degree in quality, different types of film vary greatly. They vary in their ability to render each colour with correct tone, in the speeds with which light affects their emulsions, and in their degrees of graininess.

All modern emulsions are composed mainly of microscopic crystals of silver bromide suspended in gelatin; silver chloride and silver iodide are also present but in much smaller quantities. These silver compounds are called silver halides. The gelatin is

transparent and, though hard, it permits the penetration of developer during processing and at the same time it protects the silver halide crystals within it in such a way that only those crystals which have been affected by light can be acted upon by the developer to produce silver deposits of varying density in the negative. The gelatin, a substance extracted from the bones and skin clippings of cows and pigs, contains certain organic compounds which include sulphur in their compositions and these help to make the halides more sensitive to light.

## Colour Sensitivity

So far as tonal reproduction of colours is concerned, films today are of two main types – orthochromatic (usually called Ortho) and panchromatic (usually called Pan). Ortho is little used now.

No films are yet able to render colours exactly in the tones which appear to be correct to the eye because they tend to be more sensitive to blue and violet than is the eye, which is most sensitive to yellow. Thus, for example, films are liable to show blue skies in lighter tones than the eye sees them. Therefore we place colour correction filters in front of the camera lens on many occasions in order to adjust and control the colour tones so that they eventually appear on the print in closer conformity with human vision or with the tonal effects the photographer desires.

Originally photographic emulsions were sensitive only to blue; they were quite blind to all other colours, but modern panchromatic emulsions reproduce colour tones which are very close to those registered by the eye. Orthochromatic films are less well-balanced in colour sensitivity than panchromatic, being insensitive to red and over-sensitive to blue. Panchromatic films, though not absolutely correct, are sensitive to all colours, including red.

But let us consider this important matter of colour sensitivity fundamentally. White light is composed of six main colours – red, orange, yellow, green, blue, violet. It can be split up into these colours when passed through a glass prism to form a spectrum, because each colour is refracted at a slightly different angle from the others. The rainbow is a natural spectrum produced by rain-

drops acting as prisms to sunlight. The order of arrangement of the above colours in a spectrum is as follows:

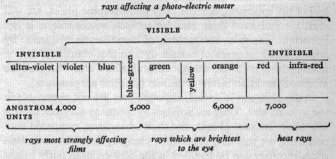

*rays affecting a photo-electric meter*

| | | | blue-green | | yellow | | | |
|---|---|---|---|---|---|---|---|---|
| | | | VISIBLE | | | | | |
| INVISIBLE | | | | | | | INVISIBLE | |
| ultra-violet | violet | blue | | green | | orange | red | infra-red |

ANGSTROM 4,000          5,000          6,000          7,000
UNITS

*rays most strongly affecting films*          *rays which are brightest to the eye*          *heat rays*

15. Colour composition of white light.

For convenience in discussing film sensitivity and colour filters, the spectrum can be broadly divided into three main colours: blue, green, and red – these being separated by two intermediate regions: blue-green and yellow. Outside the visible spectrum lie the infra-red rays at the red end and the ultra-violet rays at the violet end; these rays can affect films but they are not of exceptional importance in photography.

An opaque coloured object reflects the colour we see and absorbs all the other colours of the light falling upon it, whether white or otherwise. A white object reflects all the colours of the spectrum and a black object absorbs them all. In the case of a transparent or translucent object, such as a photographic colour filter, most of the light passes through it. In the case of an object in greys, blacks, and whites such as a photographic print, white light is wholly reflected from the white areas, not at all from the blacks, while the greys absorb an equal amount of all the colours of the white light and reflect an equal amount of all the colours.

Daylight is composed of white light containing all the colours (except at sunrise and sunset, when it may be mainly red), but artificial light does not usually contain all the colours. Light from tungsten lamps, for instance, is deficient in blue as compared with

daylight and it contains more yellow and more red – a factor which should be taken into account by the photographer.

Films and plates which are restricted in sensitivity to the blue end of the spectrum, like the early photographic plates, are still available and have their uses for subjects where colour is not important – such as the copying of monochrome originals. By adding small amounts of certain dyes to film emulsions during manufacture their sensitivity beyond violet and blue can be increased, and that is how ortho and pan films are produced.

Ortho films are still used, although they are not obtainable in the 35-mm. size. They are satisfactory for many subjects, especially where reds are absent, and their advantages, compared with pan films, are that they are slightly cheaper, they have more latitude, and they can be handled in the dark-room in fairly bright red light – a useful condition when individual plates or films are developed by inspection in a dish instead of by the time-and-temperature method in a tank. Ortho films also tend to have greater sparkle and 'snap' than pan and are therefore useful under dull lighting conditions giving little contrast, such as weak winter sunlight. On the other hand, pan films are preferable from this point of view in the light of early morning or evening when the sunlight gives a redder light than at midday.

The tendency today is to use pan films exclusively. Though sensitive to all colours, pan films are still slightly over-sensitive to blue and violet and this we can correct, if we desire, by a pale yellow filter. In daylight, pan films can, however, produce reasonably accurate colour rendering without a filter, and almost complete accuracy in artificial flood-lamp lighting.

Speed of Films

Films now vary greatly in their sensitivity to light as a whole, that is to say, in their speed. This variability is important in calculating correct exposure. To explain how different speeds are obtained in manufacture and how these speeds can be measured under different conditions would require a long technical explanation outside the range of this handbook. Suffice it to say that the faster

the film is, the coarser will be the halide crystals suspended in the gelatin of the emulsion and the more apparent will be the clustering of these crystals on an enlargement (see p. 146). Slow films have fine grain and can resolve details better than fast films, but fast films, of course, have a tremendous advantage where rapid exposure in poor light is required. And fast films, being softer (less contrasty) in tonal quality than slow films, can tackle extremes of light and shadow better than slow films; to use a technical term, they have a fairly straight Characteristic Curve as expressed on a graph.

Unfortunately, a number of different ways of measuring the speeds of film emulsions have been evolved. The first method was put forward in 1890 by Hurter and Driffield and is called the H and D method, but with the development of modern emulsions it is now obsolete. A method still very often used is the Scheiner, evolved by the astronomer Scheiner in 1894. The DIN method, which has tended to replace it, was evolved by the German Standards Association (*Deutsche Industrie-Normen*). Some film and light-meter manufacturers have provided their own gradings. It is all most confusing, but matters are improving. The American Standards Association adopted an excellent system in 1943, one which was followed by the British Standards Institution in 1947, though the numbering in the American method is arithmetical while the British system is logarithmical, an unnecessary complication. The arithmetical means that an emulsion speed of 200 ASA is twice as fast as one at 100 ASA, while the logarithmical, like the BSI, Scheiner, and DIN, is in degrees, an increase of 3 degrees meaning a double speed; that is, a 34-degree film is twice as fast as one at 31 degrees.

More changes can be foreseen. Speeds of 3,000 ASA are now in use, 6,000 is on the horizon, and soon all these zeros will become a nuisance. Let us hope that before long we shall have one, simple, standard, international rating system. Indeed, a simple additive system is now being considered by the ASA which will remove the juggling needed at present with *f* values and fractional shutter speeds (see also p. 112).

Meanwhile, for the amateur's practical needs the following conversion table may be useful. The great latitude of modern films

will take care of slight inexactitudes, particularly in the faster films. The fastest film now available, excepting the special Polaroid Land films at 3,000 ASA (see p. 128), is the Kodak 'Royal X' (roll film only). This requires special development (see p. 221). Note that each column in the table below will require half the exposure time of the one before it, reading from left to right.

| ASA (American Standards Association) | 12 | 25 | 50 | 100 | 200 | 400 | 800 | 1,600 | 3,200 |
|---|---|---|---|---|---|---|---|---|---|
| BSI Degrees (British Standards Institute) | 22° | 25° | 28° | 31° | 34° | 37° | 40° | 43° | 46° |
| DIN/10 Degrees (Deutsche Industrie-Normen) | 13 | 16 | 19 | 22 | 25 | 28 | 31 | 34 | 37 |

As a general rule for artificial light, double the exposure time shown by the photo-electric meter for ortho films and increase it by a half for pan films. For non-colour sensitive (or Ordinary) films or plates increase the exposure three times.

## Makes of Films

A list of well-known makes of panchromatic films is given below, together with their film speeds for daylight at the different gradings. Note that the speeds given are the fastest possible. An increase in exposure of half a stop will do no harm and may be desirable in most cases but adjustments can be made according to the developer to be used and, more particularly, development time and degree of dilution of developer. On the following page is a list of popular films with their speed ratings available at time of going to press (1975). Makes and speeds of colour films are given on pp. 302–3.

| 35-MM. FILMS | ASA | BSI° | DIN 10° |
|---|---|---|---|
| Agfa | | | |
| Agfapan 25 | 25 | 25 | 16 |
| Isopan IF | 40 | 27 | 17 |
| Isopan ISS | 100 | 31 | 22 |
| Agfapan 400 | 400 | 37 | 28 |

**EFKE (old Adox)**

| | | | |
|---|---|---|---|
| KB 14 | 20 | 24 | 15 |
| KB 17 | 40 | 27 | 17 |
| KB 21 | 100 | 31 | 22 |

**Ilford**

| | | | |
|---|---|---|---|
| Pan F | 50 | 28 | 18 |
| FP4 | 125 | 32 | 22 |
| HP4 | 400 | 37 | 28 |

**Kodak**

| | | | |
|---|---|---|---|
| Panatomic X | 32 | 26 | 17 |
| Plus X | 125 | 32 | 22 |
| Tri-X | 400 | 37 | 28 |

## ROLL FILMS

**Agfa**

| | | | |
|---|---|---|---|
| Isopan ISS | 100 | 31 | 22 |
| Agfapan 400 | 400 | 37 | 28 |

**EFKE (old Adox)**

| | | | |
|---|---|---|---|
| R 14 | 20 | 24 | 15 |
| R 17 | 40 | 27 | 17 |
| R 21 | 100 | 31 | 22 |

**Ilford**

| | | | |
|---|---|---|---|
| Pan F | 50 | 28 | 18 |
| FP4 | 125 | 32 | 22 |
| HP4 | 400 | 37 | 28 |

**Kodak**

| | | | |
|---|---|---|---|
| Panatomic X | 32 | 26 | 17 |
| Verichrome Pan | 125 | 32 | 22 |
| Tri-X | 400 | 37 | 28 |
| Royal X | 1,250 | 41 | 32 |

As already mentioned, the faster the speed of the film, the more will granularity result on the exposed negative. Granularity will be most apparent on the medium grey tones of an enlarged print and may often be seen on skies and similar half-tones in the form of mottling. The more the negative is enlarged, of course, the more apparent will the granularity be and this matter must therefore be taken into account when big enlargements are wanted. I am less averse to granularity than many photographers; it is not necessarily unpleasant and it can, on some occasions, actually enhance a photograph if a certain coarse texture is wanted which is in character with the subject. But we must understand how it arises and how it can be controlled or avoided.

The crystals of the silver halides in the faster films of, say, 100 to 300 ASA are not only larger than those in slow emulsions but they have greater diversity of size. In the slower emulsions the grains are more uniform in size and this tends to make the slower films more contrasty.

The granularity which is apparent on the finished print is not the visible effect of the silver particles which result from the exposed halides, for these are much too small to be seen with the naked eye even when enlarged, being at the largest only a few thousandths of an inch in diameter. The grains which can be seen on the negative or enlargement are the results of clumps or clusters of crystals which have been in contact with one another and have developed as a single unit.

Today comparatively fast films are made (say 125 ASA) which have fine-grain emulsions, Kodak Verichrome Pan being an example, and fine-grain developers are now available which reduce the tendency of crystals to cluster together during development; most of these, however, require an increase in exposure time of up to twice that for normal developers. The makers of some fine-grain developers claim that their products require no increase in exposure and yet reduce granularity. Such claims should be regarded cautiously, but there is no doubt that developers are tending to improve in this respect.

Over-exposure tends to increase grain. Therefore, expo-

sure should be kept as short as possible if the least possible grain is desired.

To produce a perfect negative which can be enlarged to any reasonable size without producing grain we must:

1. Use a fine-grain emulsion and sacrifice some film speed.
2. Avoid an exposure which is longer than necessary.
3. Avoid prolonged development.
4. Use a fine-grain developer.

The latest Kodak films show a slight gain in fineness of grain over the old ones and a considerable gain in the edge sharpness of images. Sharpness is impaired less by grain than by irradiation and this has been reduced in the new films.

Halation and Irradiation

A feature of the manufacture of films and plates is the treatment they receive in order to reduce Halation. Anyone who has taken a time exposure looking towards the east window inside a church for the first time may have been disappointed in the result because the east window – perhaps a beautiful thing with intricate Gothic curves and brilliantly coloured and patterned glass – will appear on the print as a violent white space surrounded by an effulgent halo. This is halation.

The white blankness of the window itself is caused by too great a contrast in lighting between the window and the surrounding wall. The halo is caused during exposure by light which, having passed through the emulsion layer, has been reflected back from the rear surface of the glass or film base. The halo will be less in films than in glass plates, because the distance the light travels from front to back of the base is much less in thin films than in thick glass plates.

Plates and films are now backed by an opaque coating which can be washed away before development. But this backing does not entirely eliminate the danger of halation in very contrasty subjects. In the case of an east window in a church, halation can only be avoided entirely by lighting the interior wall around the window, so reducing the contrast, and the photograph should be

taken in the afternoon or on a dull day when sunshine is not pouring straight through the window. The reason why the treatment of films and plates with a backing does not entirely eliminate the danger of halation is that the backing coat does not totally absorb all the radiations to which the emulsion is sensitive; some are still reflected.

Over-exposure will increase halation but serious halation can be treated after development of the film or plate by local reduction (see pp. 235–7, 274).

An effect producing somewhat similar results to halation is Irradiation. This is caused by the scattering of light from the

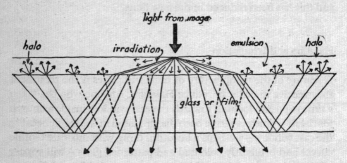

16. Section through a film or plate to show irradiation and halation. Halation comes from light rays which are reflected into the emulsion from the back of the glass or gelatine support of the film or plate; it is partly overcome by a black or coloured backing to the base; this absorbs the light rays which have managed to penetrate to the back. Irradiation is direct light scattered within the emulsion by the silver halides.

silver bromide grains within the emulsion. Therefore, the thinner the emulsion the less will be the irradiation. To refer again to the case of the church window, what is apparently all halation may in fact be partly irradiation – at least near the edge of the source of the bright light.

Irradiation can cause noticeable loss of definition around highlights, especially in over-exposed cases; for instance, it can reduce the thickness of black tree branches against a white sky and, combined with halation, it can entirely eliminate thin twigs from the negative.

The reduction of irradiation is still one of the film manufacturer's problems because it reduces general contour sharpness, or acutance, in any photograph. It is often believed that coarse grain must inevitably increase irradiation, but this is not necessarily so.

## Infra-Red Photography

The amateur may be tempted to try his hand at infra-red photography for the sake of the dramatic and long-distance landscapes it produces. Infra-red photography is mainly used, however, for record and survey work.

Infra-red rays, being outside the visible spectrum at the red end, are of long wave-length and are thus less liable to be scattered by the atmosphere even than the visible red rays. This means that if a film is prepared which is specially sensitive to these infra-red rays and all visible light rays are excluded from the camera by means of an infra-red filter set in front of the lens, strange landscape pictures are produced which give the impression that no haze or atmosphere of any sort exists. Mountains 300 miles away can be clearly recorded, contrasts are great, blue sky and water appear black, clouds are strongly marked, and green vegetation is very light in tone as though covered with snow. Because of the earth's curvature, infra-red pictures are more effective when taken as high up as possible, preferably from a mountain top.

Infra-red rays come to a focus behind the surface of the film when at its normal infinity setting, unless the lens has been specially corrected. The lens of an ordinary camera should therefore be extended away from the emulsion by about 1/200th part of the focal length. A deep red filter on the lens may be an aid to focusing, and sharpness will be assisted by stopping down the aperture to increase the depth of focus. When taking a subject at infinity set the focus at about 50 feet. Some small modern cameras will have red markings on the distance scale for infra-red film and in that case focusing will present no problem.

Most infra-red films are sensitive to blue and violet; hence the need for a special filter. If such a filter is not available a workable

filter can be concocted by combining deep red, green, and blue filters together which will absorb almost all the visible light.

A kind of infra-red picture can be obtained on fast panchromatic film by using these three filters together and increasing normal exposure time by 10,000.

A Gevaert infra-red film (35-mm. and 120-size roll film) was available at one time but has been discontinued. Kodak produce infra-red plates, a 35-mm. High speed infra-red film (also a 4 by 5 inch sheet and a 35-mm. Ektachrome Infra-red Aero colour film which is sensitive only to green, red and infra-red and not to blue. Approximate rating would be 100 ASA. Infra-red film tends to be contrasty and grainy, and has soft acutance. Ordinary black-and-white film developers can be used with about 25 per cent increase in timing above that used for a fast pan film. Infra-red material should be stored in temperatures below 10 degrees centigrade if possible, as in a refrigerator. Before being used it should be allowed to take up room temperature for a while.

# 8 Filters

## What are Filters?

The subject of filters is one which tends to bring unnecessary worry and confusion to the conscientious amateur. He can do very well for a start with only one filter of pale yellow colour which will require double exposure time or less and will render all tones well on a pan film; it will, for example, produce rich skies and cloud effects. Using different filters can become an obsession and, considering the colour tone capacity of modern pan films, they are far less necessary than is often supposed.

What are filters and what exactly do they do? They are circular pieces of a transparent material, produced in a great variety of colours, and are fixed temporarily to the front of the camera lens by means of spring clips, push-on flanges, screw-in or bayonet fittings. The transparent material may be gelatin film, gelatin film cemented between two pieces of glass, or a piece of glass which has been dyed in the mass. Gelatin filters are cheap but they tend to deteriorate with handling and are not much used. Cemented filters are the most expensive of all, especially when the glass is of special optical quality and flatness, though cheaper types are available with outsides made of plate glass. Dyed glass filters are cheaper than cemented filters, are more robust, and are likely to be optically more accurate than the normal cemented filters, but their range of colours is more limited.

Sometimes filters, or at least their mounts, are combined with a lens hood. This is a good arrangement because the use of a lens hood is particularly necessary when exposing with a filter. When buying a camera, make sure that it is possible to fix a lens hood as well as a filter to the lens mount at the same time.

According to its colour a filter will absorb some of the colours of the light entering the camera while passing others. It exercises selective control of the spectrum. The deeper its particular colour,

the stronger will be its power of absorbing the unwanted colours. The following jingle is a useful guide to the colour absorption properties of differently coloured filters:

> There are three main colours:
> Red, Green, and Blue;
> Any one of these
> Will absorb the other two.

Filters can be divided into two sorts: Correction filters and Contrast filters. The difference between them is one of degree rather than of kind. The former, being the paler, are used to improve the tonal rendering of colours and the latter, being of deep colour, are used to bring out the contrasting tones of colours very strongly by absorbing one part of the spectrum almost completely. Take as an example a bunch of flowers; here a correction filter might do no more than render the tones of red petals exactly similar to the tones of the green leaves and the picture would be flat and meaningless. A contrast filter, on the other hand, say a deep red, would render the red petals very light in tone and the green leaves distinctly dark by admitting all the red light while absorbing most of the green.

## Using Filters

The full use of filters is rather complicated because conditions are so varied. The type of film used, the colour composition of the light and its ultra-violet content, and the colour of the filter will all affect the result on the negative.

Though the tones of their colours may be infinitely varied, filters can be divided roughly into the following colour ranges:

*Correction filters:* Pale yellow, medium yellow, pale yellow-green, medium yellow-green, green.

*Contrast filters:* Deep yellow, orange, deep green, blue, red.

*Special filters:* Light blue (for electric light), yellow graded for skies, ultra-violet (colourless), infra-red, polarizing, sky, soft-focus, panchromatic vision.

Ortho film, being insensitive at the red end of the spectrum, will not be used with any filters other than correction filters or

with some of the special filters, namely ultra-violet, polarizing, sky, and soft-focus – with the possible and rare exceptions of dark green and dark yellow.

Because filters absorb some of the light, exposure must be increased when using them and the amount of increase of exposure is called a Filter Factor. Thus a filter factor of two will mean doubling the exposure, three trebling it, and so on.

The best way to use and select filters is to understand the general principles of film sensitivity and of light composition and control. As we have seen, the main object of filters is to absorb the blue and violet rays of white light to which films are over-sensitive. When in doubt about the effects of filters, take two or more trial exposures with different filters – an experiment which will, in any case, produce instructive comparative results.

A great range of filters is hardly necessary. Two would be ample for most work – a pale yellow and a yellow-green. The yellow-green will give full colour correction under most conditions, whereas a pale yellow or orange will produce good skies, will penetrate haze to some extent, and will require little additional exposure.

Treat filters with care, as you would the camera lens, and keep them clean with lens tissue. Cemented filters should be kept dry and all filters, when not in use, should be kept in a leather purse or other container having a soft leather or fabric interior.

Filter Tables

The following tables will provide general descriptions of the effects of filters, their proper uses, and their exposure factors under the headings – Correction Filters, Contrast Filters, and Special Filters:

## CORRECTION FILTERS

| Filter Colour or Type | Lightens | Darkens | Uses and Characteristics | Filter Factor Ortho | Filter Factor Pan |
|---|---|---|---|---|---|
| Very Pale Yellow (e.g. Rollei 'Sports') | Yellow and green slightly | Blue slightly | For short exposures. To increase sky contrasts and clouds. | 2 | 1·5 |
| Pale Yellow | Yellow and green | Blue | Landscapes. Removes slight haze by absorbing ultra-violet strongly. Transmits red and green freely. Partially corrects tone values of colours. Specially useful for enhancing cloud effects against blue sky. | 3 | 2 |
| Medium Yellow | Ditto | Ditto | Ditto, but more strongly with pan films. Corrects colour tone values fully in daylight. | 4 | 3 |
| Pale Yellow-Green | Yellow, Green fairly strongly | Some blue and some red | Late summer landscapes when greens are dark. Clouds, woods. Absorbs ultra-violet strongly and reduces haze. Corrects colours fully for highly red-sensitive pan films in daylight. | 3 | 2 |
| Medium Yellow-Green | Yellow. Green strongly | Blue. Red fairly strongly | Ditto, but more strongly. | 4 | 3 |
| Medium Green | Green strongly | Blue. Red strongly | Clouds and landscapes, especially where foliage is to be lightened as in woodland. Absorbs ultra-violet strongly. | 4 | 3 |

## CONTRAST FILTERS

| Filter Colour or Type | Lightens | Darkens | Uses and Characteristics | Filter Factor Ortho | Filter Factor Pan |
|---|---|---|---|---|---|
| Deep Yellow | Yellow strongly. Orange and red fairly strongly. Admits green | Blue | Darkens blue skies considerably. Penetrates haze well. | 5 | 4 |
| Orange | Yellow, orange and red strongly | Blue strongly Green fairly strongly | Renders blue skies nearly black. Stresses texture and colour tone variations in woods and on stonework. Penetrates heavy haze. | — | 4–8 |
| Dark Green | Green very strongly | Blue and red | Lightens grass and foliage. Darkens blue skies considerably. | — | 3–4 |
| Red | Red very strongly | Blue and green | As orange filter, but more strongly. Renders blue, as in skies, black. Shows grain in polished wood clearly. Brings out colour variations in stonework. Penetrates haze excellently. | — | 6–10 |

## SPECIAL FILTERS

| Filter Colour or Type | Lightens | Darkens | Uses and Characteristics | Filter Factor Ortho | Pan |
|---|---|---|---|---|---|
| Ultra-Violet (colourless) | Eliminates only U-V rays. | | For high altitudes above 6,000 feet and for seascapes. | 1 | 1 |
| Infra-Red | Dark red and infra-red. Green of plants, grass, and foliage strongly | Eliminates all other colours | For use with special infra-red emulsions. For land surveys and special long-distance landscapes. | According to emulsion. Possibly 10. | |
| Light Blue | Blue and violet | Red slightly | Only for portraits on pan films in tungsten lighting. Prevents red lips and cheeks becoming too light and blue eyes too dark. | — | 1¼ |
| Sky (yellow graded) | Yellow and green | Blue | Only half the filter is coloured and is graded off halfway to clear glass. Increases cloud effects in open landscapes without need to increase exposure. Not of great value as full yellow filter is more effective for most landscapes and few landscapes have a conveniently level horizon. They are more effective on reflex cameras than on others because effects can then be seen. | 1 | 1 |
| Polarizing | Passes all light vibrating in one plane only and eliminates all light on the opposing plane. Can be compared to a venetian blind with slits in it which can be rotated to admit light from either vertical, horizontal, or intermediate plane. Its main use is to eliminate unwanted reflections as from glass or polished surfaces, e.g. copying a picture under glass, eliminating reflections from spectacles in a portrait. Water surfaces can be lightened or darkened at will. In high altitudes it can darken blue skies in certain directions. It is the only filter which can be used in colour photography to darken blue skies. | | | 3 | 3 |
| Soft-Focus | To diffuse and irradiate contours and reduce sharpness with a soft, halo effect. Can be effective in against-the-light subjects or for portraits with back lighting Tones down contrasts. Its softening effect is reduced by stopping down aperture. | | | 1 | 1 |
| P.V. | This is a Panchromatic Vision filter. Not fitted to the camera but used in the hand for viewing subject as it will appear in monochrome on pan film. Used on its own, shows subject as it would appear without a filter on the camera but by placing the selected colour filter before it, the rendering on the film through that filter will be seen. | | | | |

Facts about Filters

The above table gives only a general working basis for filters and one must admit a number of possible variations. For example, filters do not act in quite the same way on ortho as on pan films and a yellow filter with ortho film will produce about the same effect as a green filter with pan film. Moreover, the filter factors will vary according to the depth of the filter's colour and the above factors are only approximate. Trial and error will be the best method of discovering exactly what factor a particular filter should be given. Special makes, such as the Rollei filters, will be marked with filter factors on their rims and these can be taken as being accurate.

Correct exposure is more necessary when filters are used than when they are not. Under-exposure will tend to exaggerate the effects of a filter and over-exposure will reduce them. If a dramatic sky is wanted and an orange filter is used to obtain it, over-exposure may produce, not the expected black of the blue and the white and grey of the clouds but a somewhat dull greyness all over. In general, use contrast filters with caution and do not use them when lighter correction filters are adequate.

When trying to obtain dramatic sky effects showing the blue darkly and giving plenty of texture and contrast to the clouds, other considerations than filters must be taken into account. Blue sky will show much darker just after the air has been washed by rain and it will show darker when the camera is pointed directly away from the sun; the nearer the camera swings round towards the sun, the paler will the blue sky grow. The greater the upward angle at which the camera is tilted, the darker will the blue sky grow, the sky near the horizon being always of a lighter blue than the sky above. Over-exposure will greatly reduce sky effects.

The general colouring of a landscape will affect the choice of a filter; for instance, if a landscape is reddish, yellowish, or brownish, a green filter will be unlikely to give a dark, impressive sky in that exposure will have to be comparatively long to allow the red-yellow light to pass the filter; thus the sky will be over-exposed and will lack rich tones. On dull or cloudy days remember that

*Photography*

more blue and violet light penetrates the clouds than red and yellow and adjust the filter accordingly.

Against-the-light subjects, such as those taken directly in the direction of the sun, will probably be best rendered without a filter on ortho film, because the scattered blue light will tend thus to lighten the shadows. A panchromatic film with a light blue filter will achieve the same results.

Snow scenes in sunshine are improved by a pale or medium yellow filter, for this will absorb some of the blue light reflected from the snow and will so strengthen its subtle tonal differences.

To understand the colour composition of the light you are using is important for then you can judge whether a filter is needed or not, and, if so, what kind of filter. Daylight can vary greatly in its colour content. Thus, the same effect will be obtained in sunlight in early morning or late evening without a filter as will be obtained at midday with a yellow filter, using panchromatic film in both cases, because early and late the light will contain more red. After sunset the light will grow increasingly blue.

Because tungsten artificial light is weaker in blue than daylight, it will require slightly less increase in exposure time than daylight if a filter is used. If the factor for daylight of a yellow filter is two for pan film, then that for tungsten light will be $1\frac{1}{2}$, and if the factor for daylight of a red filter is eight, then it will be four for tungsten. The reduction increases proportionately with the increase of the factor.

On ultra-violet filters: Note that ultra-violet rays come to a focus slightly in front of the focal plane and this may result in poor definition when a U-V filter is not used and much U-V radiation is about. In this circumstance a U-V filter is particularly necessary when using a wide aperture. If the depth of focus is increased by stopping down, the rays will be less likely to be out of focus and a U-V filter may not then be needed.

Filters for Colour Photography

In colour photography two filters may be useful, apart from a polarizing filter. One corrects colour values of daylight film when

used in artificial light; the other acts *vice versa.* Some colour correction may also be necessary in special circumstances. More on this subject is said in the section on colour photography and in the companion volume to this, the Penguin *Colour Photography.*

## General

As pigment is the painter's medium, so is light the photographer's medium, whether it be daylight or artificial light. How to use light creatively in photography is an art and therefore it cannot be learned completely by rule. However, the ways of using light in order to obtain a defined result and the various sorts of equipment available for artificial lighting can be explained.

## Daylight

We cannot control the sun or the weather and therefore our chief need in outdoor photography will be the patience to wait for those conditions of light which best suit the subject or the mood desired – the angle of the sun, for instance, which will most effectively reveal the forms and textures in an architectural detail.

We must realize how greatly daylight varies in strength and in quality with the time of day, the month of the year, the condition of the atmosphere, and the position on the earth's surface where the photographer is operating. In tropical or subtropical countries, photography near midday, when the sun is directly overhead, will be impossible if interesting pictures are wanted because then shadows will be lacking. The quality of light in a damp English spring will be quite different from that in the clean, dry air of a Scandinavian high summer or in the dusty air of Provence in August.

Note also that light and shade will be very contrasty when the sky is without clouds to reflect their effulgence into the shadows. And remember that film is sensitive to ultra-violet light but not so your eyes.

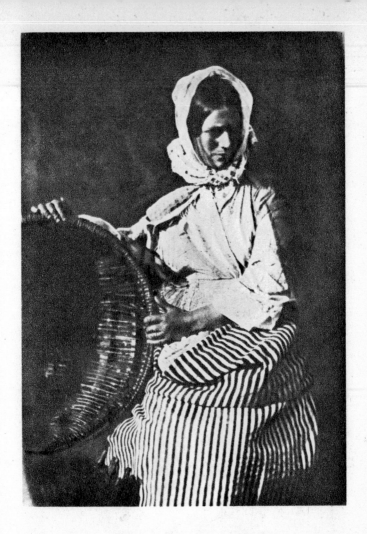

EARLY PHOTOGRAPH: Elizabeth Johnstone, fishwife, and the Beauty of Newhaven – a calotype of 1848 by D. O. Hill and R. Adamson of Edinburgh. The calotype, invented by Fox Talbot, was the first of the negative-positive processes, its negative being of paper. Hill and Adamson produced lovely examples like this one conceived with respect for the medium in broad simple masses of light and shade with a fibrous texture (*Picture Post* Library).

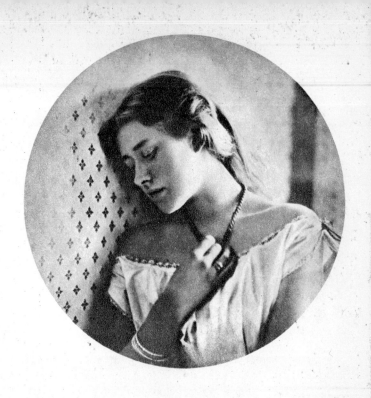

PORTRAITS OLD AND NEW: Two famous actresses of different generations. *Left*, a contemporary portrait of Anna Magnani by Herbert List, Munich, shows modern technical brilliance as well as strong but sensitive emotional interpretation of a vivid personality. *Above*, Ellen Terry as a girl of sixteen in 1864, a collodion wet-plate photograph by Julia Margaret Cameron (Gernsheim Collection); in spite of technical imperfection, the portrait has a timeless charm which is independent of its period. In both portraits the hands reveal the personalities almost as much as the faces.

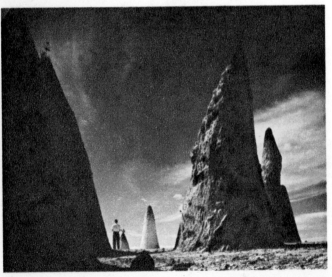

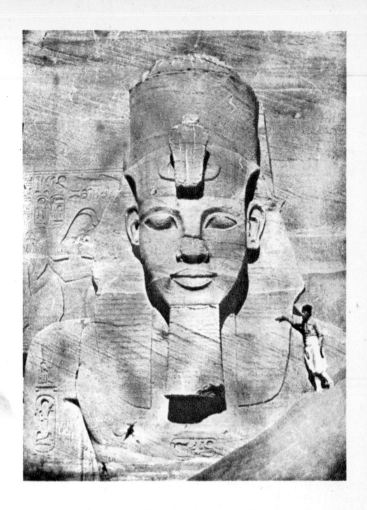

SCALE: Remove the small figures from these three pictures and their significance, including their drama, vanishes. Apart from providing the powerful feeling of size, the figures also form points of focal interest which help to bind each picture into a unity. *Top left*, launching cradle by Stewart Bale Ltd, Liverpool. *Bottom left*, tokens of earth left for measuring work done by road contractors in Brazil by G. E. Kidder Smith, New York; the viewpoint near the ground enhances the drama. *Above*, Colossus at the Temple of Abu Simbel, Egypt, a calotype of 1850 by Maxime Du Camp (Gernsheim Collection).

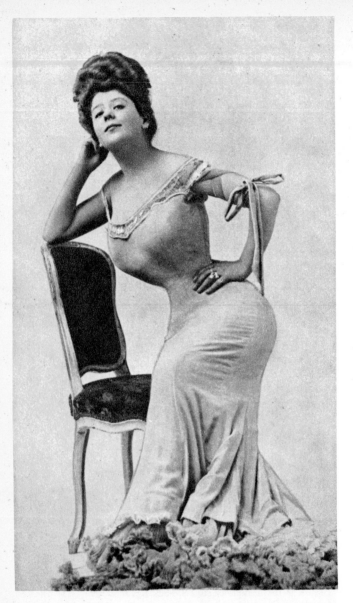

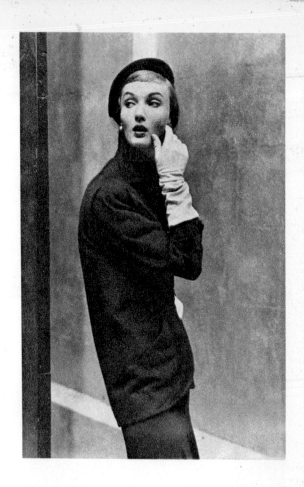

FASHION ON RECORD: Fashions change both in dress and in standards of feminine beauty. The camera records the changes for posterity without a smile but sometimes with a little help on the curves from the retoucher. Two world wars and nearly two generations separate these two types of women and their clothes. *Left*, Miss Camille Clifford, the Edwardian Gibson Girl, from a contemporary postcard (*Picture Post* Library). *Above*, a fashion photograph of 1949 from *Vogue* by Frances McLaughlin, New York (Condé Nast Publications Ltd).

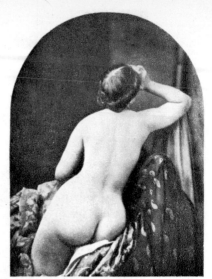

THE NUDE: Like fashion in dress the style of posing the naked body changes with the years. *Right*, a photograph of about 1860 by Oscar Rejlander who is believed to have been the first to photograph the nude (Gernsheim Collection). The picture reveals the misconception of its time that photography is a kind of painting.
*Below*, a beautiful pose of 1934 by Edward Weston, California, which is purely photographic.

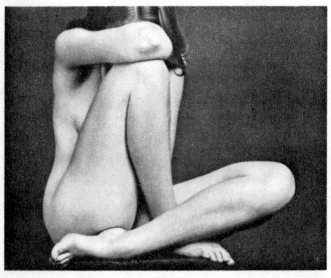

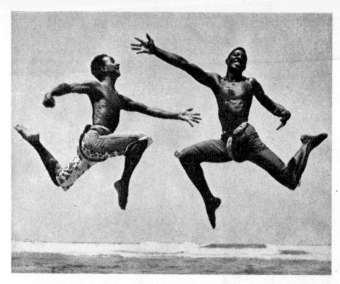

MOVEMENT CAPTURED: *Above*, two Negro dancers leap exuberantly into the air to make, for an instant, this exciting pattern captured in 1/500th of a second by A. Himmelreich, Tel-Aviv. *Below*, a stern jump of about 1885 caught in mid-air by Count Esterhazy (Gernsheim Collection) – a technical feat of photography for its time.

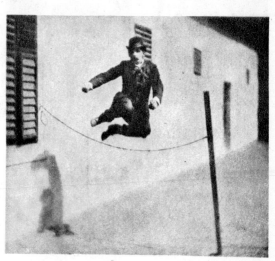

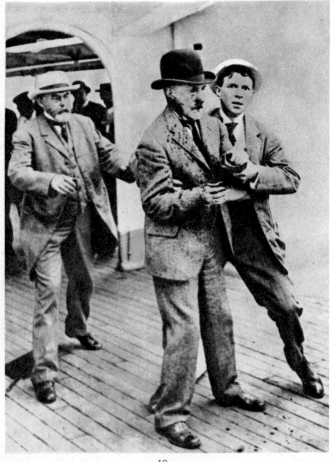

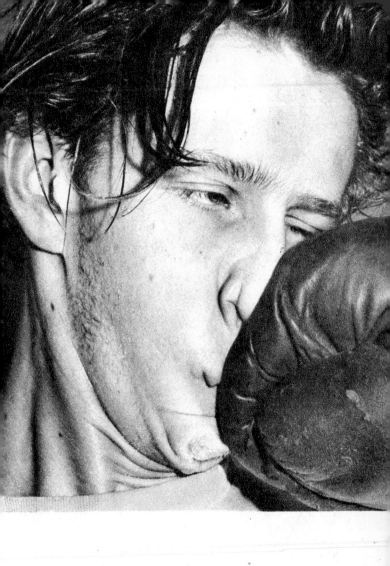

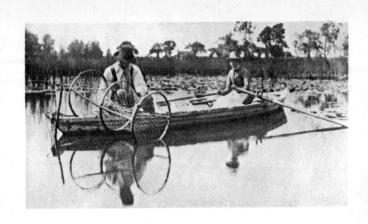

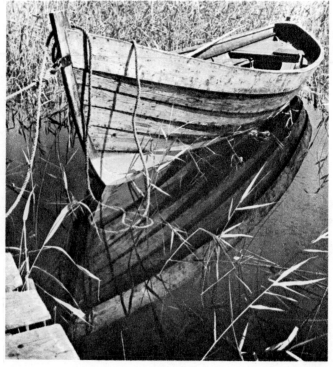

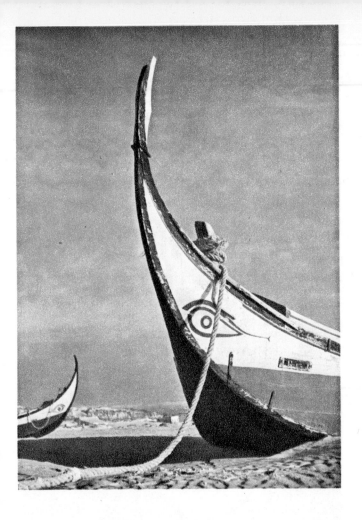

THE BEAUTY OF BOATS: Most nautical things provide rich raw material for the photographer, especially where water is available as a mirror. *Top left*, eel fishing on the Norfolk Broads as seen in 1885 by Peter Emerson (*Picture Post* Library). *Bottom left*, a boat with Viking forebears among the reeds of a Swedish lake taken by the author. *Above*, a simple but noble shot by Fernando dos Santos Taborda, Lisbon, who calls his picture 'Alerta!'

LIFE ON RECORD – IN THE STREETS: As a visual recorder of life going on through the years the camera is unsurpassed; the social historian of the future will bless its invention. *Below*, a street scene in Nicosia, Cyprus, by David Potts, London; the depth of focus of the Leica helps to produce the fascinating three-dimensional quality of this shot. *Top right*, Cardinal Paccelli in Montmartre, 1938, by that master of the casual composition and the telling moment, Henri Cartier-Bresson, Paris – another Leica shot. *Bottom right*, troubadours in Paddington by the author – a Rollei shot.

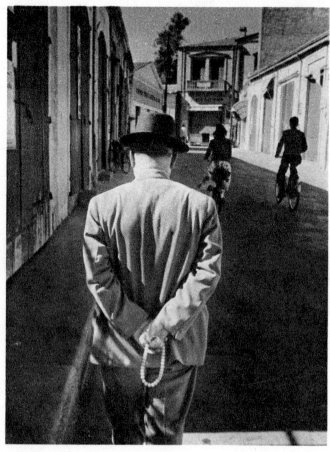

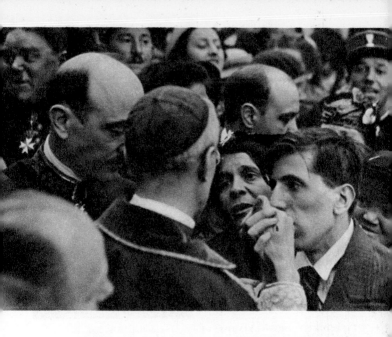

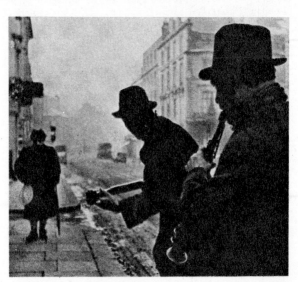

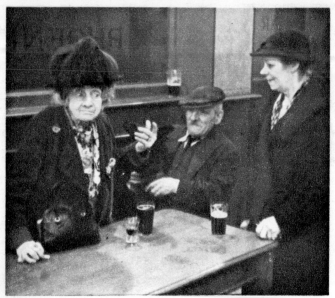

LIFE ON RECORD – LEISURE: *Above*, London pub scene, November 1938, by a *Picture Post* photographer. *Below*, 'Blackpool' by Bert Hardy, London (*Picture Post* Library) snapped with a box camera. *Top right*, outside a pub in 1876 by J. Thompson and A. Smith (Gernsheim Collection). *Bottom right*, Sunday on the banks of the Marne, 1939, a famous picture by Cartier-Bresson, Paris.

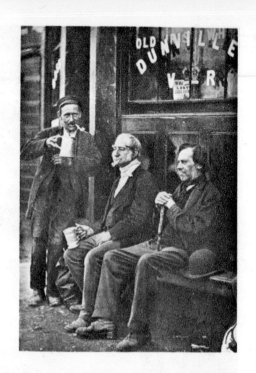

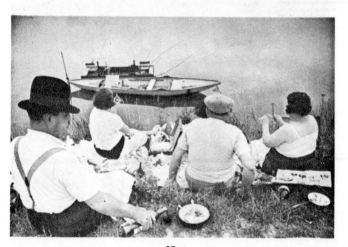

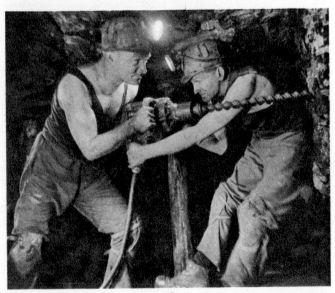

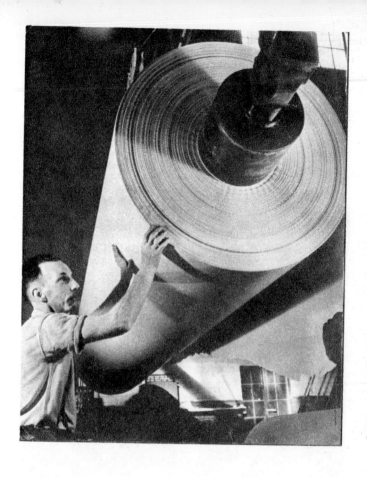

LIFE ON RECORD – WORK: *Top left*, the International Court of Justice, The Hague, 1951, in session on the Persian oil dispute; Sir Eric Beckett leans forward to talk to Professor Lauterpacht; a splendid informal shot by Bert Hardy of *Picture Post*. *Bottom left*, George Bell and Ginger Redhead drilling holes for explosive shots in a Northumberland coal mine, 1951, by Charles Hewitt of *Picture Post*. *Above*, a powerful shot taken for the Bowater Paper Corporation by Adolf Morath, London.

LIFE ON RECORD –
CONTEMPLATION:
*Left,* a bridge tournament
by Carrol Seghers II,
Miami (courtesy of *Friends
Magazine*). *Below,* under the
colonnade of St Peter's,
Rome, by Herbert List,
Munich. *Right,* the late
Dr Barnes, Bishop of
Birmingham, in his library,
by Bert Hardy of *Picture
Post*; a back view can be
as telling a portrait as
a front one.

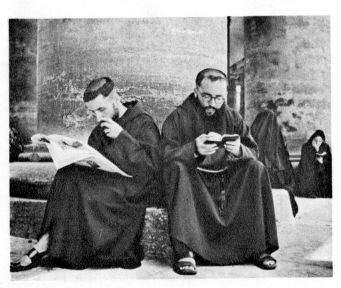

LIFE ON RECORD – HOUSE AND GARDEN: *Below*, 'The Orchard', from a platinum print of the 1890s by Clarence White, U.S.A., an early example both of soft focus and of the bold use of depth of field with its close foreground figure in focus with the distant figures. Impressionist painting shows its influence here; in spite of its self-consciousness, this remains an unusual and beautiful photograph. *Right*, 'Parlour-maid 1939' by Bill Brandt, London, is a brilliant comment evoking a whole period and social milieu which vanished for ever when the Second World War began.

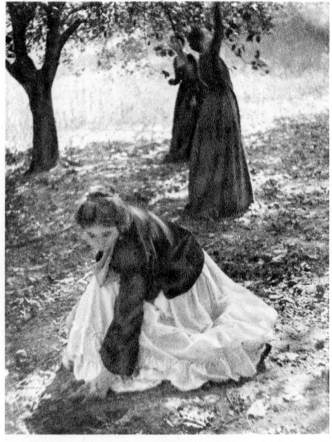

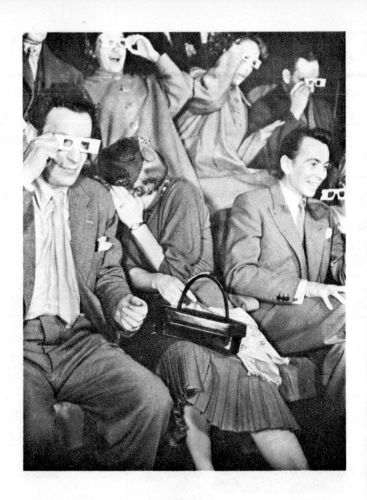

THEATRE ON RECORD: Photography in the theatre is a skilled field into which only adventurous amateurs will enter. *Above*, an interesting shot by a professional specialist – Roger Wood, London. The Candid Camera catches the reactions of an audience at the showing of an early 3D stunt film. The photograph was taken in the dark on an infra-red plate with three large infra-red flash bulbs.

SPORT: This kind of photography is itself a sport. It mostly needs fast film, fast shutter speed and fast reactions. *Top right*, Victorian mountaineers (Hulton Picture Library). *Bottom right*, a fencing lunge taken with six high-speed electronic flash tubes by Roger Wood.

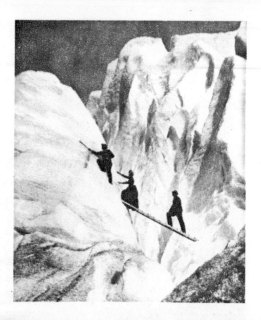

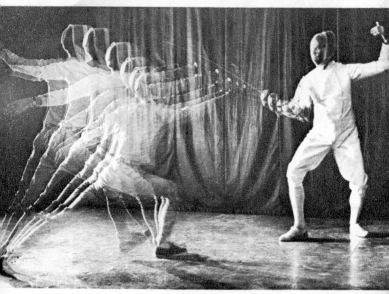

SOCIAL COMMENT: *Right*, famine in India by the late Werner Bischof,
a great camera journalist, who here created formal beauty, as in a Gothic
carving, out of misery and horror; thus he made his protest all the stronger
as did the Spanish painter Goya with his war scenes. *Above*, a grim shot in
a coal mining district of England called 'Coal Searcher, 1937' by Bill
Brandt, London – a bitter comment on idiotic social conditions.

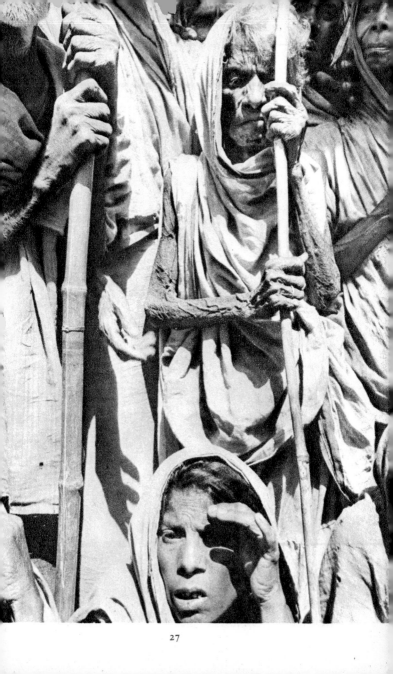

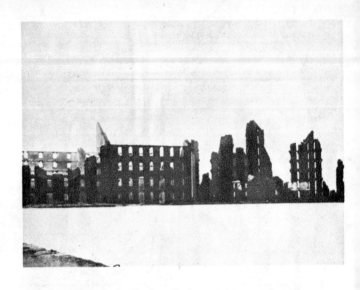

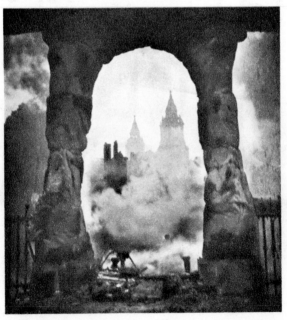

WAR ON RECORD: The early photographers, like Brady and Fenton, were the first camera journalists; they founded a remarkable tradition. *Top left*, the ruins of Richmond, Virginia, during the American Civil War recorded by Matthew B. Brady on a collodion wet plate (Museum of Modern Art, New York). *Bottom left*, the City of London after an air raid, 1940, with St Paul's in the distance, by Cecil Beaton. *Right*, General Bosquet and Captain Dampière at the Crimean War, 1855, by Roger Fenton (Gernsheim Coll.). *Below*, Château Wood, Ypres, October 1917, by an unknown war photographer (Imperial War Museum).

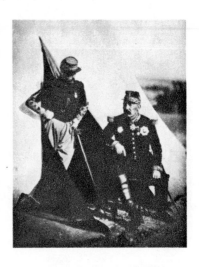

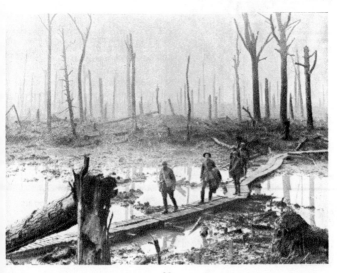

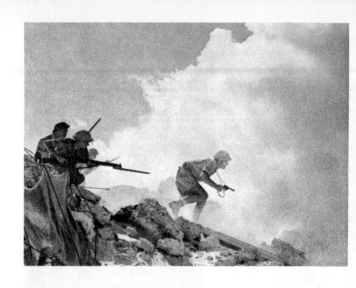

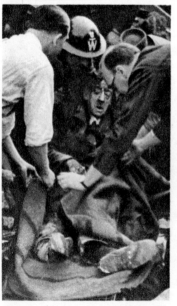

WAR ON RECORD:
*Above*, Australians in the
Second World War approach a
strong point through a smoke
screen (Imperial War Museum).
*Left*, an air raid casualty,
London, Second World War,
by a *Picture Post* photographer.
*Right*, R.A.F. problem picture:
an airfield in the Middle East
photographed from the air
during the Second World
War; it has been ploughed up
in spirals before being
abandoned by the Luftwaffe in
order to prevent its use by the
advancing Allied Air Force
(Imperial War Museum).

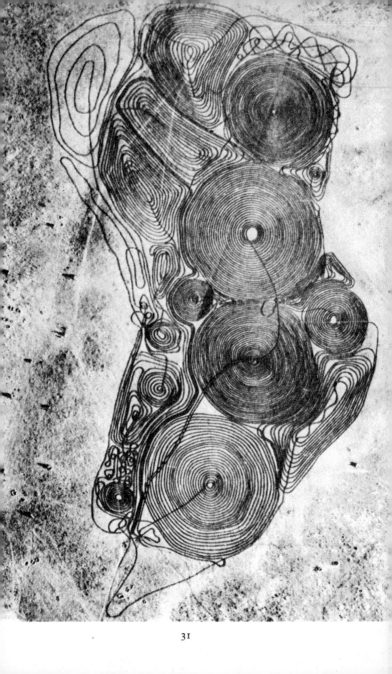

31

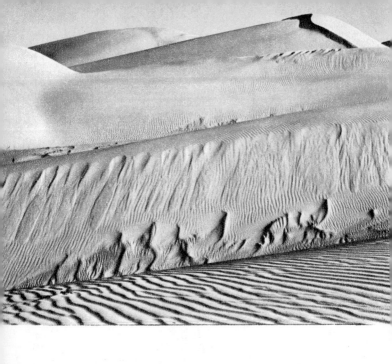

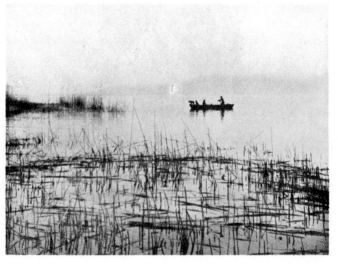

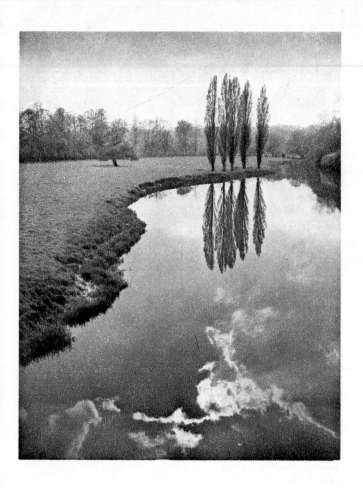

LANDSCAPE: This is among the most difficult of subjects, though popular with amateurs; the main difficulties are to visualize the scene in black-and-white and to select strong, significant forms, lines, and textures from the amorphous confusion of reality. These three examples have overcome these difficulties. *Top left*, Dunes Oceano, 1936, by Edward Weston, California. *Bottom left*, a lake scene by Werner Stuhler, Lindau. *Above*, an English river on a spring evening by the author.

SNOW: This is good photographic stuff. In general, shots must be taken against the sun to bring out tones and textures to the full, but the sun must not be allowed to shine directly on to the lens. *Above*, a car park photographed from the roof of the Shell Centre, London, by a Shell photographer.

*Right*, park railings in snow by Hans Hammarskiöld, Stockholm, a masterpiece of simplicity where all tones and textures have been deliberately eliminated to make a linear composition. *Opposite*, grand mountain drama by Andreas Pedrett, St Moritz, possessing strong line, texture, tone, scale, and depth.

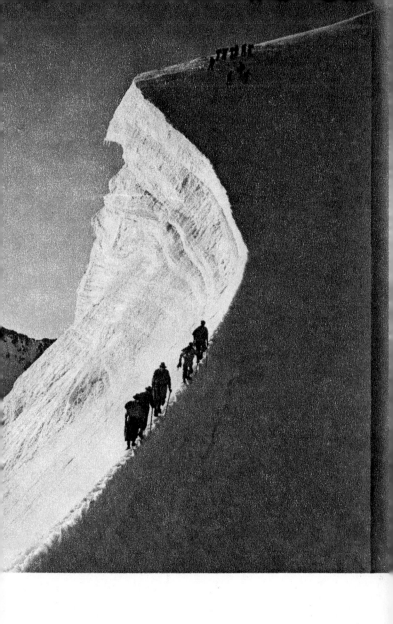

ANIMALS: This subject pleases everyone, though rarely for aesthetic reasons. Sentimentality is its worst aspect; scientific recording of wild life under the difficulties of the hunter is perhaps the best. *Left*, a touching little beast by Albrecht Brugger, Stuttgart. *Above*, a cat – undoubtedly – by Werner Stuhler, Lindau.

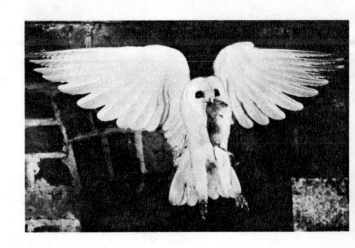

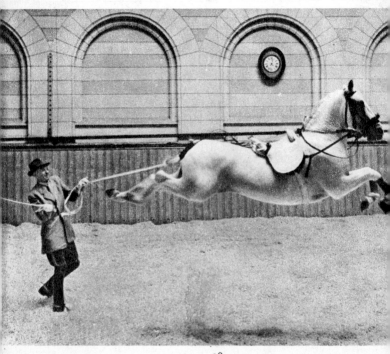

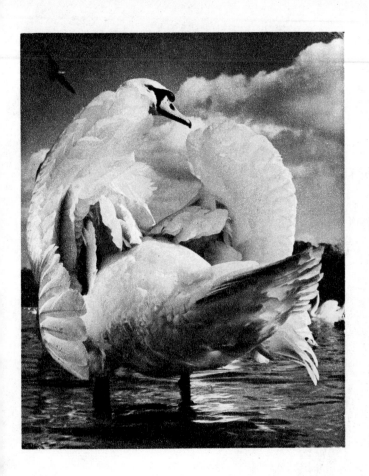

ANIMALS: Here are three splendid shots which have captured the instant when the animals have revealed their full beauty. *Top left*, an heraldic kind of barn-owl carrying a vole by Eric Hosking, England, taken with high-speed flash on a photo-electric shutter release. *Bottom left*, leaping horse with trainer by Hans Hammarskiöld, Stockholm. *Above*, a trite subject treated in an unusual way with exceptional brilliance by John Sadovy, London.

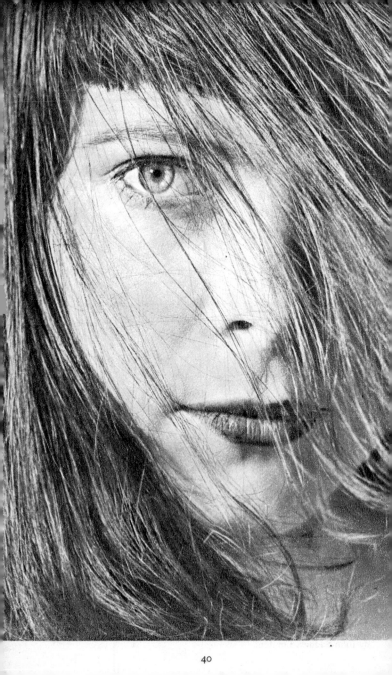

CLOSE-UP: In the close detail, photography comes right into its own as a medium of selective expression and reveals a whole new world of formal interest.
*Facing page*, 'Straight Hair' by Urs Lang-Kurz, Stuttgart (Camera Press, London).
*Above*, straw hats at an Easter parade by Arthur Lavine, New York – a Leica shot which makes a striking pattern.
*Left*, hands filing the keyhole of a safe by Adolf Morath, London, taken for the Milners Safe Co.

41

ARCHITECTURE: Photography is building with light; therefore build-
ings, especially in their parts and details, offer great scope to the creative
photographer, since they possess all the photographic needs of form,
line, tone, and texture. Among the finest architectural photographers
in the world is G. E. Kidder Smith, New York, who took the above
shot beside the cathedral at Orvieto, Italy. *Left*, a romantic view of St
Pancras Station, London, by the author. Only a small part of a Rollei
negative was used.

43

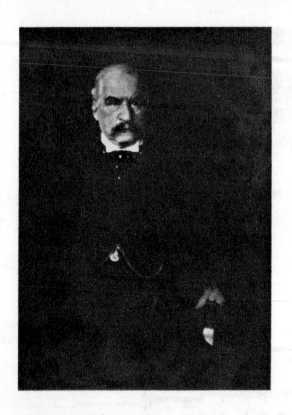

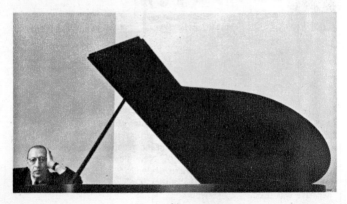

PORTRAITS OF MEN: Here photographic form, expression and the personality of the sitter should all meet. *Top left*, the famous portrait of J. Pierpont Morgan, the American banker, by Edward Steichen, U.S.A. (Collection, L. Fritz Gruber); it was taken in a few minutes to help a portrait painter. Is that the arm of a chair we see before us? *Bottom left*, Igor Stravinsky, the composer, by Arnold Newman, New York (copyright, A. Newman), a daring and powerful composition. *Below*: Piet Mondriaan, the painter, 1942, by Arnold Newman (copyright, A. Newman); the background and easel suggest a Mondriaan abstract.

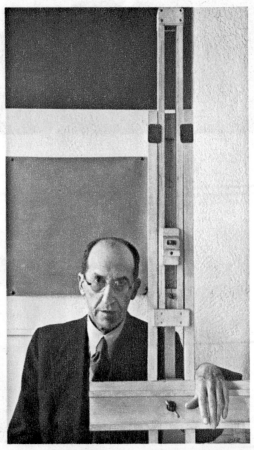

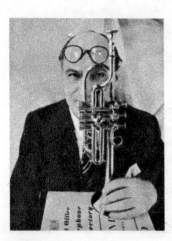

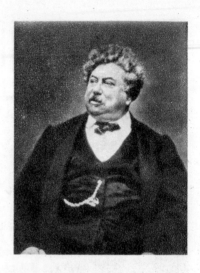

PORTRAITS OF MEN: Mostly writers here. *Top left*, Somerset Maugham by Herbert List, Munich, entitled by the photographer: 'I am certainly not a snob'. *Bottom, far left*, George Eskdale, trumpeter, by Norman Parkinson (Condé Nast Publications Ltd). *Bottom near left*, Aubrey Beardsley about 1896 by Frederick H. Evans. *Above*, Alexandre Dumas (c. 1865) by Nadar (Gernsheim Collection). *Below*, Ian Grey, economist and writer, by David Potts, London, entitled 'The Times Character' – a Leica shot.

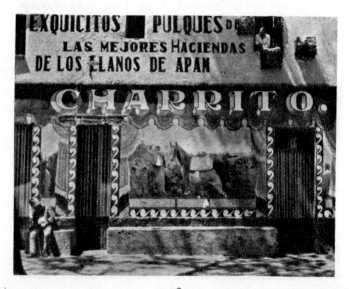

EXQUICITOS PULQUES DE
LAS MEJORES HACIENDAS
DE LOS LLANOS DE APAN

CHARRITO.

FORM: Selecting significant form amidst random chaos and reproducing it in an infinite range of tones is the photographer's creative contribution. Here are some examples of good form. *Above*, a composition of wheels by Ira Latour, U.S.A. *Left*, Pulqueria façade, Mexico, 1926, by Edward Weston, California, which uses decorative lettering as an important part of its design. *Below*, broken window, 1936, by Brett Weston, son of Edward Weston – a clever piece of selective perception of an accidental, abstract pattern.

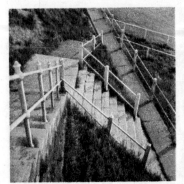

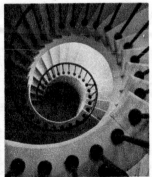

FORM: *Facing page, top left*, steps and railings by the author. *Facing page, top right*, spiral staircase by the author. *Left*, bird's eye view from the Berlin Radio Tower, winter 1928, by the late Laszlo Moholy-Nagy – a well-known classic. *Above*, 'Clydeside', by the author.

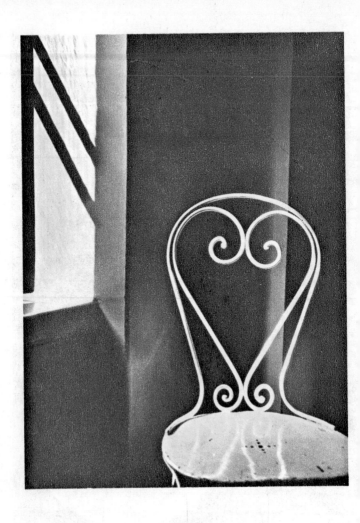

LINE AND TEXTURE: *Above*, a chair composition by Hans Hammarskiöld, Stockholm. *Top right*, a farm-gate latch of wrought iron by the author. *Right*, a stack of sawn wood on a quay by the author – an explosive effect.

52

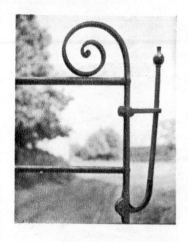

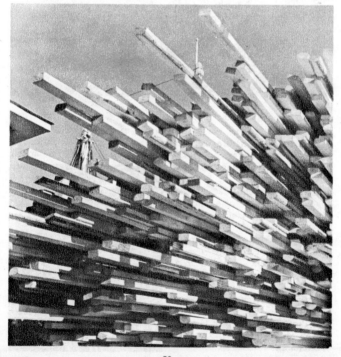

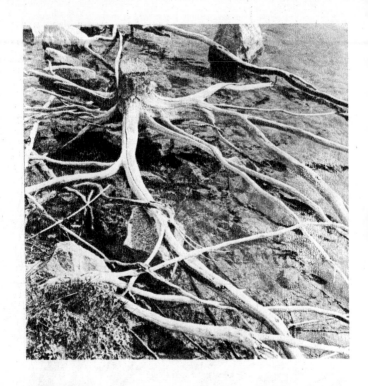

NATURE'S DESIGNS: For those with eyes to see and to select and a camera to record, nature offers an infinite variety of wonderful designs and patterns. Here are a few. *Above,* a dead tree root by the author.

*This page, right,* sponge spicules magnified 200 times by Douglas F. Lawson, England. *Facing page, top right,* the effect of a drop of milk falling into a saucer recorded by electronic flash in 1936 by Harold Edgerton, Massachusetts Institute of Technology. *Facing page, bottom left,* limestones in a pavement by Roger Mayne, London. *Facing page, bottom right,* an electrical discharge in nitrogen at high pressure by F. H. Merrill and Professor Arthur von Hippel, of the Massachusetts Institute of Technology.

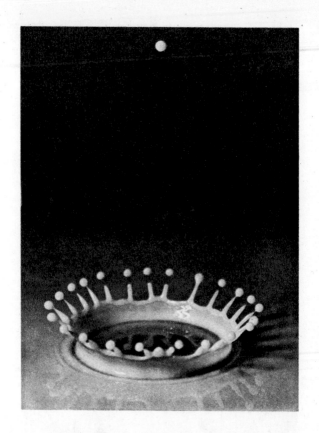

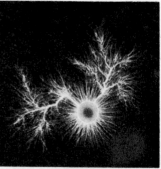

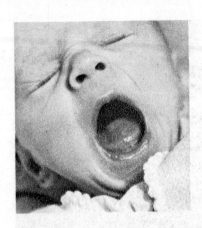

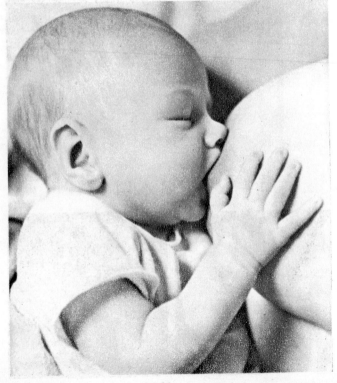

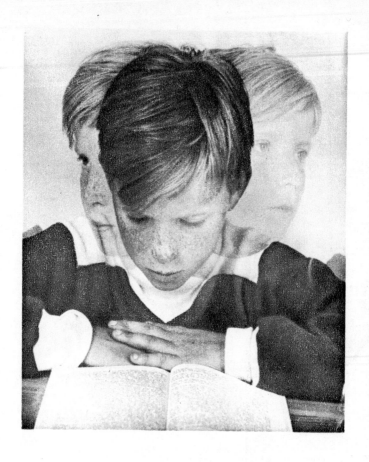

CHILDREN: Being like young animals, children are popular as photographic subjects – especially, and understandably enough, among parents who like to keep their offsprings' early looks recorded, if only in box-camera snapshots. Here are some sophisticated child portraits. *Top left*, a one-year-old yawning for food, by the author. *Left*, satisfaction recorded by Ferenc Berko, Colorado. Both are Rollei shots. *Above*, a clever trick photograph of three exposures called 'The Lesson' by Svante Lundgren, Sweden; it makes a pleasing symmetrical composition and also has the practical advantage of revealing three aspects of the subject in one photograph.

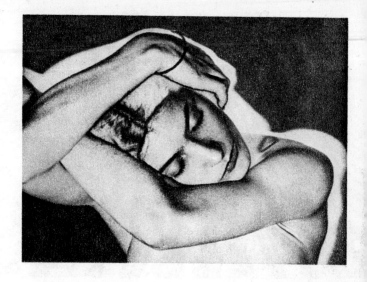

TRICKS WITH LIGHT: *Left*, nude in high key by Ferenc Berko, Colorado. *Above*, a solarization effect by Man Ray, Paris, a classic example first published in *Album of Photographs by Man Ray*, 1934. Solarization is produced by flashing the negative with light while it is in the developer; on printing, light areas appear to have been outlined with black pencil. *Below*, 'A girl I like' by Rolf Winqvist, Sweden, a charming portrait in low key which, like high key, is obtained by special lighting and processing.

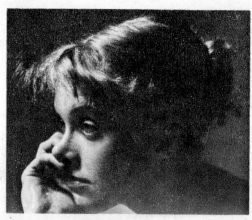

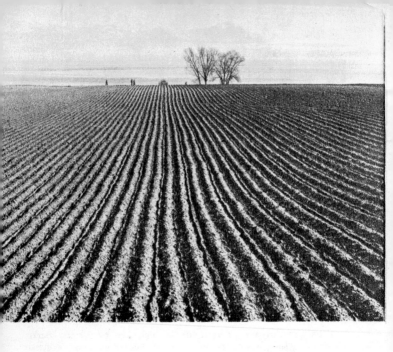

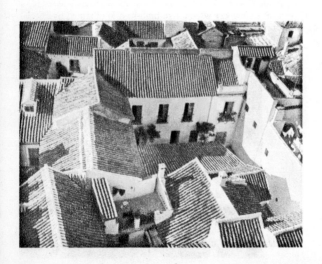

TEXTURE: Three examples of texture produced by parallel ridges. *Top left*, ploughed field by Hans Baumgartner, Switzerland; the tiny black figures and trees and the misty, far-off mountains are essential both to the atmospheric appeal of this picture and to its feeling of distance and depth. *Bottom left*, this architectonic compositions of roofs at Cordoba, Spain, by the author owes much to the texture of the tiling. *Above*, this shot from the air called 'The Harvest' by Michael Wolgensinger, Zurich, owes nearly all its delightful character to the texture of the fields strengthened by the low rays of the evening sun.

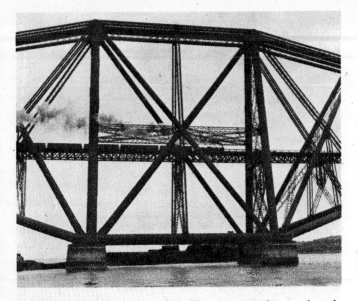

SILHOUETTE: Bones without flesh. Here are exceptions to the rule that one of the chief aesthetic virtues of the photograph lies in variety of tones. *Above*, the central tower of the Forth Bridge snapped from the ferry in a drizzle by the author. *Below left*, 'Structure' by Keld Helmer-Petersen, Denmark. *Below right*, trees in the Arizona Desert by Ferenc Berko, Colorado. *Facing page*, Essex windmill by the author.

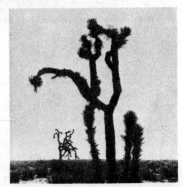

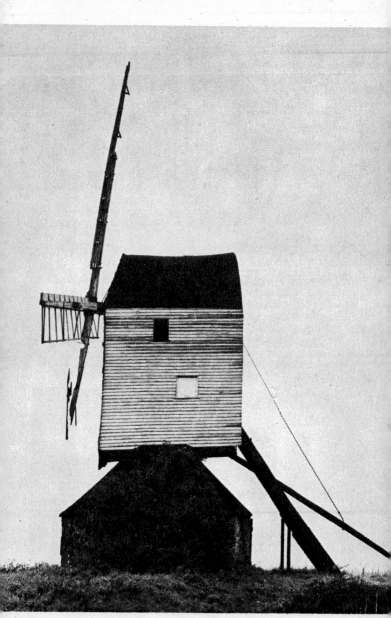

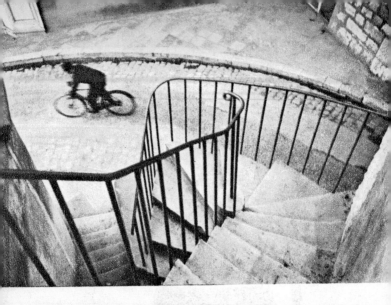

SPEED: Sharp overall focus is not necessarily ideal. A background or object blurred by its movement during exposure can convey an effect of speed. *Above*, a beautiful composition of a street at Hyères, 1932, by Henri Cartier-Bresson, Paris, gains vitality by the blurring of the cyclist as he swishes by. *Below*, 'Orient Express' by Ira Latour, U.S.A., has a streaked background which vividly suggests a rushing train; the effect is enhanced by the dark horizontal line of the window frame and the girl's wind-blown hair.

## Artificial Lighting

Of this the photographer has complete control and it therefore provides him with a fascinating medium, especially in portraiture.

Ordinary tungsten lighting from domestic electric bulbs can be used for interior photography if long exposure is possible, but, as already mentioned, exposure time according to the light-meter reading must be increased by at least 50% because of the lack of blue in tungsten light. I have myself obtained excellent results, mainly through lucky guessing of correct exposure time, in a deserted church from a weak oil lamp when no other lighting was available. The burning of magnesium ribbon or of magnesium powder is also possible though this is a more or less obsolete method.

For proper photographic lighting special apparatus is needed, and this falls into four types:

1. Flash bulbs in special holders with reflectors called flash guns, which are fired from electric batteries. These are either operated in the hand or they can be fixed to the camera and synchronized with the camera shutter. Most cameras made today, even of the simplest sort, have 'synchro-flash' attachments.
2. Flood lamps in special holders with reflectors which are attached by flex to the electric supply.
3. Spot lamps, attached to the electric supply, which direct the light in a restricted beam.
4. Electronic flash apparatus, either worked separately by hand or synchronized with the camera shutter, and powered either by the electric supply or by an accumulator or dry battery.

## Flash Guns

These are simple to use but are tending to be replaced by the small electronic lamps. Since these guns are usually fired just behind the camera lens, they tend to make pictures with a flat lighting effect in which the light falls away rapidly in the background. The light produced cannot be so readily controlled as that from flood lamps and the gun is of little use in illuminating a large interior.

For these reasons I believe they are more popular than they deserve to be, even though they can be valuable for candid snap-shooting and where electric current is not available.

The flash gun can be used outdoors as an additional light source to the sun – to lighten deep shadow, for instance, or for a close-up on a dull day where a speedy exposure is needed.

A useful feature of the flash gun is that its light power is known and is constant so that light-meters are not required when using it. The apparatus is comparatively inexpensive and new lamps cost only a few pence or so. The gun consists of a reflector, a bulb holder and ejector, a glass bulb filled with oxygen, and some in-flammable material such as shredded aluminium foil giving a short, vivid flash when ignited, a small electric battery and con-tacts leading either to a press button or to the special points connecting with the camera shutter. Most new cameras have a flash synchronizer fitted to them and most old cameras can be synchronized for flash by camera specialists. This synchronization means that the bulb is ignited automatically and the shutter of the camera opened and closed at the same time when the camera's shutter release is pressed.

Long flexes leading from the gun to the camera can now be obtained so that the bulb can be flashed at some distance from the camera – to one side of the camera, for instance, so that the flat lighting can be avoided, or by bouncing the light by reflection on to a white ceiling or wall. If synchro-flash attachments are not fitted to the camera, then the camera will have to be set on a tripod, the shutter opened on Time, the bulb flashed, and the shutter then closed.

Most flash guns are fitted with a removable screen, probably of translucent plastic, which distributes and softens the intense point of light from the bulb but serves mainly as a protector in case the bulb explodes. To spread the light and soften it by reflection you can use a white umbrella called a Paraflash.

Exposure time depends on the speed of the film, on the distance of the subject from the light, on the light-intensity of the flash-bulb used, on the aperture of the lens, and – to some extent only – on the shutter speed. As a very rough guide, the following con-ditions should give correct exposure: 1/25th second at $f/11$ on

100 ASA (fast) film at a working distance of 10 feet from the subject. Messrs Philips, who are well-known makers of flash bulbs, provide a full exposure guide and the Focal Press publishes a comprehensive flash chart.

When only one flash bulb is used – the usual procedure – a problem which has to be dealt with is the uneven distribution of light as between near and distant objects in accordance with the Inverse Square Law of light. This can be overcome to some extent when the gun is held in the hand by tilting the gun slightly upwards so that light is reflected from, and diffused by, the ceiling. Additional exposure must be given in that case.

The ignition and burning of the flash bulb takes place within 1/50th to 1/25th second, but a certain time passes until the flash reaches its highest intensity. Therefore, if the shutter speed is set at more than 1/50th second, the shutter may be closed before this peak of intensity has been reached and the shot will be underexposed. For shutter speeds of no faster than 1/50th second, ordinary flash contact, called the X setting, will suffice but the shutter speed may have to be 1/25th or 1/50th second according to the make of bulb used. If a rapid shot is required for a fast-moving subject with 1/100th second exposure or more, then full synchronization, involving pre-ignition of the bulb and called the M setting, must be used. Some shutters are fully synchronized for both X and M, others only for X.

Special rapid-burning bulbs containing an inflammable paste are available for shutters having only the X setting and with these exposures of 1/100th second can be given; the normal type of flash bulb, however, will require the M setting when 1/100th second exposure or less is required. Special long-burning bulbs are also available for focal-plane shutters in which the movement of the shutter as it travels across the film is far longer than the actual exposure of the film as a whole. Special blue 'Daylight' bulbs can also be obtained and these are valuable, for instance, when using daylight colour film.

A few more points about flash lighting: since the important exposure factor is not the shutter speed so much as the power of the flash which occurs when the shutter is open, any shutter speed up to 1/50th second will need the same lens aperture.

Orthochromatic films are excellent for flash photography, but they will need slightly more exposure than panchromatic films of the same speed value because flash bulbs emit slightly less blue light than does the sun.

If you must expose with the gun attached to the camera, then do not over-expose or even the slight modelling that is possible with flash will vanish and you will obtain only soot and white-wash; faces will appear ghastly white and unwholesome. And on no account use the gun attached to the camera when much dust or mist is in the atmosphere, or light will be reflected straight back into the camera from the particles and little will be visible on the final print except a blur.

Whoever is practised in the use of flood lamps will more easily be able to control flash lamps. He will realize, for example, (i) that a flash lamp attached to the camera gives flat lighting; (ii) that two lamps are usually better than one; (iii) that when two lamps are used, one should predominate by being nearer the subject and so provide the chief modelling, the other should be farther away from the subject to reduce the contrasty shadows produced by the first lamp; (iv) that reflectors such as white walls or ceilings, or large sheets of white board or paper, or white umbrellas, are immensely useful in softening contrasts and in achieving subtle effects of modelling – especially in portraiture.

In using flash bulbs outdoors to help the sunlight where shadows are too heavy to show adequate detail, do not overdo this fill-in lighting or a weird, artificial effect will result; the use of the extra light should not be obvious on the finished print. Outdoor flash can also be used to strengthen a sunlight effect where the sunlight is itself weak, but then the flash must come from exactly the same direction as the sunlight or artificial double shadows will be produced.

Flashlight (and floods, for that matter) can also be used with great advantage inside buildings when daylight is coming too strongly through windows which are to appear in the picture. The flashlight will counteract the intense glare from the windows. The burning of magnesium ribbon can also be used to counteract the glare.

# Flood Lamps

Special 'Photoflood' lamps with tungsten filaments are obtainable and these can be fitted into any lamp socket or into special holders with reflectors. The lamps, or bulbs, are of pearl glass and are over-run – that is to say, they give an 800-watt light while consuming only 275 watts or so. They have a short life of about two hours at the most. An ordinary light bulb can act as a photoflood if it is used on a much higher voltage than that for which it was designed.

A less costly photographic bulb, such as the Nitraphot, is slightly over-run and has a life of about 100 hours; it gives about the same amount of light as a 1,000 watt lamp of normal type.

Flood lamps are, in my opinion, by far the best form of artificial lighting for amateur work, though the considerable blue content of their light, as compared with ordinary tungsten lamps, must always be taken into account. Their great virtue is that the light they give can be controlled and arranged by eye, and a light-meter reading can be taken before exposure. You can see exactly what you are taking and you can move the lamps about experimentally; you cannot do that with flash guns or with electronic flash. You can even control the power of each lamp by using a dimmer, or rheostat – an expense which may well be justified if much work is being done, because the lives of the bulbs will be lengthened if they are dimmed down while the lighting is being arranged before and between exposures.

Inexpensive reflectors to direct the light are available and they can be obtained with stands or with hooks or clamps. More elaborate stands are made several feet high and each holding, say, three lamps and reflectors which can be moved up and down the pillar of the stand, but these are not recommended because they will cast confusing shadows and produce too many highlight points, especially in the eyes of portrait subjects. The reflectors, possibly of aluminium alloy, are made in various shapes according to the general direction of lighting that is wanted, whether concentrated or spread out, and they can be fitted with diffusion disks or with home-made affairs of glass-fibre cloth on wire frames, or even with sheets of tissue-paper having holes at their centres.

Slight diffusion by such means is generally desirable in order to soften the somewhat harsh light, especially when the lamp is placed near the subject.

Photoflood lamps are especially valuable for portraiture and more will be said about their use in this respect in the next chapter. Here it will be noted in general that two photofloods with reflectors and short stands will be enough equipment, at least for a start, and the cost of these will be small. More ambitious work may require three photofloods on tall stands with adjustable screws and also a spot lamp. But beware of the confusion that can be caused by using too many lamps and the flat and characterless forms that may result. Powerful effects can be obtained with one lamp only, provided that the deep shadows are lightened with a reflector such as a white wall or a paper sheet. After all, the sun is merely a huge single flood lamp. Note that a famous professional has written: 'Most of my portraits were made with only two flood lights and one spot.' (E. O. Hoppé in *Hundred Thousand Exposures*.)

## Spot Lights

As its name implies, a spot light produces a spot-like area of light, unlike the photoflood whose light is widely diffused. The light of a spot is hard and its purpose is not to give general lighting but to accentuate a part of the subject with a beam of light – perhaps in order to produce brilliant highlights in one area. For amateur purposes the light source will be a 500-watt filament lamp in a cylindrical housing having a reflector, a condenser lens, and air vents. The width of the beam can be varied either by an iris diaphragm or by moving the lamp nearer to, or farther away from, the condenser lens within the housing.

## Electronic Flash Lamps

High-speed electronic flash equipment is a comparatively recent development. Though costly in first outlay it is cheap to run.

Like the flash lamp, but unlike the photoflood, it can be synchronized with the between-lens shutter.

Electronic flash cannot be used at high speeds with focal-plane shutters. As already explained, in these shutters a slit travels across the film from one side to another, exposing each part as it travels. In order that the film may be properly exposed, it is therefore necessary that the light should continue for the whole time the slit is travelling across the film, which is much longer, even at the highest speeds, than the duration of the electronic flash. For this reason, focal-plane shutters can be used with electronic flash only at slow speeds when the slit opening is equal to the full width of the film aperture. This is usually $1/25$th of a second. Between-lens shutters can be used at all speeds of electronic flash.

The electronic flash lamp, also called speedlamp, speedflash, or strobolight, usually consists of a transformer, a rectifying valve, condenser, and a gas-filled lamp. The condenser builds up electricity to several thousand volts and this is discharged as an intense flash of light between terminals in the lamp. For scientific purposes, such as the recording of bullets in flight, flashes of one-millionth of a second are possible, but normal apparatus has a flash lasting about $1/1,000$th second. The equipment is therefore useful for 'freezing' any rapidly moving object, and fascinating results can be achieved by repeating flashes rapidly and regularly and so recording on one photograph a number of different positions of moving objects such as fencers (Pl. 25 bottom).

The more elaborate kinds of equipment are run off the electricity supply, but small ones, weighing only a few ounces, that can be slipped on to the camera, are available which either run off batteries or are charged from a domestic electric plug; new makes are the Agfatronic, Mecablitz, Vivitar, Braun, Sunpak, Rollei, Sola and Toshiba. Many models now measure and adjust light automatically by computer, and some have swivelling heads to adjust direction of light, as when bouncing it off a white wall or ceiling. The Rollei C26 camera, taking cartridge film, has a built-in computerized flash. These small flash lamps are likely to supersede flash bulbs almost entirely. The quality of light the

lamps give is close to daylight in its colour composition and this is a distinct advantage.

The amount of energy discharged in the lamp is measured in joules. One joule is equivalent to one watt-second – that is, the energy given off by one watt of power in one second of time. One hundred joules would therefore equal the amount of energy given off by a 100-watt electric lamp in one second. The most modest electroflash set would produce a flash of no more than 25 joules whereas an elaborate one would provide 1,000 joules.

To simplify exposure calculation every electroflash light source (or for that matter any light source) can be given a Flash Factor based on the Inverse Square Law of light, which states that light falls off as the square of the distance. That means that if you double the distance of light source from subject, you must either increase the power of illumination four times, or increase the exposure time four times or increase the lens aperture to admit four times as much light (e.g. $f/8$ becomes $f/4$). Therefore, if the power of your light source is a known constant, you can soon calculate the relationship between your $f$ stop number and the distance in feet between light and subject. If your distance is fixed, you can find out your $f$ number, and if you know what $f$ number you want to use, you can calculate the maximum distance which would give you enough light. The formula is:

$$\text{Stop number} = \frac{\text{Flash factor}}{\text{Distance in feet between lamp and subject}}$$

Note the following: synchronization is used on the camera's X setting only. The brief flash tends to produce a soft negative; therefore an increase of 50% in development is always to be recommended to increase the negative's contrast. Being close to the colour temperature of daylight, electro flashlight will require the use of daylight type films in colour work; in this the use of a colourless ultra-violet or haze filter will make the results slightly less blue. For Kodachrome use filter Kodak IA and for Ektachrome Kodak 8IB.

An apparatus is now available called a Phototronic Slave Unit, by which one to three light units, either flash bulbs or electronic apparatus, can be fired at will without intervening wires. This is

particularly valuable, of course, in the photographing of wild animals.

## General Advice on Lighting

When using any light source, build up from one lamp; make one lamp the dominant one to create the main highlights and shadows and use the other lamps as supplementaries to fill in shadows which are too deep or to create secondary shadows of interest. This will mean that one lamp will be nearer the subject than the others, or at least more powerful than them, and that the secondary lamps will tend to be on the opposite side of the subject to the dominant lamp.

When combining daylight with artificial light in a room, use the daylight as general diffused light and use the lamp to create the dominant effect of light and shadow. For portraiture, a window, a single flood lamp and a white reflector can produce a remarkable range of effects.

An effective way of using a spot light is to play it on the background, notably to produce a circular pattern behind a portrait head. Alternatively it can be used behind the head, but not shining directly at the camera lens, to produce a scintillating light on the hair; this is especially flattering in women's portraits.

Take care of cast shadows and do not allow them to dominate unless that is your deliberate intent. You may be concentrating your attention so strongly on the main points of interest in your subject that you fail to notice an ugly, heavy, and far too definite shadow in the background.

Special white umbrellas on stands can be bought which produce reflected light either from lamp or flash gun.

## High-Key and Low Key Lighting

A high-key photograph is one in which very little shadow is evident and in which the light tones are dominant, ranging from white to grey and stopping there (Pl. 58). The effect is partly

obtained by processing but partly also by lighting during exposure. Contrast is sacrificed in the interest of subtle half-tones. By its use, delicate, charming, ethereal results can be achieved, though not strong ones. The subject should therefore suit the treatment.

The high-key effect is obtained in lighting fairly simply by providing a brilliant light near the camera lens, by keeping the subject well away from the background, and by keeping the background white by means of separate lights. When applied to portraiture, the lens and the light should be kept slightly below the eye level of the subject and soft lighting should be directed towards the head from points situated slightly behind the head. Over-exposure must be avoided and soft films and developers must be used. In the printing, soft paper, over-exposed in the enlarger (possibly twice the normal exposure), must be used and developed in a warm-tone developer, diluted five to ten times. More is said on processing control in Chapters 11 and 12.

Low key is the opposite of high key (Pl. 59 bottom). Here the normal range of tones is restricted to dark or near-dark tones. Again the subject of the picture must be suitable to the style and could possibly be one of dramatic mood. The highlights will be low in tone but not under-exposed and black or near-black on the print. Low key is produced mainly by limiting the lighting to one lamp – possibly a spot light. Processing will consist of printing on a contrasty paper fairly fully exposed in the enlarger and perhaps over-exposed in some parts. Development of the paper should be normal and the print should then be bathed in warm water at about 100°F. This will spur on the developer which remains in the emulsion and will strengthen the details in the highlights.

## General Advice

Some notes follow on ways of dealing with special kinds of photography – portraits, landscapes, snow scenes, night scenes, architecture, documentary and candid photography, abstractions, tricks, and micrography. Only some broad instruction can be given because each subject calls for a whole book of its own; those who wish to specialize must go to the best sources of information and some of these have been listed in the Selected Bibliography at the end of the book.

First of all, here is some general instruction:

*Camera drill.* Open back of camera and insert film. Close back and turn winding knob until Number 1 appears in the little window Cover up the red window of an old camera if using a pan film as this is sensitive to red light which may penetrate the paper backing of the film if the window is not covered. Select your viewpoint, take a meter reading or otherwise assess exposure time, adjusting this to your aperture, speed of film, and filter to be used, if any. Adjust your aperture lever to the desired *f* stop. Focus the lens. Fix your selected filter to your lens. Set your shutter speed. Expose with a gentle squeeze. Wind on the film to Number 2. Record in a notebook the film and exposure numbers, the subject, the speed and type of film used, the aperture selected, the exposure selected, the type of filter used, the focusing distance, the conditions of light, the time of year, the time of day, and any other relevant information. This recording of exposures is strongly recommended to the beginner, for it will be instructive. Special log books can be purchased but any pocket notebook will suffice with appropriate lines ruled in and headings inserted.

*Pressing the Trigger.* Many shots will be taken without a tripod

and then the avoidance of camera shake is essential. When pictures turn out to be fuzzy on enlargement, the camera is often blamed unfairly as having a poor lens; the real cause may be camera shake. Therefore, never attempt to take a picture at an exposure of more than 1/25th of a second without a tripod or other firm support. Even 1/25th of a second is risky. The way in which the camera is held in the hands and the way the trigger is pressed are important, especially when the camera is held at eye-level. Keep elbows close to the body, half-empty the lungs, hold the breath, relax the muscles slightly, and squeeze rather than jab the trigger, slowly and gently, as though firing a rifle.

*Other Tips.* Do not load your camera in bright sunlight but always retire indoors or into a shadow to do so. If you do not, light may creep on to the film at the edges.

When using a bellows camera it is wise to wind on the film just short of the next number immediately after exposure and then to complete the wind just before the next exposure. The reason for this is that when the camera is opened the suction caused by the bellows may pull the face of the film out of the flat plane; the slight tightening before exposure will bring it back to flatness again.

If the plate, or film, holder has a slide in front of it, do not forget to remove the slide before exposure. It is easily forgotten. A friend to whom I once lent a camera to record his foreign travels returned home in high excitement with what he believed to be hundreds of splendid photographs. On development every negative was a complete blank. He had forgotten my instruction to pull out the protective metal slide before exposing.

Do not allow the camera to lie for long periods in the sunshine; light may penetrate the camera and the lens may suffer. The rubbery material of focal-plane shutters may also suffer.

*A Rough Exposure Guide.* If no exposure calculator or light meter is used, the following rough guide may prove useful:

On a sunny day in May, June, or July between 10 a.m. and 2.30 p.m. in Great Britain (Greenwich Time), using a film of 25 ASA speed and an $f/11$ stop, a shutter speed of 1/50th of a second

will give perfect results for general subjects where excessive shadow does not predominate and no filter is used.

By the sea with much sky visible and excessive overall brightness, a stop of $f/16$ at 1/50th of a second, or a stop of $f/11$ at 1/100th of a second may be more than enough.

For close-up portraits under normal outdoor conditions as described above, give double the exposure you would give for more distant subjects.

In May, August, and September add 50% to the above exposure times. In March double them. In February and October treble them between 11 a.m. and 1 p.m. and quadruple them at 10 a.m. and 2 p.m. In January, November, and December quadruple them between 11 a.m. and 1 p.m. and multiply by six at 10 a.m. and 2 p.m.

When the sun is slightly obscured by cloud or mist, give double the normal exposure, and under dull or very misty conditions (or under trees in bright weather) quadruple it. For very dull conditions increase it at least eight times.

For bright conditions inside a building turn all the above readings in seconds into minutes at least, that is multiply the equivalent exposure for outdoors sixty times at least. A well-lit room on a bright day in summer with stop at $f/11$ might need 2 seconds or more. A portrait taken indoors on a bright day within 4 feet of a window may be possible with stop at $f/6.3$ and 1/5th of a second.

When photographing moving objects, exposure will have to be as fast as possible if the image is to be sharp and that means that the aperture will have to be increased accordingly. An object moving directly towards the camera, or directly away from it, will need less speed than one moving across the field of vision. Here is a rough guide for a 50 ASA film speed:

| Object | Distance away from camera | Moving towards, or moving away from, camera | Moving across field of vision of camera |
|---|---|---|---|
| People walking or moving normally | 25 feet | 1/50th second | 1/150th second |
| Car or galloping horse | 25 feet | 1/200th second | 1/500th second |
| Trains at 30 miles an hour | 50 feet | 1/100th second | 1/300th second |

The above exposure times should be doubled when the distances are doubled and should be at least halved if distances are halved.

Portraiture

This is the most subtle, the most difficult, and, in many ways, the most interesting and rewarding kind of photography. More than aesthetic sensibility and technical efficiency are needed to be a good portraitist. The interaction of two human personalities enters into the creation. Therefore a rapport must be established between the photographer and his subject.

The famous portrait photographer, Baron, once said to me during an interview: 'To be a successful portraitist, either your photography must be good or you must have sufficient personality to be able to direct the sitter. You can get along with either but you must have one or the other.' The early wet-plate photographer, Nadar, used to say that it was possible to take a good portrait only of a friend. There is much truth in that, though one could add that it is possible to understand and to make friends with a subject at a first meeting.

The fact is that obtaining a 'likeness' is not a mechanical act; it is highly personal and subjective. A human being is a far less fixed and rigid entity than is often supposed; the concept of personality is much more the result of a particular relationship between two people under certain circumstances. To a more or less degree everyone contains something of every human emotion, good or bad, and a relationship between two people stimulates some of these emotions and represses others in both the people. Moreover, each individual sees another differently from every other individual.

What is more, nearly everyone has a visual image of himself which is quite different from the image seen by others. Hence the immense amount of re-touching of photographs in which professional photographers are more or less compelled to indulge if they are to survive.

Self-consciousness in the sitter is a frequent problem which has

to be solved by the relationship between photographer and his sitter. Another problem is the overcoming of boredom in the sitter. Both problems can be solved by easing the tension with good-humour and conversation in which the sitter is likely to find interest; also in taking one's time without flurry or worry in a relaxed mood. Angus McBean, the famous theatrical photographer and portraitist, expresses this personal matter sensitively when he writes: 'You have at your mercy that tender thing – a human being – with a lot of light turned on its most tender point, its personal appearance. . . . Do everything to make them unselfconscious. Make little flattering noises. . . . Joke, make them laugh.'

A useful trick with a particularly self-conscious sitter who will not relax is to pretend to make an exposure and then as soon as the sitter has relaxed to take the actual exposure.

In general, smiling portraits should be avoided for they are not easy to live with unless the smile is an exceptionally charming and subtle one. But make your sitter smile and laugh before you expose because this will relax the face muscles.

*Lighting in Portraiture.* As a means of creating interesting form and texture by photography, portraiture is particularly powerful, for there is nothing more intricate and subtle in form and texture than the human body – especially the ever-moving face. To bring out and record that form and texture, and with it the unique personality of the sitter, by means of proper lighting must be the chief aim of the portrait photographer. Something about lighting by artificial means has already been said. Here are some points especially applicable to portraiture:

Suit the kind of lighting to the character of the face. Whereas that mysterious, dramatic quality gained by lighting from below may suit an ageing actor or a highly sophisticated poseur, it will hardly do for a child of twelve, however precocious. The more natural and unsophisticated the sitter is, the more natural should the lighting be – and by 'natural' is meant that which most nearly approaches sunlight, that is one powerful single light shining down at an angle combined with overall general lighting.

Outdoors, hazy sunlight is better than brilliant sunlight, because then harsh shadows will be avoided.

For beautiful women, a good lighting arrangement is one strong overhead lamp shining directly down on the hair, a weaker reflected light on the face for softness, and a spot light from behind the sitter to give a halo effect. Note the proportions of the head and select a view-point accordingly; if the face is a trifle too broad at the chin, then take the shot slightly above the centre of the face, and *vice versa*; in that way perspective will come to your aid. And realize that a sitter can also stand and can also lie down; a close-up of the face taken from above when the body is lying on the floor can produce attractive results.

Never forget the softening effects which can be produced with reflectors and with diffusing screens in front of the lamps. And realize that softening effects can also be produced by keeping a lamp slightly on the move during exposure and also by moving it away from the subject.

*Backgrounds.* In general, keep these simple and in character with the subject. For the beginner, the plain background which is white or light grey will be adequate and a great deal can be done with that by lighting alone.

Keep the subject about three feet away from the background unless a special effect is wanted. As a rule keep the background out of focus by using a fairly large aperture.

All kinds of background effects can be created by quite simple means, especially with different fabrics – towels, corrugated asbestos sheet, draped sacking, wallpaper, the black of night through a window or through a doorway into an unlit room.

*General.* The 35-mm. camera is not the best kind for portraits. The large plate camera and the reflex, single or twin-lens, are excellent, particularly when long-focus lenses are used.

Use panchromatic film, either without a filter or with a pale blue filter in tungsten light. In general, avoid full-face views unless the face is unusually symmetrical. And make the face look into the picture rather than out of it.

The amateur without lavish studio equipment may be able to

obtain the most interesting results with the close-up – one which fills the whole picture space, or more than fills it, so that only part of the face is recorded. A view of three-quarters of the body should make full use of the hands, possibly to create a pyramidal composition; hands reveal personality almost a much as the head and should be treated accordingly (Pls. 2, 3, 45, 46).

Landscapes

Landscape photography presents no great technical difficulties beyond the deciding of exposure, aperture, and kind of filter, but to obtain a strong and interesting composition in landscape is difficult (Pls. 32, 33, 60 top, 61). Results are so often disappointing usually because the photographer has been beguiled by atmosphere, colour, and even smell when he should be seeking strong, simple, visual forms.

*Some General Advice.* Bring out the clouds with proper filter and as short an exposure as possible. Obtain a sense of depth by contrasting close objects with distant ones and by stressing receding planes. Avoid scenes with too much detail – too much uninteresting foliage, for instance. Beware of the dull effects produced by large areas of grass or gravel. Look for strong contrasts of tone as well as for strong, clear, simple forms and lines. In general, avoid the straight horizon that cuts the picture into two equal parts. Remember that the camera always tells lies and try to understand how it will lie on each occasion. Above all, *eliminate and simplify.* Say what you want to say with the utmost possible simplicity and remember that the part is often more expressive of the whole than the whole itself.

The level of the camera is important; the higher you are, the more will the foreground dominate the picture and the less important will the sky be. And *vice versa.* The lower you are, the stronger will be the value of vertical objects, especially in the foreground (Pl. 4 bottom). On the whole, high view-points will provide the more interesting patterns by disentangling and clarifying the main features and lines of the subject (Pls. 60 bottom, 61).

Light is, of course, all-important. A subject which is flat and boring at midday with the sun behind the camera may make a superb picture when the sun is in the west in the late evening and the shadows are long (Pl. 61). Sun behind the camera can be effective when the dominant interest is the skyscape. Dull weather is generally hopeless for open views.

A boring landscape picture may be caused by lack of any sense of size. Where this is likely to occur try to bring in some object which gives a sense of size – of scale; perhaps a human figure, a fence or gate, a cottage, an animal.

*Water.* This can be a great help in landscapes, especially when it is still and acts as a reflector or when it scintillates in the sunshine. But water can be too still and then it can be made more interesting in texture by some induced disturbance such as the casting of a stone into the water to create ripples. Avoid over exposure or the subtle tones and highlights in the water will be killed. When water is moving rapidly a fast exposure will be needed or an uninteresting blurred effect will result; 1/50th to 1/100th of a second should be fast enough even within a distance of 20 feet.

Waterfalls always seem to attract the amateur photographer, but these are usually poor subjects because their attraction lies in their sparkling movement and that cannot be captured in a still photograph; it will appear unnaturally frozen – at least at high shutter speeds. However, every rule has its exceptions.

*Filters and Lenses.* For most landscape purposes a yellow filter needing double exposure and a medium-speed pan film are most suitable. If lenses cannot be interchanged on your camera, the ordinary lens of medium focal length will be adequate for most purposes, and if a long-focus effect is required, the picture must be composed on only part of the screen or view-finder and that part only used during printing or enlarging. Where lenses can be interchanged, a long-focus lens will be very useful; a wide-angle, or short-focus, lens will hardly ever be required, though it is occasionally useful to record wide panoramas.

*Mountain Photography.* This can be exciting and might almost be

called a form of architectural photography (Pl. 35). Are not the Alps, asked Ruskin, 'the cathedrals of the Earth'? Mountain photography presents its own special problems and possibilities. Reducing the ultra-violet light is necessary in high altitudes, either with a colourless ultra-violet filter or with a yellow filter. Deep filters should be avoided on the whole because they tend to kill the impression of distance.

Though a lens of normal focal length is the most useful in mountain photography, a telephoto lens can be a boon – for instance, to record a view across a wide valley. Lenses of long focal length are also useful, especially when their angle of view is 25 degrees or less. Remember, however, that definition produced by telephoto lenses will be less sharp than that produced by lenses of normal focal length, particularly in the shadows. Comparatively flat lighting is therefore the best. Clear atmosphere helps, of course, but trembling in the air on warm days must be noticed and its recording avoided.

*Snow.* This gives fine scope because snow provides those subtleties and varieties of tone and texture to which only a photograph can give full meaning (Pls. 34, 35, 50 bottom). Here again special problems arise, notably in lighting. Sunshine behind the camera should be ruled out entirely, for then nothing but flat whiteness will result. Sunshine helps, but it should fall at a low angle to give adequate shadows, tonal differences, and textures. The sun should be in front of the camera rather than behind it and probably the best effects will be captured *contre-jour* – directly against the sun. In that case a lens hood must be used and possibly also some shading from hand or hat to prevent the sun's rays shining directly on to the lens or on to the inside of the lens hood. Shadows will be cast towards the camera and exposure time may therefore have to be increased, perhaps doubled, but it is safer to risk underexposure rather than over-exposure in order that the subtler tones may not go unrecorded.

Against-the-light photography presents one of those few occasions when a soft-focus attachment can produce a charming effulgence. Use a pale yellow filter always for snow pictures in order to strengthen the bluish shadows and give rather more than

the extra exposure demanded by the filter factor – say 50% more – because blue light will predominate overall in snow and a yellow filter tends to absorb blue light.

*Against-the-light.* This need not be confined to snow scenes or even to landscapes in general. It is applicable to every kind of photography and has the special value of creating a sense of depth, of simplifying form into bold masses and of dramatizing a subject by eliminating unwanted details. Careful exposure will help to prevent too strong a contrast between shadows and highlights; excessive contrast can also be prevented in processing by using a soft type of developer and by keeping time of development to the minimum. Except for snow pictures, generous exposure will be needed to avoid dull, black, featureless shadows. Too long an exposure, on the other hand, will kill the details in the highlights and may produce halation and irradiation.

## Night Photography

Photographs can be taken in moonlight, but exposure time, as compared with that in daylight, will have to be increased by at least a hundred-thousand times – say 15 minutes at $f/5\cdot6$ at full moon. Neither the moon nor its reflection in water can be included in the field of view. Light from a half-moon will not, surprisingly enough, require double the exposure time of that from a full moon but will have to be increased *five* times.

Night photography in general, say of a street or a flood-lit building, does not present any great difficulties. A tripod will be needed in most circumstances and, if a small stop and long exposures are given, passers-by will not be recorded provided they keep on the move. Using a stop of $f/16$ with a fast pan film of 100 ASA, an exposure of 5 minutes might be ample. Cover over the lens with your hand or hat if some vehicle with headlamps passes before the camera or you will record disconcerting lines of light.

Shorter exposures are, of course, possible with a wider aperture and even snapshots are sometimes possible given a fast lens, fast film, full development of film in a fast developer, and strong

artificial lighting such as that from a shop window. A rough guide: try your exposure meter on the bright lights and multiply the reading by twenty to forty times.

Wet streets can provide interesting effects and they help to strengthen the light. Other possibilities for photography at night, besides street scenes or flood-lit buildings, are firework displays; for these the aperture can be set at $f/8$ and the shutter left open at Time – perhaps through several items of display to increase the glory. Here colour film can give fascinating, if fortuitous, results, but if colour film is used the stop may have to be increased at least to $f/5\cdot6$ because colour film is comparatively slow.

If something more than the strong contrasts of deep night photography is wanted – something which shows a certain amount of detailing in the half-lights and shadows – use the last dim light of dusk together with any artificial light available.

Architectural Photography

This can be defined either as photographing beautiful structure, or photographing structure beautifully, or doing both together. Thus architectural photography can be divided into three groups: the Survey, the Illustration, the Picture. The compartments are not water-tight and they may run into each other.

The Survey consists of the pure record for the use of students, historians, stage and film designers, renovators and so on. It is made simply to provide as much documentary information as possible and nothing more. Making architectural surveys with the camera is dull but useful work.

The Illustration is a record of a beautiful or interesting structure which also makes a picture in itself (Pls. 42, 43, 63). It presents a building, group of buildings, or detail of building, not merely as a factual record or survey, but in as attractive a way as possible in order to reveal, perhaps only by suggestion, the beauty and the spirit of the building. By selecting the right viewpoint, choosing the right light and sky, and composing carefully in the viewfinder, the best qualities of an architectural design can be revealed. Sometimes a prosaic building can appear to have virtues

which in fact it does not possess. Such a photograph not only proves that the camera is a good liar but that the photographer has more visual sensibility than had the designer of the building. In such a case the photographer has, in a sense, created a new and improved visual conception out of the old one.

The Picture is of that sort which deliberately sets out to make a pattern or composition from architectural raw material which in itself may, or may not, have aesthetic value as architecture. Here the recording of the building as such is of no importance. The picture is itself architectonic (Pls. 4 top, 28 top, 50, 60 bottom, 62, 63, 64 top). The material may be found in strange places and in strange forms – part of a ruined tomb, a bombed site, a pile of box-lids. This kind of architectural photography is itself architecture in its purest, formal, sculptural, external sense. It is building with light and in this sense *all* pictorial photography could be called architectural.

Most people are interested in architecture only in its associational, historic, and romantic aspects. Such interests are irrelevant to the making of pictures out of architecture except in so far as historical knowledge helps one to find the formal qualities and the inspiration that is desired. Old buildings provide rich material for the photographer, perhaps more than do modern buildings, not on account of their histories or other associations, sentimental or otherwise, but on account of their formal qualities and, above all, on account of that texture and patina which only time can create.

As in other kinds of photography, the part in architectural photography may be more telling than the whole. Seek details, then, rather than whole buildings; isolate interesting details from their surroundings and concentrate on selecting a part which the eye, roving over the whole of a building or wall, may miss.

In medieval buildings, like the great cathedrals, look for soaring verticality and use a rising front if your camera has one; look for the poetry of structure; analyse the structure and *feel* the stones pushing and working to create a calm stability; look for the drama of light and shade, the chiaroscuro; look for interpenetrating spaces and the exciting suggestion of 'something round the corner' – for interior 'landscaping'; look for carved stone details of strange human heads, strange animals, and intricate foliage of

brilliant craftsmanship in which English country churches are so rich; look also for carved oak in places like the choir stalls (using a red filter to bring out the grain). Move the camera around, seeking the unusual, revealing, queer-angle shot; you will discover plenty such, perhaps most in the directly upward shot, say of a vault having a complex pattern of ribs, or upwards into the extraordinary, geometrical lines and shapes above a cathedral crossing. Look out for monuments and tombs and pick out their most telling details according to the available light or to the light you can yourself create with photofloods (and official permission).

In post-Reformation buildings, perhaps the exteriors offer more scope than the interiors. Bear in mind that the classic orders were originally designed for a climate of brilliant sunshine in which reflected upward light had its visual effects on mouldings. Classic architecture cannot tolerate lack of sunshine, whereas the pinnacled Gothic, designed for misty, northern climates, can be most dramatic and effective in silhouette against a stormy sky. Seek the fine church monuments of post-Reformation times, notably the painted Jacobean; seek the grand staircases in the big houses, the theatricality of the Baroque as at Blenheim Palace; seek the little details of knockers, door hoods, balusters, fireplaces in the small Georgian houses – the dignified street pictures of towns like Bath – the climbing street of white Regency houses decorated with delicate black ironwork and backed by dark blue skies – the picturesque street vistas, too, of our small towns with their strange yet harmonious mixtures of different styles and times, especially blocked vistas.

Modern architecture at its best also declaims the poetry of structure but in the new manner of steel, concrete, and glass. We no longer see architecture as mere wall decoration but as three-dimensional massing and as designing with space itself. In the great, shimmering sheets of plate glass you will find many possibilities for photography, especially as a reflector.

Trees and foliage are useful adjuncts in architectural pictures because they act as powerful foils – almost, one could say, as baroque decoration – to the geometry of buildings. Provision of scale is important and the placing of figures at the right points can make an architectural photograph come alive. The achievement

of depth and of perspective by proper lighting is important, too, in order to bring out the three-dimensional form strongly, and in this the inclusion of dark foreground objects may be a help. In general, sunlight should be fairly low on the horizon in order to stress forms and textures.

Unless done deliberately to obtain a queer-angle shot or unless converging lines are to be corrected later in the enlarger, the camera should be kept absolutely vertical in order that the vertical lines of the building may appear vertical in the print. Nothing harms an architectural picture more than a weak convergence of verticals caused by a slight tilt of the camera; converging lines deny the essence of architecture – stability. This means that the best type of camera for architectural work is one having a rising – and preferably also a falling and sliding – front. Indeed, the ideal architectural camera is the old-fashioned Field camera, or hand-or-stand camera, possessing all the movements as well as triple-extension, interchangeable lenses and focusing screen. For distant shots of details the long-focus lens is invaluable and for interiors the wide-angle is often essential, especially in confined spaces. For details, however, a twin-lens reflex camera is ideal because it makes selective composition and sharp focusing easy, simple, and direct.

I have myself used a Rollei for many of my architectural pictures and in using it I have partly overcome the problems caused by the lack of rising front in several ways. By masking the focusing screen vertically, tall buildings can be included completely without tilting if taken at some distance, and any excess of foreground can be eliminated when enlarging. If the foreground is included it can be made interesting by including in it some close object and this will also help to increase the sense of depth. If the camera must be tilted slightly in order to include, say, a tower, then the converging lines can be brought back to verticality in the enlarger by tilting the printing paper or the negative or both (p. 268). The result will not be strictly accurate because some distortion of height will result; the building will appear in the picture to be slightly higher than it is in fact, but this is rarely of consequence, the extra being about 5%.

A Rollei, in particular, has a special virtue in architectural work,

for, by using the Rolleikin attachment, a special mask over the viewing screen, and 35-mm. film, the lens becomes virtually one having a long focus.

Another solution to the problem of including high buildings in a picture without a rising front is simply to find a vantage point high up – for example, from a roof, window, or hillside.

A sturdy tripod is essential in architectural work both indoors and outdoors, because small apertures may often be needed to produce crystal sharpness with great depth of field. A pair of simple flood-lamp holders and reflectors are also useful equipment. Avoid flashlight, but you can use strips of magnesium ribbon to light up dark shadows in interiors which are otherwise lit by daylight; the burning of as much as 18 inches of strip may be necessary. If you must illuminate a large interior in which there is much darkness high up near the ceiling, then attach a flood lamp to a long pole and hoist it aloft.

Two final tips: When photographing small interiors avoid the inclusion of too much furniture; include less than is normal to the room. To overcome excessive contrasts, as in a dark room with a window framing a view, wildly overexpose and wildly under-develop.

## Life on Record

The snapshooting of human beings or animals in some natural activity in everyday surroundings without premeditated arrangement, and usually without the subjects being aware that they are being photographed, is a fascinating activity. This is pictorial journalism, famous masters being Bert Hardy, once of *Picture Post* (Pls. 16 bottom, 18 top), and Henri Cartier-Bresson (Pls. 15 top, 17 bottom). This is the most popular sort of photography among amateurs and it also fills the periodic picture magazines. The single picture in this sphere may have a formal, aesthetic significance but its main object is to make a comment or to tell an anecdote without words. It may also have great documentary interest and value – it may provide in a series of pictures, for example, the kind of life that goes on aboard a trawler; it may tell

the tale of a battle or merely record the gyrations of a pet cat or the grimacing and splashing of a baby in its bath.

The so-called candid picture will often include action such as that of a pair of dancers leaping in the air (Pl. 9 top), or of athletes flying away on a hundred yards sprint, or of racehorses falling over a fence. It may also be a news photograph of some dramatic or historic event (Pls. 10, 30). The candid photo is essentially a record of some phase of life going on; it always tells some kind of story. Reformers are particularly keen on its use, for example to record a group of skeletal people during an Indian famine (Pl. 27), or slum dwellers at leisure in some great and squalid city. This kind of documentary picture has been described as belonging to the Ain't-it-a-shame school to distinguish it from the Ain't-it-lovely school of the pictorialist; like architecture, photography has its New Brutalism. The candid photograph could also include the Ain't-it-funny-ha-ha, the Ain't-it-funny-queer, and the Cor-look-at-her-legs schools.

In this recording of life going on, photography has had a tremendous social effect and here photography has entirely ousted painting and drawing as a vehicle of propaganda and information, leaving painting in a somewhat uncertain, esoteric, and self-conscious position without close contact with the general public.

For this kind of photography there is no doubt that the true miniature, such as the Leica or the Contax, is the ideal type of camera because it has considerable depth of focus and a fast lens; moreover, it is economical in the use of film because a great number of experimental shots can be taken at little cost, the negative size being so small.

In poor lighting a fast pan film should be used and, if the negatives are likely to be under-exposed, a special developer such as May and Baker's Promicrol can be used and full development given in order to bring out as much detail in the shadows as possible.

This candid camera, life-going-on, photography can be great fun and it can be aesthetically creative. At its best – as in the Cartier-Bresson pictures – not only does it tell a story but it also makes a picture of formal aesthetic value. When this synthesis occurs the photographer has really conquered his medium.

Bert Hardy has given good advice in an article in the English magazine, *Photography*:

The camera artists ... will tell you that they size their subject up, and arrange the lighting and the pose in a way that will suggest the essential character of whoever it is they're photographing. I don't work that way. I just get my guinea-pig talking, try to get him interested in, even excited about, the topic, so that he'll make different faces and use different gestures – and then I blaze away. Back at the office I can run through the lot, and pick out what seem to be the most revealing pictures. But, as you see, it's the reverse of the 'artistic' technique.

Once Bert Hardy had an assignment to photograph Pandit Nehru and he relates:

I got the journalist to talk to him: and to tell the truth the interview was rather dull, and it was nearly finished, and I was a bit worried because I'd got nothing striking out of it. Then by chance Nehru happened to pick up a rose, and smell it, and put it down. In that moment I had my picture. It has been used all over the world. It is a picture that looks as if it had the whole of India's history behind it, away back to the Mogul emperors.

To snatch the odd picture very quickly, Hardy says:

I usually take a chance. I'm not always correct on distance, because I rarely stop to focus, in case I miss the picture. My principle is: grab it first, then have a second go if you have time to focus. In any case, a slight out-of-focus fuzziness often rather helps the atmosphere of certain candid pictures.

Hardy gives this useful hint:

A rule I sometimes adopt in night-clubs and such places, where a lot is going on all the time, is to keep the camera set at a certain distance, say six feet. Then, if the odd incident crops up, I can quickly be within six feet of it, rather than take time off to focus.

It is interesting to note that Hardy almost never uses flashlight because

it ruins the atmosphere of a picture and destroys any emotional or sentimental quality a scene may have. It is something I detest. Yet there are occasions when I need to use a flash in the streets at night. If

so, I use it quite independently of the camera. That is, I make it throw the same kind of light as a street lamp or an open door.

Finally, a hint for taking objects which are moving fast across the field of vision. When the minimum possible exposure of, say, 1/200th of a second will not produce a sharp image, as it well may not when the subject is a racing car or a galloping horse, panning must be used. Panning consists in moving the camera round in the same direction and at the same speed, relatively of course, as the moving object, exposing as you move it. The background will appear blurred but this may enhance the effect of the speed of the moving object. Alternatively the camera can be kept still so that the subject itself appears blurred in the picture while the background appears sharp (Pl. 64 top). In the photo-finish cameras used on racecourses a kind of automatic panning is used in that the film itself, though not the camera, moves at the same relative speed as the horses.

## Abstractions and Experiments

Abstract photography – the making of patterns having aesthetic formal value for the sake of the patterns and not for the sake of the story, not even for the sake of the story-in-the-pattern – is the most sophisticated and the least popular sort of photography. It is sometimes called Subjective Photography. Only the cultivated aesthete will find much pleasure or meaning in it. Yet the attempt to create abstract forms and patterns by means of photography can be a powerful means of visual education for anybody and a valuable exercise for every kind of photography. Here are a few practical notes on ways of creating abstractions, as well as on experimental picture-making:

*The Photogram.* This is a photograph made without a camera. It consists simply of laying objects on a piece of photographic printing paper and exposing the paper to light; the paper and objects can be laid on the base-board of an enlarger and the enlarger light used; alternatively, a flashlight or a torch can provide the light. Opaque objects will leave a white impression when the

paper is developed, uncovered areas will be black, and translucent objects will show as grey tones. The possibilities of pattern-making by this means are infinitely varied and are limited only by the photographer's imagination. A few suggestions: cut-glass

17. Photogram (Joseph Foldes, New York).

tumblers or wine glasses, cellophane strips, curled, shaped, engraved or inked, oil or paint squeezed between glass plates, bent wire arrangements, play with a small light source moved over the paper's surface as though it were a pencil, a pine cone, an egg beater, woven linen, tracing paper, cigarette smoke. The possibilities on colour-sensitive printing paper are considerable in this field.

*The Light Box*. Light possesses a tremendous psychological power because it is so deeply immersed in the farthermost recesses of our unconsciousness, and because it is so intimately connected with our space experience as to be almost identical with it. For visible space is lighted space and with light therefore we can evoke space experience. I felt that if I could create a virtual world of darkness, which I could then develop into a disciplined world of light, I would be approaching the solution of the problem of controlled selection. The achievement was perhaps simpler than the wish would indicate.

I made a box, which was open on one side and with many holes cut into all sides. These holes were used for suspending objects and also served as openings for light to enter. Over these openings, objects (wire screen, etc.) could be placed and projected on the materials inside the box. When desired the front could be covered with glass so that smoke or gas could be introduced into the box. This would enable one to study and photograph light in a purer form, as a beam, solid and beautiful, apart from its bondage to objects. The inside of the box was painted black. With this simple device a great measure of control over light can be exercised. . . . The light box, therefore, has significance for any artist. Working with it can give him a deeper insight into the visual-psychological elements that play an important role in making any picture exciting and meaningful.

So wrote Natan Lerner, the inventor of the Light Box, and the words are quoted from Moholy-Nagy's *Vision in Motion*. No further details are given about the box itself, such as dimensions, and since I have had no opportunity to experiment with this fascinating invention I can merely suggest that the size of the box must be at least four feet long by, say, three feet wide, and two feet high; probably the bigger the better. It could be made of wall board or plywood. The camera lens would be inserted into a central hole at one end and then the scene set with any materials or 'light modulators' in order to create three-dimensional forms, receding planes, and lighting moods. Spot lights shining through

holes at the sides of the box could be directed as desired and some could be filtered. Mist in the form of tobacco smoke could be puffed into the box to produce shafts of light. And so on.

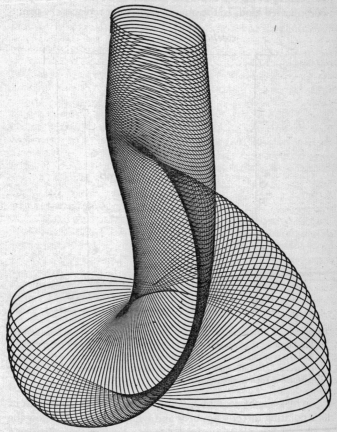

**18.** Physiograph (Günter Vester, Essen).

*Physiographs.* These are created by swinging a torch, its reflector removed, on the end of a pendulum above a camera with its shutter open. An infinite variety of beautiful patterns of line can thus be

created. A physiograph is, in fact, a kind of harmonograph – that is a drawing made with a special instrument having a pen resting on a piece of paper and connected through a universal joint to a pendulum swinging below, a pendulum of either a simple or complicated kind. In the physiograph, light replaces the pen.

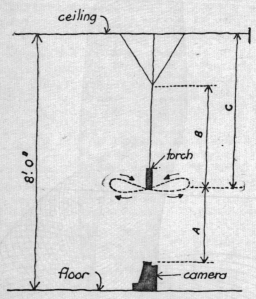

19. Making a physiograph: *A* is the distance between camera lens and the light bulb of the swinging torch; *B* is the distance between the light bulb and the point in the string at which side strings are fixed; *C* is the distance between light bulb and ceiling. The relation between *B* and *C* sets the pattern of the physiograph.

To make a physiograph, place the camera on the floor with its lens pointing directly upwards and lying immediately below the torch which has been suspended from a hook in the ceiling on a piece of string. Two other strings are hung from hooks several inches to either side of the main string to which they are connected at a point, say, three-quarters of the way down so that they form a V. The strings and the torch should be so arranged that when

the torch is given its first swing to set it in motion the movement of the light comes within the area of the negative in the camera. Turn the torch on, turn the room light off, set the torch swinging and open the shutter. Using a fast film, the aperture may be set at about $f/11$ but the correct stop will have to be discovered experimentally by tests. After several minutes' exposure the track made by the swinging light will have produced a delightful linear pattern on the negative and this can be enlarged in the ordinary way to make a white linear design on a black background.

The use of three strings will produce fairly simple patterns according to the kind of motion produced when the torch is first set going as a pendulum. But more strings can be attached to the main central string from points around it on the ceiling to produce more complicated designs. Tests will tell you how best to arrange the strings to obtain the kind of results you want and no doubt an arrangement of strings having definite mathematical relationships will produce the best designs. The way the torch is first swung will vary the designs – perhaps in a circular motion or in an oval one or in a figure of eight.

The above method of making physiographs is somewhat haphazard and crude. More controllable designs can be made by using a proper harmonograph machine. By its use truly wonderful patterns can be produced which might be called visible music or dancing light in that clear harmonic relationships of mathematical beauty are created by the pendulum arrangements.

*Superimpositions.* Interesting and significant effects can be obtained by taking two photographs on one negative or, better – because this gives more control – by superimposing one negative on top of another when enlarging or printing. Strange, suggestive, surrealistic compositions can thus be made.

*Distortions* can be produced by various means such as the placing of prisms or mirrors in front of the lens during exposure, by photomontage (the composing together of different prints and perhaps the re-photographing of the final result on one complete negative), manipulation during processing such as the dropping of oil or soap-suds into the developer or the heating of emulsion.

Tone elimination that leaves only pure black and white is another printing eccentricity.

*Bas-reliefs* can be made by printing a negative and a contact positive made from the negative on a transparency, one being laid over the other slightly off register.

*Solarization.* By considerably over-exposing a film or plate the image is solarized, that is to say, it develops directly as a positive. On ordinary emulsion about 1,000 times the normal exposure is required to effect this. The so-called Sabatier effect is produced by flashing the negative with vivid light while it is in the developer. Edges of the lighter tones become dark grey due to irradiation, so that the light areas appear to have been outlined with a black pencil. This effect was called, somewhat incorrectly, Solarization by Man Ray when he first applied it to his remarkable experiments in the thirties, and so it is still called (Pl. 59 top).

The process is tricky and uncertain but it can produce interesting results given a certain amount of luck. To avoid spoiling a good negative, it is better to make a new negative from the original for the experiment by photographing a good contrasty enlargement made from the original negative using a slow plate or film. Develop the second negative in an open dish and when it has had about one-third of its full development flash it with a bright torch or other light for a moment and then continue the development. The white outlines will then begin to form and will appear as black or dark grey, of course, on the subsequent print. The intensity of the line will vary with the length of the first development, the amount of flashlight to which it has been exposed, and finally with the length of the second development after the flash. The ordinary room light of the dark-room will probably suffice for the flash – say a 60-watt bulb at 5 feet from the negative; the light must be turned on and then off at once.

*Photographics* are ways of converting ordinary photographs with their wide range of tones to pure blacks and whites, or, in colour, to a few limited hues. Lith films and papers can be used in these processes. Grain texture can be introduced in place of half tones,

while line effects can be achieved by using positive and negative bound together. The various techniques are explained in *Photographics: Line and Contrast Methods* by Pär Lundqvist (Focal Press), a useful and attractive work I translated from the Swedish. If you have the time, much joy can be found in these methods, although, like bromoil, they are nearer the graphic arts than pure photography.

## Photomicrography and Other Kinds

There are many other kinds of photography than those discussed in this chapter – each requiring its special technique. Among them is photomicrography, the taking of minute objects through a microscope; this is mainly of scientific value but it also has design possibilities (Pl. 54 bottom). Another kind is photo*macro*graphy, or macrophotography, which is the photographing of small objects without a microscope but with a triple-extension bellows camera or with a miniature camera having special extension tubes. There is also the fine, bloodless sport of photographing wild life (Pl. 38 top); there is fashion photography (Pls. 6, 7), a skilled professional job; there is astronomical photography.

All these kinds cannot be discussed here, but a word may be said about photomicrography. This requires no special skill and no special camera but it does, of course, require a microscope and also much patience. Wonderful results can be achieved by quite simple means and curiously enough the camera lens has no part to play in this at all. If the camera lens can be removed it should be removed and the aperture placed over the top of the microscope lens; if the camera lens cannot be removed the lens is focused at infinity. Focusing is accomplished by turning the knob of the microscope so that the microscope lens acts as the camera lens.

The gap between camera and microscope should be covered with a collar to prevent stray light from entering the camera. A sturdy tripod should be used to support the camera. The light on the subject can either be reflected by the mirror situated below the microscope's sub-stage or it can be made to shine directly upwards below the sub-stage and the subject or specimen to be

recorded. The lamp will be housed in a box having a hole in its top through which the light can pass. Special small lamps are required, used with a transformer. Filters for the light may be useful, such as one of yellow-green colour when using pan film; a red filter may be needed if the specimen is very blue. It is impossible to give proper exposure times because the factors are so variable; only experiment will teach you.

The lighting methods described above apply only to translucent specimens. In the case of opaque objects the light must be directed straight on to the specimen through a special microscope spotlight having a controllable diaphragm.

**PART THREE**
*Processing*

General

Every serious amateur will want to develop his own films and print his own enlargements. There is nothing very difficult about this, given a little practice and much patience. The results of your own work will be far better than those produced by commercial mass processing. Processing, least of all printing, is by no means a dull, mechanical business but requires creative skill as well as knowledge.

The technically perfect photograph will result not only from proper exposure and proper development of the negative; the enlarger will play a big part in producing the final desire – the perfect print – because the enlarger is an important instrument of control. Processing the negative and processing the print must be regarded as interdependent activities, as two stages in one operation, rather than as separate activities – the reasons for which will be revealed later.

In photography the aim should be to reduce the number of variable technical factors to the minimum, for this will allow greater freedom to the creative powers. In processing, for instance it is a mistake to experiment continually with different chemicals and methods. Try out various methods when you are beginning, by all means, but when you have found those that produce for you the results you want stick firmly to them.

Now let me explain simply and step by step how I develop and print in my bathroom, for this will give an overall account of processing at its least complicated. After that, I will expand with details, variations, refinements, and general information.

Photography

My Own Procedure

*Film Development.* The bathroom window is blacked out with a
sheet of plywood edged with black velvet, the door is closed and
any stray light seeping in below it is stopped with a length of
cloth. With the room light on, Johnson's Unitol, Kodak D76,
Ilford ID11 or a similar developer is mixed according to the
maker's instructions with water at about 68°F, and this solution
is poured into a clear glass bottle through a funnel holding a filter
paper. Three ounces of acid fixing salt with hardener are then
dissolved in warm water, cold water being finally added to make
20 ounces; the solution is poured through a paper filter into
another bottle and cooled in cold water to about 68°F. The
working table is a drawing board lying across the upper half
of the bath and covered with newspaper (oilcloth would be
better).

The room light is switched off and in complete darkness the
film is unwound from its paper,* care being taken not to pull off
the sticky tape holding the film to the paper at one end too rapidly,
in case 'miniature lightning' flashes and fogs the end of the film.
With scissors the corners are cut off that end of the film which will
first be inserted into the developing tank to ease its entry into the
reels. Next, the film is pushed into the reel of one of those round,
black, light-tight, plastic developing tanks, the flanges or cheeks
of the reel having spiral grooves on their inner surfaces. The
grooves of the spirals can be 'oiled' by running a lead pencil round
them before use.

The holder with film inserted is now dropped into the tank,
which contains plain water at about 68°F, and the tank is covered
with its light-tight lid. From now on all operations can be carried
out in the light. The agitating or twiddle stick is inserted into the
hole at the top of the lid and the holder is turned round a few
times anti-clockwise within the tank. After a minute the water is
poured away and the developer is poured into the tank through
the hole in the lid. Development takes place within about fifteen

* 35-mm. film will have no paper backing, being contained in a light-tight
cassette.

minutes, the exact length of time being determined by the temperature of the developer, the type of film used, and the general degree of film exposure; full instructions are provided with the developer. The temperature of the developer must not be less than 60°F or more than 70°F. Low temperatures not only make development sluggish but may alter the chemical effects of the developer, while high temperatures will kill the details of the highlights and will tend to make the surface of the film dangerously soft. Too drastic a change of temperature – say of 10° or more – between developer and washing water or fixer must also be avoided or crazing of the emulsion, called reticulation, may result.

While the film is developing, the holder is agitated in an anticlockwise direction at intervals; this is especially important during the first few minutes of development. The purpose of this agitation is to stir up the solution so that development is even over the whole film surface. Agitation for 15 seconds at minute intervals should be sufficient but this is done without spinning the holder too violently. Note that agitation tends to speed up development; it should therefore not be overdone or the film may be overdeveloped and grainy.

When development is complete the developer is poured back into its bottle through a funnel and immediately the tank is filled with clean water, which is agitated for a few seconds and then poured away. Then the fixer is poured into the tank and agitated at intervals during fixing time. After the film has been fixing for a few minutes the lid of the tank may be removed; a slight milkiness will then be apparent on the film. The full fixing time will be about ten minutes; the exact time can be gauged by the period in which all milkiness takes to disappear, for the film should remain in the fixer for *twice* that period. The fixer is then poured back into its bottle and the film is washed in tap water for 1 hour, either still in its holder or loose in a basin of running water with film clips attached to either end; if in the holder, then the water is run into the tank through a tube, the end of which is stuck into the hole in the top of the reel so that the water percolates to the bottom of the tank and replaces there the weak acid solution which has sunk to the bottom; if in the basin, then the water is changed completely

every ten minutes to make sure that the tainted water is not retained at the bottom of the basin.

The film is hung to dry in an atmosphere which is as warm, dry, and free from dust as possible; the bathroom itself will probably be as good a place as any. The film can be hung with special stainless steel clips to a horizontal piece of string. Before being hung the film can be given a final rinsing in a solution containing a wetting agent and this helps the film to dry evenly without water marks.

When the film is dry the unwanted and unexposed ends of the film are cut off first as these may be a trifle damp. Then each exposure is cut off and each is stored in a negative envelope of translucent paper. With 35-mm. film the film can be cut into sections of four frames (exposures) each, as these are easier to handle than single 35-mm. frames.

The fixer can be used again but for not more than five 120-size films in all. Some developers can also be used again but not all. For each film, development and fixing time should be increased by 15% because the solutions grow weaker with use.

*Printing and Enlarging.* A contact print of a negative measuring $2\frac{1}{4}$-inches square or less is too small to be of great visual interest except as a test of the quality of the negative and as a record. Contact prints are made in a printing frame. The negative is inserted into the frame in contact with the paper and the frame is held 3 feet away from a subdued electric lamp for several seconds. The paper is then developed in some standard developer such as Ilford's Bromophen or Johnson's Contrast, is afterwards dipped into a bowl of fresh water, and is placed for about five minutes face down in a bath of acid fixing salt mixed in the proportion of 2 ounces of salt to 20 ounces of water. The print is finally washed in running water for an hour and is dried in an electric drying and glazing machine. If glossy paper is used, the print is pressed on to the shiny metal glazing plate with a roller squeegee, having received a dip in glazing solution; the plate is wiped over with this glazing solution after each print, or set of prints, has dried and been removed. If no drying machine is avail-

able, the prints can be dried naturally on a towel or sheet of blotting-paper and the curl produced can be eliminated by running a straight edge firmly along the back of the dry print, the right side lying face down on some fairly hard, clean surface. Glazing can be done by pressing the print, after a dip in glazing solution, on to a piece of clean plate-glass, such as a mirror, with a squeegee. To prevent the prints sticking to the glass when dry, the glass can be polished before use with French chalk.

When the enlarger is used, the negative, with a suitable mask of translucent red celluloid around it, is inserted in the holder between two sheets of glass. If the negative is too dense to make accurate focusing easy, a thin negative is first inserted so that accurate focus can be obtained; alternatively a discarded and greatly over-exposed negative with strong scratches made in the emulsion can be used. (Special focusing negatives can also be obtained.) The dark-room is now lit with a safelight holding an orange screen to which the bromide paper will not be sensitive. On the board across the bath are now lying a dish of developer, a bowl of fresh water, and another dish of acid fixing salt solution mixed as for contact prints.

A test exposure of, say, 2 seconds if the negative is normal, is now made on a strip of bromide paper. This is immersed in the developer after exposure, is washed in the bowl for a moment, and is then immersed in the fixer. The room light is switched on and the test is examined. The development should have been allowed to go as far as it could without producing stains and will have taken about five times the period required for the image to begin to appear from the moment of immersion. Speed of development, which will be a minute or two, as well as some degree of contrast, can be varied by varying the strength of the developer; temperature will also affect speed and contrast to a small degree.

When correct exposure from the test has been gauged the room light is switched off and a sheet of bromide enlarging paper is taken from its envelope or box, the remaining paper being safely covered afterwards. The sheet is pinned down with special pins at each corner on to the base-board in the proper position and the enlarger switch is turned on for the necessary time. The lens stop

has, by the way, been turned to about $f/11$, or perhaps to an even smaller stop, according to the density of the negative.

During exposure a great deal of control can be exercised. For example, some parts – perhaps the sky – can be given a few seconds additional exposure by withholding light from the rest of the image by shadowing this with one or both hands or with some other object such as a piece of cardboard. Specially shaped pieces of some opaque material fixed to the ends of long, thin handles can be obtained (called dodgers) to withhold light from some parts of the print, but these are something of an unnecessary luxury and a piece of board, or perhaps a piece of cotton-wool, cut or teased to the shape required and attached to a piece of stiff wire, can easily be made at home. If adequate coverage cannot be given with the hands, cut out a special piece of cardboard to fit the required area on the print. Any object like this which is used to withhold light should be kept moving slightly during exposure in order to avoid hard and unnatural changes of tone. Deep shadows will probably need some covering up so that their details may show on the print and so that they do not create too dark a tone. The giving of extra exposure to some parts of a print – as for example the sky where the clouds would otherwise be too indefinite and underprinted – is called burning in.

After exposure the paper is developed as previously described for contact prints. The paper should be slid sideways into the developer and then the developer should be allowed to flow over the surface evenly; once it is covered the dish is rocked gently during development. When the print appears to be slightly darker in its tones than it should be when seen in bright light, the print is lifted at one corner, the surplus liquid is allowed to run back into the dish, and then the print is immersed in the bowl of water for a few seconds. From there it goes into the fixer where it is rocked for a moment. The room light is switched on and the print examined. If successful, the print is then turned face down in the fixer and left there for about 5 to 15 minutes according to the state of freshness of the solution. When many enlargements are being made the fixer should be changed after every ten half-plate prints have been treated. The developer is merely strengthened from time to time.

The prints are washed in the basin of running water for an hour
and are occasionally moved so that they do not stick together. The
basin is emptied and refilled every ten minutes so that the salts
which are washed away and settle at the bottom of the basin are
entirely removed.

After drying, either naturally or in the machine, the edges of
the print are trimmed with a guillotine and then any spots caused
by dust are touched out with black water-colour, watered as
required, and a fine sable brush. The print can be mounted on a
fashion board if it is to be for exhibition, using rubber solution
and a squeegee. Both the back of the print and the corresponding
area on the mount are spread with rubber solution, a knife being
used to spread it evenly and thinly. The advantages of rubber
solution are its excellent adhesive power and the ease with which
any surplus solution round the edge of the print can be removed
when dry simply by rubbing with a clean cloth.

So much for methods of processing described at their simplest.
Now for more details, alternatives, elaborations and refinements.

The Dark-room and its Equipment

Planning the base of processing operations, the dark-room – or
adapting a bathroom or kitchen by a provisional arrangement –
is mainly a matter of common sense. The dark-room must be
light-tight when required but it must also admit air for breathing.
It must have water, preferably both hot and cold, and preferably
supplied through a mixer tap. It must have working-top areas
and, if possible, cupboard space for storing apparatus and chemi-
cals. It must have electricity laid on for lighting and also, if pos-
sible, for heating of a kind that cannot be seen – such as electric
tubular heaters. It must have at least one sink or basin – preferably
two – each supplied with running water. It therefore follows that
the average bathroom with basin and bath is a fairly adequate
place in which to work. The ideal warm-water supply would come
from a tank fitted with an immersion heater to keep the water
temperature constant at 65°F by means of a thermostatic control.

Arrange things in the way you would plan a kitchen – that is in

logical sequence: table-top for negatives and printing papers, followed by the enlarger, then by developer dish, stop bath or washing dish, fixer dish, basin for washing prints or negatives. In a bathroom the most convenient place for the dishes is on a board or wooden grid placed at a convenient height over the bath; the ideal arrangement for dishes would contain a drip tray beneath the grid connected by a rubber tube to the bath outlet, because this would prevent the staining of the bath with chemicals. If such

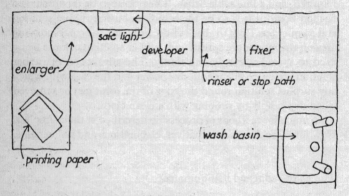

20. A bathroom converted to a dark-room.

a drip tray is not used, the bath can be half-filled with water, which will neutralize any spilled solutions. Over the bath is hung the safelight and there also may be a shelf to take the bottles of chemicals, tins, measures, funnels, and thermometer.

The safelight can be adjusted to suit varying conditions with removable glass filters of different colours which are supplied by the makers. A red filter can be safely used with ortho films, for instance, when these are being developed in an open dish; a dark-green filter can be used with slow pan films; an orange filter can be used with bromide papers. Infra-red films will need a special filter. The bulb in the safelight is a special one supplied by the makers. The safe minimum distance between the light and the sensitive material will depend on the type of safelight used. With a light giving direct illumination, 3 feet will be the minimum for a Standard Wratten Safelight with a 25-watt pearl lamp, but 5 feet

will be necessary with a Kodapan Wall Lamp having a 15-watt pearl bulb. With a lamp giving indirect light reflected from the ceiling, 10 feet minimum distance will be necessary for types like the Wratten Ceiling Reflector Lamp with a 25-watt pearl bulb. These indirect lamps are preferable to the direct types when the dark-room is likely to be in constant use, because they give a good overall light and so ease the strain on the eyes.

Where no water has been laid on – for example where a garden shed has been adapted to a dark-room – a tank of water will have to suffice for the source of water and the films and papers will not be washed in running water but in successive changes of water – say six baths giving a soak of 5 to 10 minutes each.

Blacking out the window light is important, and for this a hard-board or plywood sheet on a timber frame faced with black felt is effective. To give extra protection the edges can be sealed with adhesive tape. A simpler method is to use opaque curtains pinned down at the edges and bottom; a more complicated one is an opaque roller blind, possibly of black paper, running in a light-tight frame. Before uncovering a sensitive material such as a fast pan film in the dark-room, a test should be made by remaining in the darkness for 10 minutes; a room that appears to be perfectly black at first may eventually show itself to be dangerously light with many bright cracks appearing around the door or window blackout when the eyes have grown accustomed to the darkness.

For the less ambitious dark-room, a trap in the window covering can be made which will admit air from the open window but will exclude the light. For the proper dark-room, however, a Colt extractor fan or a Vent-Axia fan, specially trapped for dark-rooms, should be fixed high up in the door, in the outer wall, or in a partition. The fan by itself will not be enough for it will only extract the air; some way for fresh air to enter will be needed as well and this can be made low down either in the door or in the window blackout by cutting a hole and covering it with a kind of box containing a double right-angle channel (as shown on p. 208).

Benches, or working tops, should, if space permits, be separated into dry and wet sections, preferably at opposite sides of the room. This arrangement will prevent papers and negatives from becoming damaged by water or chemicals. Tops should be 3 feet

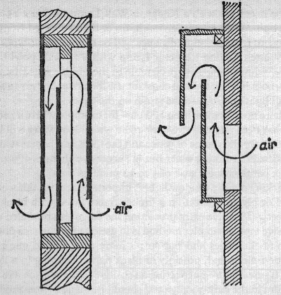

21. Sections of two alternative light-tight ventilators in a dark-room door or window blackout.

6 inches high from the floor, if possible, and should be covered with some non-absorbent material such as lead, linoleum, or American cloth; waxed hardwood such as teak is also suitable. If a kitchen sink is used having teak draining-boards on each side, these draining-boards can be used as working tops and the dishes can be propped level by battens; this is a convenient extempore method because the developing dish can be placed on the left, the fixer dish on the right, while the sink itself can contain a stop-bath or an intermediate wash and can also be used for the final washing.

Many other ideas will occur to the ingenious amateur. For example, a board can be placed over the basin to make a table for the enlarger; or a cupboard can be built under the basin with a double door which, when open, will provide supports for a table-top in front of the basin; or both wet and dry working tops can be arranged over the bath, the two being divided by a vertical screen; or the bath boards can be hinged to the wall and held back to the

wall when not in use with cabinet turns. Even portable, cabinet dark-rooms have been designed.

A useful device in the dark-room is some kind of printing-paper container which is light-tight, because, when many prints are to be made, such a box will do away with the tedious unwrapping and rewrapping of the paper and the replacing of it in the envelope or box in which it is supplied. Special boxes are made but an alternative is to use a drawer below the dry working top which can be made light-tight round its edges by wooden strips or black felt. A refinement would be the wiring of the drawer in series with the room light so that this will not go on when the drawer has been left open by accident.

The ideal dark-room will be warmed with non-visible, thermostatically controlled electricity such as a tubular heater, and this may with advantage be fixed below the wet working top so that it will not only heat the room but will help to maintain the temperatures of the solutions when in use. Alternatively, special thermostatically-controlled electric warm-plates (and also immersion dish warmers) are obtainable for maintaining the temperatures of solutions, but these are luxuries. A home-made warmer can be contrived which is light-tight and heated within by an ordinary carbon-filament bulb. Take care, incidentally, that all electrical points are properly earthed, because electricity can be particularly dangerous in the presence of water.

Other dark-room equipment may include a special dark-room clock which will count seconds and minutes. The use of luminous watches is inadvisable for they may fog highly sensitive materials if they come too close to them. A thermometer with a range from about 60° to 120°F is essential. One or two measuring containers, preferably unbreakable, will be needed and, of course, a collection of suitable dishes. Dishes can be had in enamelled steel, stainless steel, glass, porcelain, plastic, and hard rubber; of these I prefer the stainless steel or rubber ones because they do not chip or break and are easily cleaned. Do not use enamelled steel dishes for colour films if they are chipped, because the steel may produce an undesirable chemical reaction. Avoid *papier mâché* dishes.

A luxury is a special print washer, which may be a perforated dish supplied with a jet of water from a rubber tube which keeps

the prints on the move and separated. Another luxury is a densito-
meter, an instrument for measuring the density of a negative and
so ensuring correct exposure during enlarging without the need
to make a test strip. A modern exposure control device is the
Lumimeter, giving the exact exposure needed for different grades
of paper and magnifications; alternatively, a Sixtus photo-electric
meter with a Laborphot reflex mirror device can be used. Probably
the best, the cheapest, simplest, and quickest method in the long
run of ensuring correct exposure is the test strip (p. 260).

Balances are hardly necessary unless you are mixing your own
chemicals. Proprietary developers are already measured out for
you in the correct quantities and acid fixing salt can best be
measured out in a small cup holding 2 ounces when full. A wooden
plate-rack will be a necessity when developing plates. This is
merely a rack with grooves in which the plates can be stood on
their edges when drying.

Cleanliness is essential in the dark-room. All apparatus and the
hands should be washed continually. Chemical deposits can be
removed with a 2% solution of hydrochloric acid. Plenty of clean,
dry towels are an advantage. The dark-room should be kept as
free from dust as possible and too much movement about the
room should be avoided for this stirs up the dust. A moistened
cloth placed over the fresh-air inlet will help to keep outside dust
from entering the dark-room in dry weather. When using chemi-
cals which stain the hands or are likely to produce skin troubles
like Metol dermatitis, rubber gloves can be used. Always wash the
hands under a running tap after handling a chemical and before
drying the hands; the towel will otherwise soon become impreg-
nated with the chemicals.

The walls and ceiling of a dark-room should preferably be of a
light colour, but cream rather than dead white, and the wall
surface should be washable. Linoleum, rubber, or roofing felt are
suitable materials for covering the floor. Incidentally, do not store
equipment or papers in the bathroom, for the atmosphere there
tends to become damp at certain times.

Let me assure the reader, if he is now bemused, that perfectly
good negatives and prints can be produced with these few essen-
tials:

Spiral tank for developing films.
Measuring container showing 20 ounces maximum.
Thermometer.
Spoon or glass rod for stirring and dissolving the chemicals.
Bottle of your chosen developer or tin of developer powders for dissolving.
Tin of acid fixing salt, preferably with hardener.
Safelight with removable orange filter for printing or enlarging.
Two dishes.
Special timing clock or just a watch with a second hand.
Enlarger if possible.
Box or packet of contact printing or bromide paper for enlarging.
Couple of sponge racks for placing across the bath, and on which to lay the dishes.

## Developers

Developers exist in great variety but they can be broadly classified into Normal and Fine-Grain. They vary considerably in their results, especially on the tones of the negative and on its degree of granularity, and they may affect the exposure time of the negative, that is its speed. Some fine-grain developers, for instance, require the film to have had extra exposure and others exist which are a compromise between the normal and the fine-grain types, and these require no extra exposure, or very little extra exposure.

This variety of developers means that some control of negatives is possible *after* exposure by the choice of a suitable developer – a control that is not often needed but may, on occasion, save an otherwise hopeless case, perhaps of serious under-exposure. Time of development is crucial.

Some developers are suitable for rapid development in a dish; others are suitable for the slower time-and-temperature development in a tank. Some are suitable for negatives only; others can be used as universal developers for both films and prints. Some produce hard effects – that is strong contrasts between highlights and shadows with a reduction of half-tone gradations between the extremes; others produce soft effects without extremes and with a subtle range of gradations. Hard effects may be desirable, for

example, in pictures relying on silhouette or for technical illustrations, but normal or fairly soft negatives produce the better enlargements and are certainly desirable if the subject is itself contrasty, as it may well be, for instance, in against-the-light subjects. The main thing in general, when selecting a developer, is to find one which seems to suit you well and then to stick to it.

The composition of modern developers is complicated and the amateur will be well advised to use a recognized, ready-prepared brand of well-tried and reliable formula rather than to mix his own super soups. But a rough explanation of how developers work may be welcomed here by those who like to know why things happen the way they do.

The main ingredient in a developer is the reducing agent. This reduces the silver salts in the gelatin of the film's emulsion which have been affected by light – the latent image – to black metallic silver. The stronger the light has been on a part of a negative, the heavier and deeper will be the silver deposit. The agent will not seriously affect those silver salts which have not been exposed to light and these will eventually be washed away by the acid fixer. Metol, Hydroquinone, Glycin, Amidol, Pyrogallol, and Paraphenylenediamine – and derivatives of these – are the best-known of these reducing agents and each has its own characteristics. For instance, Metol gives good shadow detail, while Hydroquinone gives good contrast.

These agents work slowly on their own and so an alkaline accelerator is added such as sodium carbonate – though borax is used in fine-grain developers of the Metol-Hydroquinone type to reduce alkalinity. The reducing agents also need a restrainer to prevent the developer's gradually working on the unexposed silver salts and so chemically fogging the whole negative; this is usually a bromide salt such as potassium bromide. Still another chemical is added as a preservative to retard oxidation with its discolouring effect, and for this sodium sulphite is generally used. Oxidation will occur slowly in any case unless the developer is kept away from air; therefore, as little air as possible should be left in the top of the bottle containing a developer; an old trick to eliminate the air in a bottle is to drop small glass marbles into it until the liquid reaches the stopper.

Paraphenylenediamine is a weak ultra-fine-grain agent giving very soft results and the need for considerable increase in exposure times, but none has yet surpassed it in minimizing grain; it is much used in colour-film development, but its action is slow, it tends to stain the skin, and it is a poison. Pyrogallol, commonly called Pyro, is not often used today because it stains easily and soon oxidizes. Amidol, however, is a universal agent still much used, especially for prints, although it does not keep for more than 24 hours in solution once it has been mixed with sodium sulphite (in this case acting as an accelerator). Amidol stains the fingers, but is very useful in the tropics or in high temperatures because it produces very little swelling in the emulsion. Meritol is a derivative of Paraphenylene and, combined with Metol, forms an excellent fine-grain developer, though it does stain the fingers.

Metol is often used as a reducing agent; on its own it produces very soft effects, but combined with Hydroquinone it makes an excellent universal developer of the famous 'MQ' type which is the most widely used of all developers for both films and prints. An MQ is a clean developer, it does not stain, it keeps comparatively well, and when combined with borax as the accelerator it makes a good semi-fine-grain mixture. The well-known Kodak D76 is such a mixture. MQs without borax work fairly rapidly, and are thus useful in dish development when too long a development time would be tiring to the operator.

Hydroquinone is not often used alone as a reducing agent because it produces too much contrast, but, as mentioned above, it is often used with Metol.* By varying the proportions of Metol and Hydroquinone and adjusting the quantities of sulphite and carbonate, a great variety of contrast values and development

*A new agent which may take the place of Metol is Phenidone, which Messrs Ilford have put on the market and are now incorporating in their former MQ formulae. These they are renaming PQ. Phenidone is claimed to be the first new developing agent of importance since Metol was introduced in Germany in 1891. In conjunction with Hydroquinone, it is more efficient than Metol and the amount used is between one-tenth and one-fifth the quantity of Metol which would be required. It produces a less alkaline result than comparable MQ types and thus keeps longer. Its rate of exhaustion is also lower when in use. Nor does it produce the dermatitis which sometimes results from Metol and it does not stain fingers or clothes.

times can be obtained. Here is a typical MQ formula for universal development:

| | |
|---|---|
| Metol | 14 grains (·9g) |
| Sodium sulphite (anhydr.) | 220 grains (14·25g) |
| Hydroquinone | 56 grains (3.6g.) |
| Sodium carbonate (anhydr.) | 300 grains (19·4g.) |
| Potassium bromide | 4 grains (·26g.) |
| Water to make | 20 ounces (568 ml.) |

Mix the chemicals in the order given above. For bromide papers add an equal quantity of water and add two drops of 10% bromide for each ounce. For dish development of negatives add an equal quantity of water and develop for $3\frac{1}{2}$ minutes at 65°F. For tank development of negatives mix one part with three parts of water and develop for 7 minutes at 65°F.

We have already classified developers into Normal and Fine-Grain. These now require further classification and description. But first we must understand this matter of Contrast.

*What is Contrast?* Contrast can be defined as the relationship between the amount of light transmitted by the darkest parts of the negative and that transmitted by the lightest, or thinnest, parts. The degree of contrast is determined by the term Gamma. The gamma value of a negative is the ratio of negative contrast to subject contrast. Thus, if the highlights of the subject reflect 100 times the amount of light as the darkest shadows, the gamma value of the negative will be 1 if the thinnest parts of the negative (those representing the darkest shadows) pass 100 times the amount of light as the most dense parts (those representing the highlights). If the shadows of the negative transmit only 70 times as much light as the highlights, gamma will be 0·7; if 120 times, gamma will be 1·2, and so on.

The kind of negative emulsion, the kind of developer, and the time of development will all affect the gamma value. Most films will produce high gamma, i.e. strong contrast, after long development, but the softest films will not do so, however prolonged the development. For $2\frac{1}{4}$-inch square negatives, a gamma value of 0·9 will be advisable for general work, but 35-mm. negatives will

require 0·7 or 0·8. Large plates may require stronger contrast with 1·2.

Method of enlarging may also condition gamma needs; for example, an enlarger using diffused light will require a more contrasty (high gamma) negative than one using a condenser.

Note that many negative developers will allow for under-exposure by over-development in order to produce a tolerable result if first-rate print quality of wide tonal range without undue contrast and free from grain is *not* required.

Note also that the latitude of modern films is such that exposure may vary as much as 3:1 at least and still be correctly exposed, i.e. the gamma of a negative may be the same for an exposure of 1/100th second as of 1/30th second for the same subject photographed under the same conditions. The only difference between the negatives is that the denser negative of 1/30th second exposure will require longer printing time and will tend to be more grainy.

For a very contrasty subject, gamma may have to be very low because then even the softest paper may not be able to encompass the great tonal differences. In such a case, use a fast film, for that will be comparatively soft; develop in a soft developer; increase exposure time and decrease development time. Note that the degree of detail retained in the shadows without the blocking (dead whiteness) of highlights is the final basis for judging contrast.

*Normal Developers*. These are also sometimes called 'ordinary', 'old', 'high energy', or 'non-fine-grain'. They are relatively cheap to produce and are rapid in action, though most of them can be slowed down if diluted with water; thus, though normally used for dish development, they can be used for time-and-temperature development in a tank if water is added. They tend to produce negatives with relatively coarse grain and are not suitable for miniature work. But they are valuable where a negative has been under-exposed and contrasts must be increased as far as possible. It must be realized, however, that to divide developers into soft-working and contrasty types, as is sometimes done, is misleading in that a soft-working developer will generally produce sufficient contrast if development is prolonged, in which case grain is also likely to be increased.

*Fine-Grain Developers.* These can be subdivided thus:

1. Retarded or semi-fine-grain.
2. Normal fine-grain.
3. Ultra-fine-grain.

It must be remembered that several factors tend to produce the granularity of clumping: fast films, over-exposed negatives, over-developed negatives, the use of non-fine-grain developers. Thus in miniature films the minimum correct exposure should be aimed at, they should not be over-developed, and a fine-grain developer *must* be used. The type of fine-grain developer selected for 35-mm. films will depend on the size of enlargement required, the degree of exposure given and the speed of the film used. It is all a matter of balancing the variables according to the conditions and the final requirements. For instance, if a rapid exposure is necessary, then extremely fine grain may have to be sacrificed in the cause of speed of exposure. (Note that a diffusion-type of enlarger will reduce the grainy look in a print as compared with a condenser-type and so also will soft or rough paper.)

The more energetic a developer, and the longer it is allowed to act, the more obtrusive will the grain clumping become and vice versa. A fine-grain developer is thus one which is slow and gentle in action. Development is not taken too far. The result is a fairly soft negative requiring normal or contrasty printing rather than soft printing.

In general, if films of a speed no greater than 30 ASA are used, *any* fine-grain developer will produce negatives which can be enlarged to twenty diameters without producing serious grain.

The retarded type of fine-grain developer is the least effective in reducing granularity, but it does not require the extra exposure which the other types of fine-grain developers require. However, the retarded type gives a finer grain than the normal type and with the maximum energy and a fair degree of contrast. It can be used with 35-mm. negatives if these are under-exposed, provided a moderately slow film is used and very big enlargements are not wanted. Development in this type is retarded by keeping the alkali accelerator low in quantity, that is gentle in action. The most common type of retarded fine-grain developer is an MQ,

with borax in place of the usual potassium or sodium carbonate.

A proprietary make of MQ-plus-borax developer, apart from the famous Kodak D76 already referred to, is Ilford's ID11.

Although these retarded types were first produced as fine-grain developers, they do not, in fact, produce a very much finer grain than ordinary MQ developers, but their virtue lies in their allowing the shortest possible exposure and the greatest possible speed of film. D76 is now, indeed, used as a standard all-purpose developer by amateurs. Its formula is:

| | | |
|---|---|---|
| Metol | 17½ | grains (1·1g.) |
| Sodium sulphite (anhydr.) | 2 | ounces (56·7g.) |
| Hydroquinone | 44 | grains (2·8g.) |
| Borax | 17½ | grains (1·1g.) |
| Water to make | 20 | ounces (568 ml.) |

By adding 125 grains of boric acid, the energy of this developer is very greatly reduced and with it graininess, though the effective film speed will also be reduced. This addition of boric acid, in fact, turns a retarded fine-grain type into a normal fine-grain type.

The Normal Fine-Grain and the Ultra-Fine-Grain developers not only possess a retardant, but contain a solvent of silver bromide which tends to prevent the particles from clumping by dissolving away their edges. Typical of such solvents is potassium thiocyanate. Because it reduces the amount of silver deposited, extra exposure of the negative is required and this may vary from 50% to double.

Times of development for fine grain will vary with the type of developer, development temperature, and type of film. All proprietary brands of developer give full instructions for the varying conditions, but 12 minutes can be taken as the average time at 65°F. The times given by the makers tend to be too long rather than too short and they imply suitable agitation during development, say for 10 seconds each minute. Continual agitation right through the development may halve the development time needed. Most developers can be used several times, but if the best results are wanted a fresh developer for each film, or possibly pair of films, is recommended.

If under-exposure of negatives is suspected, a semi-fine grain developer, such as D76, should be used rather than an ultra-fine-

grain type, whereas the ultra-fine-grain types should be used for over-exposed films. Contrast can be increased by lengthening development time and will tend to be greater in the less fine-grain developers.

The general rule for 35-mm. films is to obtain a thin, detailed, grainless negative by use of right speed of film, minimum correct exposure, minimum correct development time, and the use of a fine-grain developer to suit the exposure and film conditions. The same applies to the larger size negatives such as the 2¼-inch square, though here the use of ultra-fine-grain developer is rarely necessary. A fast pan film such as Ilford's excellent HP4 will, for instance, show little granularity, provided it is not over-exposed or over-developed, in a normal fine-grain developer even on an enlargement as big as 3-feet square produced from a 2¼-inch square negative.

*Two-Bath Development* is especially useful for negatives which have a high contrast, such as those produced in artificial light. The procedure is: Immerse the film first in a bath of low alkali content containing the reducing agent and then transfer the film without washing to an alkaline solution where the development will take place. (In a few formulae, some development will take place in the first bath.) For special cases, both of negatives and prints, this is an excellent method because it allows considerable control of both highlights and shadows. What happens, in effect, is that the emulsion first soaks up the agent so that in the second bath the agent retained in the emulsion has been used up in the highlights before they are over-developed, while the shadow details go on developing.

*Dye Development.* This substitutes the silver deposit in the emulsion for a dye, the silver being dissolved away during fixing. The Kodachrome and Agfacolor colour films are processed by this principle. It produces an exceptionally fine grain. For black and white negatives, this method is still in an experimental stage.

*Tropical Developers.* Special processing is necessary in the tropics owing to the high temperatures of solutions there, which may not

only produce fogging but may swell or even melt gelatin emulsions. In many tropical parts ice is obtainable; then solutions can be cooled to 70°F and no troubles will arise. But where ice is unobtainable special developers and hardeners must be used. These will require additional potassium bromide as restrainer and additional sodium sulphate (Glauber's Salt) to prevent swelling of the gelatin. The developer should be of a kind which is as free of alkali as possible because alkali tends to swell gelatin. Amidol is a developer of this kind. Films should be hardened after development and before fixing, or they can be fixed in a solution containing a hardener made, say, of chrome alum and sodium sulphate crystals.

A hot-weather developer which can be used safely with temperatures up to 90°F is one having an agent of paraminophenol with sodium sulphite and sodium sulphate. This gives a comparatively fine grain and well-graded negatives.

In the tropics, plates and films should be kept in sealed containers – sealed possibly with adhesive tape. Once opened deterioration may be rapid, particularly in damp climates; exposure and development should therefore be made as soon as possible; the latent image tends to fade rapidly after exposure and before development. Drying of films after fixing and washing should be as rapid as possible to avoid attacks by bacteria and insects. Insects can be excluded by drying within a mosquito net; alternatively the film can be dipped in alcohol to make drying almost immediate. A 3% solution of carbolic acid (Phenol) will provide a final bath after washing to act as an antiseptic against bacteria.

*Developer Improvers.* These are added to developers, both for films and papers, in small quantities. Several proprietary products are available. They are particularly valuable when using films or papers which may be old and stale and may otherwise show fogging. They also allow a greater degree of over-exposure without loss of quality. Improvers can be used with most developers but they are especially suitable with MQ types.

*Diluting Developers.* The energy of a developer generally varies with its dilution with water, but development time does not

necessarily vary in direct proportion to the amount of dilution. With Glycin and Pyro-Soda developers, the proportion is direct – that is to say, if a developer is diluted with its own bulk of water, development time will be double that of the developer without the additional water. But the rule does not apply to some other developers such as Metol and Hydroquinone or to fine-grain developers containing much sulphite. A fine-grain developer may, indeed, have to be diluted five times before development time needs to be doubled.

*Physical Development.* This differs from chemical development in that the developer contains silver salts. It is useful in producing particularly fine grain. The process may consist in treatment in a fore-bath of potassium iodide and sodium sulphite solution, and subsequent development in a solution containing silver nitrate and sodium sulphite to which is added an exciter solution of MQ developer plus sodium sulphite and tribasic sodium phosphate. The film is then fixed and washed as usual but must be allowed a longer time than normal in the fixing bath. Full details of the process are given in C. I. Jacobson's useful manual *Developing* (Focal Press).

*Proprietary Developers.* Too many are available to list and describe in detail, but here are a few popular and useful makes. Well established and normal are D76 (Kodak), the similar ID11 (Ilford), and Rodinal (Agfa). Giving slightly finer grain are Unitol (Johnsons), Microphen (Ilford), Promicrol (May and Baker), Ilfosol (Ilford), Refinal (Agfa). Ultra-fine-grain is given by Microdol-X (Kodak), Perceptol (Ilford), and the speedy Atomal (Agfa). Patersons produce a range of developers: Acutol is for slow films, giving brilliance and a little extra speed; Acuspecial giving good acutance, fine grain and some extra speed; Acuspeed giving maximum increase in film speed on fast films and useful when lighting conditions have been poor. Aculux FX24 is a fine-grain developer giving good tonal qualities with half a stop increase of exposure which will phase out the older Acutol for slower films.

Note that, broadly speaking, developers vary in their effects on grain, on tonal gradation, acutance and film speed. Fast films

tend towards granularity, and developers should therefore be chosen according to film speeds.

A good general combination is a pan film of about 125 ASA (like Kodak Verichrome Pan or Plus X) developed in a semi-fine-grain type (like Kodak D76).

The new very fast Kodak 'Royal-X' pan film requires either Kodak Time-Standard developer or Kodak DK50 if best results and utmost speed of film are to be obtained. The use of a stop-bath is essential to prevent dichroic fog.

## Development Methods

Two methods of developing films or plates exist: (i) Development by inspection in an open dish, carried out in a safelight; (ii) Time-and-temperature development in a light-tight tank controlled by the temperature of the solution and the time of development.

The first method has the advantage that each separate plate, cut film, or roll film can be given the degree of development which looks best. But it has the disadvantage that, in order to avoid light fogging, only a very dark-green safelight can be permitted when developing fast pan negatives and this will have to be so subdued that it will be almost useless; moreover, the process is messy especially with roll films, scratches and abrasions are likely to occur on the emulsion, and a fair amount of experience is necessary. The long 35-mm. roll films will certainly have to be developed in a tank, unless a special revolving drum is used. Time-and-temperature development in a tank is now almost universally preferred by amateurs, reliance being placed on fairly accurate exposure and on the considerable latitude of modern films to produce a series of good negatives on one roll. Dish development is more suitable for plates than roll films, though plates and cut films can also be developed in special tanks.

*Development by Inspection.* Plates and cut films are first washed and then placed, emulsion-side up, in the developer dish (preferably white) with the dish first held at the slope so that the liquid flows to one end; the dish is then lowered so that the developer

flows over the surface of the plate evenly. While development is taking place over several minutes, the dish is gently rocked from time to time to ensure even development and to obviate air bubbles (the equivalent of agitation in a tank). A wetting agent added to the developer will prevent air bubbles.

The highlights will appear first and then slowly the half-tones and the shadow details. The negative should look somewhat darker than it would appear in normal light before the plate is removed from the developer. If the negative is under-exposed, then no details will appear in the shadows, however long the development is continued. If the negative is over-exposed the whole image will appear too rapidly as though the plate had been fogged; nevertheless, development of the plate should be carried out to the bitter end – at least it should be fairly close to normal development time because a comparatively good print may still be possible; if development is stopped too soon the negative will be flat, dead, and without sufficient contrast. The negative should be judged less by its density than by its contrast.

The plate can be taken out of the developer now and then and held up to the safelight for inspection, but this should not be over-done or aerial fogging – fogging caused by contact with the air – may result. The plate should be held along its edges by thumb and finger and the surface should not be touched. The plate should be exposed to the safelight as little as possible; indeed, the dish may well be covered over during development between moments of inspection.

When you are developing a roll film in a dish, the film must be see-sawed through the solution, but before immersion it must be see-sawed through water until it is limp.

The speed of development will vary with the type of developer used, but the time between first immersion in the dish and the first appearance of the image will indicate the energy of the developer. To obtain a standard time of development for a particular solution, this period between immersion and first appearance of image can be multiplied by a definite number to give correct length of development time. This number is called the Watkins Factor, being a discovery of the English photographic pioneer, Alfred Watkins. With Hydroquinone developers the

Watkins Factor may be as little as five, but with Metol it may be as high as thirty or more. Factorial development is now little used except for slow plates.

*Tank Development.* A variety of plate and roll-film tanks are available, some of which must be loaded in a safelight, or, in the case of fast pan emulsion, in complete darkness, either in a light-tight room or in a changing bag. Others can be obtained which can be loaded in daylight. Today tanks are usually made of plastic of the spiral-reel type, but a modernized version of an old type can also be obtained; this is the apron tank in which the film is coiled within a moulded apron inside a light-tight box; the apron keeps the coils apart. When the film has been wound within the apron, the whole reel can with some makes be immersed in the tank in daylight if desired, since the apron is light-tight.

More simple tanks are available without this daylight-loading device and these consist of round, light-tight boxes, each having a spool or reel in the form of a removable film-holder with flanges at each end containing spiral tracks into which the film is pushed in the dark. In some, the depth of the spools can be varied to suit different sizes of film and some exist with three connected reels in the tank so that several films can be developed at one time. All have some method of agitation, either with a stick or a press knob. Agitation once every minute is recommended in normal tanks but some will need more or less continual agitation. When using multi-reel tanks turn the tank upside down and then back again at once three or four times during development (as well as agitating) in order to keep the solution well mixed.

Most spiral tanks have transparent reels to enable the light flashing required in the processing of reversal colour films to be accomplished without removing the film from the reel.

Development and fixation procedure in these tanks has already been described. A few points may now be added. When mixing chemicals, the right order is essential and each powder must be thoroughly dissolved before the next is added. Pour each powder into the water slowly while stirring vigorously and use warm water at about 120°F. This, of course, must be subsequently cooled to about 68°F.

22. Common type of film developing tank with a reel having spiral flanges to hold the film while keeping its surfaces apart. Large sizes take a number of reels up to eight for 35-mm., and six for 120-size film.

The initial washing of the film is not essential but is recommended. If a wetting agent is not used, lift the tank slightly when the film has been inserted and the lid is on, and then strike it down smartly once or twice as soon as the developer has been poured in. Any air bubbles will thus be dislodged.

*Stop Bath.* Instead of washing the film between development and fixation, a stop bath may be used instead. This is a mild acid bath which checks any further development, prevents staining, and keeps the fixer bath fresher. A 2% solution of acetic acid is commonly used and such a stop bath is suitable for both films and papers. A hardening stop bath can also be used, which not only checks development but hardens the emulsion and so protects it from scratches, reticulation, or other damage. It is especially valuable for 35-mm. films where considerable enlargement will be required and scratches (particularly noticeable on half-tones) will therefore be annoying. A good hardening stop bath formula is:

| Chrome alum | 180 grains (11·6g.) |
| Sodium bisulphite | 180 grains (11·6g.) |
| Water to make | 20 ounces (568 ml.) |

This solution must be freshly mixed but can be used for several films running. The film is left in the bath for 5 minutes and is occasionally agitated. The bath is then poured away into its container and the acid fixer is immediately poured in.

Most of the well-known makers supply ready-made stop baths.

## Combined Developer-Fixer

Although many attempts, more or less successful, have been made to combine the two stages into one, the two-stage process of developing and fixing has remained unchanged in principle since Fox Talbot's day. Now several effective baths which combine developing and fixing are on the market. Ilford have introduced Monophen, indicating the use of Phenidone (see p. 213n.). It is diluted with an equal quantity of water, and developing and fixing are carried out in about six minutes, irrespective of temperature, say between 65° and 80°F. At the end of six minutes no further increase of density occurs, so that over-development is impossible. Control of density and contrast is also impossible and the gelatin emerges soft and vulnerable. Only 5 minutes' washing is needed. The influence on emulsion speed is insignificant.

A similar product is Unibath made by the Cormac Chemical Corporation of New York. This claims to increase film speeds from two to four times. It appears to produce more grain in high-speed films than a normal developer. It can be used up to 125°F and, as in the case of Monophen, 5 minutes' washing is enough. Monotenal, made by Tetenal of Hamburg, is another combined developer-fixer but is not recommended for high-speed films.

The advantages of these new baths are obvious: simplicity and speed. Exact temperature control is not needed and little water is required either for diluting or washing – great advantages in primitive or tropical conditions. The disadvantages are the lack of power to control density and graduation, vulnerable softness of the emulsion, and the causing of grain in high-speed films.

They may have an important future but at present they are likely to have their appeal mainly to amateurs who are not perfectionists and to journalists working against time.

## Fixing

Fixing consists of removing by chemical means the substances in the emulsion which have not previously been affected by light and by the developer, thus rendering the negative or print fixed – that is unalterable by any subsequent action of light.

For all modern films and papers containing compounds of silver, the main chemical for fixing is sodium thiosulphate, called Hypo. The word Hypo comes from Hyposulphite of Soda, an old chemical term. For films a solution of about 20% (at most) is used – that is, about four ounces of hypo to a pint (20 ounces) of water; in this the silver compounds are converted into soluble compounds which are afterwards washed away in water.

To prevent staining, to stop further development immediately, to give even fixing, and to avoid a softening of the gelatin should the fixer grow weak and alkaline, a weak acid is added to the fixer – at least for all fixing except that of the old-fashioned P.O.P., or daylight, contact printing paper; for this no acid was added to the hypo.

A good standard acid fixer for negatives is:

| | | |
|---|---|---|
| Sodium thiosulphate (Hypo) | 6 | ounces (170g.) (maximum) |
| Sodium sulphite (anhydr.) | 90 | grains (5.8g.) |
| Potassium metabisulphite | ½ | ounce (14·1g.) |
| Water to make | 20 | ounces (568 ml.) |

Dissolve the hypo and sulphite in a small amount of warm water (say 120°F) and add the metabisulphite when the liquid is cold. This fixer can also be used for prints, but for these the solution can be 30% weaker.

Most photographic chemical firms produce proprietary brands of acid fixer in powder or liquid form, with or without an alum hardener. These, if powder, should be dissolved in warm water because the dissolving of the powder will greatly reduce the temperature of the water and also because the dissolving will be

quickened. Hypo solution is stable and can be stored for an indefinite period.

When a film or plate has been cleared of its milkiness, it is not necessarily fully fixed. The time taken for the milkiness to disappear should be doubled for safety's sake, though less time can be given if the fixer is freshly mixed. If the fixer is stale – that is, if it has already been used – a longer time should be given; indeed, if the fixer has been used too much, proper fixing may be impossible, however long the time given. As a working rule a pint of fixer (20 ounces) should not be allowed to fix more than 375 square inches of film (five 120 spools) or about 500 square inches of paper (eighteen half-plate prints) (p. 243). Even these figures are too lenient if the very best and most permanent results are wanted. Do not replenish a stale fixer by adding more powder but mix a fresh dish.

When in its fixing bath, a film should be agitated as for development, that is, for about 10 seconds every minute. In a fresh solution fixing should take from 8–10 minutes in all. If the film takes longer than 10 minutes to clear of milkiness under normal conditions of temperature and mixture, the fixer is too stale and should be discarded.

A weak fixer does not harm provided that time of fixing is extended according to degree of dilution. Too strong a bath, however, should not be used, for it may not only damage the gelatin but it may attack the silver particles and fade the image, especially in the shadows in the case of negatives, or in the highlights in the case of paper positives. For the same reasons, fixing should not be unduly prolonged in a normal solution.

The film should not be exposed to white light during the minute after it has entered the fixing bath – that is, until the developer retained in the film has been neutralized. Then the film can be examined in full light.

A hardening fixer not only fixes a film but hardens the gelatin at the same time and so mitigates the danger of damage to the emulsion in the form of abrasions and scratches, both during washing and when dry. Hardening has other advantages: it reduces the time of drying and it gives cleaner negatives when the washing water is hard. As a rule a hardener should always be used

for 35-mm. negatives because in these all faults such as scratches are so greatly magnified in enlargements. The usual hardening ingredient is white potash alum, possibly with boric acid and/or glacial acetic acid added to extend the life of the hardener. Manufacturers provide liquid hardeners which can be added to the ordinary acid fixer.

Washing

The final wash can be carried out with the film still in the tank, but, if this is done, a rubber tube should lead from the tap to the hole at the top of the reel (the lid having been removed), so that the water will run down the central duct to the bottom of the tank. The reason for this is that the deposits which are washed out of the film are heavier than water and sink to the bottom where they may remain during the whole time of washing unless precautions are taken. If this tube cannot be arranged, it is advisable to empty the tank completely and refill it several times with fresh water during the washing period.

Proper washing is essential. Inadequate washing may not show for months, or even years, but the ultimate result will be that the residual by-products of development will attack the silver image and produce fading and staining.

A plate can be washed rapidly under a spray in no more than 10 minutes, but a film with a gelatin coating on both sides must be completely immersed in water which changes at least every 5 minutes. For very urgent work, a plate can be temporarily washed for printing under a running tap for $1\frac{1}{2}$ minutes. The use of a clearing agent will reduce washing time to a quarter where there is little water or speed is needed.

For general purposes, however, at least half-an-hour must be allowed in running water – longer in cold weather. When water is scarce, the film can be soaked in at least six separate changes of water for 5 minutes at each soaking; when the film remains in a spiral tank during washing, the reel should be agitated occasionally during each 5-minute soaking. This soak-and-change method is very effective and by no means merely provisional.

When roll-film tanks with aprons are used, the film should be removed from its apron before washing. When any film is removed from its apron and tank and washed, for instance, in a hand-basin, it should not be allowed to coil up but should have clips fixed at each end so that it lies more or less flat in the water, image side uppermost.

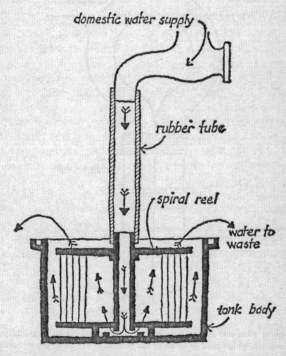

**23.** Section showing an arrangement for washing a film in a developing tank. The water penetrates to the bottom of the tank where the chemicals to be washed away tend to settle.

When washing either films, plates, or papers in a basin in running water, it is a good idea to run a rubber hose from the tap to the bottom of the basin and to drain the water away at the top of

the basin by the weir overflow; in this way the water at the bottom of the basin will be changed and remain pure.

To reduce washing time considerably, you can use a clearing agent like Speedwash in the water. This is particularly valuable if you are short of time or water or both.

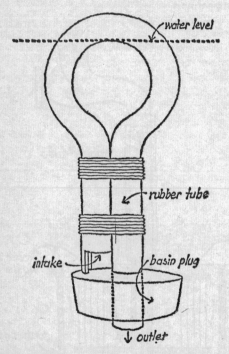

24. Siphon arrangement for a basin in which prints are to be washed: the chemicals which tend to settle at the bottom of the basin are removed by this means.

To make sure that films (or prints) have been thoroughly washed, the following test may be made. Prepare a solution of:

| | | |
|---|---|---|
| Potassium permanganate | 9 grains | (·58g.) |
| Sodium carbonate | 12 grains | (·78g.) |
| Water to make | 20 ounces | (568 ml.) |

Collect the drainings from the film (or print) in a glass vessel and fill another glass vessel with fresh water. Add a drop of the above solution to each of the two vessels; then, if the pink colour remains in the one containing the drainings for as long as it does in the one containing pure water, the washing has been adequate. A made-up test solution of this kind is Kodak H.T.Ia.

A film should not be transferred suddenly from a fixer of, say, 65°F to very cold tap water. Cold water should be introduced gradually, if at all. Reticulation may otherwise result – a physical effect and not a chemical one.

When washing has been completed, a few drops of a wetting agent may be added to the last tank of water. This will ensure an even flow of surface water off the film when drying and will prevent the formation of globules of water on the emulsion which could produce circles of calcium deposit on the denser areas.

Hang the film up to dry with clips at each end in a warm, dust-free place. Special stainless steel or similar clips can be bought, but clothes pegs or hooks made from paper clips will serve well. Surplus water can be wiped away with a soft, damp chamois leather or with one of those special viscose sponges supplied by the photographic shops, also dampened. But be careful that no grit adheres to the leather or the sponge or the film may be damaged by scratches down its entire length. If you are not in a hurry, it is safer to leave the film alone.

## Negative Faults: Avoidance and Treatment

*The Perfect Negative.* The first step towards producing a perfect negative – that is one which makes a perfect print – is correct exposure. The second is correct development. An under-exposed negative is flat in appearance and too transparent, and it has no details in the shadows; shadows will appear on the print as black, boring patches.

Something can be done to improve a slightly under-exposed negative after development if faint shadow details are visible on the negative, but there is no hope for one which is seriously under-exposed, not even prolonged development, because if light has

produced no effect at all on parts of the negative, nothing can be done except to make another and longer exposure of the same subject.

Under-development, unlike under-exposure, will show details in the shadows but highlights will lack density and the negative as a whole will produce a print lacking sparkle and contrast. An under-developed negative is one which is likely to benefit by intensification more than an under-exposed one because all the details will be there; sufficient contrast alone will be lacking. Under-development may result, not merely from too brief a development time, but from the use of too weak and exhausted a developer. The remedy is to treat the negative with an intensifier (see p. 234) or to use contrasty printing paper, or to do both.

An over-exposed negative will appear very dark and dense; highlight details will be lost and the whole may be fogged. However, there will be more chance to produce a good print from it than from an under-exposed negative. The over-exposed negative cannot be improved by reducing the time of development to any appreciable extent for that will merely produce a very flat result; the negative must be fully developed to bring out the contrasts and, if very dense, it can then be treated with a reducer (p. 235). If a reducer is not used, the time of printing will have to be long.

Over-development does not have the same effect as over-exposure, but produces a much more contrasty result with very dense highlights. The remedy is to treat the negative with a reducer or to print it on soft paper or to do both.

If the negative is both too contrasty and has fogged shadows, it has been both over-exposed and over-developed. The remedy is to treat it with a reducer and to use soft paper.

If the negative shows a grey fog all over, including the unexposed edges, the probable cause is exposure to light, perhaps that of a safelight which is too bright, or to stray light seeping into the dark-room. Other possible causes are over-development, the use of too warm a developer, staleness of film, or aerial fogging.

If the negative has had proper exposure, other faults produced during processing may mar it. Dust flying about the dark-room may settle on the negative during development or drying to produce spots. Care and cleanliness is the preventative. Spots may

also be produced by particles of chemical which have not been dissolved. The remedy is to make sure that the chemicals are fully dissolved when making up the solution and, if necessary, to strain the solution before use. To avoid spots on enlargements entirely is almost impossible and these must be treated on the print by spotting (p. 278), but spots caused by dust or other troubles should be avoided during processing as far as possible because spotting and touching-up is a tiresome activity.

Air bubbles remaining on the emulsion surface during development may produce fairly large white spots on the negative. Agitation and sharp movements at the start of development are the preventative in the case of tank development, and removal of the bubbles with a soft brush or with gentle rocking is the preventative in the case of dish development.

Uneven drying may produce dark patches on the negative, and perhaps distortion of the emulsion, especially in a very warm atmosphere. The preventative is to dip the film in a wetting agent before hanging and to remove surplus water with a damp chamois leather immediately after hanging.

If a fog appears on the negative which is pink when the negative is held up to light or green-blue when seen in reflected light, then probably the developer was stale or contaminated with hypo, or perhaps the hypo was stale and contained too much carry-over of developer. This 'dichroic' fog can be removed with a very weak solution of Farmer's Reducer (p. 235).

If bands of light tone appear across the negative, especially in skies, the cause is probably uneven development possibly combined with over-exposure. The preventative is proper exposure and adequate agitation or rocking during development.

If very dark bands or patches appear on the negative (probably round the edges), the cause is leakage of light into the camera.

Thin lines running down the length of the roll film have two possible causes. The first is roughness on the rollers in the camera, one of which may have jammed. The rollers should be re-plated, but temporarily they can be smoothed with very fine *flour* emery paper. The second possible cause of lines is the scratches caused by pieces of grit in the chamois leather or viscose sponge used to remove surplus water when the film is hung to dry.

*Scratches on a Negative.* These can be treated by sandwiching the negative in oil or glycerine between two pieces of clean glass before printing. Ordinary olive oil or castor oil can be used, or any other clear, thin oil. Proprietary scratch removers, such as the P.A.C. Resistol, are available; these are poured on to both sides of the negative and then the negative is dried. These scratch removers are really varnishes which have the same refractive index as the film gelatin; they have the added advantage that they protect the negative from further damage.

*Stains.* There are various ways of treating stains on negatives, the causes of which vary. If the cause cannot be diagnosed, bleaching and re-development may be necessary. Blue, red, or greenish discoloration is usually caused by the anti-halation layer (the backing) and is easily cured: immerse the negative, after fixing and hardening, in a 1% solution of sodium carbonate and wash. Alternatively, treat the negative with a weak alkaline solution such as water with a few drops of ammonia added.

Whitish scum marks caused by hard water can usually be removed by wiping the negative with a moist chamois leather, viscose sponge, or cotton-wool swab; if this is ineffective, the negative can be gently rubbed with Baskett's Reducer (p. 236), or the negative can be bathed in a 2% solution of acetic acid followed by refixing for 5 minutes and washing. Silver stains and general dirt can easily be removed by gently rubbing with chamois or cotton wool moistened in methylated spirits.

*Intensifying a Thin Negative.* In general, both intensification and reduction of negatives are to be avoided and a really poor negative should be discarded. Sometimes, however, a poor negative may, for some reason, be highly valued and irreplaceable, and then it can be improved to some extent before printing. Various proprietary intensifiers and reducers are available.

The object of intensification is to increase contrast rather than overall density. For increasing contrast and strengthening the shadow details of a somewhat under-exposed negative, the Ilford Uranium Intensifier, consisting of two stock solutions – the first of uranyl nitrate, the second of potassium ferricyanide – is a good

brand because it intensifies the shadows more rapidly than the half-tones and highlights. Full instructions are supplied by the makers. The treatment should not be taken too far or the preferential action on the shadows will be lost. The negative when dipped in the solution becomes opaque and brown in colour, and after treatment it is washed in several changes of still water until the stain has disappeared. A few drops of acetic acid should be added to the water because alkaline water (such as tap water) may dissolve the intensification.

For safety's sake, a dry negative to be intensified should be re-fixed for a short while and then washed before treatment. If a proprietary intensifier is not used (such as Kodak IN5 Silver Intensifier), the following uranium intensifier is a good formula to make up:

| | | |
|---|---|---|
| A. | Uranium nitrate | 100 grains (6·5g.) |
| | Water to make | 10 ounces (284 ml.) |
| B. | Potassium ferricyanide | 100 grains (6·5g.) |
| | Water to make | 10 ounces (284 ml.) |

Mix four parts of A to four parts of B and add one part of glacial acetic acid. Wash the negative in still baths containing a pinch of common salt until the stain is cleared.

If an under-exposed negative is particularly precious and the risk of chemical intensification is undesirable, the following mechanical method can be used: Make a contact transparency on process film or plate from the original negative, giving minimum exposure and maximum development. From this positive transparency make a contact negative, again giving minimum exposure and maximum development. Contrast can be further increased by printing this second negative in a condenser enlarger and by using contrasty (hard) paper.

*Reducing a Dense Negative.* The most common reducer and possibly the best and most famous is Howard Farmer's Reducer. Make up a 10% solution of potassium ferricyanide; this will keep fairly well in the dark. Add one part of this stock solution to about 10 parts of 20% hypo solution, the hypo (sodium thiosulphate) being *non-acid* and crystalline. If the negative is dipped in this mixture, the general fog will be rapidly attacked and the fainter

densities will be the first to be reduced. The negative should be withdrawn just before the desired state of reduction has been reached and then washed at once under a tap. If the proportions of the mixture are one part of ferricyanide to 50 parts of hypo, reduction will be slower, the denser parts of the negative will be attacked first and the contrast will be reduced. The mixture should not be used for longer than 10 minutes, when it must be discarded and a fresh mixture used. After treatment wash the negative as usual. Normally the negative should be well soaked in water before treatment, but greater contrast can be obtained by treating it from a dry state. Kodak R.4a is a proprietary brand of Farmer's Reducer.

Local reduction of parts of a negative can be effected with Farmer's Solution which is weak in the ferricyanide. Then the solution is applied with a small swab of cotton wool or a camel-hair brush. This is a tricky and risky operation because it is difficult to keep the action within the desired bounds. Frequent washing of surrounding areas with water is recommended during treatment. The yellow staining which results from the treatment can be removed by immersing the negative in an acid fixing bath for a few minutes.

Local reduction is particularly useful in cases of halation. For such strong local reduction an abrasive rather than a chemical reducer is preferable. Such an abrasive is Baskett's Reducer which is made by mixing one part each of olive oil, terebene, and Glove metal-polish in paste form. This mixture should be strained before use to remove large pieces of grit. Simply rub the over-exposed part of the negative gently and patiently with a small piece of cotton wool dipped in the liquid and wrung out.

All this messing about with intensifiers and reducers will rarely be necessary, and not many wrongly exposed or wrongly developed negatives are worth the trouble of treatment. All modern printing papers have so wide a range from very soft to very hard grades, and these papers can be developed in so wide a variety of solutions which also give control of contrast, that very few negatives will be worth treating chemically before printing.

*Mechanical Reduction.* This is an ingenious method without

chemicals or abrasives and is very effective where a negative is too contrasty and produces dead highlights. It is achieved by masking the negative with a positive transparency. Make the positive contact transparency from the negative in a printing frame on any film or plate but preferably on a non-colour sensitive plate such as Ilford's Ordinary or Kodak's B40. The positive should be rendered slightly unsharp by placing a few sheets of clear film (say old film washed clear in warm water) between plate and negative and by giving exposure below an enlarger and through a diffusing screen. This diffusing screen can be made of clear glass on which a piece of tissue paper rests; it should stand on end supports a few inches above the printing frame, lying on the baseboard of the enlarger. The positive transparency should be given a short development, say half the normal, so that the image is very thin and far less contrasty than the negative. The final print, whether contact or enlargement, is made by printing from the two transparencies set together in as perfect a register as possible. Incidentally, the object of making the positive transparency slightly unsharp – by the interception during its production of clear film and tissue paper – is to render this registration easier and any slight lack of conformity less noticeable in the final print. Note that when making the final print, the negative is placed below the positive, its emulsion side downwards; the positive will have its emulsion side upwards, facing the light source. Here also the sheets of clear film are sandwiched between the transparencies.

*Reducing Granularity.* If granularity in a negative is severe, it can be reduced during enlargement by introducing a special diffusing disk below the enlarger lens. This will soften the print. Alternatively, in place of the disk, some material such as bolting silk or chiffon may be used. An enlarger with a diffused light will be preferable to one having a light condenser, because this will tend to soften the print by scattering the light. Soft paper will also reduce grain.

A good print depends on: (i) A good negative, more or less correctly exposed and developed; (ii) The choice of a suitable printing paper; (iii) Correct exposure in the printing frame or enlarger; (iv) Appropriate and correct processing of the print.

## Printing Papers

Photographic papers can be classified as (a) Printing-Out Papers (P.O.P.) and (b) Development Papers. Printing-Out Paper was first put on the market in 1891 and it is rarely used today; the name arises because the image is produced during exposure and not as a latent image during development. P.O.P. is used only for contact printing by daylight. The image must be allowed to darken more than would be finally correct because the fixing, which must be in ordinary, *non-acid* hypo, bleaches the image to some extent. P.O.P. always has a gelatino-chloride emulsion.

Development papers, in which the latent image must be produced by development after exposure, are now in most general use. Their light-sensitive emulsion is similar to that of films and plates with the difference that their sensitivity is restricted to the ultra-violet, violet, and blue parts of the spectrum. Since they have to deal only with the monochrome of negatives, sensitivity to all colours is not necessary; moreover, this lack of overall sensitivity has the advantage that the papers can be handled in yellow, brownish, or orange light according to whether the emulsion is chloride, chloro-bromide, or bromide in composition. Between the sensitive emulsion and the pure paper backing is a layer of baryta or barium sulphate in gelatin; its purpose is partly to protect the emulsion from any chemical action from impurities

in the paper but mainly to purify the whites by preventing the paper's absorbing the emulsion and so lessening the brilliance of the image. In glossy papers a very thin final layer of gelatin covers the emulsion, while in matt papers starch or some other granular material is mixed in the emulsion.

Development papers, as stated, are of three kinds:

1. *Chloride paper*, still called Gaslight Paper, a name deriving from the earlier days before electric light became universal; Kodak Velox was a typical brand. This paper was not particularly sensitive and was commonly used for all contact printing; hence its alternative name – Contact Paper. It could be handled in moderately bright artificial light such as indirect electric light shining through a door, or in candlelight, or in the light from a safelight shining through a bright yellow filter.

2. *Chloro-bromide paper* is used both for contact printing and enlarging, one make being expressly for contact work and another for enlarging. In sensitivity it lies generally between gaslight and bromide papers, having an emulsion mixture of silver chloride and silver bromide. It is brownish warm in tone, especially when development is not taken too far; indeed, by suitable lengths of development, tones can be varied from reddish brown to warm black. Ilford Ilfomar and Kodak Bromesko are examples of this type of paper. When handling them, a light brown safelight must be used.

3. *Bromide paper* is the most light-sensitive of development papers, its main emulsion ingredient being silver bromide in gelatin. It must be handled in a safelight of orange colour. Ilfobrom and Kodak Bromide are typical papers of this sort.

These development papers can be obtained in a variety of contrast grades. Chloro-bromide and bromide papers can also be obtained in various surfaces and weights. The grades of contrast are called by terms which are somewhat vague and variable and need standardizing – terms like Vigorous, Extra Hard, Hard, Normal, Soft, Extra Soft. Some makers provide as many as six different grades; thus almost any negative, unless quite exceptionally badly exposed or developed, is catered for. Unfortunately, no standard terminology has yet been agreed upon by manufacturers so that, for example, one manufacturer's 'soft'

paper may have the same effective grade as another's 'normal' paper. The British Standards Institution now recommends: Grade 0, extra soft; Grade 1, soft; Grade 2, normal; Grade 3, hard; Grade 4, extra hard; Grade 5, ultra hard. Ilfobrom is produced in these five grades with the special advantage that they all have the same sensitivity.

Surfaces vary from rough and heavily textured kinds, through so-called velvet, rough lustre, matt, and semi-matt to glossy. Tones also vary, being white, ivory, or cream. A cream paper may be suitable, say, for sunny subjects and for prints that are to be sulphide-toned (p. 273). Glossy surfaces provide the most brilliant prints; these can be glazed to a higher degree on a glazing plate when drying and in this form they show details with the greatest possible clarity; therefore they provide the best finish for photographs which are to be reproduced in magazines or books.

Choice of surface is otherwise a matter of taste and the popular taste is for a semi-matt or rough finish on big enlargements, because the large areas of tone gain in visual interest by virtue of the texture, grain is less apparent, and re-touching is easier and less apparent. A pleasant paper for enlargements to my mind is that with glossy surface left unglazed.

The speed, or sensitivity to light, of papers varies as between different makes and as between different grades. Moreover, speeds change during storage.

A very important new kind of bromide paper is that having polyethylene coatings on the front and back which make for rapid processing and drying. It may soon supersede existing papers entirely owing to its time-saving convenience, and it is available both for colour and black-and-white printing. Because it does not absorb much liquid since only the emulsion takes it up and not the base, this paper can be developed, fixed, washed and dried in a few minutes. It lies quite flat on the enlarger board, and remains so during processing and after drying; it is also self-glazing in its glossy form. Kodak make Veribrom in both glossy and semi-matt finishes, the former being in five grades and the latter in four. Ilford make Ilfospeed in glossy, semi-matt and silk finishes, in six grades.

Ilford have, in fact, developed a whole system for Ilfospeed

paper, with a developer containing Phenidone and Hydroqui-none, and a fixer without hardener (hardener being needless and requiring double washing time). Prints up to 16 inches square can be dried in the Ilfospeed 4250 dryer, a costly but useful apparatus. Only two minutes washing in running water is needed as against an hour or more with normal papers, and no electric drying and glazing machine is required. By these means a print can be processed, washed and dried in four minutes flat. If the special dryer is not used, a print can simply be laid on a sheet of fluffless blotting paper and blotted with another sheet; it will dry without curling.

A point to realize about printing papers is that their density range is below that of negative material; the blackest black will not be truly black nor the whitest white truly white. Details which are clearly visible in the shadows of a negative may not be repro-ducible on a print. The reason is that transmitted light as seen through a negative transparency has a far greater range of density than the purely reflected light of a positive print. The varying brightness values of a subject between the lightest and darkest areas, that is its degree of contrast, may range from about 750 to 1 in outdoor scenes, though the average value is more like 160 to 1. Because of the flare light within a camera, the scattered inter-reflections which fall like a slight fog on the whole of the sensitive emulsion during exposure, the full contrast range of the subject can never be recorded on a negative. The ratio of the brightness scale of the subject to that of the image on the negative is called the Flare Factor and this may vary between $1\frac{1}{2}$ and 9 according to the degree of brightness of the subject and the design of the camera. An average Flare Factor for an amateur camera would be 4. Thus an average subject having a brightness scale of 160 to 1 will show a brightness scale on the negative of only 40 to 1. On the other hand, some subjects could give a scale on a negative as high as 1,000 to 1. Glossy paper may be able to reproduce some negative scales in full because the possible scale is about 60 to 1. Matt paper, however, has a range of only about 15 to 1. Hence the value of glossy prints when half-tone reproduction is contemplated. Print quality will not seriously suffer in spite of this reduction of tonal range, provided each tone of the print is in the same proportion

to the others as is each tone to the others in the subject itself – that is, the tone values of the print must have the same comparative ratios, so far as possible, as the tone values of the subject.

The number of tones which the eye can distinguish in a good printing paper varies as between glossy and matt. In glossy paper the number may be as many as 150, whereas on matt paper it may be only 100 owing to the loss of reflective power.

A paper will have a definite Exposure Scale – that is the ratio between length of exposure required to produce the faintest tone and the length required to produce the darkest possible tone, there being a point beyond which no increase of exposure will produce any greater degree of blackness. In a soft paper this Exposure Scale may be 70 to 1 (the softest available is as much as 120 to 1), but in a very hard paper having the same emulsion it may be only 5 to 1. The number of perceptible tones in both cases will, however, be the same provided the surface is the same. By selecting the right grade of paper we can control our degree of contrast on the print according to the degree of contrast on our negative. To use the full tonal range of a paper will not be possible, because no highlight in a negative will be quite opaque and no shadow quite transparent; the *effective* Exposure Scale of a paper is therefore less than the potential Exposure Scale.

If a negative is somewhat contrasty, as it may well be if over-developed, then a soft paper must be used. If a negative is thin and flat, as it may be if it is under-exposed or under-developed, then a hard paper must be used. A normal, perfect negative will, of course, require paper of a normal grade. A contrasty negative on a hard (contrasty) paper will produce a lack of intermediate tones, a 'soot and whitewash' result. On the other hand, a soft, flat negative printed on a soft paper will produce a grey, dead print without sufficient contrast and with too close a range of intermediate tones. To express the matter in technical terms: the Exposure Scale of the paper must match the Density Scale of the negative. It is therefore possible to develop a negative to a degree of contrast which is wrong for one grade of paper and right for another. We thus have considerable latitude both in variations of exposure on a film and in variations of its development, thanks to the wide range of paper grades available. On the other hand, we

must realize that the latitude of papers is less than that of films, so that their exposure and development must be accurate.

Incidentally, the effect of light on development papers is exactly the same as that on negative emulsions: the greater the amount of light falling upon it, the greater will be the black silver deposit produced.

*Paper sizes*. The following are the standard paper sizes available, together with the area of each sheet in square inches and square

| Standard Paper Sizes In. | Cm. | Area Sq. in. | Remarks | Number of prints that can be developed in 20 ounces of MQ solution | Number of prints that can be fixed in 20 ounces of acid fixer |
|---|---|---|---|---|---|
| $1\frac{7}{8} \times 2\frac{3}{4}$ | $5 \times 7$ | $5\frac{1}{4}$ | V.P.K. | 18 doz. | 8 doz. |
| $2\frac{1}{2} \times 2\frac{1}{2}$ | $6\cdot5 \times 6\cdot5$ | $6\frac{1}{4}$ | Twin-lens | 15 doz. | 7 doz. |
| $3\frac{3}{4} \times 2\frac{1}{4}$ | $6\cdot5 \times 9\cdot5$ | $9\frac{1}{4}$ | | 11 doz. | 5 doz. |
| $4\frac{1}{2} \times 3\frac{1}{2}$ | $9 \times 11\cdot5$ | $15\frac{3}{4}$ | Quarter Plate | 6 doz. | 3 doz. |
| $3\frac{1}{2} \times 5\frac{1}{2}$ | $9 \times 14$ | $19\frac{1}{4}$ | Post Card Size | 5 doz. | $2\frac{1}{2}$ doz. |
| $4\frac{1}{4} \times 6\frac{1}{2}$ | $12 \times 16\cdot5$ | 31 | Half Plate | 3 doz. | $1\frac{1}{2}$ doz. |
| $6\frac{1}{2} \times 8\frac{1}{2}$ | $16\cdot5 \times 21\cdot6$ | 55 | Whole Plate | $1\frac{3}{4}$ doz. | 10 sheets |
| $8 \times 10$ | $20\cdot3 \times 25\cdot4$ | 80 | | $1\frac{1}{4}$ doz. | 8 sheets |
| $10 \times 12$ | $25\cdot4 \times 30\cdot5$ | 120 | | 10 sheets | 6 sheets |
| $12 \times 15$ | $30\cdot5 \times 38$ | 180 | | 6 sheets | 4 sheets |
| $15 \times 18$ | $34 \times 46$ | 270 | | 4 sheets | 3 sheets |
| $16 \times 20$ | $40 \times 50$ | 320 | Suitable exhibition size | 3 sheets | 2 sheets |
| $20 \times 24$ | $50 \times 60$ | 480 | | 2 sheets | $1\frac{1}{2}$ sheets |

centimetres, the name of the size, if any, or comments, and the number of prints of each size which can be developed and fixed in given quantities of solutions before these become exhausted.

An acid stop-bath used between development and fixation, such as Kodak S.B.I., has about the same capacity as a fixing bath, and by using a stop-bath the capacity of the acid fixing bath is doubled.

## Lantern Slides

Lantern slides are similar to development papers, except for the differences that the base of lantern plates, or slides, is glass instead of paper and that the standard sizes are restricted. The old standard size in Great Britain is $3\frac{1}{4}$-inches square but a popular

size in America is $3\frac{1}{4}$ by 4 inches, while a new international size is $2\frac{3}{4}$-inches square (corresponding with the $2\frac{1}{4}$-inches square negative which can be printed in contact with the plate). The miniature size is 2-inches square (corresponding with the 35-mm. negative suitably masked). Thus Great Britain now has three standard sizes – 2-inches square, $2\frac{3}{4}$-inches square, $3\frac{1}{4}$-inches square. Projectors, formerly called Magic Lanterns, are usually made to take $3\frac{1}{4}$-inches square lantern slides but their carriers can be adapted to take the smaller sizes, and projectors are now made specially to take the smaller sizes, notably those now popular for projecting 35-mm. colour transparencies.

The virtue of slides as compared with paper prints is that, like negative transparencies, their range of tones is much greater. The best slides are made from fairly contrasty negatives which have been given full development. Lantern plates are made with chloride (gaslight or contact), chloro-bromide, and bromide emulsions just like papers, though their range of grades is limited to contrasty, normal, and soft.

Making lantern slides is no more difficult than paper printing and can be done either by contact exposure in a printing frame or by exposure in an enlarger. A good developer would be an MQ such as Kodak D163 for the black-tone bromide plates, Kodak D166 for the warm-tone chloro-bromide plates. When fixed, hardened, washed, and dried, the plate is covered on its emulsion side with a piece of clear glass and the two are bound together with adhesive paper strips, perhaps with a framing mask of black paper between.

## Developing Prints

The most usual developers for development papers now possess as their reducing agents Metol, Hydroquinone and Phenidone. Typical proprietary print developers for bromide papers are Kodak D163 and Ilford PQ Universal and Bromophen. Development times will be about 30 seconds to 1 minute for chloride papers and $1\frac{1}{2}$ to $2\frac{1}{2}$ minutes for bromide papers, both at 65°F. Chloro-bromide papers can be developed in an ordinary bromide

paper developer though they may develop more rapidly therein than bromide papers.

If warm black tones are desired in chloro-bromide papers, normal to full development must be given, but if browner tones are desired the developer must be diluted with water, say four or five times, and exposure of the paper must be lengthened considerably.

Though Phenidone is now taking the place of Metol in Ilford formulae (see p. 213n.), the old Ilford ID20 formula is as follows:

| | | |
|---|---|---|
| Metol | 15 | grains (1g.) |
| Sodium sulphite (cryst.) | 1 | ounce (28·35g.) |
| Hydroquinone | 60 | grains (3.9g.) |
| Sodium carbonate (cryst.) | 1½ | ounces (42.5g.) |
| Potassium bromide | 20 | grains (1·3g.) |
| Water to make | 20 | ounces (568 ml.) |

For use, dilute with an equal quantity of water.

The difference between this bromide paper developer and the ID36 used for chloride (gaslight) papers is merely that ID36 contained about one-fifth of the quantity of potassium bromide. A soft-working developer might contain no hydroquinone and not much metol. A contrasty developer would contain a good deal of hydroquinone.

I always use Johnson's Contrast Developer for bromide paper enlargements as I find that this gives brilliance to the print while permitting a certain degree of control of contrast according to the degree of dilution of the developer; and it seems to suit the comparative softness of my negatives, which are usually on fast pan film developed in Johnson's Unitol. Contrast Developer is energetic and fast working and this saves time when a great number of prints are to be made; it is therefore popular among pressmen and commercial photographers. The formula is unpublished, but it is of the MQ type. It can be used for developing plates and films in an open dish but it is unsuitable for tank development, however much it is diluted. Another useful developer is Paterson's Acuprint.

To bring out the full rich tonal range and contrast of a print never work with exhausted developer. And never under-develop the print. Do not, for instance, take the print out of the developer

if it seems to blacken too quickly; take another sheet and give a shorter exposure. Doubling the development time given by the makers of a developer will do no harm and will increase contrast; but too long a development may produce staining.

Procedure for development of both contact prints and enlargements is very similar to that of development of plates or cut films in a dish: exposure, dish development, quick-wash or stop-bath immersion, fixation, long wash. A stop-bath (p. 224), or acid rinse, may be given instead of the intermediate wash between developer and fixer, a brand being Kodak SB1. The stop-bath will neutralize the alkaline developer in the print. The SB1 formula is:

| | |
|---|---|
| Glacial acetic acid | 2½ drachms (9·7g.) |
| Water to make | 20 ounces (568 ml.) |

Incidentally, if you wish to make a large print and you do not possess a sufficiently large dish, find an impervious smooth board, such as a piece of hardboard, place the moistened exposed print upon it, emulsion side up, and sweep a large swab of cotton-wool dipped in developer across its surface, working zigzag from top to bottom; re-dip the swab and repeat as many times as necessary until development is complete. Then prop the board up in a sink so that the surplus developer drains away and treat as before, first with a stop-bath solution and then with a fixer.

Details in a highlight can often be strengthened by rubbing it with a finger dipped in hot water towards the end of the development time.

## Fixing Prints

Fixing and washing prints are important, for on these the permanence of prints depends – their freedom from fading and staining in the future. Acid fixing salt, preferably with hardener, is used for fixing papers (other than P.O.P.) as for fixing negatives. The fixer formula is given on p. 226, but proprietary brands can be obtained. The solution should be more diluted for papers than for negatives; it should be about 15% solution – that is, 3 ounces of fixing salt to 20 ounces of water. Use as large a fixing dish as

possible because this will give the prints room and lessen the chance of their sticking together.

Having placed the print in the fixer, rock the dish for a few seconds and make sure that the whole surface of the print is covered with solution during the whole time of fixation. Place the print face downwards and move the prints about from time to time to prevent their adhering to one another. Fixing time should be about 5 minutes in fresh solution, but longer than this as the fixer grows staler – up to, say, 20 minutes. Prints should not stay in the fixer for longer than is necessary or they may fade a little and some of the details in the highlights may be bleached away. Half-an-hour is too long and 1 hour may have a serious effect. Do not use a fixer for papers which has already been used for plates or films. The temperature of the fixer should be about 65°F; a warmer solution will reduce the required fixing time and a cooler one will increase it, but do not go below 60° or above 70°.

*Two-bath Fixing.* This is the best method to use. The first bath is an acid one as used for normal fixing, but the second bath is hypo without acid. Five minutes is given in both baths and the baths are both used for twice the number of prints which could be permitted in a single, normal fixer. When the first bath has become exhausted, the second bath takes its place and acid is added to it (p. 226); then a fresh non-acid second bath is prepared. If hardening liquid is used, this should be added only to the first bath because then the final washing time can be reduced. (Note that in the case of prints, a hardener will necessitate double the normal washing time.)

Washing Prints

This can be carried out in running water in a basin but the prints should then be moved continually so that they do not adhere to each other for long periods. A better method is to run a tap into a bowl and to siphon out the water from the bottom of the bowl through a rubber tube with one end hanging over the side of the bowl; the prints can be made to float by attaching small corks to their edges. An equally satisfactory method is to soak the print in

a still bath of water for 5 minutes, then to drain it off and repeat six times at least. Special print washers can be obtained which are satisfactory, though costly.

You can wash prints in a bath of running water by hanging them from spring clothes-pegs which are suspended from rods or sticks supported by the sides of the bath.

If the tap-water is unclean or is too aerated, a special filter can be obtained to fit on to the tap and this will remove all solid particles and excess gases from the water. A useful guide:

| Weight of Paper | Method of Washing | Minimum for Urgent Work | Normal | For Prolonged Storage |
|---|---|---|---|---|
| Single-weight | Running water | 20 minutes | 40–60 minutes | 1½–2 hours |
| | Separate changes of 5 minutes each | 5 changes | 12–15 changes | 20–30 changes |
| Double-weight | Running water | 40 minutes | 1½–2 hours | 2–3 hours |
| | Separate changes of 5 minutes each | 10 changes | 20–30 changes | 30–45 changes |

If a hardener is used in the fixer, the above times should be doubled. Note also that the temperature of washing water should not fall much below 60° or rise above 70°F.

Kodak Hypo Clearing Agent can be used for reducing washing time of prints, as of films or plates, to a quarter of the normal. Such hypo eliminators do work.

Making Prints Permanent

Though hypo can be eliminated from plates and films completely by washing, no amount of washing will completely eliminate hypo from prints. This means that all prints, unless specially treated, will fade in time, though perhaps not for several decades. The reason for this is that some sulphur will remain in the print and sulphur is the chief enemy of silver. In warm, damp, tropical climates deterioration of prints will be much more rapid than in cool climates and there complete elimination of hypo may be necessary by other means than washing alone – as it will also be

anywhere if absolute permanence is desired. This permanence can be accomplished by treating the print in a hypo eliminator such as Kodak HE1, the formula of which is:

| | | |
|---|---|---|
| Hydrogen peroxide (3% solution) | 2½ ounces | (71g.) |
| Ammonia (3% solution) | 2 ounces | (56·7g.) |
| Water to make | 20 ounces | (568 ml.) |

The solution should be freshly made. Its effect is to oxidize the thiosulphates to sulphates, the latter being harmless and removable by washing for about ten minutes only. The print should also be washed for about a third of the normal time before treatment in the eliminator – say 20 minutes.

Not only the retention of the thiosulphates prevents permanence. Hydrogen sulphide is also an enemy, and this is found in the atmosphere of cities where coal and coal-gas are burned. Protection against this can be given by sulphide toning (p. 273).

If any sediment is noticeable on the print after washing, swab down the surface with a cotton-wool swab or a viscose sponge; this may well be needed if the water is hard and chalky. A final dip in a wetting agent will help the print to dry evenly.

Drying and Glazing Prints

Prints can be dried in various ways. Whichever way is used, first remove surplus moisture by pressing the print between two sheets of colourless, fluffless, photographic blotting-paper. Then hang the print up on a line with clips or lay it face down on photographic blotting-paper or on some clean, absorbent material such as muslin, cheese-cloth, or towel. In these ways of natural drying the print will curl and this curl can be removed in one of two ways: (i) By running a straight rule firmly across the back of the print while it rests on a smooth surface; (ii) rolling the print up, face outwards, and leaving it in a cardboard roll for a few hours.

The best method of drying prints, especially when many prints are being made, is to use a special electric drying apparatus which merely consists of a metal surface, below which is an electric warming element and above which is a hinged canvas flap to keep the prints flat. Various standard sizes are made from 5 inches by

7 inches to 18 inches by 24 inches, some being double sided. A chromium plate can be purchased with each drier; if a glossy print is laid face down on this plate immediately after washing and then the surplus water is removed with a flat or roller squeegee it will dry with a highly glazed surface. The use of a proprietary glazing solution will help to make the glazing full and even;* dip the print in the glazing solution before laying it on the plate and also rub some of the solution over the plate with a Spontex or chamois cloth before the print is laid on it. Lay a sheet of photographic blotting-paper between the prints and the canvas cover. Do not leave the prints in the drier longer than is necessary or the edges will cockle.

A more elaborate drier than the one described above consists of an electric warming element thermostatically controlled and incorporating a thermometer and a screw press. This apparatus ensures a completely flat print and it can also be used for dry-mounting prints and for flattening mounts and papers.

If you do not possess a drying and glazing machine, glazing can be accomplished in another way on a sheet of prepared plate-glass or on a special ferro-type plate, though this method, being a cold one, takes much longer than glazing in a drying machine. In the case of plate-glass (such as a mirror) wash the surface well with hot water containing a little soda, rinse in clean water, polish with a duster and a mixture of 10% ammonia and methylated spirits in equal parts; next dust the surface with French chalk and rub the surplus away, or else apply glazing solution. All this is to prevent the prints from sticking to the glass when dry. A print which has been hardened is less liable to stick than one which has not. Place the wet print on the glass, lay a piece of blotting-paper over it and roll a squeegee several times across the blotting-paper. Turn the glass round (if clear glass) to see that all air has been excluded between print and glass. Allow the print to dry slowly in a fairly warm place; if the print has been hardened the glass can be stood 5 feet away from a fire.

All this time and bother can now be greatly reduced by using the new resin-coated papers such as Ilfospeed and Veribrom, already described on p. 240.

*A squirt of liquid soap serves well enough and is cheaper.

## Contact Printing

In contact printing the first requirement is a printing frame to suit the size of the negative. To this can be added a mask of proper size if a sharp, white border is wanted around the print; it may be of red celluloid and can be obtained at any photographic shop.

When using the faster bromide paper for contact printing the exposure will have to be far less than that for chloride paper. Cover the front of the printing frame with a diffusing screen of white blotting-paper, use a 25-watt lamp at a distance of 18 inches and expose for about four seconds.

If you are afraid the orange safelight you work in with bromide paper is too bright and may fog the print during development, make a test with an unexposed piece of printing paper by leaving it face up, but with one half covered, for a slightly longer period than the time of development – say 3 minutes – placing it near the development dish. If the uncovered half shows any greyness when developed as compared with the half that has been covered, then the light is not safe and must be subdued or removed to a distance.

When much contact printing is to be done and consistent results are wanted, a printing stand or a printing box can be used. A printing stand consists simply of a baseboard on which the printing frame is laid and a post rising from one side of the board on which a lamp-holder can slide up and down and be fixed with a wing screw or similar fixing. This can easily be made at home.

A printing box can also be made at home, though it can be obtained in the photographic shops. It consists of a box containing a red-light bulb and a white bulb of 60 or 100 watts for printing. The top of the box is glazed and on the glass, with red light on, the negative is placed, emulsion side up; on top of the negative is placed the paper, emulsion side down; a hinged pressure-pad keeps the two in contact and exposure is made by switching on the white light. Alternatively, the light may come on automatically as the pad is pressed down; the top of the box may also contain a masking device. Control of degree of light cannot be obtained by varying the distance of the light from the paper and must be achieved by varying the power of the bulb or by inserting tissue paper between negative and lamp; nor can shading

of parts of the negative during exposure be carried out as it can be by the ordinary method of contact printing or by the use of the enlarger. Box printing therefore has its limitations, though it is useful for mass printing.

## Enlargers

Enlarging is printing by means of a projector. Basically, enlarging consists in projecting an illuminated negative through a suitable lens on to a light-sensitive paper which has been fixed either to a baseboard or to an easel. The size of the enlargement will be controlled by the distance of the enlarger body, which contains the lamp, the negative and the lens, from the baseboard or easel. In order that the image cast on to the board may be sharp, the lens can be moved either way until focus is achieved.

*Types and Makes of Enlargers.* Enlargers, sometimes called projection printers, can be divided into two kinds: (i) the old-fashioned horizontal type, and (ii) the modern vertical type. The principles on which they both work are the same and the chief difference between them is that the vertical type takes up less working space in the dark-room than the horizontal type and is less cumbersome; enlarging range, however, may be more limited in the vertical type than in the horizontal. The vertical enlarger has the advantage that the horizontal image cast can be more conveniently focused and the paper be more easily placed in position.

These two main types can be subdivided into two sub-types according to the method of light control: (a) the type whose light penetrates to the working lens through one or two condenser lenses, and (b) the type whose light penetrates to the working lens through a diffusing screen of ground, or opal, glass. The former concentrates the light strongly so that a contrasty, brilliant light falls on the paper and exposure time is relatively short. The latter diffuses and scatters the light, absorbing some of it, especially the blue part of it, so that a softer, weaker light falls on the paper and exposure time must be relatively long. Directed condenser light

may, indeed, produce at least double the contrast range on a print as compared with a diffuser light. Diffused illumination tends to subdue the effects of grain and of small defects or dust on the negative. It is usually found on the cheaper enlargers and in those used for large negative sizes. Diffusing enlargers do not produce very brilliant and detailed enlargements, but they can be useful in portraiture when large negatives are made which have been retouched.

On the other hand, condensers, while producing even illumination and bright, detailed prints with short exposures, may give too much contrast to a print. The best enlargers combine the main features of diffusion and condensing, the diffusing screen being placed between the lamp and the condenser lens. An opal bulb will have a certain diffusing effect in an ordinary condenser enlarger.

The sketch overleaf shows how an enlarger is made. First comes the opal lamp of special make contained within a lamphouse with ventilation ducts, trapped against light. Next comes either a diffusing screen or a condenser probably consisting of two plano-convex lenses with their flat surfaces facing outwards; this condenser directs the rays of light in such a way that they cast a bright and even disk of light on to the negative below. The more elaborate enlargers may contain both a diffusing screen and a condenser. Then comes the negative carrier which slides into the base of the lamp-house; it will probably consist of a wooden or metal frame holding two sheets of glass between which the negative is sandwiched. Some carriers are glassless, an advantage to the extent that the number of surfaces to hold dust or marks is reduced from six to two. Below the carrier is a space enclosed either by bellows or a movable metal tube, and at its base is the projector lens and an iris diaphragm for controlling the amount of light which will fall on to the baseboard below. The distance between the lens and the negative carrier will be adjustable for focusing. The lamp-house can move up and down a column by a sleeve so that the size of the image falling on the baseboard can be adjusted to suit the selected paper size. Thus it will be seen that an enlarger is a kind of camera; indeed, a camera can be used to form part of an enlarger.

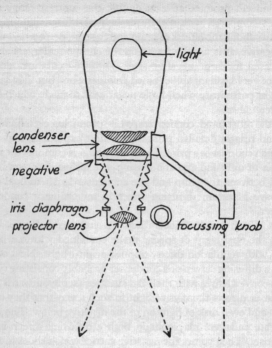

**25.** Basic parts of an enlarger.

In most enlargers the position of the lamp-house on its column and also the focusing of the lens must be carried out manually and separately. Some makes, however, contain a device whereby focusing is carried out automatically as the lamp-house is moved. Semi-automatic focusing is provided in some models whereby corresponding scales on column and focusing mount allow manual focusing without the need to examine the image on the baseboard. Mechanical catches sometimes aid this semi-automatic type. Another kind of semi-automatic focusing uses the rangefinder principle; here the enlarger projects two lines on to the baseboard and by turning the focusing mount in the right direction the lines are made to coincide; when this happens the

lens will be focused and the image on the baseboard will be sharp. Refinements such as these are not essential but they save time and trouble when much work has to be done.

Some enlargers have extra long bellows or other kinds of extensions between negative carrier and lens, so that they can produce not only enlargements but reductions also. For enlargements the distance between lens and paper will be longer than that between lens and negative; for prints of equal size to the negative the distances will be equal; while for reductions the distance between lens and negative will be greater than that between lens and paper.

The vertical enlarger has less range than the horizontal type with its separate vertical paper easel, but some vertical enlargers have their lamp-house attached to the column in such a way that it can be swivelled through 90 degrees to form a horizontal enlarger when enlargements are wanted which are bigger than the baseboard will take; in that case a vertical easel board will be needed to hold the paper, or a wall. Such a swivelling lamp-house will also allow the enlarger to be used as a projector of positive transparencies. When specially large prints are needed and the lamp-house cannot swivel to a horizontal position, it can usually be swivelled on its column through 180 degrees and a larger baseboard placed below it, possibly on the floor; alternatively a mirror can be placed at an angle of 45 degrees on the baseboard and the reflection cast on to a vertical easel or on to a wall; in that case, of course, the negative will have to be placed in reverse in the carrier or the print will be in reverse.

The lens is as important to an enlarger as it is to a camera, and if a negative has been produced by a camera with a fine lens we should use an apparatus to enlarge it which has an equally good anastigmat lens. A poor lens would produce an enlargement lacking sharp definition and blurred at the corners. Most enlargers are supplied with their lenses but lenses can be obtained separately and it may be possible to use your camera lens in your enlarger if this is detachable; Leica lenses, for instance, can be used on most 35-mm. enlargers.

The focal length of the lens should be the normal one of the camera in which the negative has been produced; that is, it should

be about the length of the diagonal of the negative. If the focal length is too short, the lens may fail to cover the negative adequately and corners will fade off. A lens of long focal length will work well, but the distance between lens and paper will then have to be rather long and will therefore need an inconveniently long pillar. The lens aperture at $f/6 \cdot 3$ or $f/5 \cdot 6$ will be adequate but $f/4 \cdot 5$ or $f/3 \cdot 5$ will be more satisfactory in that they will pass plenty of light at their full apertures which will make focusing easier and will allow exposure times to be shorter without loss of definition.

In enlarging, length of exposure is not as important a matter as it is with a camera because the negative and the paper do not move. A lens wider than $f/5 \cdot 6$ may not produce good definition at its greatest aperture and may also need such short exposure times that control during exposure will be impossible. Too small a stop, on the other hand, may make exposure times excessively long. A good enlarger lens should not produce distortion or curvature of field in the print, and it should be of such a focal length that its position below the condenser transmits the greatest possible amount of light focused by the condenser; the focal length of the projector lens should, in fact, be about twice the focal length of the condenser lens and will then be slightly less in length than the diameter of the condenser. Therefore, it is not generally satisfactory to use one enlarger for various sizes of negative unless both condenser and projector lens can be changed to suit the size of negative and also to suit each other.

If you are making an enlarger yourself or wish to adapt an enlarger for any abnormal purpose, the following equations are useful, for they will allow you to calculate how many diameters of enlargement can be obtained given the focal length of the lens and any one of three distances between: (i) lens and negative, (ii) lens and paper, or (iii) negative and paper; alternatively, given the number of diameters wanted and one of the three distances, you can discover the focal length of the lens; thirdly, given the number of diameters and the focal length of the lens, you can discover any one of the three distances. Note that the number of diameters, or $D$, is the number of times of linear enlargement, e.g. when $D$ is eight (designated $\times 8$) a negative measuring 1 inch

by 1½ inches will produce a print measuring 8 inches by 12 inches. The equations are:

Distance between lens and negative $= F+(F \div D)$
Distance between lens and paper $= F+(F \times D)$
Distance between negative and paper $= 2F+(F \div D)+(F \times D)$

where $F$ is the focal length of the lens and $D$ is the number of diameters of enlargement. The equations are not infallible, being incorrect to a small extent for a few lenses, but as a general guide they are reliable.

All the best enlarger lenses today are coated to increase the amount of light they will transmit and to reduce the scattered light reflected from their surfaces; the result is a more brilliant print. The best lenses are now also colour corrected for enlarging from colour transparencies.

Special opal lamps for enlargers can be obtained with powers between 60 and 200 watts. Future developments are likely to provide cold cathode fluorescent tube lamps which give a brilliant light, last a long time, and have the great advantage that they remain cool. An enlarger can soon become rather hot if it is being used for some time continuously and this may cockle the negative or even soften the negative's emulsion.

Makes of enlargers vary a great deal in price, quality, efficiency, refinement, size, and type. At the simplest and cheapest level is the fixed-focus enlarger, usually in the form of a box, which can only enlarge a standard negative to one standard size – say 35-mm. film to quarter-plate prints. It consists merely of a long box at one end of which the negative is placed under opal glass and at the other end of which is placed the printing paper; the projector lens lies in between in a fixed position on a partition and exposure is made either by daylight or by some artificial light source outside the enlarger. A fixed-focus enlarger can easily be made at home out of wood using either a detached lens or the whole of a camera with its back removed to take the negative.

Another type of enlarger is a small portable one which folds away into a box for easy transport and takes its light power from a battery or accumulator. This is invaluable when mains electricity is not available.

The general run of amateur enlargers falls into three groups:

those taking 35-mm. negatives and enlarging satisfactorily to about eight diameters; those taking $2\frac{1}{4}$-inch-square negatives and enlarging to about six diameters; those taking $2\frac{1}{4}$ by $3\frac{1}{4}$-inch negatives and enlarging to about five diameters. Enlargers taking quarter-plate and half-plate are also made. Some models can be adapted to suit varying sizes of negative by changing the lens and also the condenser to suit the selected lens.

As already mentioned, the better vertical enlargers are so built that the whole of the lamp-house plus negative carrier and lens can be swivelled in the vertical plane. In that way not only can the enlarger be turned into a horizontal type when big enlargements are wanted, not only can it be used as a lantern-slide projector, but it can allow adjustment of the angle of the negative relative to the baseboard. This is useful when bringing converging lines on the negative (as of a building) to the vertical (p. 268). A tilting negative carrier will have the same effect.

One type of enlarger has a sensible sloping arrangement of the column which supports the lamp-house so that the arm holding the lamp-house to the column can be short and rigid. The better enlargers have refined arrangements such as a rack and pinion to ensure very accurate focusing. Baseboards are usually of wood but metal ones are also made. Sometimes a masking frame, either with two or with all four sides adjustable and marked in inches, is supplied as part of the enlarger, but usually it is obtainable as separate equipment. It is useful if white borders are wanted round the print; it helps you to compose part of a negative; it holds the paper quite flat. A masking frame is not essential and pins or adhesive tape will serve well enough to keep the paper firmly on the baseboard during exposure.

A weakness in many enlargers is the smallness of the iris stop markings which are difficult to read in a safelight. Some enlargers overcome this by having diaphragms which click into place at each stop when the iris ring or lever is turned. Another weakness in many enlargers is the lack of any means of tilting the negative carrier and/or the baseboard. A provisional tilting baseboard can be arranged, but in order to straighten converging lines in the enlarger, both tilting negative carrier (or as mentioned above, a tilting lamp-house) and tilting baseboard are desirable (p. 268).

Enlarging Procedure

Enlarging drill can be described in the following nine steps:

1. Clean the enlarger – lens, condenser, and baseboard. In enlarging, dust is the devil. The lens should be gently dusted with a soft brush or preferably with an anti-static polishing cloth. When a piece of glass is polished vigorously the dust may be removed but immediately it attracts even more dust to itself because of the static electricity generated by the rubbing. The special cloth acts on the glass in such a way that it repels the dust electrically.

2. Dust the negative if necessary with a soft brush such as one made of squirrel hair.

3. Insert the negative into the carrier, having wiped the glasses of the carrier with the anti-static cloth.

4. Insert the carrier into the enlarger, image side of negative facing downwards. Switch off the room light and switch on the enlarger light. Unless focusing is automatic, adjust the position of the lamp-house for the size of print required while focusing the lens approximately.

5. Focus the negative on to a sheet of white paper laid on the baseboard, the lens stop being at its widest. A special focusing negative can first be used if desired or very accurate focusing can be achieved by using a reflex focusing magnifier; this reflects the image on to a ground-glass screen which is then viewed through a magnifier. The focusing magnifier (such as the Vidox) has the virtue of giving a greatly enhanced brilliance of the projected image. This is a more accurate method than focusing directly from the negative or using a special focusing negative. Probably none of these devices will be necessary; direct visual focusing from the negative itself is usually accurate enough and then, if desired, part of the image can be viewed through a magnifying glass of long focal length.

6. Close the iris diaphragm down one or two stops as seems judicious. This will reduce the chance of inaccurate focusing

affecting the final print because the depth of field will be increased as in a camera. Note that reducing the aperture by one stop does not necessarily mean that the exposure must be doubled as is the case in a camera; the rule applies only to diffuser enlargers and not to those having condenser lighting. The factor will vary with the type of condenser enlarger used.

7. Turn out the enlarger light, or swing the red filter which some enlargers possess in front of the lens to cut off the beam of white light from the baseboard. Now test for exposure time. The simplest, and perhaps most effective, method is to pin a strip of the printing paper to be used on to the baseboard across a significant part of the image containing both highlights and shadows and then to give an exposure which is based on guesswork mixed with experience and intuition, timing either with the second hand of a watch or with a special timer or by counting. Then develop the strip fully, fix it for a moment, and inspect it in the room light. Make another test if the first is too far wrong to give sufficient indication of the required adjustment necessary for the final print.

A more elaborate test method is to pin a strip, or even half a sheet of paper, on the baseboard and then to give a series of five trial exposures across the strip by covering sections of it with an opaque card. Expose the whole, say, for 2 seconds; cover four-fifths and expose for another 2 seconds; cover three-fifths and expose again for 2 seconds and so on, until at the fifth and last exposure only one-fifth is covered. The strip when developed will show exposures of 2, 4, 6, 8, and 10 seconds and will give an excellent indication of the correct exposure required, whether this is exactly on one of the steps or intermediate between two of them. A second test strip in steps can be given if there is any doubt about exposure but this time the steps can be much shorter in time – say three steps only at 1-second intervals. Practice will reduce the need for tests of any kind to a minimum.

Even more elaborate methods of making exposure tests can be applied which use either a photo-electric or a visual enlarging exposure meter. The two known factors used in calculating the unknown factor, the length of correct exposure time, are the brightness of the light source which is discovered by the photo-

electric meter and the degree of sensitivity of the paper selected. But these methods are complicated and are hardly likely to be used by the average amateur. The trial strip is simple, accurate, and empirical.

A slight elaboration of the trial strip method is to use a Step Wedge. This consists of a film having a number of steps of tone of increasing density which is placed on top of the trial strip of paper. Only one exposure is made and the strip when developed will show a series of images representing different exposure times, each step having a time factor corresponding to a certain exposure.

8. With the enlarger lamp off, or with its beam covered with the red filter, place a piece of enlarging paper on the baseboard in its correct position. This position can best be fixed by having a special card covering the baseboard which is marked with the outlines of the standard paper sizes; these can be purchased or made at home with pen, ink, and ruler. The paper can be fixed flat on the baseboard either with a masking frame or with corner pins pushed in diagonally so that they cast as little shadow on the paper edges as possible. Alternatively, short pieces of surgical tape can be used; each corner piece of tape will be in two parts about two inches long overall and the two parts will be stuck together for part of their lengths; one end will adhere to the baseboard and the other end will adhere to the underside of the paper. The advantage of this method over pins is that no shadows will be cast which will necessitate either the cutting of the edges on the final print or touching up. (The new semi-coated papers like veribrom (p. 240) will be flat by themselves.)

9. We are now ready to expose for the final print. Exposure can be timed with a watch or with a second clock in the same way as the trial strip was timed; alternatively, a luxury gadget can be used. This is the time switch which is wired between the enlarger and the electric plug; it is pre-set for any desired exposure time between 1 second and 5 minutes and it automatically switches off the light when time is up. After exposure, develop, fix, and wash the print as already described.

Control During Printing and Enlarging

Very few photographs cannot be improved by some control during printing. Control comes under these headings:

1. Selecting part of the negative for enlargement.
2. Giving extra exposure to parts of the print, called 'printing up' or 'burning in'.
3. Withholding exposure from parts of the print, called 'shading'.
4. Controlling definition and texture.
5. Correcting converging verticals.
6. Printing with double negatives, called 'combination printing'.
7. Tone separation.

1. *Selecting Part of the Negative for Enlargement*. We have already discussed the aesthetics of this matter and came to the conclusion that the image as seen as a whole at the time of exposure tended to possess more vitality than one which was subsequently cropped. However, a picture may have been deliberately taken with cropping in view and have been visualized for this at the time of exposure. It is possible also that part of a negative may accidentally make a better picture than the whole, or it may merely need slight cutting at one side to improve the proportion or the balance.

When exposing only part of a negative, it is wise to mask the negative itself to the proportion desired in order to cut out the surrounding reflections from the unwanted parts of the negative on the baseboard; this will eliminate the slight fogging which may otherwise result. Black paper will serve well for this masking.

2. *Printing Up Parts of a Print*. This is done by covering part of the beam of light falling on to the paper with an opaque card, or with the hands, so that those parts of the printing paper which are not thus shaded receive additional exposure. This shading is particularly valuable for increasing the tones of skies and enhancing cloud effects. Keep the card or the hands moving slightly so

that noticeable demarcation is not produced. Of course, cards with variously shaped edges can be cut to suit the negative image – for example, to cover trees which project into the sky.

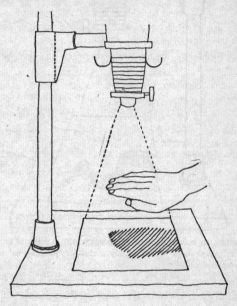

26. Controlling an enlargement during exposure by shadowing with the hand.

Vignetting around a portrait head can be done with a card having a large hole cut out of it – the card being kept on the move during exposure. Small black areas of the negative image can be given extra exposure with cards having holes of suitable size cut in them and this will bring out the details in a highlight in the print which might otherwise be a blank white.

Do not hold the card or the hands too close to the paper or the shadow edges will be too sharply defined. The amount of extra exposure needed will depend on circumstances and will have to be discovered empirically.

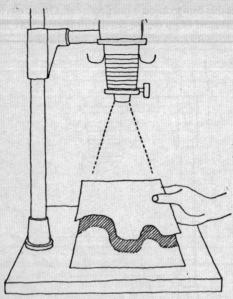

**27.** Controlling an enlargement by shadowing with a piece of cardboard cut to the required shape – particularly useful for 'burning in' clouds.

**3.** *Shading Parts of the Image*. This is printing up in reverse. Where small areas are to be less exposed than the rest of the print, as, for example, small areas which are too light on the negative image and represent the shadows on the final print, fingers of the hand can be used, or, if the shapes are unsuitable, then dodgers. These are small opaque pieces of card of requisite outline – or possibly a piece of cotton wool teased to shape – fixed to the ends of wire handles about one foot long. A set of dodgers can be purchased but they are easily enough made at home. As with cards or hands, dodgers should be kept moving slightly during exposure.

By using a very large dodger the corners and edges of the print can be darkened to concentrate the interest in the centre of the picture – a trick which can be useful in portraits.

Instead of withholding light from some parts, additional light can be cast on areas which are to be darkened by 'flashing' with

a pen torch to produce local fogging. The torch must be fitted
with a short extension tube of black paper having a cap at its free
end in which a hole of suitable size is cut; alternatively a cone of

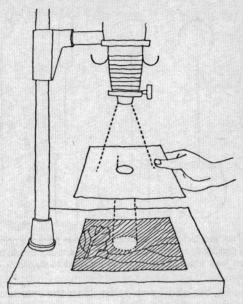

28. Controlling an enlargement by withholding light from all parts except
one spot which requires extra exposure, e.g. a dense highlight.

black paper can be fitted. While the flashing is in progress the red
or orange filter is swivelled in front of the lens of the enlarger.

4. *Controlling Definition and Texture.* The best way of obtain-
ing a soft effect of outline and definition is to take the original
negative with a soft-focus filter on the lens, but softness can also
be obtained in the final print by attaching a soft-focus filter or a
diffusion disk in front of the enlarger lens during the whole – or
better, during half – of the exposure time. Diffusion disks can be
obtained with different degrees of diffusing power. No increase of
exposure is needed but contrast will be diminished by about half

a grade and this must be taken into account when selecting the grade of paper to be used. The degree of diffusion can be controlled, not only by selecting a disk with a certain degree of dif-

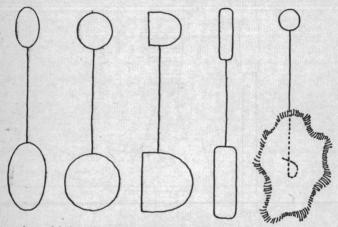

29. A set of dodgers for cutting off light from certain parts of a print, such as a small, dark shadow, during enlargement; the one on the right has an end of cotton wool which can be teased to the required shape.

fusing power, but also by stopping down the aperture during exposure when a disk is being used; in this way a disk which normally diffuses strongly can be weakened in its power.

It must be understood that the effect obtained by using a soft-focus filter on the camera is quite different from that obtained by using a soft-focus filter or a diffusion disk on the enlarger. On the negative in the camera the highlights will overflow into the shadows and so a bright effulgence is produced. In the enlarger, however, the reverse takes place because the light is coming through a negative; thus the shadow, being light in the negative, will overflow into the highlights which are dark in the negative and a gloomy image is produced. This diffusion through the enlarger has its possible advantages – for example, in softening wrinkles, gradations, and details in portraits and in low-key subjects.

A softer effect than normal can be obtained without soft-focus filter or diffusion disk in three ways: (i) by using a paper with a rough texture; (ii) by making part of the exposure slightly out of focus with a wide stop and then completing the exposure by stop-

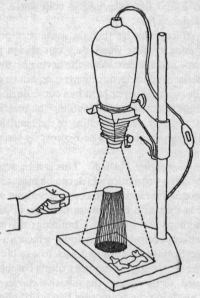

30. Using a dodger.

ping down, when the image will become more clearly defined; (iii) by rubbing a small amount of vaseline on a clear-glass plate and holding this below the lens during exposure while moving it about slightly.

To vary the overall surface texture of a print, texture screens can be introduced in contact either with the negative or with the paper. In either case the material should be in close contact with the film or paper – in the case of the paper, preferably under a sheet of clear glass. The choice of material is wide – tissue paper, *crêpe georgette*, embossed glass, a glass plate sprayed with lacquer.

Texture screens can also be photographed to make texture negatives.

Deliberate reticulation can be obtained to give a crazed effect by developing the negative at about 110°F, or by after-treatment by bathing the negative in a 10% solution of sodium carbonate at about 120°F and then washing in cold water. The negative should be hardened first.

All these effects may be thought somewhat phoney by the purists, but even at their worst they can always provide good entertainment – and sometimes results having aesthetic meaning.

Other experimental tricks during printing can be enjoyed, such as keeping the printing paper bent in a curve during exposure to produce strange distortions; by doubling the printing as already described (p. 193); by partial melting of the emulsion on a negative to produce grotesque faces or figures; by tone elimination.

5. *Correcting Converging Verticals.* This can be accomplished in an enlarger and is a procedure which can be most useful in architectural photography taken with a camera without a rising front. The picture is shot with the camera pointing upwards in order to include perhaps the whole of a building; this results in the perspective effect of converging verticals – a most un-architectural effect. The verticals can be brought back to a stable parallel state in the enlarger by placing a temporary tilting baseboard upon the level baseboard, or by sloping the negative carrier where this is possible, or by tilting the temporary baseboard one way and the negative carrier the other way.

The simplest kind of tilting baseboard can be contrived simply by resting one end of a firm board on a book or a box of suitable height. (A matchbox with its three heights can be useful.) A more permanent kind would be one having a support and a universal joint that can be clamped in the right position of slope with a wing screw.

Four snags arise from this method: first, the whole width of the negative cannot be used since the sides of the image cast by the enlarger will converge and will have to be trimmed; secondly, there will be some distortion of the height of the building – that is to say, it will appear higher in the print than it would appear in

reality; thirdly, one end of the image cast will not be in focus when the other end is in focus; fourthly, the light falling at the higher end of the tilted board will be stronger than that at the lower end.

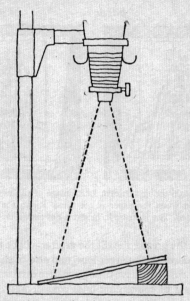

31. Adjusting converging verticals as in the case of a building photographed with the camera tilted upwards. The enlarger diaphragm must be stopped down to increase the depth of focus of the lens; if this is not done, part of the print will be out of focus and blurred.

The first snag can be overcome by reckoning when taking the picture that the sides will have to be removed during printing. Nothing can be done about the second snag but in most cases it will not be of consequence.\* The third snag can be overcome by focusing the centre of the image cast by the enlarger and then stopping down the diaphragm considerably to increase the depth

\*The increase in height will, of course, vary with the angle of tilt of the camera but it will usually be about 5%. It will be less when the baseboard is tilted than when the negative carrier is tilted.

of focus of the lens. The fourth snag can be overcome by judicious and progressive shading of the higher half of the tilted paper during exposure. The angle of the tilt will, of course, be conditioned by the extent of the tilt of the camera when the negative was

*paper*

32. Adjusting converging verticals. Left, image of the negative thrown by the enlarger when the paper is not tilted. Right, the image when the paper is tilted. The increase in height is not shown on right.

exposed and the greater the tilt the greater will be the importance of stopping down the enlarger lens, and also of shading.

Not many enlargers have tilting negative carriers, but they help the adjustment of converging lines considerably. The tilting of the baseboard on its own may be sufficient without the tilting of the carrier but if both carrier and baseboard are tilted in opposing directions, the degree of tilt of each can be halved.

6. *Combination Printing*. This is particularly useful where a negative is 'bald-headed', that is, where the sky is boringly white and blank. The negative is printed in the ordinary way; it is then removed and a special sky negative is inserted into the enlarger. Another exposure is given to the print from this sky negative, the lower part of the print being shaded during exposure either with a card or with the hands.

Sky negatives should be made with short exposures in order that all the tones of clouds may be reproduced, and they should

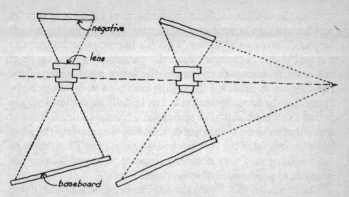

33. Adjusting converging verticals. Left, baseboard only tilted. Right, baseboard and negative carrier of the enlarger both tilted; in this case the angle of tilt of the baseboard can be halved.

be taken at the same time of day and with the sun in the same position relative to the camera as existed when the picture to be enhanced by this negative was taken. If this is not done, the sky will appear artificial on the final print. The landscape enthusiast and the architectural photographer may like to make a good collection of sky negatives from which a suitable one can be selected for a particular picture; the circumstances under which each sky negative was made should be recorded on its envelope container. Sky negatives should be taken as high up as possible, say from a house-top or a hill in the open country, in order that tilting the camera may be avoided; tilting may produce incongruous and artificial effects. Make sure that the shadow side of the clouds corresponds to the way the shadows fall on the main negative; reverse the sky negative before exposing it in the enlarger to provide for this, if necessary.

Many interesting effects can be made by combination printing, effects limited only by the photographer's imagination: multi-face portraits; bas reliefs made with a negative in combination with a positive transparency produced from the negative and printed together just off register; combinations of positives and negatives in various other ways; introduction of foreground motifs such as tree branches, grasses, and so on. This is a kind of photomontage.

7. *Tone Separation*. A form of combination printing is that by which a negative is separated out into two or more negatives, each having different tonal values. This is a fairly new technique and a splendid one because it brings the considerable tonal range of the negative transparency within the lesser tonal range of the printing paper. Provided the negative contains all details in highlights and shadows, these details can be fully reproduced on the print by this method of tone separation when the ordinary straight method of printing would not do this, however cleverly the print has been treated in the enlarger and the developer. Thus, through tone separation, a very contrasty negative or a very flat one can be made to produce a first-class print.

The process is as follows: the original negative is broken down into two (or more) negatives; one of them is made to reveal the highlight details and gradations fully, the shadow details being absent; the other is made to reveal the shadow details and gradations fully, the highlights being so dense as to be virtually opaque. First, place the original negative in a printing frame in contact with a sheet of film, a process plate, or a chloro-bromide lantern plate and make a positive transparency like an ordinary contact print. When it has been washed and dried make registration marks at the top and bottom of the positive in the form of pinholes or small scratched crosses.

Print the two negatives from this positive transparency in a printing frame, each in a different way. The first negative must be printed on a contrasty process plate or film and be developed in a contrasty developer or else very fully in a normal developer. Fix, wash, and dry in the normal way. This first negative will show the shadow details and the highlights will be blocked. The second negative must be printed on a soft plate or film and be developed in a soft developer or in a weak normal developer. Fix, wash, and dry. This second negative will show the details in the highlights and the shadow details will be missing.

The final print is now made on one sheet of bromide paper in the enlarger. First print the hard negative giving normal exposure and pin-prick or pencil the registration marks on the baseboard during the exposure. Cover the enlarger lens with a red or orange filter and replace the hard negative with the soft one, making sure

in the light available through the lens filter that the registration marks tally. Give a fairly short exposure. Process the print in the normal way.

A perfectly graded print can be made by this fascinating method from a negative which, at first sight, looks unpromising. Moreover, a great variety of tonal effects can be produced, from a normal print to one containing no half-tones at all but pure black and white. As many as four or five separation negatives can be made, each containing only one tone. This is full printing control and it is pure photography.

A modification of this tone separation process can be carried out when exposing the subject with the camera, but when this is done the object must be a still one and the camera must, of course, be fixed to a tripod or be held firmly by some other means. Simply take two exposures, one for the shadows and the other for the highlights and print the two as indicated above.

### After-Treatment of the Print

*Brown Toning of Bromide Prints.* Many methods are available of toning to achieve monochrome finishes of various colours – sepia, purple, blue, green, and red. Here we shall mention only a particular one which produces a pleasant brown colour and has the added advantage that, unlike many toning methods, it makes a print permanent.

First, the bromide print must be slightly over-developed in the normal way to be full and contrasty. Then it is bleached in the following solution:

| | |
|---|---|
| Potassium ferricyanide | 1 ounce (28·4g.) |
| Potassium bromide | 1 ounce (28·4g.) |
| Water to make | 10 ounces (284 ml.) |

That is a stock solution, and for use 1 ounce of it is added to 10 ounces of water. The stock solution must be stored in a dark bottle in darkness.

Move the print about in this solution until all that remains is a pale yellowish image. Then wash the print in running water until

it is free of the yellow-green stain. Next, immerse the print in a solution of the following darkener:

| | |
|---|---|
| Sodium sulphide | $\frac{1}{2}$ ounce (14·2g.) |
| Water to make | 10 ounces (284 ml.) |

That again is the stock solution, from which for use 1 ounce is added to 10 ounces of water. This should also be stored in a dark bottle in darkness.

In this second solution the print will soon darken to a pleasant brown shade. Soft paper will tend to produce a warmer colour than a contrasty one, and the less potassium bromide is used in the first solution the warmer will the tone be. Wash the print, of course, after treatment and dry in the usual way. Kodak T52 is a proprietary sulphide sepia toner of this kind.

*Treating Print Faults.* As with negatives, various methods can be applied to treating prints which have been wrongly exposed or developed, such as intensifiers and reducers, but such ameliorations seem hardly justifiable and the results are less satisfactory than they can be with negatives. A print failure can be discarded and another and better print can soon be made, if the negative is good, whereas a negative may not be repeatable.

If a print looks fairly good towards the end of its time in the developer but has too little detail in the highlights, these highlights can be improved by finishing the development in a bath of warm water at about 100°F. The developer which is left in the emulsion will then continue to work on the whole print, but much more actively on the highlights than the shadows where the developer will have lost most of its energy. A 5% solution of sodium carbonate in place of the plain water will enhance the effect.

Sometimes local reduction is useful, especially in removing dark spots, caused perhaps by scratches or abrasions on the negative, or to give an added sparkle to a highlight. This can be done by lightly spotting the area to be reduced with a half-damp fine sable water-colour brush dipped in a ferricyanide-hypo reducer (p. 235). Work on the dry print in a good light, stippling the brush vertically on to the area to be treated; do not paint on the solution or the surrounding area may be affected. As soon as the action seems to have worked far enough wash the print.

## Touching up Negatives and Prints

The local reduction by chemical means described towards the end of the last chapter (p. 274) is a form of 'touching up'. It can be carried beyond the simple purpose of removing black spots on a print or of brightening a highlight. By its means a whole background can be weakened on a print or removed entirely so that pure white results. This is called 'blocking out'. Soak the print in water for a few minutes, then place it on a sheet of glass and remove the surplus water with a cloth or with photographic blotting-paper. Now paint the reducer round the edges of the main subject first with a fine sable brush and then fill the rest of the background with the solution, perhaps with a larger brush. The effect of the reducer can be checked at any point desired by immersing the print in water. When the reduction has gone as far as desired, complete the process with a thorough wash.

This blocking out can also be done on a negative provided it is not too small. For treating a negative in this way, and for all negative retouching, a retouching desk will be needed (p. 276). The background touched out on the negative will, of course, appear black on the print.

This leads us to the subject of physical retouching of prints and negatives with pencil, water-colour, dye, and retouching knife. A good enlargement can certainly be produced without the need for any retouching on either negative or print and that is the ideal to aim at. But only extreme care will allow this, particularly the care taken to prevent dust falling on to the negative or printing paper during exposure in the enlarger. Most enlargements can be improved by judicious touching up, if only in the form of spotting out dust marks, scratch marks, and other small blemishes. Retouching on the grand scale to produce 'artistic' effects may be necessary to the survival of the professional portraitist, but it

should be avoided as un-photographic by the amateur. Apart from the aesthetic aspect, touching up at a professional level is highly skilled craftsmanship which takes much experience and practice to learn. It has been well said that 'manual beautification of photographs is a perversion of photography', but even to the amateur retouching is a necessary evil for the removal of blemishes, and a certain amount of beautification of a close-up portrait can be justified – such as the removal of a freckle or a pimple which will not be there in a week's time in any case.

Retouching media are the same for both negatives and prints – pencil, water-colour, dye, and knife. Because the negative may be small and in reverse, retouching there will be far more tricky than on an enlargement. In general, therefore, the amateur is advised to restrict retouching to his prints, even though a practised hand can deal with minor flaws on negatives even down to 35-mm. size. Treating a negative has the advantage that only one session of retouching will be needed for an indefinite number of prints made from that negative – unless, of course, one master print is retouched and then re-photographed to provide a second master negative (p. 280).

*Negative Retouching.* The first essential is a retouching desk. Basically this is a sloping surface made of a wooden frame surrounding a translucent diffuser of opal glass or ground glass with polished surface uppermost. Through this easel, light is made to shine. The negative is placed over the glass so that the details can be properly seen. A simple model would have a wood frame, struts, and a white sheet of paper beneath it to reflect light from a window; a more complicated model would possess an electric light inside a box as its light source. A hood around the top and sides of the easel, painted black inside, will help to exclude unwanted and disturbing external light, while masks of suitable size around the negative will exclude unwanted internal light. An extra movable mask with a circular hole in it can also be used to restrict the light further to the small working area of the negative. A refinement would be a subsidiary, revolving frame within the main easel frame so that oblong negatives can be dealt with either in a vertical or a horizontal position; alternatively masks cut

vertically *and* horizontally for the same sized negative could be used. The handyman should be able to make such a retouching desk with a few pieces of hardwood, plywood, screws, and glue, though standard makes can be obtained in the shops.

When retouching very small negatives, say of 35-mm. size, a magnifying glass held on a support in front of the easel will be indispensable; alternatively, a pair of magnifying spectacles can be used.

Retouching methods applied to negatives are the same as those applied to prints, apart from certain differences, and these methods are described below. The differences in the case of negatives are that:

(i) A retouching desk must be used.

(ii) When a pencil is used, the negative must be treated first with retouching medium, a kind of varnishing fluid which is sparingly and gently rubbed on to the negative emulsion with a smooth cloth, or with the finger tip, and allowed to dry. Such a fluid can be obtained in the shops, but the varnish whose formula is given on page 279 can also be used. The fluid will dry in a minute or two and will then have provided a surface on which the pencil will 'bite'. The pencil, say of HB scale of softness, should have a sharp point and should be worked in a more or less vertical position in a series of circular scrolls until the right tone has been produced. The medium should not be applied when using water-colour or dye but only when using a pencil; nor should a pencil be used when the fault to be remedied has penetrated to the bare glass or film base of the negative; in that case dye or water-colour will serve better.

(iii) When enlargements are to be made, the negative is best retouched with dye and this dye can be applied, like a reducer, to cut out the entire background so that it will appear white on the print; a red dye instead of a grey one can be used because this will be clearly visible and thus easier to manipulate round the delicate edges of the main subject than a grey dye.

(iv) When using special black or grey water-colour for spotting, a small amount of gum added to the water-colour will help

and this can be obtained simply by wiping a moistened brush across the gum of an envelope flap.

(v) Manipulating a retouching knife or safety-razor corner on a negative is possible to remove black spots, but the knife or razor must be wielded with very great delicacy in order that the emulsion surface may not be penetrated.

*Print Retouching*. This falls under two main headings: (i) treating white spots and lighter areas in order to make them darker; (ii) treating black spots and darker areas in order to make them lighter. In either case the retouching should be like invisible mending; it should not show, either when looked at directly or when seen sideways; in the latter case, the scratching or spotting should not be obvious as a change of texture.

Something has already been said about treating black spots chemically and of removing dark backgrounds with a reducer. Now for the knife method. Special small lancet blades can be obtained, some of which can be fitted to an ordinary pen-holder like a nib, but safety razor blades, possibly split in two diagonally, will do very well. The knife or razor blade must be as sharp as possible. It should be applied with the blade almost parallel with the print surface and the damned spot or other offence should be removed by gently stroking it backwards and forwards with the blade, care being taken not to penetrate the emulsion surface or to remove too much of the emulsion at once. To hide the rough surface produced, the scratched area can be touched up with a thin solution of gum and water.

Spotting with a soft pencil can only be applied to a print with a matt surface and is no use on glossy or glazed surfaces. Pencil spotting is best restricted to spots and small areas rather than to large areas. The main trouble with pencil work is that it can easily be rubbed away. To prevent this happening three methods can be applied: (i) hold the print for a few moments after spotting in the jet of steam from the spout of a boiling kettle; this will melt the surface of the emulsion so that the gelatin merges with the pencil work; (ii) rub the whole surface of the print with a wax compound such as white shoe cream, using the cream sparingly and rubbing it in evenly with a circular motion; then polish the surface with

a soft cloth; (iii) apply a special varnish, such as that given below, to the whole print with a pad of soft cloth.

Spotting with water-colour paint is perhaps the best method for it is the most easily controlled. Use a good quality artist's water-colour such as Payne's Grey, possibly mixed with burnt umber for the prints of warmer tone; or use the special materials such as Johnson's Spotting Medium, Kodak Spotting Black, or Winsor and Newton's Spotting Colours. Brushes should be of best quality sable with sharp points, probably of 0 to 00 size. Match the pigment to the tone of the area surrounding the spot to be treated as required by adding water; apply the brush fairly dry in an almost vertical position, working the brush with a series of tiny dots from the outside to the inside of the spot. The retouching can be fixed by one of the three methods described above for pencil work.

Water-colour spotting is possible on glossy papers and a little gum added to the brush (as from an envelope flap) will help to make the result glossy, so that it blends in texture with the rest of the print's surface. The best method, however, is to glaze the print a second time without soaking it too much. For this it is wise to cover the print surface before placing it in the glazer with a colourless print varnish of the following composition:

| | | |
|---|---|---|
| Borax | 160 grains (10·4g.) | |
| Glycerine | 290 minims (17 ml.) | |
| Shellac | 320 grains (21g.) | |
| Water | 10 ounces (284 ml.) | |

Boil the mixture for 20 minutes, add 2½ ounces of methylated spirit and filter.

Spotting with dye: Use a special dye such as Johnson's Black Negative Dye or Martin's Retouching Dye. This can be applied on a print to be glazed as well as on matt surfaces, because it is absorbed by the emulsion and remains fixed – unlike pencil or water-colour. Work on a damp print laid on a sheet of glass or on a board of some kind. Since the dye can only be removed by prolonged soaking in water and even then not completely, the work should be built up gradually, using a fairly watered-down tone applied in two or more coats if necessary. Stipple the dye on to the surface with a fine brush as with water-colour.

## Re-photographing

When a great deal of retouching must be done on a print and many prints from the same negative are required, the print can be re-photographed to provide a negative with all the faults made good for every future print.

Re-photographing can be done either with a camera – provided this produces a fairly large negative and has a double extension of bellows – or with an enlarger. In either case strong artificial lighting, shining on to the print to be photographed from both sides and shielded from the lens of the camera or enlarger with reflectors, is advisable. A matt, but not a rough, print surface should be used to avoid unwanted reflections.

If the enlarger is used, it is worked in the following way, in reverse. The print to be photographed – or for that matter any object – is placed on the baseboard, is adequately lit as described, and exposure is made on a plate held in the negative carrier. The plate can be a slow Process, or Ordinary, plate or cut film, or it can be a chloro-bromide lantern plate of medium contrast grade. First focus the lens on to the baseboard to the size of the print to be photographed, using any focusing negative, emulsion side uppermost. Place the print on the baseboard in the right position, and, in the safelight, place the plate in the negative carrier emulsion side uppermost, backing it with black paper on the upper side if it is not already a backed plate. Now carefully cover up the lamp-house all round the negative carrier so that no light can reach the plate except through the lens of the enlarger. Expose the plate by the lighting system described above or otherwise by removing the lamp from the lamp-house, if this is possible, and using this to illuminate the print on the baseboard. The hole left at the top of the lamp-house must, of course, then be properly covered; the light should be moved round the print to ensure even illumination and it should be held above the level of the lens to prevent any direct light from the lamp penetrating through the lens.

Develop the plate in any normal MQ developer and fix and wash as usual. If a reproduction of some black-and-white object is wanted – such as a manuscript – then a contrasty or lith film

should be used and the developer should be of a contrasty type such as one having hydroquinone only without metol.

## Trimming and Mounting

The finished print will not look its best until it is trimmed and mounted. Trimming can be done with a straight metal edge, preferably that of a right-angled set square, and a trimming knife or razor blade. A sheet of glass makes a good base. A better way is to use a special print trimmer or guillotine which automatically gives a right-angled cut and is quick to use.

Special mounting boards are obtainable but so-called Fashion Boards are excellent; these can be obtained at any artist's colour shop in various sizes. Choice of mounting method is a matter of taste, but probably plain white matt backgrounds are the best without any additions such as ruled borders or sinkings. Small prints look well with fairly generous borders but for an enlargement of, say, 16 inches by 20 inches, a mount of 20 inches by 25 inches is probably adequate. Give a wider margin to the base than to sides and top, and make the latter all equal in width. Mark the print corners on the mounting board with pencil dots and join these up with light pencil lines as guides. As adhesives three alternatives exist: special photographer's paste, rubber solution, dry mounting tissue.

Only the special mounting pastes should be used because ordinary office paste or gums may be chemically impure and their acidity may affect the print in time. Even the special pastes have the disadvantage that they tend to be hygroscopic, that is to say, they tend to hold moisture and in cities the moisture may absorb the hydrogen sulphide in the air to the possible detriment of the print. Other disadvantages of pastes are that they are messy to handle and may not mount flat. If paste is used, it should be applied to the back of the print very evenly and be smoothed down with a straight edge. The print is then placed in position on the mount and is rolled flat with a squeegee.

A rubber solution, such as Cow, is preferable to paste, but solution intended for tyre repairs should not be used. Spread

the solution thinly and evenly on the back of the print and then also on the area of the mount which is to be covered by the print; it is important to cover both surfaces. Wait until the stuff is tacky, then place the print in position marked on the mount and squeegee hard from the centre out towards the four sides. Wait 10 minutes and then use the squeegee again. Any surplus solution can be wiped away with a soft, dry cloth and will leave no mess.

Dry mounting is perhaps the best method, but only if it is done with a special mounting press. It can be done, so they say, with an ordinary flat-iron heated to the temperature of boiling water, but I have never found this satisfactory in my own experience; sooner or later bubbles of air show themselves.

Dry mounting is done with special tissue made of shellac which melts when heated and so impregnates the mount and the back of the print. The tissue is made in standard print sizes and also in rolls. Take a suitably sized tissue and with a small hot iron specially made for the purpose (or with the point of an ordinary domestic iron) dab a small area of the tissue so that it will stick to the back of the print. Now place the print with its tissue backing on to the mount and dab the underside of the corner of the tissue so that it sticks to the mount. Cover the print with a metal sheet and insert print and mount into the Dry Mounting Press. Turn the screw of the press and keep the print therein for about 10 seconds or more at a temperature, shown on the built-in thermometer, of 180°F. Remove the mounted print and gently bend it back and forth to stretch the shellac which has now melted into the fibres of the board and print back; this is to prevent the mount's curving inwards. Finally trim off any tissue showing at the edges with a sharp knife or a razor blade.

If it has not already been treated, the print can now be spotted and retouched if necessary; the mounting board provides a good backing on which to work. To protect it and to lengthen its life, the print can finally be treated with a colourless varnish such as that described on p. 279. Another varnish that will remove all signs of touching up is a mixture of copal varnish and artist's turpentine mixed in the proportion of 1 to 3 respectively. Spread it on evenly with a soft rag.

**PART FOUR**
*Colour*

General

Colour photography needs no special camera though the lens should be a good one having a maximum aperture of not less than $f/6 \cdot 3$ and preferably $f/4 \cdot 5$ and it should have been colour-corrected during manufacture. Most modern lenses are so corrected. The shutter should be reliable and, if much colour work is done, it should be tested, and adjusted if necessary, because accurate exposure is essential to colour work.

In some ways colour photography is easier than black-and-white; in other ways it is more exacting – as we shall see. But provided the instructions are followed carefully, any snap-shooter can obtain good technical results under normal lighting conditions.

The first fact to realize – one of the greatest importance – is that the latitude of reversal (positive) colour films is less than that of black-and-white films. Whereas a variation of three diaphragm stops will produce a good result in black-and-white, a variation of half a stop either way is the limit for colour. If funds permit, it is therefore wise to take three exposures of each subject with half a stop variation between each – at least where any doubt about correct exposure exists. Because of this restricted latitude, contrasty subjects should be avoided, the best results being obtained when the contrast between lightest and darkest tones is no more than four to one. Fairly soft, flat but bright light is therefore the best – for example, sunlight shining through thin cloud is generally preferable to brilliant, unobscured sunlight.

As a working rule, though not as a dogma, expose with sunlight behind the camera in order to avoid deep shadows; the working rule for black-and-white of avoiding back lighting is thus reversed for colour work. Early morning and late afternoon give warmer colours and a cloudy day is good for close-ups. In artificial

*Photography*

lighting the same general rules apply: flat lighting falling from
an angle of about 45 degrees from directly behind or close to the
camera and softened with a diffuser such as muslin.

A second point to realize about colour films is that they tend to
be slower than black-and-white films; hence the need for a lens of
fairly large aperture.

A third point to realize is that colour photography can be con-
trolled with far less ease than black-and-white in processing and
touching up. Control must be applied during exposure in the
form of proper exposure calculation, proper lighting, and the use
of colour-correction filters if necessary.

A good exposure meter is particularly valuable in colour work.
If you do not own one, the instructions about exposure issued with
the film should be followed. In smoky towns where the air is
polluted, the exposure may have to be doubled.

Over-exposure will produce a thin transparency with weak, pale
colours, whereas under-exposure will produce dense transpar-
encies and, if under-exposure is only slight, brilliant colours.
Either way the colour balance will be wrong, but slight under-
exposure (say by 25%) is preferable to over-exposure.

A factor that must be taken into account when calculating the
exact exposure and diaphragm stop is that the light-passing power
of a lens is reduced when the distance between lens and the
sensitive film surface is increased to bring close objects into focus.
This must be accounted for and the equation for calculating the
adjustment is given on page 109.

Another important piece of advice: Always use a lens hood. The
reduction of scattered, unwanted light within the camera is even
more important in colour work than in black-and-white.

We must understand from the start that the colour film will
evaluate colours differently from the human eye – though not
necessarily 'incorrectly'. The eye is conditioned subjectively by
the mind and what we think we see may not be at all the same in
colouring as what we actually see. For example, we know that our
subject is wearing a white dress and we think that it is still white
when she is standing under a leafy tree; in fact, the filtering of
the sunlight through the leaves will have made the dress pale
green in colour and the colour emulsion will record it as such.

Similarly we consider her complexion to be at all times of a delicious, peachy pink but, exposing on a sunny day without correction filter to adjust the blue cast from the sky, we shall be shocked to find that the colour film has recorded the skin as having a slight indigo tint and, worst of the horror, as veined and blotchy.

We must realize also that adjoining colours may affect each other through the light which each reflects, whereas our mind has unconsciously 'filtered' these effects away. A snow-white swan seen floating on a blue lake may be recorded on the film as though dipped in a pale blue dye. The quality of daylight, its spectral composition, varies greatly from day to day and from hour to hour and this must also be taken into account.

## Aesthetic of Colour Photography

Something has been written already about this subject (pp. 62–4). Here are a few added thoughts. First, we must see with quite a different vision for colour photography than for black-and-white. We are trying to make a picture with the flat surface shapes that colours make rather than with the strong lines, three-dimensional masses, textures, and tonal contrasts we seek in black-and-white. We must compose with coloured areas rather than with tonal volumes. Contrast is achieved with changes of colour rather than with changes of tone. Extremes of light and shade must therefore be avoided for aesthetic as well as technical reasons.

The close-up or the moderately close, flat, two-dimensional pattern, well filling the whole frame, will generally give richer and more interesting results than the distant view or the deep perspective. All irrelevant details, as in backgrounds, should be avoided, and piecemeal, scattered subjects (such as distant landscapes, or mixed flower borders) are rarely successful. Simplicity, boldness of shapes, and restraint in colour should be the aim.

The range of colours, the palette so to speak, should be restricted and balanced. If the colour contrasts are strong, then tonal contrasts should be the more carefully avoided. The most effective colour pictures I have seen are those in which the colour range is

restricted almost to a monochrome with just a touch of brighter colour as a focus or as subsidiary points of interest. Try to create a colour scheme of harmonies and contrasts, keeping to a certain key, whether it be warm as in reds, oranges, and yellows, or cool as in greens and blues. A touch of cool colour in a general framework of warm complementary colours, or *vice versa*, will be more telling than a chaotic mess of all the colours. Realize that complementary colours, that is, opposite colours such as red and blue-green (cyan), or blue and yellow, will tend to enhance each other's brilliance.

It is a mistake to assume that we must always achieve colour results which are 'correct' – that is as similar as possible to the actual colours of the subject photographed. By the use of filters and by the application of experience, we should be able to control colour results to a large extent and to be able to assess what colours will appear on the finished transparency or print. Almost never will the colours be the same as those we believed we saw in reality at the time of exposure. If we produce a print on paper from a colour transparency or by separation negatives and dye transfers (to be described), considerable control of colours will be possible by the way of masking and colour filtering in the enlarger; thereby a wide creative scope will be possible.

## Which System ?

The methods of colour photography used at the present time can be divided into three main groups:

1. The Integral Tri-pack Positive (Reversal) Transparency system, directly providing transparencies in positive colours. The term Reversal denotes that the negatives are reversed to positive colours during processing.

2. The Integral Tri-pack Negative Transparency system, which produces a transparency in negative colours and is used to make either a print in positive colours or a separate positive transparency.

3. The Three Negative Separation system. This involves the exposing of three separate negatives on black-and-white pan-

chromatic film, each through a special colour filter, and the subsequent production of three pigment, or dye, transfers laid together in register to produce the final print. This is the traditional system, of which Vivex Carbro, now defunct, was the classic example. It has been in use for many years and has yet to be surpassed by more modern methods in the rendering of colour. Note that a colour transparency can be separated out in three black-and-white separation negatives for dye or pigment printing provided a mask is used to reduce contrast, but the results are not likely to be quite so good as when the separation negatives are the originals.

When deciding which system to adopt, the first inevitable question is: What is the objective? At its simplest this question reduces itself to: Slides or prints? If the intention is to produce direct colour transparencies for enjoyment through a hand-viewer or by projection on to a screen, then the Reversal (positive) films should be used, either of 35-mm. or 2¼-inch-square size. If the intention is to produce a coloured print, then either negative colour films should be used of as large a size as possible, or, preferably, the three separation negative system for printing with the Kodak dye transfer process. If the intention is to produce a coloured block for mass production in a magazine or book by printing, then either the positive transparency or the print is suitable, though most block-makers today are happiest with large positive transparencies such as Ektachrome sheet film; in general they consider the 35-mm. transparency too small.

The easiest system for the amateur is the direct positive transparency processed by the makers; Kodachrome 35-mm. film is an excellent and well-established film of this kind, producing brilliant and comparatively correct colour rendering, including good blues, without a correction filter. In films like Kodachrome, the price includes processing.

Whether you want prints or transparencies, you must realize that the transparency will always show colours far more brilliantly than the colour print – just as in black-and-white. In one sense, a colour transparency can be likened to a window of stained glass and a colour print to a painting.

## Light and Colour

The systems outlined above will be described in detail later. Meanwhile, some general information on the composition of light and colour and their effects on photographic colour media must be given. An understanding of the basic principles is necessary if we are to produce the best results in colour. (See fig. 15, p. 141.)

What we call 'white' light is composed of all the colours of the spectrum: red, orange, yellow, green, blue, indigo, violet (for the memory: Richard Of York Gained Battles In Vain). The light from the sun contains those colours, each of which has a different wavelength, red having the longest wavelength and violet the shortest. Incidentally, the existence of the indigo as a distinct colour is often questioned. Outside the visible range is infra-red at the red end and ultra-violet at the violet end, both of which can affect photographic emulsions and must be deliberately countered or catered for. (Beyond ultra-violet come the X-rays.)

We can, however, reconstitute white light by combining red, green, and blue-violet light. These are the Primary Colours. By combining these three in different proportions we can produce *any* colour.

Making a new colour by combining other colours is called an additive process. Making a new colour by filtering away or absorbing other colours is called a subtractive process. For instance, yellow light is produced either by combining red light and green light (additive) or by removing blue light from white light (subtractive). Thus a yellow flower appears yellow because it subtracts blue from the white sunlight – it absorbs the blue rays and reflects the green and red. The complementary (or opposite) colour of yellow is blue because, added together, they complete white light. The complementary of green is magenta (blue-red) and that of red is cyan (blue-green). This means in the three-colour processes of photography that:

*Yellow* (green-red) on a negative colour transparency will produce its complementary *blue* on a positive transparency or print.

*Magenta* (red-blue) on a negative transparency will produce

its complementary *green* on a positive transparency or print.

*Cyan* (blue-green) on a negative transparency will produce its complementary *red* on a positive print or transparency.

Magenta subtracts green from white light and is therefore sometimes called 'minus-green'; yellow is similarly 'minus-blue' and cyan is 'minus-red'. Alternatively, cyan plus magenta make blue; cyan plus yellow make green; yellow plus magenta make red. Yellow, magenta, and cyan are the colours recorded respectively on the silver bromide of the three layers of the ordinary tri-pack colour film.

Red, green, and blue hardly exist in reality as pure colours. There is always a certain amount of the other colours mixed in with a primary, however pure it may look. So it is also with what we call 'white' light. Even daylight varies enormously in its colour composition, however white it may appear to be at most times. Black is, of course, merely lack of white light; a black object will absorb all three primaries equally and will reflect none. Grey is merely lack of some white light; a grey object absorbs a certain amount of the three primaries in equal proportions and reflects a certain amount in equal proportions. No object will reflect, or absorb, a particular colour if that colour is not contained in the light falling upon it. An object may therefore reflect and absorb colours differently according to the different kinds of light falling upon it. To realize this is important to the colour photographer because if he knows what are the colour contents of a particular light he can exercise control of the effects of the light on his colour emulsions. He must realize, for instance, that sunlight through clouds at midday will have quite a different colour content (more blue) from direct sunlight at evening (more red); that sunlight on a mountain-top will contain far more ultra-violet than sunlight on lowland. He must know that daylight is more blue than the light from photoflood lamps and that light from photofloods is more blue than that from half-watt lamps.

Can the colour composition of light be deliberately measured? And if so, how? The colour composition of a light source is

defined by its Colour Temperature. If an object is heated sufficiently it becomes incandescent and emits light, first at the red end of the spectrum and, as it glows hotter, the light picks up the colours of the spectrum until it glows finally with a white light. A poker, for example, will first glow red, then orange as it becomes hotter and then, if it is heated sufficiently, it would finally shine 'white hot' – the general tendency being the hotter the bluer. That is why sunlight has so much blue in its composition and why, because their filaments are hotter, floodlamps emit bluer light than half-watt lamps. Half-watt lamps, that is the ordinary household electric bulbs, give a much redder light than the eyes realize, about three-quarters of their radiation being infra-red which we feel as heat.

Colour temperature is measured in degrees Kelvin – that is the absolute scale, or Centigrade plus 273 degrees, the measure being based on a theoretically perfect radiator of heat. Light may vary in its temperature from some 2,500° to 20,000°K or more. The effective colour temperature of indirect sunlight on the earth's surface after it has been partly absorbed by the earth's atmosphere or by clouds may reach 20,000°K. The result on a colour photograph may render the shadows in a sunlit scene much bluer than our eyes led us to believe they were.

In spite of these colour temperature variations, we can call most daylight white except perhaps during a brilliant orange sunset, when, even to the eyes, the colour temperature is very low. Colour films, however, are more sensitive to changes in colour temperature than the human eye and changes of hue can be detected upon them after such small variations as 100°K.

Colour Temperatures of various light sources are approximately:

| Light Source | Degrees Kelvin |
|---|---|
| Candle | 2,000 |
| 60-watt tungsten lamp | 2,500 |
| 500-watt tungsten lamp | 3,000 |
| Photoflood lamp | 3,400 |
| Flashbulb (clear) | 3,800 |
| Electronic flash | 5,000–7,000 |
| Morning or afternoon sunlight | 5,000 |

| Light Source | Degrees Kelvin |
|---|---|
| Midday sunlight | 6,000 |
| Overcast sky, up to | 6,800 |
| Hazy sky | 8,000 |
| Clear blue sky | 10–25,000 |
| Sunrise or sunset, as low as | 2,000 |
| North skylight, up to | 15,000 |

The 'unnatural' colouring of many colour photographs *may* be caused by lack of balance in the composition of the three colour layers of the film, but it may be less 'unnatural' and more real than we may think. To render our colour photographs 'natural', in the sense that they appear as we think they should appear – or, alternatively, to be able to control their colours and falsify them deliberately when exposing – we must:

(a) Know the sensitivities of our film to different colours. (Even different batches of the same make of film can vary a little both in relative colour sensitivity and in speed.) Note that most colour films for daylight are adjusted for light of about 5,400° Kelvin, while colour films for artificial light are suitable for about 3,200°K.

(b) Know the Colour Temperature of our light.

(c) Know the effects of different compensation filters on the make of film we are using. (Or, if using lamps, the effects of colour filters placed over the lamps.)

A colour film is designed to give 'correct' colour rendering for a light of a given Colour Temperature. If the light we use does not conform with the Colour Temperature, or if we do not modify the Colour Temperature of the light with filters so that the light contents are adjusted to the film's character, the resulting colours on the film will be 'out of balance' and may have a definite overall colour cast; what should appear to be white or grey may, for instance, appear pale blue or a definite blue tinge may cover the whole transparency.

Special photo-electric colour meters have recently been designed by which the Colour Temperature of light can be measured. From readings we can judge whether or not the light conforms in colour content with that for which our film has been designed. If it does not conform, a suitable colour-correction

filter can be fitted in front of the lens before exposure to adjust the light.

Most amateurs will not possess these colour meters, which have so far been used mainly by professionals working in their studios. One such meter, the American Eastman Colour Temperature Meter, is no longer being made; the Kodak firm will in future stress the particular lamps which should be used with their films and will provide general advice about light composition. Apparently daylight readings from the meter proved to be somewhat misleading.

## Filters for Colour Photography

For straightforward colour photography under normal conditions, no colour correction filters are necessary. If you do consider a filter is necessary, then take the same shot both with and without the filter just in case you have miscalculated. Note that when unfiltered light is correct for a particular film, or when the light has been rendered correct by a suitable filter, the result will show white as truly white without any colour cast and greys will be truly grey.

Correction filters for colour photography are of gelatin containing a very low concentration of dye. They are much paler than the filters used in black-and-white photography. Filters in colour work come under the following headings:

1. Colour Compensation Filters for adjusting the Colour Temperature.
2. Conversion, or Correction. Filters for correcting films made for use in daylight so that they can be used in artificial light, and *vice versa*. For example, Kodak's Wratten 85 converts a Kodachrome A (made for artificial light) to a D (made for daylight).
3. Haze, or Ultra-Violet, Filters such as Wratten 1, Ilford Q, or Ansco U-V15 or U-V17.
4. Polarizing Filters to reduce scintillations or excessive highlights as reflected from glass or water. Because they cut out

some of the light from skies, they will render blue skies darker. For colour work polarizing filters *must* be of the neutral, colourless type. Double or treble the normal exposure (or equivalent increase in diaphragm stop) will be required with a polarizing filter.

Most colour films tend to give a slightly blue cast under normal daylight conditions (partly owing to ultra-violet rays) and so a pale amber, or haze, filter can be fitted and kept there for average outdoor shots. In very early morning or late evening, unless conditions are cloudy, a pale blue or pale green filter may be needed to balance the excessive redness in the light.

Conversion filters will be blue to correct a daylight film to artificial light and amber to correct a film for artificial light for use in daylight. When the amber filter is used the speed may be reduced by only 40%, but when a daylight film with a blue filter is used for artificial light, the film speed may be reduced four times. It is therefore sensible to use a colour film for the light conditions for which it has been designed. Blue-coated flash bulbs, such as Philips P56, will produce light equivalent in Colour Temperature to daylight and if these are used a daylight film requires no conversion filter.

Most makers of colour films produce Correction filters. The Kodak series are known as Wratten Colour Compensation, or Light Balancing Filters.

For cutting out excessive ultra-violet light, a U-V or 'haze' filter will be needed (such as Wratten 1 or 1A). These are colourless and require no extra exposure. An amber filter will also cut out ultra-violet as well as violet rays. Film makers provide full instructions for the use of compensation filters and the effects these have on film speed.

Long Exposures in Colour

To achieve correct colours when taking long exposures indoors in poor light is difficult because reciprocity failure may occur. This means that the three emulsions will become slower as time

passes and at an unequal rate. The usual result is a blue cast. Films vary in this respect and some practice may be needed with a selected film to achieve balanced colour values with the use of correction filters. Some films produce a cast after only $\frac{1}{10}$th of a second; others will give correct values for much longer. I have found Agfacolor Professional, for example, will remain correct without filters for 45 seconds or longer. Kodachrome requires colour correction filters as follows:

| $\frac{1}{10}$th of a second | CC05R | (no increase of stop) |
| 1 second | CC10R | ($\frac{2}{3}$ increase of stop) |
| 10 seconds | CC20R | ($1\frac{1}{2}$ increase of stop) |
| 100 seconds | CC25R | ($2\frac{1}{4}$ increase of stop) |

My Penguin Handbook, *Colour Photography*, covers filtering and other matters in fuller detail.

## Additive System

The differences between the Additive three-colour screen or *réseau* film and the Subtractive tri-pack film were explained on pp. 50–52. To recapitulate briefly: In the Additive system the photograph on panchromatic emulsion is taken through a screen having minute squares or lines of blue, green, and red dye. When developed and reversed to positive the image in the silver deposits obscures the colours of those squares not required; those that are required to show are not blocked by the silver deposits.

| | | | | | | | | | | | | | |
|---|---|---|---|---|---|---|---|---|---|---|---|---|---|
| | | | | | | | | | | | | | *film base* |
| R | G | B | R | G | B | R | G | B | R | G | B | | *réseau* |
| | | | | | | | | | | | | | *varnish* |
| | | | | | | | | | | | | | *emulsion* |
| | | | | | | | | | | | | | *black paper* |

34. Section of an old type of additive colour film (Dufaycolor) with its screen or *réseau* of minute areas of red, green, and blue.

The method is little used now for it has two disadvantages. First, the screen absorbs too much light, so that the transparency loses two-thirds of its brilliance even in the white areas. This means that large projections from a lantern are not possible unless the lamp used is excessively powerful. Secondly, the screen will be visible as a grain if enlarged beyond a certain point. On the other hand, the colour is truer and tends to be softer than in Subtractive tri-pack films, the exposure latitude is somewhat greater, processing could be done at home (not possible with some Subtractive films), and a certain degree of control by means of reducers and intensifiers is possible during processing. Perhaps the Additive process is at its best when the larger commercial sizes of cut film are used.

## Subtractive Systems

Today only the Subtractive, three-layer or tri-pack films are in general use by amateurs. Two kinds are now made: the Reversal type which produces a directly positive transparency and the Negative type which requires printing to produce a positive either as a transparency or on paper. (The Additive system was of the Reversal type only.)

Both Reversal and Negative types of Subtractive films are made in two, and sometimes three, varieties to suit either daylight or artificial light. Daylight films are usually labelled D, those for Photoflood lamps A, and those for studio tungsten lamps B. As we have seen, Conversion Filters can be used to render one type suitable for a kind of lighting for which it has not been primarily designed.

| UNEXPOSED FILM | THE POSITIVE |
|---|---|
| Blue sensitive emulsion | *Yellow image* |
| YELLOW FILTER | |
| Green sensitive emulsion | *Magenta image* |
| Red sensitive emulsion | *Blue image* |
| Film base with anti-halo coating | |

35. Section of a subtractive colour film (Kodachrome and many others) with its three layers.

The Subtractive tri-pack film consists of three very thin layers of emulsion. The upper layer records only blue-violet light, the middle layer only green and the bottom layer only red. Between the top layer and the middle layer is a yellow dye which is dissolved during processing; the top layer, sensitive only to blue and violet, is the old Ordinary type of emulsion and the yellow dye prevents any blue light penetrating to the second and third layers while allowing green and red to penetrate. The second layer is orthochromatic and insensitive to red; it will therefore record green. The third layer is an emulsion more or less exclusively sensitive to blue and red and hardly at all to green; because all blue has been absorbed by the top layer and the yellow filter below it,

this bottom layer will record only red. During processing all the silver deposits on the three layers are replaced by the appropriate dyes of the three primary colours or their complementaries, according to whether the film is Reversal or Negative. The silver deposits are eventually dissolved away entirely.

To explain the process more fully: During the first step of processing, the three layers are developed as ordinary black-and-white images, without colour. In positive (reversal) films, the film is then exposed to white light, which makes the remaining undeveloped silver able to be developed. A second development is then given in a special developer which acts on each layer, producing the appropriate colour dye in proportion to the amount of silver reduced. At this stage the film is completely opaque, since all silver has been blackened. Next the blackened silver is bleached and dissolved away, together with the yellow separation layer, leaving nothing but the colour images.

In colour negatives the first development produces the appropriate dyes as the silver is reduced, and the blackened silver is then bleached. The final fixing bath removes the silver, leaving the finished colour negative.

The dyes which replace the silver deposits are practically grainless and so the old problem of grain which arises in black-and-white photography need not worry us in the three-layer colour processing; even 35-mm. colour transparencies can be enlarged to any practicable size with little appearance of grain. Dust is another matter.

Never keep a colour film too long in the camera and see that it is processed as soon as possible after exposure or the freshness of the colours may be lost. After processing, handle the transparencies carefully and mount each frame either between glasses or insert it into one of those special holders which the shops supply.

Colour Films Available.

Most of the available tri-pack films are made in 35-mm. size taking twenty frames each, but some are available as larger roll films and others also as cut films.

Kodachrome, at time of writing obtainable only in 35-mm. and the small cartridges, was the first tri-pack film to be marketed, for it appeared in 1935. This is an excellent reversal type which must be processed by the makers, the processing being complicated.

Ektachrome, also a Kodak product, is a type which can be processed at home. Agfacolor followed Kodachrome in 1936 and this is available in both Reversal and Negative forms. Kodacolor, introduced in 1942, is the equivalent of Kodachrome but in negative form. Other types of film and their characteristics are listed on pp. 302–3.

Whatever the type of film, nearly every one requires its own method and special chemicals for processing; as yet there are no universal methods as there are with black-and-white. Home processing consists of treatment in five or more different solutions. It takes much longer than processing of black-and-white, but is not difficult. A limited amount of control of colours may be possible by shortening or lengthening the time of treatment in some of the solutions. For instance, slight under-exposure followed by first development for a longer time than is recommended may produce more brilliant colours or modifications of colour compositions. On the whole, this kind of experimentation is possible only for those with a great deal of spare time and spare cash. Control at time of exposure is more satisfactory.

## Home Processing

A rough description of the procedure with a typical kit will indicate what is involved. Part 1 contains first developer and colour developer. Part 2 contains Hardener, Bleach, and Fixer. All the chemicals are in powder form; they must be dissolved in water and the solutions poured into five separate bottles. A spiral tank is used. Load tank with film in total darkness and with lid on develop for 20 minutes in First Developer. Wash for 20 minutes. Remove film from tank and expose both sides thoroughly to a Photoflood lamp for about $1\frac{1}{2}$ minutes for each side. Replace film in spiral holder. From now on the film can be treated in ordinary artificial light, though not in daylight. Develop for 10 minutes in

the Colour Developer. Wash for 20 minutes. Harden for 8 minutes. Wash for 5 minutes. Bleach for 10 minutes. Wash for 5 minutes. Fix for 8 minutes. Wash for 20 minutes. Rinse finally in water containing a wetting agent. Dry.

The processing of Ektachrome is very similar, though the chemicals are made by Kodak. Distilled or boiled water in all cases is preferable to tap-water, but it is not essential. Exact temperature control is very important.

The latest and most remarkable colour film is the 35-mm. High Speed Ektachrome (reversal only at 160 ASA in daylight). Thus colour transparencies can now be obtained in poor light with good depth of field and with improved latitude so that a less accurate exposure is necessary than with the slower films. Colours are fairly soft, shadows show plenty of detail and contrasty subjects can therefore be taken.

The Kodachrome 25, new version of the famous old 35-mm. colour film, has a speed two and a half times the original and thus a wider exposure latitude (25 ASA instead of 10). The colour rendering and resolution are also improved.

Some well-known colour films now being produced are noted on the next two pages. The reader must realize that modern colour photography is young and is developing rapidly – so rapidly that published information on the subject tends soon to be partly out of date. Read the following therefore as marked Errors and Omissions Excepted:

## COLOUR FILMS: REVERSAL (POSITIVE)

| Trade Name | Sizes | Balanced for | ASA Speeds |
|---|---|---|---|
| Agfachrome Professional S50 | 35-mm. and 120-roll film | Daylight | 50 |
| Agfachrome Professional L50 | 35-mm. and 120-roll film | 3,200°K Tungsten | 50 |
| Agfacolor CT 18 | 35-mm. and 120-roll film | Daylight | 50 |
| Agfacolor CT 21 | 35-mm., 126 cartridge and 120-roll film | Daylight | 100 |
| Ektachrome X | 35-mm., 110 and all roll films | Daylight | 64 |
| Ektachrome High Speed | 35-mm. and 120-roll film | Daylight | 160 |
| Ektachrome High Speed Type B | 35-mm. and 120-roll film | 3,200°K Tungsten | 125 |
| Ektachrome Professional | 120-size and sheet | Daylight | 50 |
| Ektachrome Professional Type B | 120-size and sheet | 3,200°K Tungsten | 32 |
| Orwochrom UT18 | 35-mm. and 120-roll film | Daylight | 50 |
| Peruchrome C19 | 35-mm., cartridge and 120-roll film | Daylight | 80 |
| Kodachrome 25 | 35-mm., 828 film | Daylight | 25 |
| Kodachrome 64 | 35-mm., 126, 110 | Daylight | 64 |
| Kodachrome II Professional Type A | 35-mm. film | 3,400°K Tungsten | 40 |

## COLOUR FILMS: NEGATIVE

| Trade Name | Sizes | Balanced for | ASA Speeds |
|---|---|---|---|
| Agfacolor CNS | 35-mm., cartridge and 120-roll film | Daylight | 80 |
| Agfacolor CN 110 | 110 cartridge | Daylight | 80 |
| Kodacolor II | 35-mm., and 110 cartridge for Instamatic cameras | Daylight | 80 |
| Kodacolor Vericolor II Professional, Type S | 35-mm., roll and sheet film | Daylight | 100 |

Colour Correction after Processing

Some degree of colour correction in transparencies is possible after processing by very simple means. If the transparency has colours which are out-of-balance and a definite overall cast is evident, bind it between two pieces of glass together with a pale colour filter of gelatin to compensate. Too much blue, for instance, can be corrected with a yellow filter. Tinted cellophane sheets can be used as alternatives to gelatin filters.

Monochrome Printing from Colour Transparencies

Excellent black-and-white enlargements can be made from colour transparencies because the film has little grain. With colour negatives the procedure is simple and the positive black-and-white enlargement can be made direct as for ordinary black-and-white enlarging, though soft-grade paper will probably be needed because colour transparencies tend to be somewhat contrasty. Moreover, reds will be too dark and blues too light unless an orange filter is used. However, Kodak now produce a special panchromatic paper called Panalure which yields black-and-white prints from colour negatives with tonal rendering similar to prints made on ordinary bromide paper from negatives on panchromatic film. It must be developed in almost complete darkness because of its sensitivity to all colours, so that clear inspection during development will not be possible.

With reversal (positive) transparencies, the procedure is slightly more complicated. Either an enlarged negative is made from the transparency and is then printed by contact, or is further enlarged – or a contact negative is made from the transparency and is then enlarged in the usual way. A panchromatic plate or cut film should, of course, be used for the intermediate negative.

# 16 Colour Prints

## General

As in black-and-white photography, the print in colour is far less brilliant than the transparency. This is inevitable because the print is seen by reflected light, whereas the transparency is seen by direct, penetrating light. Nevertheless, the colour print has its attractions in that it does not require a medium such as a viewer or a projector to display itself adequately. At present a disadvantage of colour prints is their tendency to fade in time, at least if exposed continually to very bright daylight.

The various colour print systems now available are:

1. The making of three black-and-white negatives on panchromatic emulsions exposed directly to the subject, each through a different filter – red, green, and blue. The negatives are then printed on bromide paper, converted to three coloured dye transfers or pigment reliefs which are finally transferred in register to a paper backing.

2. The making of three separation negatives through the three coloured filters from a colour transparency either by means of a camera, an enlarger, or contact printing frame. Thereafter the printing is accomplished as in 1 above.

3. Printing from either a negative or positive transparency direct on to a material such as paper or white opaque celluloid which has an integral tri-pack, or three layers of emulsions, similar to those of tri-pack colour transparencies.

## Prints from Three Transfers

This is the oldest surviving colour print system, the most laborious of all but the most controllable and the most rewarding. It

permits a degree of control of colours in the final print comparable to that obtainable in ordinary black-and-white bromide printing. Moreover, the prints are comparatively fadeless.

First take the three separation negatives through the three special tri-colour gelatin filters of red, green, and blue on panchromatic film or plates. The filters used should be those specially made for the particular film or plate selected. The photographing of the three negatives can be done in an ordinary camera of any size, though the larger the better. The main requirement is a firm base such as a sturdy tripod because the camera must not move even a tiny fraction while the three exposures are being made – that is for at least 20 seconds. Each exposure must be timed according to the filter factors recommended by the makers.

This method of taking three successive pictures means, of course, that only still subjects can be photographed with an ordinary camera. When a moving subject is wanted in this colour process a one-shot camera must be used – that is a camera specially made to take the three exposures simultaneously, like the Eves One Shot. Such cameras are complicated and costly, but with them the finest colour prints can be made. To increase the speed with which the three exposures can be made, a repeating back can be used, such as the Autotype, which brings the plates into position rapidly within seven seconds. A still more rapid type of back is the old Vivex Automatic Repeating Back which brings the plates into position by a clockwork mechanism within about two seconds.

Today the preference is not to take the three separation negatives with the camera but to take single tri-pack shots on colour transparencies and then to separate these out into the three negatives with the enlarger.

The three separation negatives must be of exactly the same density, though each will represent a different colour. The density can be checked in each negative by comparing an identical patch of some object which was grey in the subject and therefore contained the three primaries in equal quantities. The three negatives must be given identical development; control will come, not at the development stage, but later during printing.

The Kodak Dye Transfer process of printing in colour from

three separation negatives is briefly as follows: The negatives are
each printed by contact or enlarged on to Kodak Matrix film, a
yellow-dyed silver bromide emulsion on a celluloid base, expo-
sures being made through the base. The three celluloid films are
developed in a tanning developer and then dipped in a stopbath.
They are now washed in hot water; the washing removes all the
gelatin in the emulsion except that which has been affected by
the silver deposit formed during development. A gelatin relief
image is thus formed. When dry, each of the three matrices is then
dipped in a special dye, the respective colours being yellow,
magenta, and cyan, that is, those which are complementary to the
respective colours of the filters used in exposing the original
negatives. The gelatin reliefs will absorb different amounts of dye
according to the thickness of the gelatin at each point. The images
are then rinsed in weak acetic acid and the length and strength of
the rinse will give some control of the colours of the first print.
Finally, the three reliefs are successively pressed with a squeegee
or copying press on to a gelatin-coated Dye Transfer Paper – all
three being kept strictly in register by means of a Dye Transfer
Blanket. In this way the three colours are transferred to the final
paper base to make the colour print, the sequence being cyan,
magenta, yellow. Up to a hundred prints can be made from the
same matrices or reliefs.

Unfortunately, the excellent old system of Autotype Trichro-
matic Pigment Papers is no longer available.

## Separation Negative System with Transparency

This method is the same as the previous one described, with the
difference that the three separation negatives are made, not direct
from the subject, but from a positive colour transparency. For
success in this method the transparency must be of good quality
because any faults it may have tend to be exaggerated in the
printing. The three separation negatives can be made by re-
photographing the transparency with a camera, or with an enlarger
using the tri-colour filters. Exposures through the three filters
will vary in time. Alternatively, contact negatives can be made

through filters and subsequently enlarged as the part-images.

Masking may be necessary when making the colour separation negatives and this may be density, or contrast, masking or colour-correction masking. A transparency may have too wide a density range for reproduction on paper and this density can be reduced by combining a weak and slightly unsharp monochrome negative in register with the transparency before making the separation negatives. The masking negative will have been made by contact with the transparency; it will add neutral density to the highlights without affecting the shadows. Colour-correction masking adjusts the colour balance of the separation negatives and consists in combining a positive monochrome image, made by contact on non-colour-sensitive film or plate (Ordinary) from the red-filter negative, with the green-filter negative, and combining one made from the green-filter negative with the blue-filter negative.

## Direct Colour Printing

The direct colour print is similar to the tri-pack colour transparency, though its base is either opaque celluloid or paper. It can be produced from a positive transparency and reversed during processing, or it can be produced more easily from a colour negative without reversing. Some systems can be processed by the amateur, others only by the maker or the trade. These direct colour printing methods are undergoing rapid development and the situation is fluid.

Positive colour transparencies called enprints are now produced by the trade from colour negatives, for a few pence each. So far, I have found the aesthetic results depressing compared with those of the brilliant little reversal transparencies; but we must hope for improvements. Note that it is perfectly possible for the amateur to print a negative transparency from a positive one, using daylight film in artificial light; from the negative a positive print can be made on tri-pack paper using a yellow colour-correction filter.

Encouragement of the advanced amateur to do his own colour

enlargements by simplified means is now being given by the big film and paper manufacturers who are producing special kits for processing. The excellent Durst system of colour-print enlargers with dialled and infinitely variable filtration, using Agfa papers, and only three chemicals, is now being marketed by Johnsons of Hendon. Patersons produce a cylindrical processor which can be manipulated in daylight once the print is in the tank. Kodak also market a do-it-yourself enlarging kit involving three baths.

Apparatus is now being made by which a 35-mm. camera can produce inter-negatives from positive transparencies as the first step to making colour prints on multi-coated papers.

A new development in colour printing is resin-coated paper whose paper base is covered on both sides with poly-ethylene so that only the emulsion takes up the processing liquids, thus saving time, chemicals and washing needs; curl is also eliminated.

## Conclusion

If you now feel alarmed at the amount of knowledge that seems to be necessary to produce a simple snap, take comfort in this thought: that all you need to do at first is to buy a box camera and a film at your local chemist shop, insert the film into the camera under the eye of the chemist himself, go home, wait until the rain stops, then look into the viewfinder, hold steady, press the lever calmly, wind on the film, and, when the roll is all exposed, return it to the chemist for treatment and wait hopefully for the best. You may have produced some excellent pictures. Then perhaps you will grow more ambitious and return to these pages for advice. But remember what the Dodo said: 'The best way to explain it is to do it.'

# Selected Bibliography

## HISTORY

*The History of Photography from 1839 to the Present Day*, by Beaumont Newhall (Secker & Warburg). A classic, beautifully illustrated in black-and-white.

*A Concise History of Photography*, by Helmut and Alison Gernsheim (Thames & Hudson). Generously illustrated in colour and black-and-white.

*History of Color Photography*, by J. S. Friedman (Focal Press).

*A Century of Cameras (1839 to 1940)*, by E. A. Lothrop (Fountain Press).

## AESTHETICS

*Principles of Composition in Photography*, by Andreas Feininger (Thames & Hudson). A professional's views.

*Art and Photography*, by Aaron Scharf (Allen Lane The Penguin Press). On the relationship between painting and photography.

## TECHNIQUE

*The Focal Encyclopaedia of Photography* (Focal Press). General reference work by international team, fully illustrated.

*35 mm. Photo Technique*, by H. S. Newcombe (Focal Press). Informative; has gone into many editions.

*Camera Movements*, by G. L. Wakefield (Fountain Press).

*Lighting for Photography*, by Walter Nurnberg (Focal Press). Well illustrated, well established.

*Developing*, by C. I. and R. E. Jacobson (Focal Press). Valuable, well established.

*The Complete Art of Printing and Enlarging*, by O. R. Croy (Focal Press). Comprehensive, well illustrated.

*Enlarging*, by C. I. Jacobson and L. A. Mannheim (Focal Press).

*Retouching*, by O. R. Croy (Focal Press). All the amateur needs to know.

## Photography

# Index

*Numbers in bold type refer to plates*